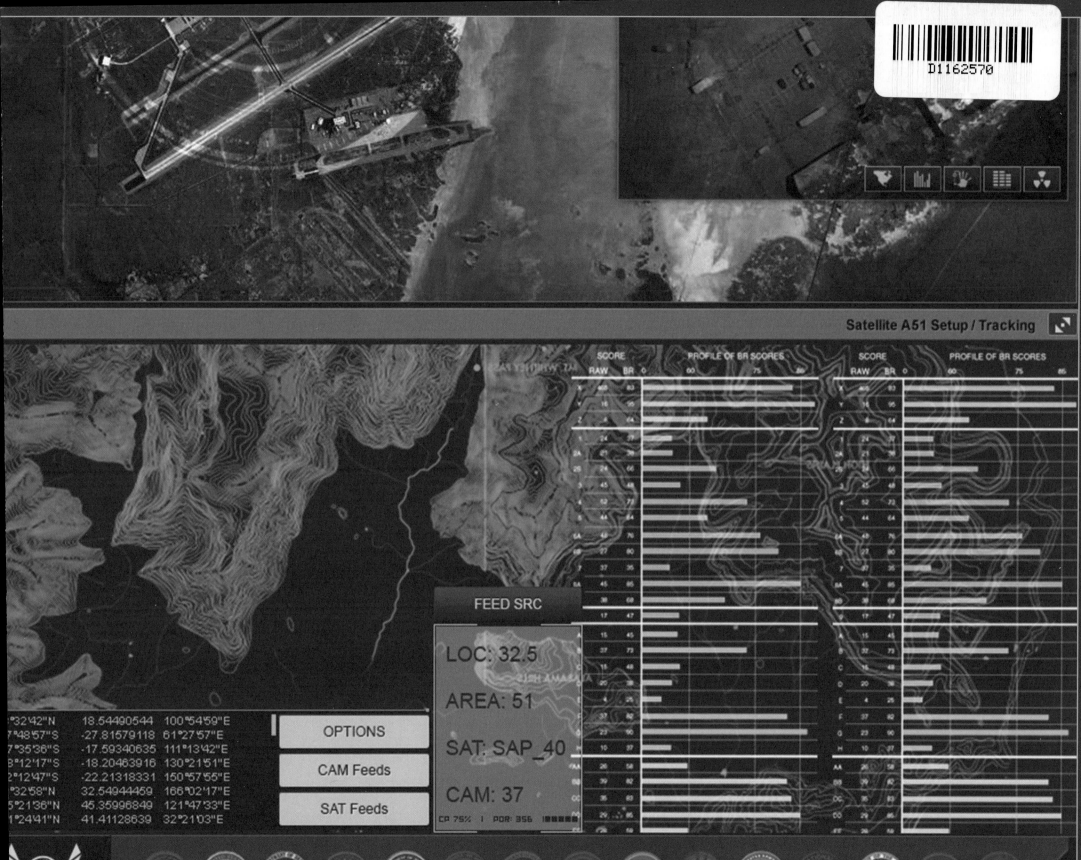

THE ART & MAKING OF

INDEPENDENCE DAY

RESURGENCE

The Art and Making of Independence Day Resurgence
ISBN: 9781785651373

Published by Titan Books
A division of Titan Publishing Group Ltd.
144 Southwark St.
London
SE1 0UP

First edition: June 2016
10 9 8 7 6 5 4 3 2 1

To receive advance information, news, competitions, and exclusive offers online,
please sign up for the Titan newsletter on our website: www.titanbooks.com

Did you enjoy this book? We love to hear from our readers.
Please e-mail us at: readerfeedback@titanemail.com or write to Reader
Feedback at the above address.

A CIP catalogue record for this title is available from the British Library.

THE ART & MAKING OF

INDEPENDENCE DAY

RESURGENCE

SIMON WARD

FOREWORD BY

ROLAND EMMERICH

TITAN BOOKS

CONTENTS

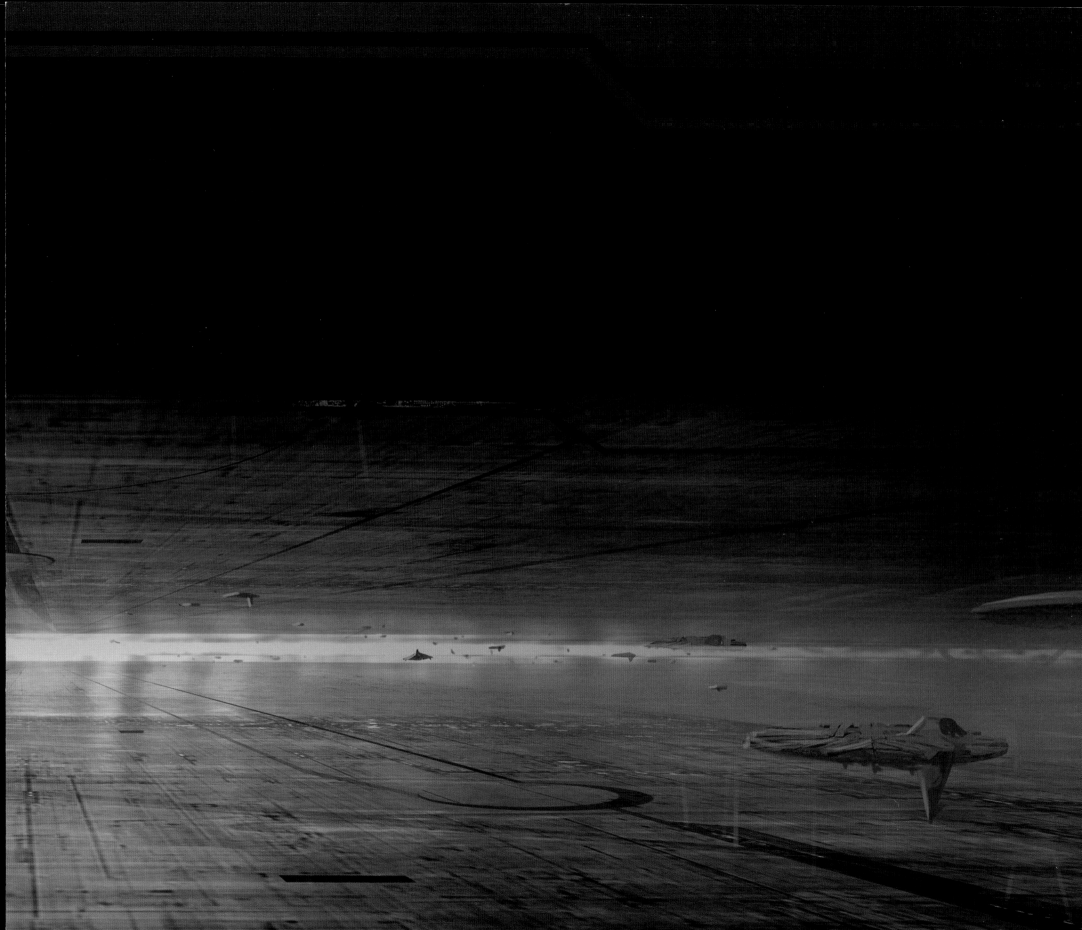

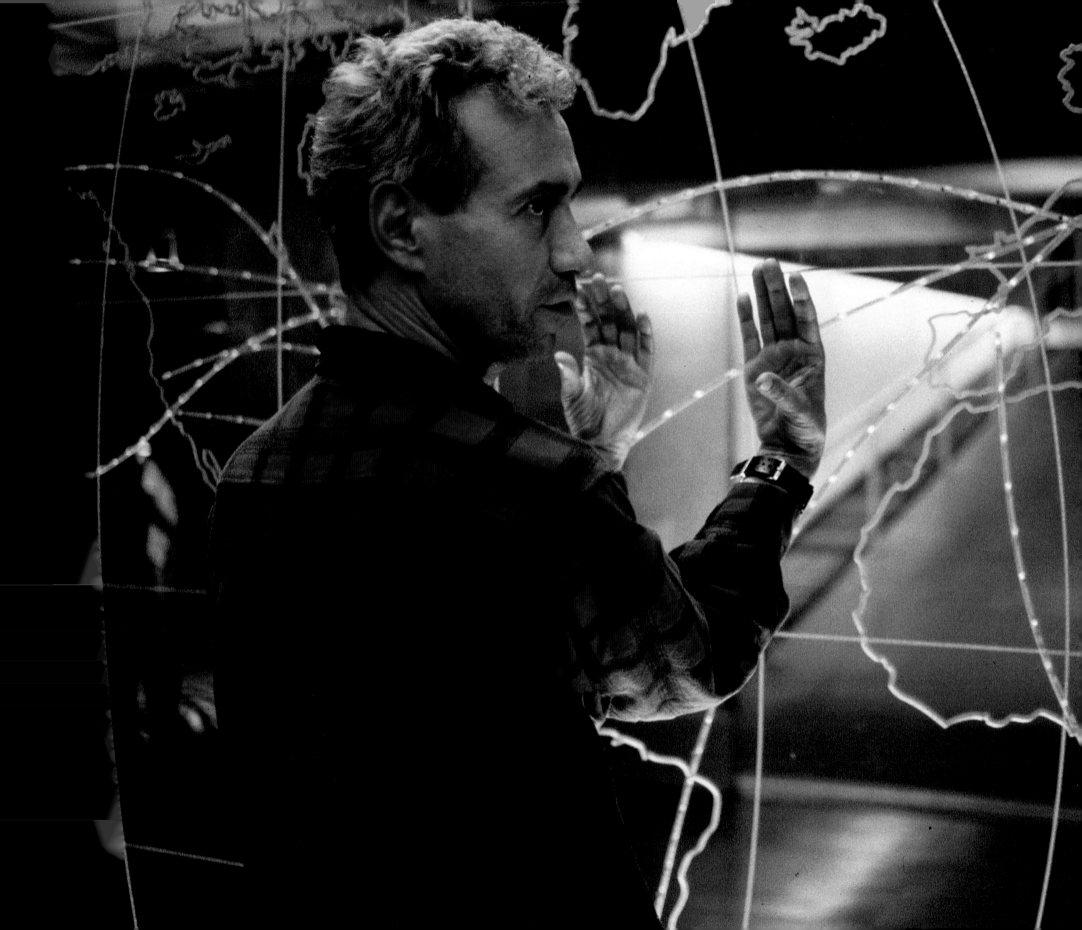

FOREWORD

In 1996, an alien invasion-disaster movie made using practical effects, miniatures, pyrotechnics, and world-class actors became the highest grossing film of the year worldwide. It was a fun, un-cynical event that you watched on the biggest screen you could – screens big enough to show you a spaceship hovering over, and then wiping out, an entire city.

And now we're back. It's still fun, we still have world-class cast and crew, but we're bigger. Much bigger.

I always publicly said we were going to do another one. It's the film the fans have always asked us about. For Dean Devlin and I it was about getting the story right and waiting for the reason to do it. 2016, the 20th anniversary, made sense for us and the characters. It brought us to a realistic place where the world and technology – both real and fictional – had changed enough to allow us entry into a whole new story.

It was like a school reunion, seeing old friends both in front of and behind the camera again. Enough time has passed that there was no sense of obligation – everybody came back because they wanted to, because they care about continuing the story in an exciting, worthy way. The new generation has brought a freshness to the franchise and pushed it in a new direction that I believe the fans will love. This has been the most exciting thing for me – this handover from old to new, this next step.

The technicalities of making an *Independence Day* movie have changed in almost every way. We shot everything in-camera on the first film. The dogfights, for instance, were second unit and very time-consuming, taking 3-4 weeks. This time the dogfights took 3-4 days on bluescreen. It was fast, really fast, which is more fun for actors.

The schedule for *Resurgence* was to shoot in 75 days; we added three days for reshoots and coverage. Not bad for a film of this scale. In addition there was no second unit – something I've never done before. On this one I wanted to shoot it myself. It means I can't blame anyone if I'm not happy with something. What does this mean? Panic. Panic, but excitement, constantly. It's frightening and fun – much like any good alien invasion movie should be.

The only way to make a film like this is with people with incredible imaginations who are the best at what they do. If you have that then the universe is the limit.

This book is a story 20 years in the making and presents to you as much as we can of all the work done by these amazing designers, builders, effects teams, actors, and more. From the earliest ideas and designs in *Independence Day*, featuring models and miniatures that brought what became a huge movie to life, to *Resurgence* and the hundreds of pieces of concept art, set photos and the practical builds, such as our amazing Moon Tug – it's all in this book you hold in your hands. These are huge films, telling an enormous story about mankind and the human spirit. And this is an appropriately huge book; a record of the incredible contributions from just some of the gifted collaborators I have had the pleasure to work with. Together we have destroyed a world, rebuilt it, now destroyed it again. After going through all this, twice, our beloved characters are still standing, and so are all the people who worked on the films. I hope this book shows our filmmaking process, our journey but also our passion and enthusiasm for this world.

It's time to celebrate *Independence Day* – and kick some serious alien ass – again.

ROLAND EMMERICH

A HISTORY OF THE ALIEN WAR

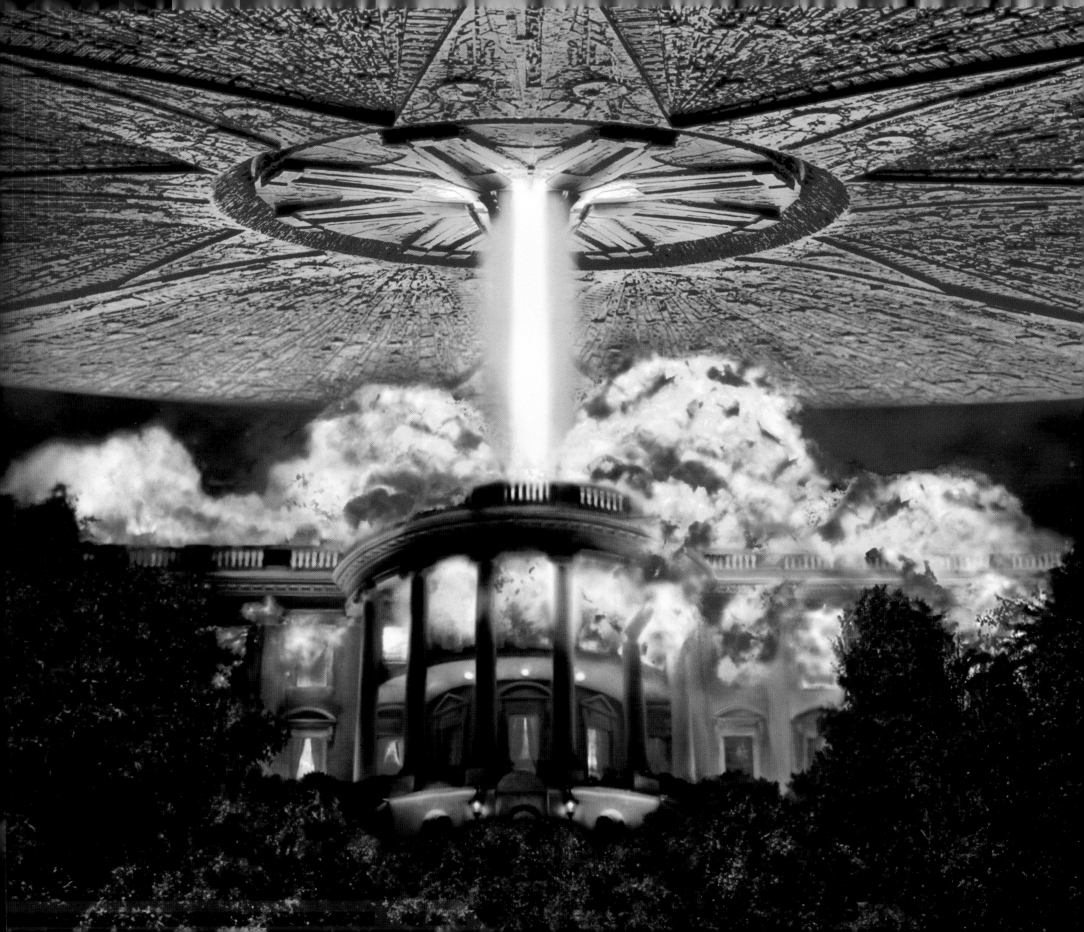

DAVID LEVISON

A HISTORY OF THE ALIEN WAR

I never wanted to travel in a spaceship.

I prefer a bicycle. I like it here on Earth, on the ground, and protecting the environment was and is my chief concern. Protecting and preserving our Earth – against pollution, the deterioration of the ozone, the exhaustion of natural resources. And against hostile alien forces intent on eradicating mankind.

On July 2nd 1996, I was playing (and winning) chess with my father, Julius.

On that day, the world and the history of the world changed forever. Unbeknownst at first to the majority of the population, alien forces arrived just outside our orbit, sending out their ships to the key cities on our planet. Like chess, they moved their pieces into position – and waited. The ships were big. Huge. More enormous and more intimidating than we could have ever imagined. The whole world seemed to fall under their shadow as they hovered silently. Finally, after centuries of wondering, we knew we weren't alone in the universe. But we didn't feel like we'd made a new friend either.

At that time I worked at Compact Cable in New York city, with my good friend (and boss) Marty Gilbert, keeping communications and transmissions active. When the spaceships rolled in all the lines went down and the satellites were scrambled. I pacified Marty (for a few moments), set to repairing the problem, and I found something, something hidden away, something that I wasn't supposed to find. Embedded within our own satellite transmissions was a signal belonging to our new arrivals. They were using it for two purposes: To co-ordinate their movements and as a countdown. To what? In my experience, it's tradition on Earth for a countdown to end with a bang.

I told Marty to get out of town. I grabbed my father and we headed to D.C., where my estranged wife Connie worked at the White House. President Whitmore and I had had some minor disagreements in the past: At one point all the evidence seemed to suggest that he and Connie were having an affair. They weren't, but I only found that out after I hit him.

For the time being I was able to put all that behind us. I told them about the countdown. The President ordered an evacuation of all major cities and the White House.

There's things you don't forget: your bar mitzvah, your wedding day, your first checkmate. I remember sitting on Air Force One on July 3rd with the only people I loved next to me as the countdown reached zero.

The spaceships unloaded their weapons directly onto the cities below and everyone in them – those welcoming the

"BILLIONS OF PEOPLE DIED IN THOSE FIRST FEW SECONDS."

aliens and those trying to escape alike. Walls of fire swept through New York, D.C., Los Angeles, London, Moscow, and many more on a scale we could never have imagined even in our darkest nightmares. We had been warned for decades about what would happen if we mistreated our precious planet, but no one expected this. I'm not for a second claiming this was karmic or that this was some kind or divine punishment. No, we knew who was responsible. And we had to fight back.

The President, General Grey, and what little remained of the US government ordered a response, and our best squadron, the Black Knights, took to the sky from El Toro, California, lead by Captain Steven Hiller. According to him, his exact words were that he was "just a little anxious to get up there and whoop E.T.'s ass."

They engaged over California and Nevada, with the spacecrafts releasing smaller attack ships – faster, better

equipped and in far greater numbers than our or any country's air forces. We found out the hard way that all their ships, big and small, were protected by shields. It rendered our weapons completely ineffectual. We listened and watched helpless as the Black Knights were whooped. It took a few hours for us to find out, but Steve Hiller was the only survivor, and he had a reward for his troubles: a live alien specimen.

Meanwhile, back on Air Force One, we were having an empirical debate. "Truth, justice, and the American way," that's what we say, but it's incredible how often each of those cancel the others out. My father was loudly claiming that this whole apocalypse could have been avoided, we had time to prepare because of the alien crash landing in the 1940s at Roswell, and the subsequent findings at Area 51, Nevada. Everyone in the room, including me, told my poor, deluded father he was wrong. We knew he was wrong. That was the truth. Until it wasn't. To paint a slightly more accurate picture, an alien craft had crash landed at Roswell, Area 51 did exist, and it had been, unsuccessfully, kept secret for 50 years.

Ladies and gentlemen: truth, justice and the American way. And like that, a quick plane ride, a casual reference to 'plausible deniability,' and millions of American deaths later, we were at Area 51.

It was impressive. Shiny. I'm unsure how environmentally friendly it was, but it had a fridge filled with alcohol, which I, to my shame, investigated thoroughly after the President ordered a nuclear strike against the alien crafts. A nuclear strike that would destroy whatever life was remaining in our land.

I've never understood his thinking on this point. I could

never understand anybody who would make that decision. If we can't have the Earth to ourselves, then no one can? Everything must die? It doesn't make sense at a moral level or for any species who simply want to survive. It isn't forward-thinking and investing in the future, but the President made the decision in the heat of the moment, when he was angry.

But I'm getting ahead of myself. Heat of the moment. Slow down. Where was I?

We arrived at Area 51. The research facility was headed by Dr. Okun and he brought us to his pride and glory: a 50-year-old, semi-functional alien craft. In the last few days, since the attacks, the ship had come to life. Okun called it "exciting"; Whitmore begged to differ.

Further into the facility the good doctor showed us the three alien specimens they had preserved. Here's what he told us: they breathe oxygen, have eyes and ears. Their bodies are frail, like ours, but are housed in biomechanical armor. They have no vocal chords and he surmised they communicated telepathically – a theory he was soon able to test directly.

Captain Hiller arrived, carting his new extra-terrestrial friend in the back of a pick-up truck. From what I learnt later, it seems that Okun and his team began an immediate autopsy, believing the creature to have perished. First its fingers moved, then its hand. Then its tentacles.

Everyone in the operating room was killed. When Whitmore, General Grey, and Major Mitchell (who worked at the facility) arrived on the scene what they found was Okun at the mercy of the alien. One of its tentacles was coiled around his neck and it used him to communicate to those outside. It used Okun like a parasite uses a host, enslaved.

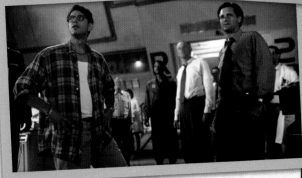

It said it wanted our world. It wanted us to die. There could never be peace between our species. All good news.

With those three strikes, he was out. Mitchell shot the creature, Whitmore ordered a nuclear strike, and I went to get a drink.

My dad and I tell the next bit slightly differently. He found me not at my best in the hangar housing the spacecraft. I'd drank too much and felt as hopeless as I ever had. I was angry and helpless. The aliens had won the battle and now we were going to win the war via mutually assured destruction. I had failed to protect the planet and I had failed my father and Connie – we may have been separated but I still loved her dearly.

Dad came in. I kicked something. I fell down. My head hurt. He said he had lost faith and hadn't spoken to God since my mother died. But things could be worse. At least I still had my health.

He claims he said (and I quote): "In our darkest hour, when all hope is lost, never give up! You have to have faith!" And then he came up with the idea that saved the world.

Or rather, he warned me I would catch cold. And a thought occurred to me.

I had already stumbled upon the aliens' signal once. If I could hack into their transmission again and introduce a computer virus, it could, could, deactivate their shields. That could (I really cannot stress 'could' enough) give our flyboys enough time to do their thing and bring the ships down.

There was only one problem. Although, that isn't true; there were many problems. But we were desperate.

The main problem was getting close enough to the mothership sitting outside our orbit and delivering the virus directly into their mainframe. The solution: Steve

Hiller and I in the Area 51 alien craft, casually drifting into the solar system, straight into the mothership itself. Just for good measure we'd drop a nuclear warhead in there as well, make our excuses, and leave.

No applicable move exists in chess for what we were trying to do, but if it did it would probably be something like sending a pawn to snuggle up to the opposing queen while every single other piece just runs havoc behind them.

I like Steve. For a hotshot pilot, he's a grounded guy who loves his family.

He's a brave man and a hero. I trust him. Although he's obsessed with fat ladies singing.

So my issue with going up into space and Trojan-horsing our way into the alien mothership wasn't Steve. No, my issue with going into space was going into space. And there were some things to take care of before we left.

I readied the virus for delivery while our team contacted the world's remaining armed survivors using good old fashioned Morse code. Together they coordinated the time when all fighters would take to the air and attack the ships over their respective countries, in sync with when the virus should have taken down the defensive shields.

Then there were goodbyes. Throughout all the chaos of the last two days, Whitmore's wife, Marilyn, was missing, her escape helicopter having never made it out of California. It is to his great credit that even though his every other waking thought must have been for her safety, he never let it show but

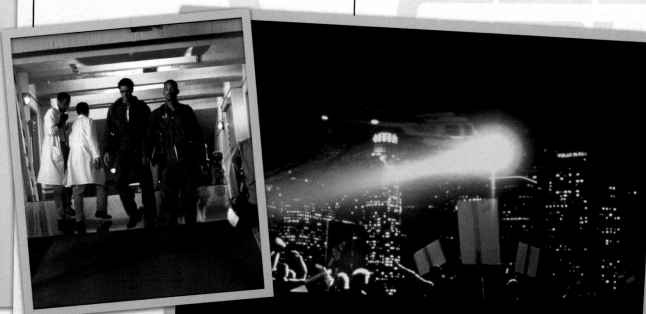

rather acted like a leader throughout the lowest moments of mankind's history. Steve's girlfriend, Jasmine Dubrow, survived the attack on Los Angeles and in making her way through California and Nevada she helped all those she could, including Marilyn. When Steve tracked them all down and brought them to Area 51, everyone who could be saved was saved. But for others it was too late.

The President was with his wife at the end.

Jasmine and Steve made their relationship legally binding, with her son, Dylan, serving as the ringbearer. Connie and I witnessed. I think seeing them make their promises reminded us what we had once had – and could have again.

If I ever came back from space.

On July 4th, Independence Day, mankind retaliated. A lot of lost souls came together for one final push. This was our last and only roll of the dice. The President gathered before everyone and said as much. He said we would make it. I truly think all those listening believed him and sometimes that's enough. Belief.

Unfortunately, no amount of belief could make me happy about flying in a spaceship. They even tried to make me feel the part by putting me in a fighter pilot outfit. I was impressed they had my size – I am quite tall.

As squadrons across the world took flight, Steve launched us out of Area 51, although not before handing me a cigar (well, one of dad's cigars) and announcing we would smoke them together when we won. Not if, when.

Flying through the sky, up out of the atmosphere was just as hideous as I expected it to be. Too fast. Too fast. But when we broke through into space, calm settled. It was beautiful. The stars still shone as brightly despite all the devastation and death back on Earth.

Ahead of us was the mothership. The destroyers that had laid waste to our cities had all detached themselves from her. With each of those casting a shadow over an entire city, what had issued them was immense. It floated contemptuously before our planet, dispassionately sending out its forces to kill us, take our planet, and move onto the next. When Dr. Okun

had been strangled by the alien, Whitmore had been able to, briefly, see its thoughts. He said the aliens were like locusts; swarming, devouring. And now, thinking Steve and I were part of the plague, the mothership brought us home.

We were drawn inside the ship and saw immediately that 'ship' did not do it justice. It was a city. It was a world. No up or down, just spreading out endlessly in all directions around us. Like the suits the creatures wore, the environment looked biomechanical: living technology everywhere. Dark compartments, sectors, pillars, and gangways sprawled, and deep in the blue-green glow there was activity. The aliens scuttling as if in a hive.

They docked our craft and I got to work uploading the virus. It was nothing; any brave, highly intelligent, tall, eco-warrior could have done it. I inserted it into their system and hoped it was enough for our boys back on Earth. We had no way of knowing what was happening there and how we were doing. We just had to believe they would be okay. And launch a nuclear warhead just to be on the safe side.

CLASSIFIED

The virus did take and all the shields were disabled. Now we were able to actually fight. The President took to the air and led the way and every man and woman who flew that day, and everyone who cared for those left behind, was a hero. The one I never got to have a conversation with and wish I had was Mr. Russell Casse. From what I was told by his children afterwards, Russell had been a pilot, a crop duster, and for the last few years, a drunk. He had claimed to have been abducted by aliens before and as a result his life had slipped out of his control somewhat. But something had changed in the last few days, and with his final gesture he became the sort of father he'd always wanted to be.

The aliens were overwhelming us by sheer numbers. We could pick some off but weren't making a dent on their defences. That was until Russell did something extraordinarily foolish and extraordinarily brave. He told his children he loved them and then flew his plane right into the heart to the destroyer – into the weapon at its centre. The alien craft exploded and collapsed to the earth.

Rest in peace, Russell.

Steve likes to talk about what happened to us as we fled the mothership. I don't. It was the most stressful 30 seconds of my entire life and his shouts and triumphant roar didn't help.

We dropped the warhead and our craft was released from the dock. Steve then had to fly us out of the place before the whole thing went up or before they shut the exit on us, whichever was soonest. And both were very, very soon.

It is at once a blur and also 30 seconds in which I can remember every single detail. Like the crafts chasing us and opening fire on us. Like the activity all around as panic spread through the ship. Like the thought of Connie, my dad. Like me telling Steve to go faster as the doors were shutting.

"Must go faster," was about the best I could do as my stomach dropped and my nervous system failed. I could see the doors closing. There was no space left and no way we could ever get through and when I looked again and Steve had finished screaming, we were somehow outside. We'd made it? I didn't believe that for a second. We were going to die in that labyrinthine mothership. Weren't we?

No, we made it.

And we smoked cigars.

All over the world the ships were brought down. We'd won. The aliens were defeated and we could rebuild our home.

In the space of three days, the world had changed forever. The whole of the planet united in a single goal, fighting one common enemy. That is unprecedented in the history of our species and the greatest building block we could have for starting again. I do find it ironic that we came together and triumphed on a day named for independence and separation. But I'm guessing extra-terrestrials don't have a good sense of irony.

One last thing I've been asked to put in: if you want to learn more about the alien war you can pick up How I Saved the World, by Julius Levinson. My father's modest, self-effacing tome can be yours by simply handing over $9.95 and all sense of good taste.

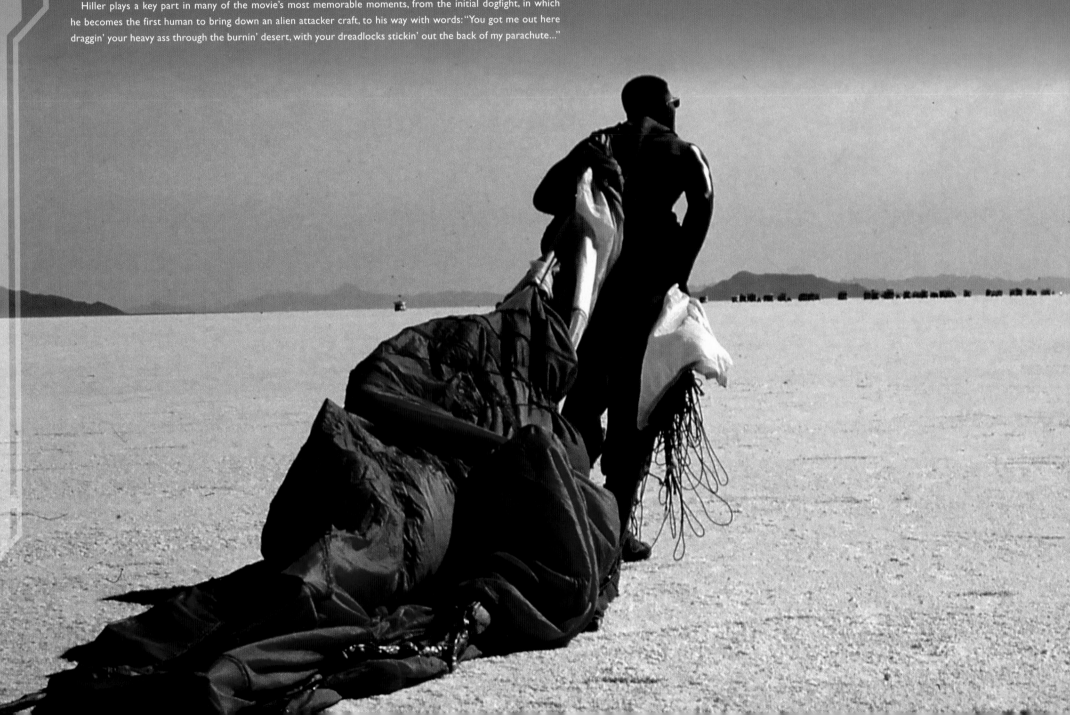

CAPTAIN HILLER

WELCOME TO EARTH

S teven Hiller, captain of the Black Knights squadron, is the charismatic, confident, and heroic pilot who dreams of being an astronaut. He also wants to relax with his girlfriend, Jasmine (Vivica A. Fox), and her son, Dylan (Ross Bagley), over the fourth of July holiday weekend and have a barbecue. The arrival of the alien invaders scuppers his leisure time plans but does enable him to achieve his ambition.

Hiller plays a key part in many of the movie's most memorable moments, from the initial dogfight, in which he becomes the first human to bring down an alien attacker craft, to his way with words: "You got me out here draggin' your heavy ass through the burnin' desert, with your dreadlocks stickin' out the back of my parachute..."

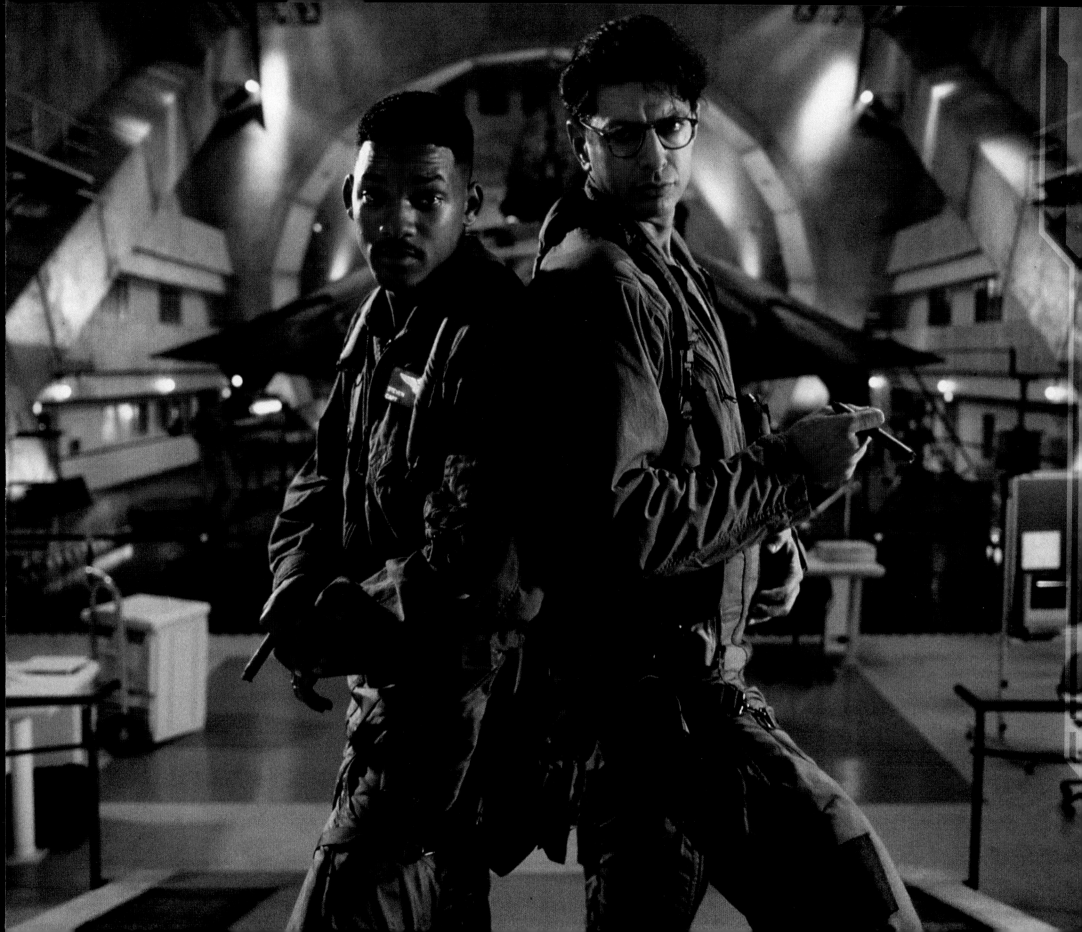

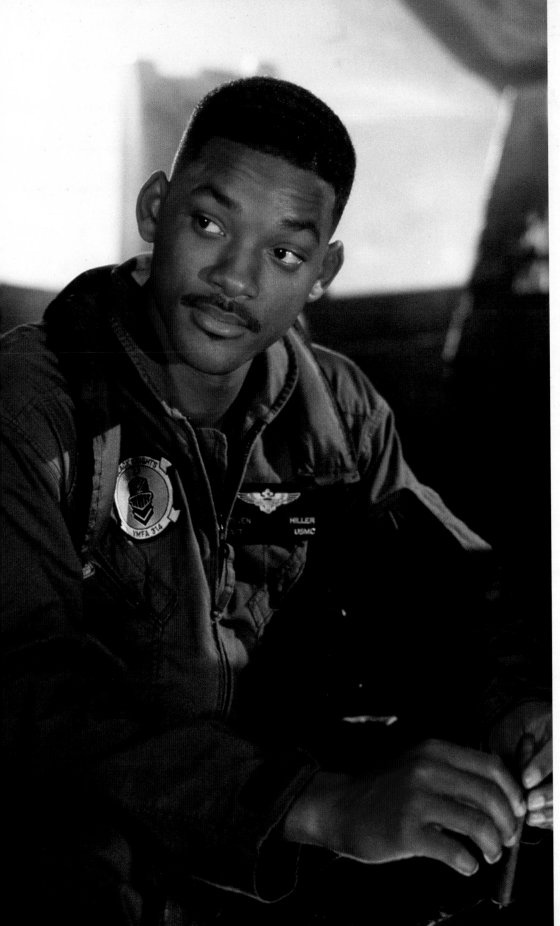

Will Smith plays Hiller in what was his first major blockbuster role and his everyman character (albeit a flying ace) is an integral part of the ensemble. Much of the film, and, indeed, the fate of humanity rests on his shoulders. Smith knew what a major opportunity the project was and was committed to giving his all, as Vivica A. Fox remembers: "Working with Will was just a true experience – he's in my heart and always will be. He's like my role-model. I remember that he was just so serious, this movie meant everything to him. I remember we had a couple of days off and I was hanging-out with Margaret – who played the President's secretary – and we were enjoying a couple of margaritas in the Jacuzzi, and Will walked past and said, 'What are you doing?' and I said, 'Well, it's my day off,' and he said, 'Oh no, you don't realize how serious this movie is.' We went up to his room and started exercising, and doing push-up and sit-up contests. He said, 'You have to understand – this movie is going to change both our careers, I want you to take it seriously,'' and I said, 'Okay, I'm with you, I'm with you!' And of course he was right, it was huge, and it did change our careers and opened up new chapters for both of us."

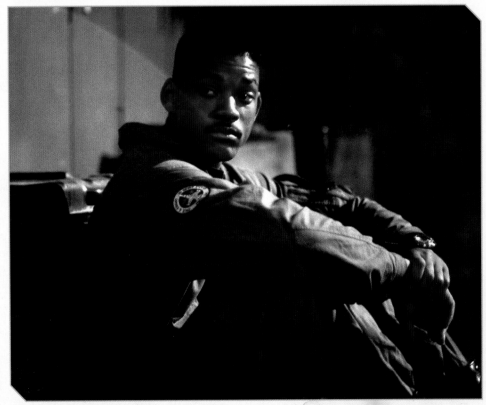

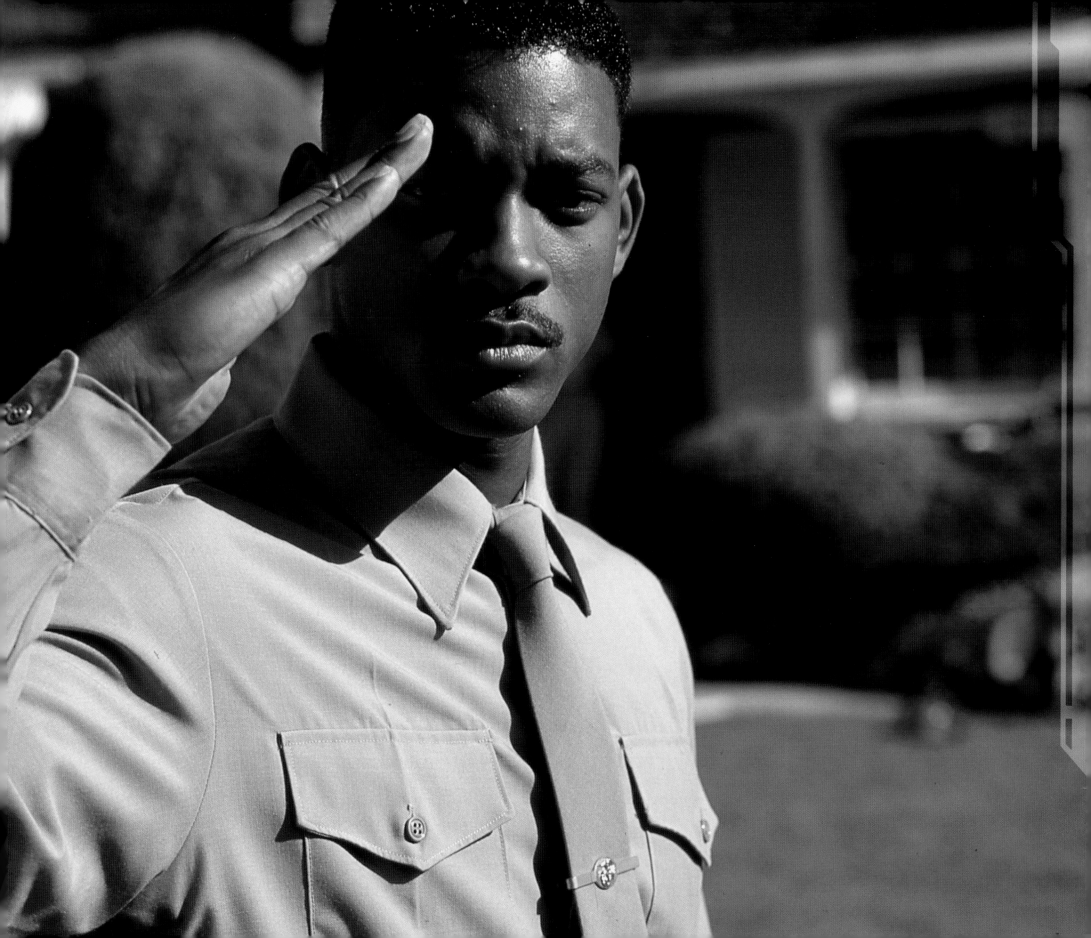

JASMINE DUBROW

Jasmine is an exotic dancer, mother of Dylan Dubrow (Ross Bagley), and the girlfriend (soon-to-be wife) of Steven Hiller. When Los Angeles is decimated, Jasmine, Dylan, and their dog, Boomer, make their way out of the city and across the desert to Hiller's base, El Toro. Along the way, Jasmine takes survivors under her wing, caring and helping for all she can.

A survivor and a matriarch, Jasmine takes on a great deal of responsibility, even looking after the First Lady. She pursues her own storyline and arc in the *Independence Day* ensemble, meaning Fox had her own action sequences and hero moments. "I just remember working with the dog, and my son, and being out in the desert, baking to death, driving a truck, and I was thinking, 'I like doing action – awesome!'...I'll never forget being at the premiere, and after the scene with the fire in the tunnel when I saved my kid and the dog, everyone applauded and I thought 'Oh my God, this is so cool!'"

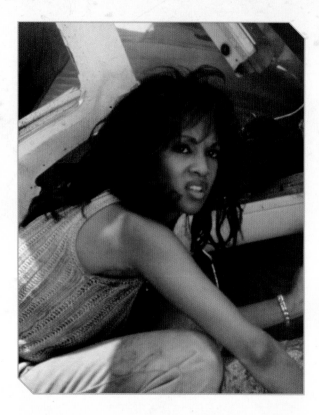

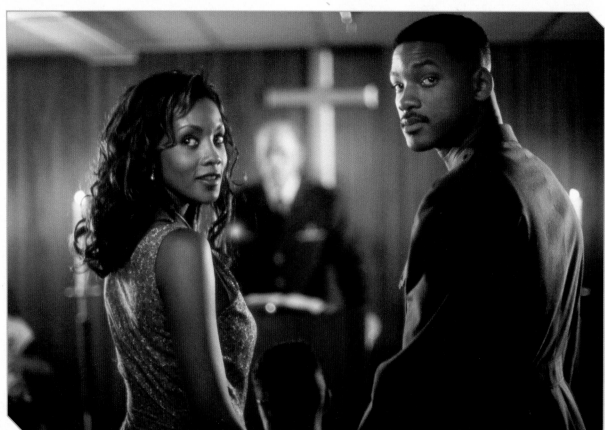

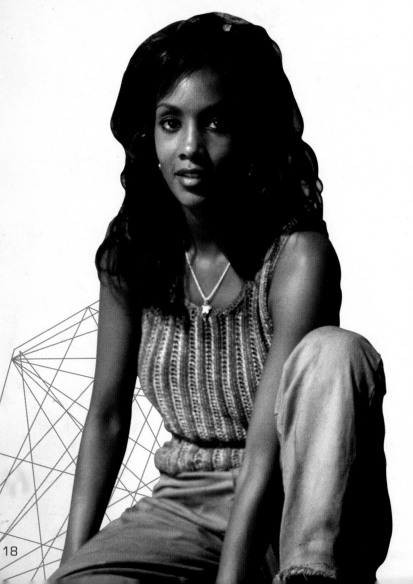

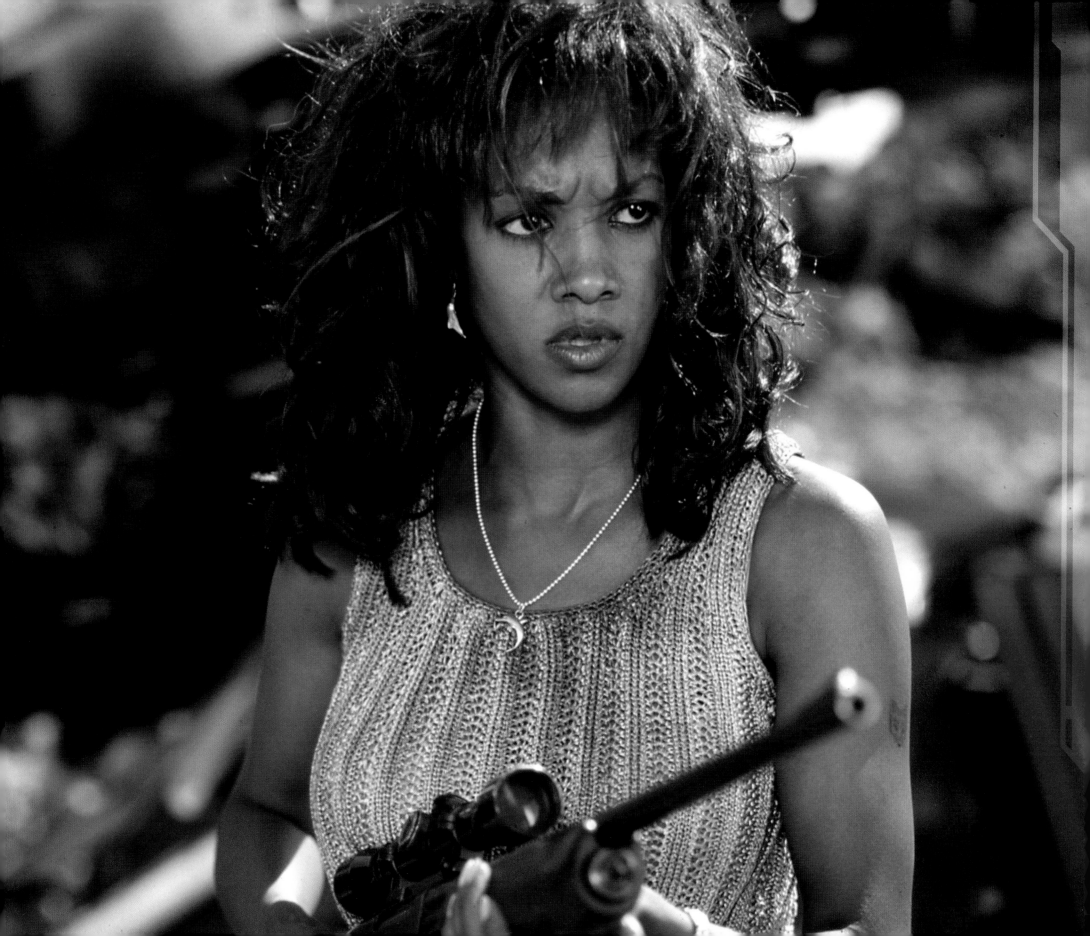

DAVID LEVINSON

evinson is a conscientious and resourceful MIT graduate who works for a satellite company in New York City – or, as his father Julius (Judd Hirsch) calls him, a 'cable repairman.' It is David who discovers, by intercepting their signal, that the aliens are going to attack. He warns the White House, enabling him, his father, his ex-wife Constance, President Whitmore and the President's daughter Patricia, to get to safety. When all other responses fail, David engineers a computer virus to bring down the alien's defences, clearing the way for mankind to fight back. From cable repairman to Earth's savior in just three days.

David is played by Jeff Goldblum, who brings his particular brand of thoughtfulness and sensitivity to the role. He is in no way a socially awkward 'tech genius' who cannot relate. On the contrary, he cares for the planet and the people around him.

The process of shooting this major blockbuster with director and co-writer Roland Emmerich, and discovering at its heart that Independence Day is a movie about people working together was creatively inspiring and encouraging to Goldblum: "I found Roland to be a wonderful director and the ideas of it to be nutritious. Even while we were shooting [they] kept sort of feeding me with new creative appetites and ideas and I kept thinking about all that stuff during the movie and realising what it was most deeply and interestingly about."

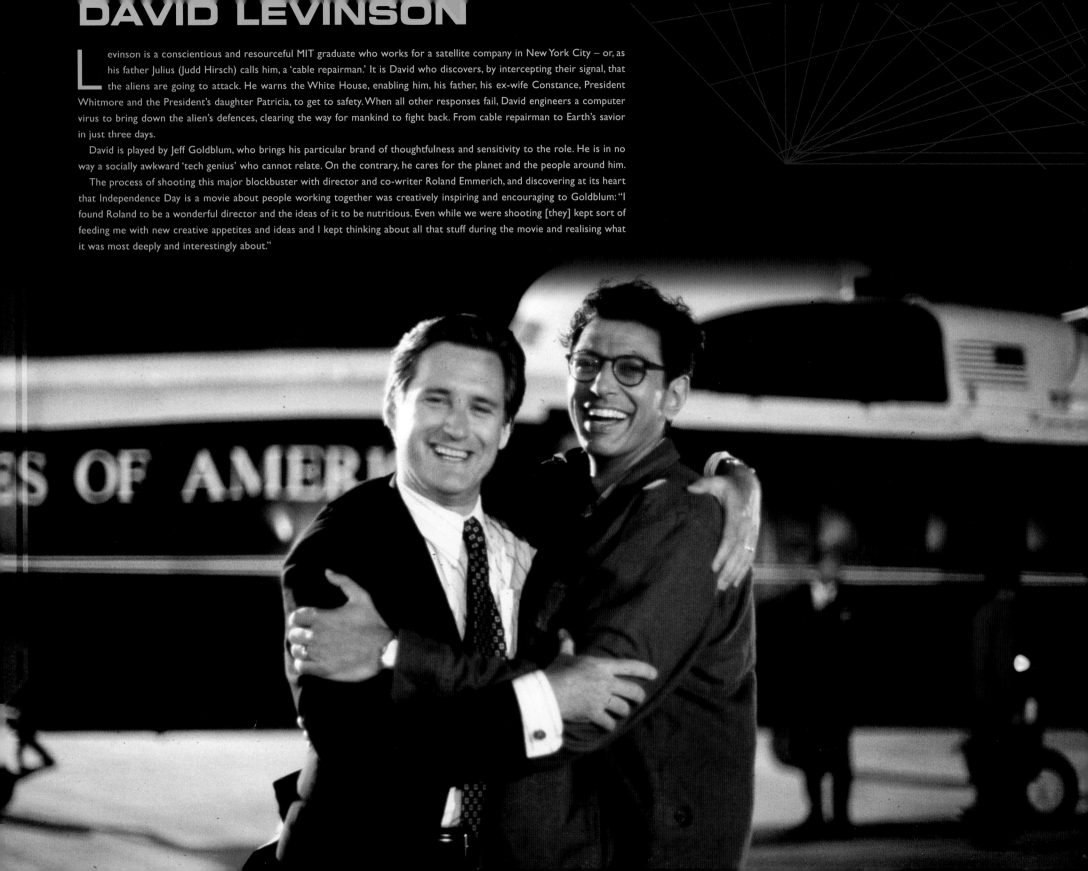

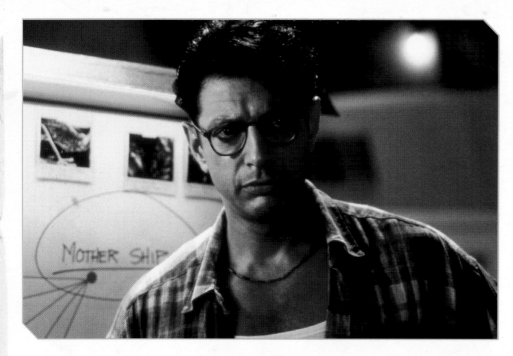

ABOVE: Levinson outlines his plan of attack using the available tools: a marker pen, a whiteboard, and his own intelligence.

RIGHT: Goldblum on set with his estranged wife, Connie (Margaret Colin). For Goldblum, the movie is concerned with big ideas about our planet and mankind's responsibility to it, a soulfulness beneath the special effects that he and Emmerich both focussed on: "This strange opportunity in the story that we have to erase boundaries and become a singular Earth family, it's a delightful, inspiring idea to me. And I think there's something even more in this that all, not only humans on this planet but creatures — all living creatures — are entitled to equal happiness and life and we have to share the planet with every species."

THOMAS J. WHITMORE

I n 1996, Whitmore was the youngest president in US history. A veteran fighter pilot of the Gulf War, his youth, at first seen as his strength, is later criticized as inexperience and his approval ratings drop. When the aliens attack, he shows the United States and the world the leader and hero he can be.

Bill Pullman brings a nobility and everyman charm to the role that makes him believable as both a family man and someone who can inspire his people, described by producer and co-writer Dean Devlin as "making tough decisions in the face of personal loss."

Throughout the film, action sequences and large-scale disasters are sandwiched between more intimate scenes of characters working their way through the problems and trying to find a way forward. The personality and sincerity of the characters is key for the audience and actors. "It had a different quality from other sci-fi movies," says Pullman. "There's a great love at the center of it. A love of the characters, for each other in these crisis situations, and a great love connected to humanity and the possibility that it can survive.

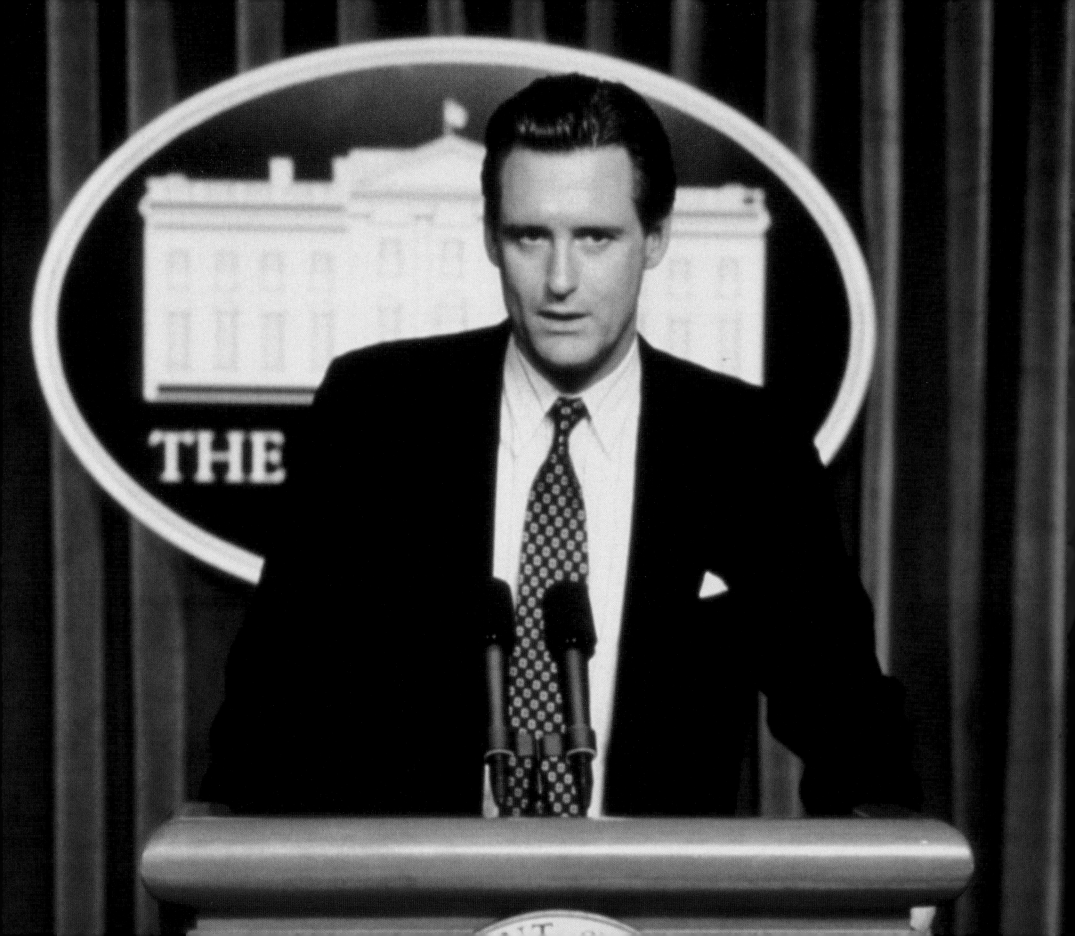

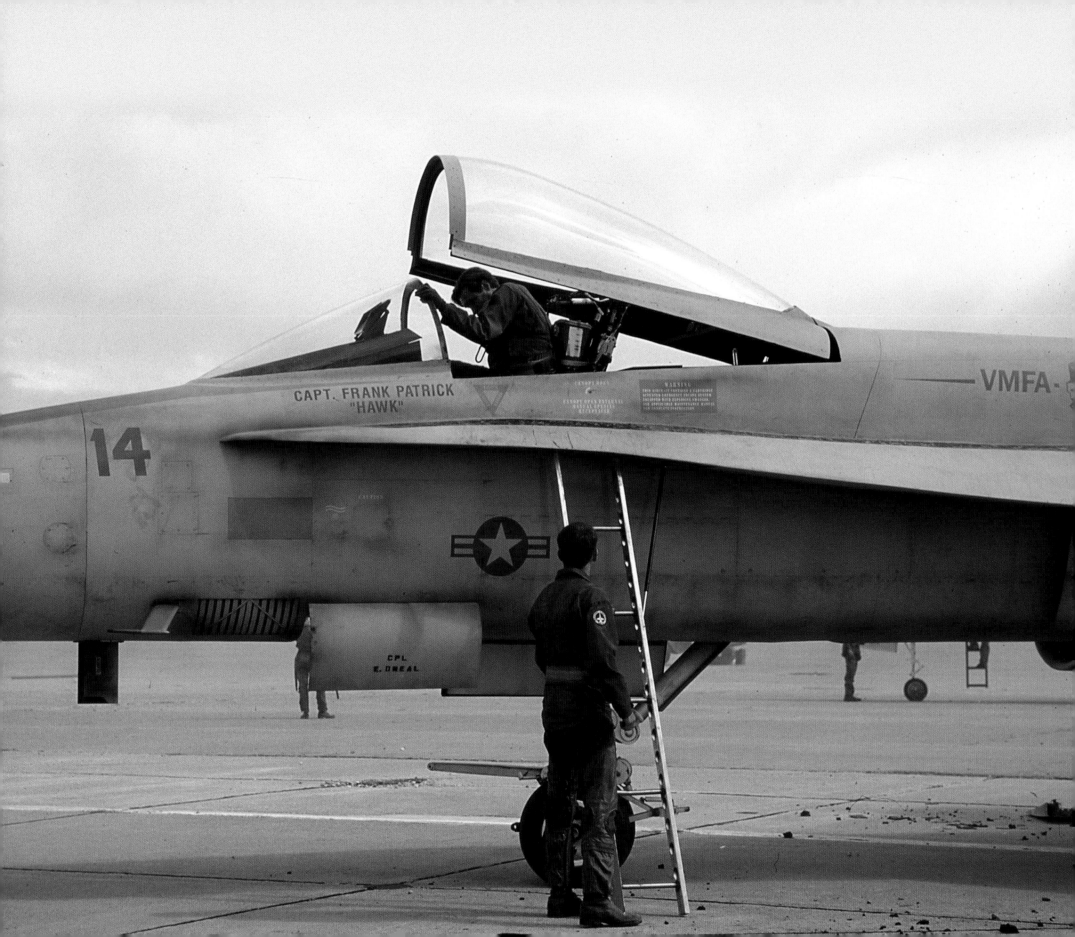

"There probably were times when Whitmore was advised to act in war - there was a bit of Hamlet it in him - where he didn't necessarily want to pull the trigger on every choice that was available and I think in retrospect that he was wise to do that," summarizes Pullman. "I don't think that was a wrong thing."

Producer and co-writer Dean Devlin described Steven Hiller as being the heart of the movie, David Levinson the brains, and Whitmore the soul. He is devoted to his wife, Marilyn, and daughter, Patricia, but does not let his emotion compromise his job when his wife goes missing during the invasion. It is up to him to keep a level head as the situation worsens and to ultimately lead the retaliation from a fighter jet cockpit. Filming the dogfights largely depended on practical effects; a cockpit was built with a realistic exterior and a wooden prop interior with no need to be disguised as the camera never goes inside the plane. Looking back on the flying sequences now, Pullman remembers, "I think even at that time it was considered old school: all the miniatures and all the practical sets that were there and even just being in the fighter plane, having a diorama on hydraulics that's moving rather than some kind of bluescreen thing - that was really old school."

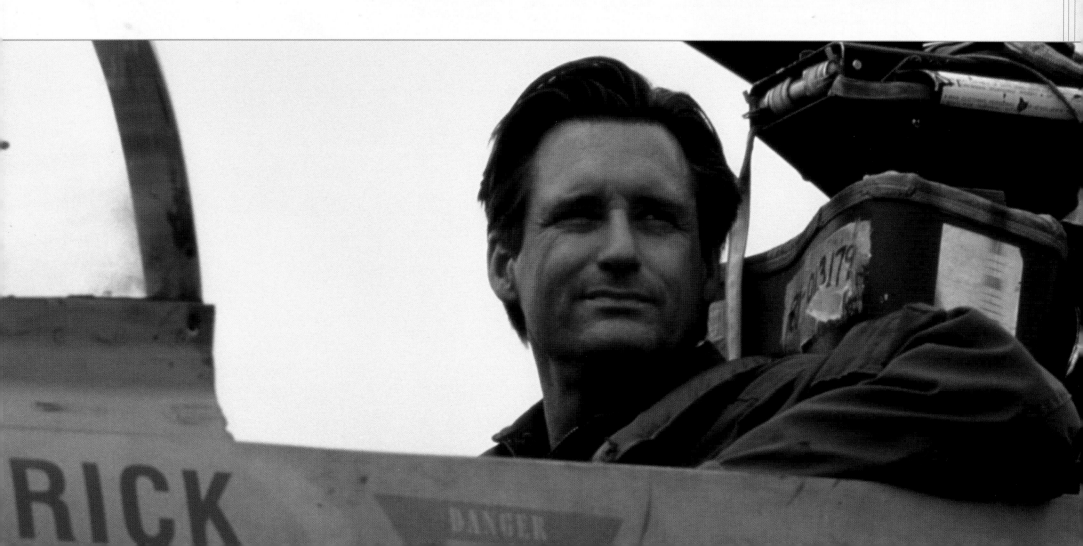

BUILDING THE ATTACKER

When the survivors arrive at Area 51, they are let in on a secret: An alien craft crash landed on Earth in 1947 and has been stored in the highly classified complex in Nevada.

Production designer Oliver Scholl worked on creating a real, tangible model of the main attacker ship. "We built the interior and exterior of the attacker in one set," he says. "Meaning the attacker that was actually sitting on the stage had a full interior that you needed to shoot. So you could take the whole front third of the attacker off and stick a camera in the back. It sounds really easy but it was really impractical, so that was a real torture job for [director of photography] Karl Walter Lindenlaub and for the shooting crew afterwards. But the cool thing was you had a full interior and you only had to build it once, so you saved some money. That's what I remember, shooting those sets were like my big babies."

The Area 51 set itself was an awe-inspiring achievement, creating a realistic environment for the cast and crew.

"What was really great was to be on a stage at Howard Hughes facilities," Scholl continues. "In one continuous walkthrough, you could walk down the ramp that goes into Area 51, walk through the whole length of the lab, walk up into the observation room where David is having his drink and they're having their discussion looking out into the attacker bay, and then have the door come down and walk out and stand there with the attacker and everything. That was one continuous piece. You could do the one thing in one take… As a designer when you open the set and hand it over to the shooting company, you never know what you're going to get afterwards. With Roland, what I've found is, the stuff usually looks better and bigger than what you handed over. He's got an eye for tweaking it the right way and making it larger than life. That's what I love about him."

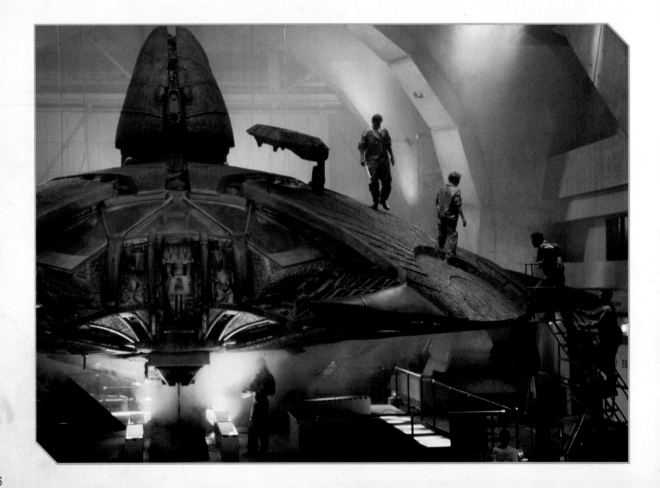

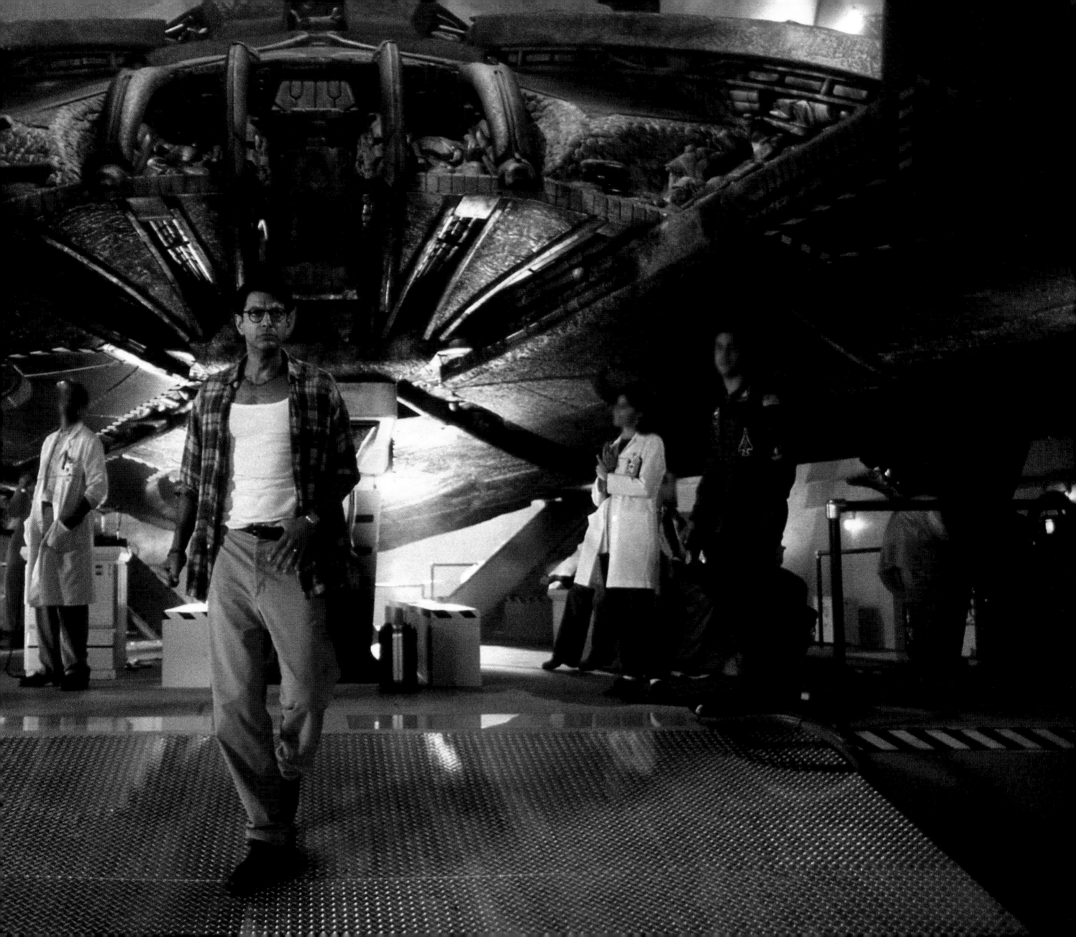

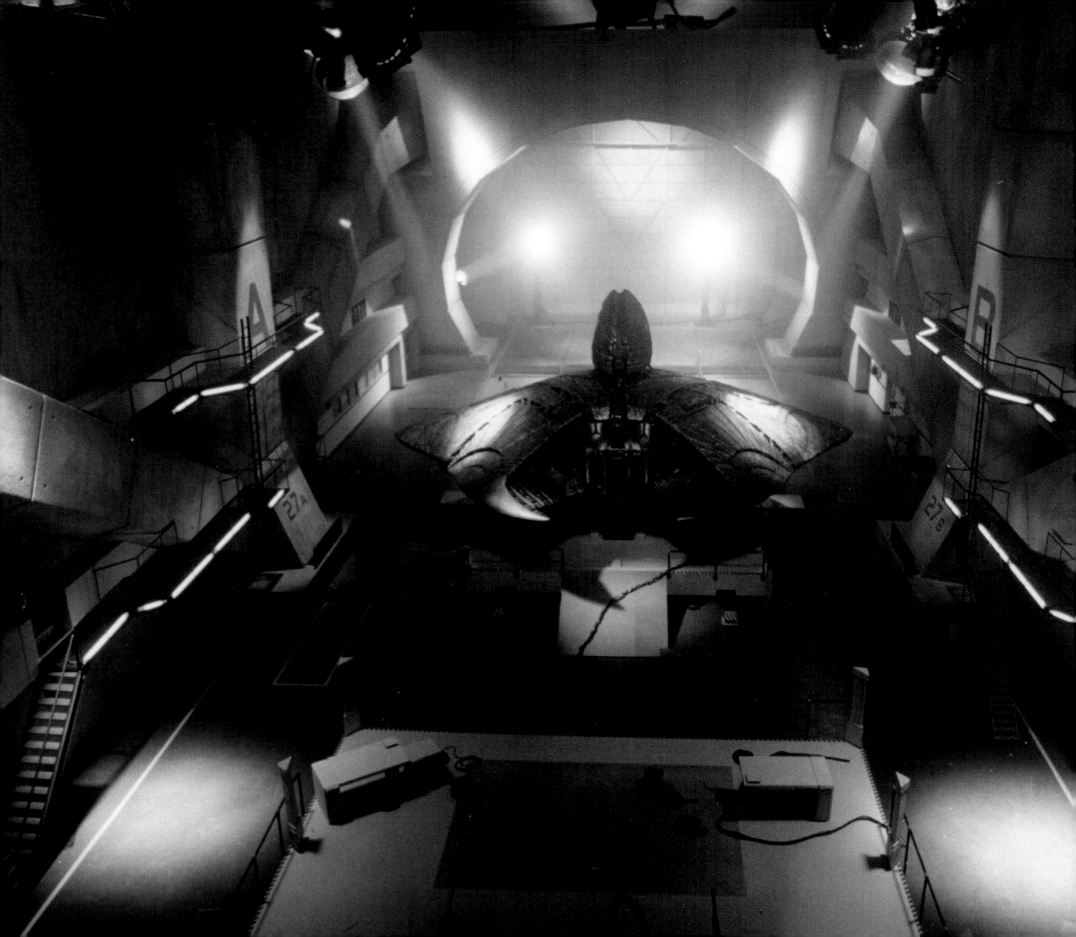

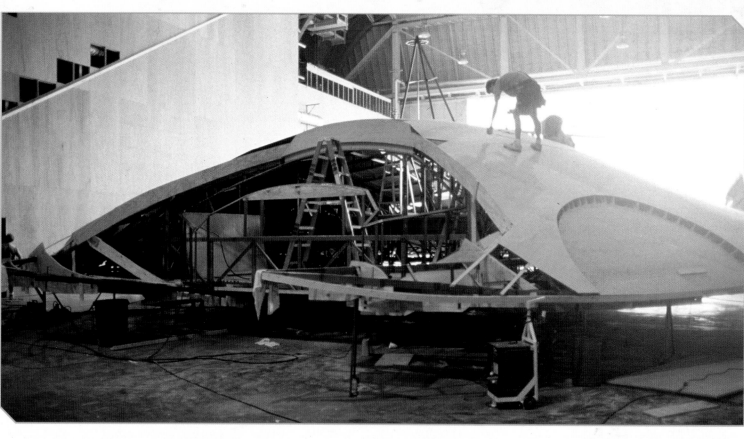

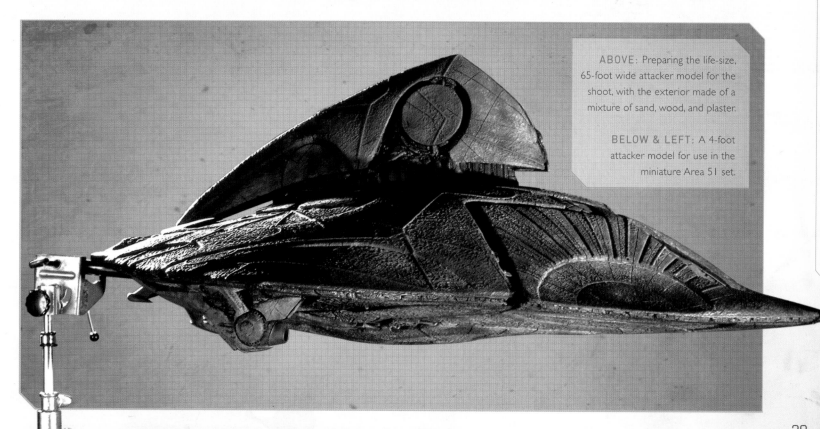

ABOVE: Preparing the life-size, 65-foot wide attacker model for the shoot, with the exterior made of a mixture of sand, wood, and plaster.

BELOW & LEFT: A 4-foot attacker model for use in the miniature Area 51 set.

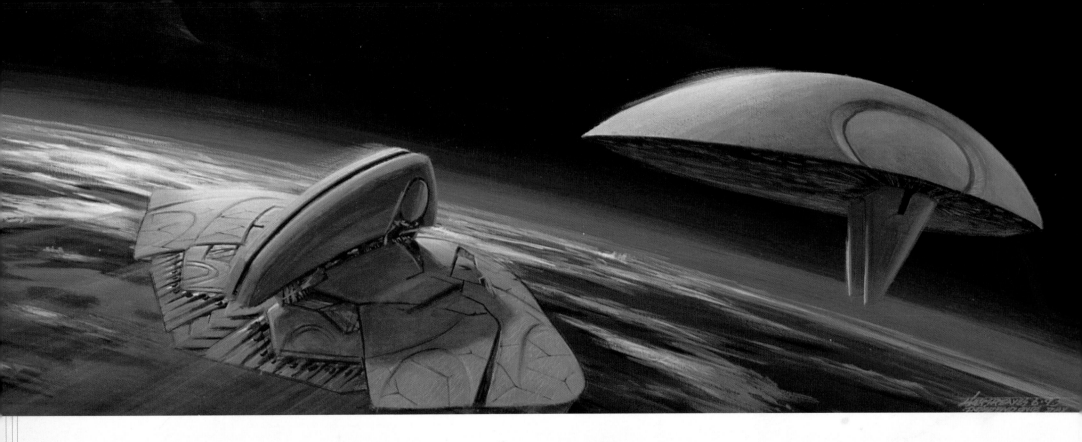

ATTACKER DESIGNS

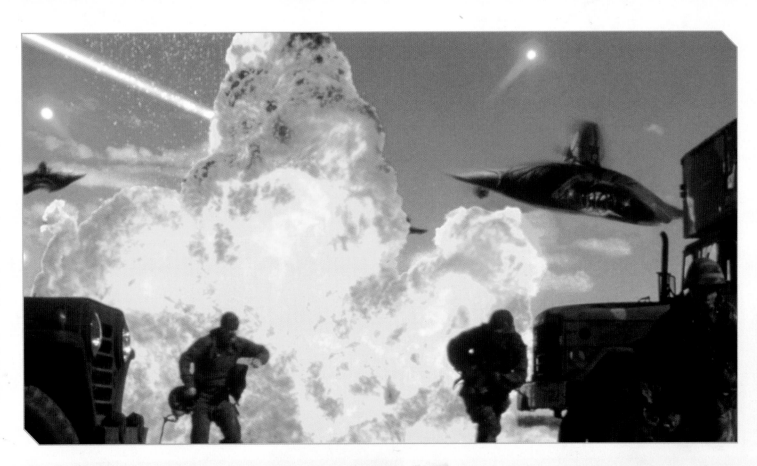

After the initial wave of devastation from the destroyers, the US air force, led by Hiller's Black Knights squadron retaliates but is soon countered by the smaller alien craft, the attackers, which separate off from the destroyers.

At its heart, *Independence Day* has much in common with disaster movies of the 1970s and science fiction of the 1950s, an influence that is visible in the craft design. Production designer Oliver Scholl remembers working on the attacker aesthetic: "For the destroyers, Roland just likes the simple, classic saucer look, which is also what's in the attacker shape... it has the single Mohawk on top, but it's basically a saucer that's a bit twisted."

Production designer Patrick Tatopoulos explains how a moment of serendipity brought them the final design that was used: "I sketched the alien first then the craft. Then I realized the top of the craft is the same as the head of the creature. This was an accident, but it was instinct – a through-line in the design."

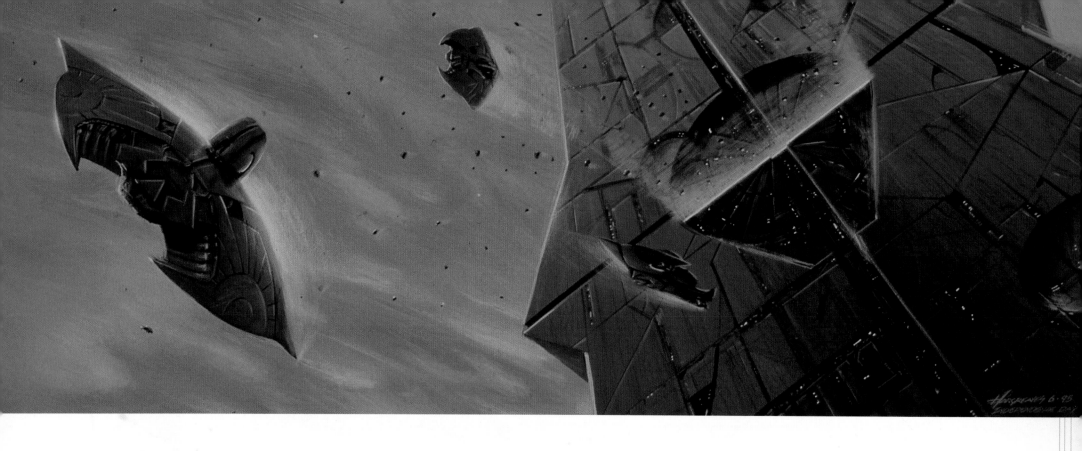

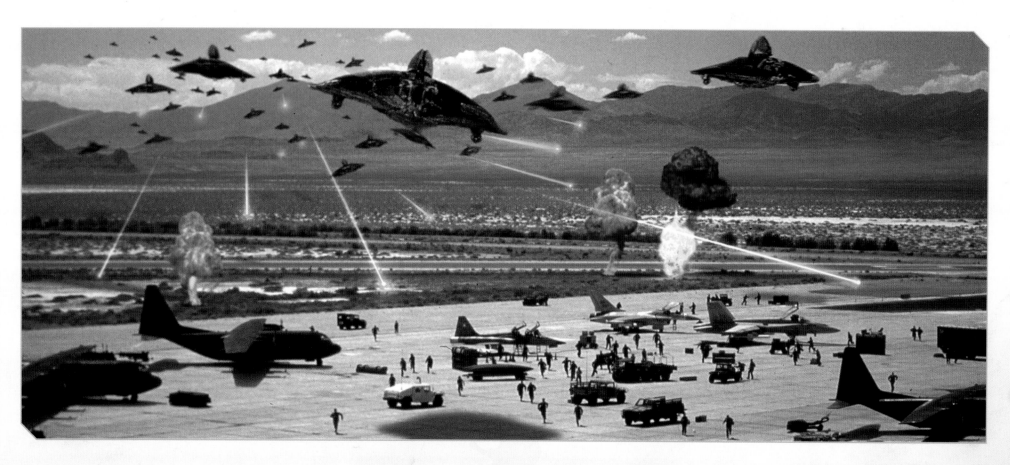

DR OKUN
AND "THE FREAK SHOW"

D r. Okun has spent a long time underground. As chief scientist and overseer of Area 51 – the research facility 24 floors beneath the Nevada desert – Dr. Brackish Okun (Brent Spiner) has devoted all his time and energy to studying the aliens who crash-landed on Earth in 1947. When the President and his fellow survivors arrive, Okun is their guide through Area 51. What he may lack in social etiquette he makes up for with enthusiasm and a highly intelligent understanding of the extraterrestrial visitors. As seen in mankind's response to the threat, it is not about out-fighting the aliens, more about out-thinking them and, along with his unruly hair and dress sense, Okun is a combination of personality, passion, and expertise.

"I just like the fact that he was kind of completely out there," says Spiner. "I mean, I had this sort of concept of him being like a Berkley grad back in the late '60s who took one too many tabs of acid. But he was actually a genius and so he's very effective at what he does… he's kind of a wild character and that's really fun to play."

Okun takes the survivors to one of Area 51's prized possessions: Preserved alien specimens. Oliver Scholl collaborated closely with Roland Emmerich when designing this set: "The vault room, the laboratory, where the aliens are hanging in there, that was when Roland put his foot down. We didn't have water in them originally because it was getting too heavy and they were supposed to be suspended. Roland didn't care about suspending them, he wanted them filled with water, and he was completely right. That is one of the coolest moments, when that room opens, the wall goes up, and you have the big round door. That scene and then the lab itself – the shooting and the aliens coming to the window – that was a really fun environment, also, design-wise, because it was all laid out modern-style with drawer systems, lab walls, so it's really cool."

BELOW: "One day I was standing, talking to Jeff Goldblum outside of his trailer and he says, 'You know, I've got a feeling about this movie.' And I said really? And he goes, 'I think it's gonna be really something,' and lo and behold, it just exploded. I was surprised, not because of the work that was being done or anything like that, it just hadn't occurred to me that this was gonna be a giant film. I just thought it was a, you know, another day at the office." *Brent Spiner*

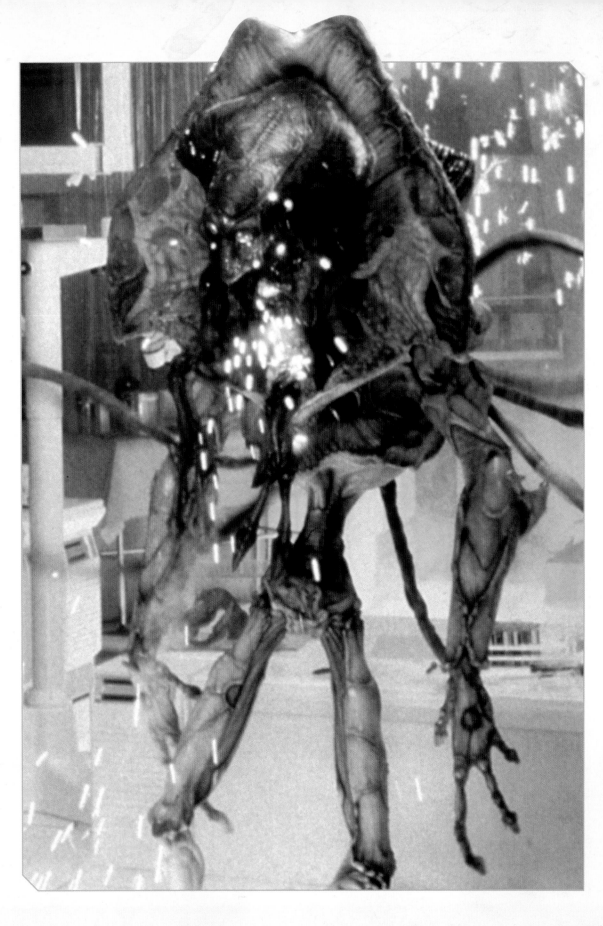

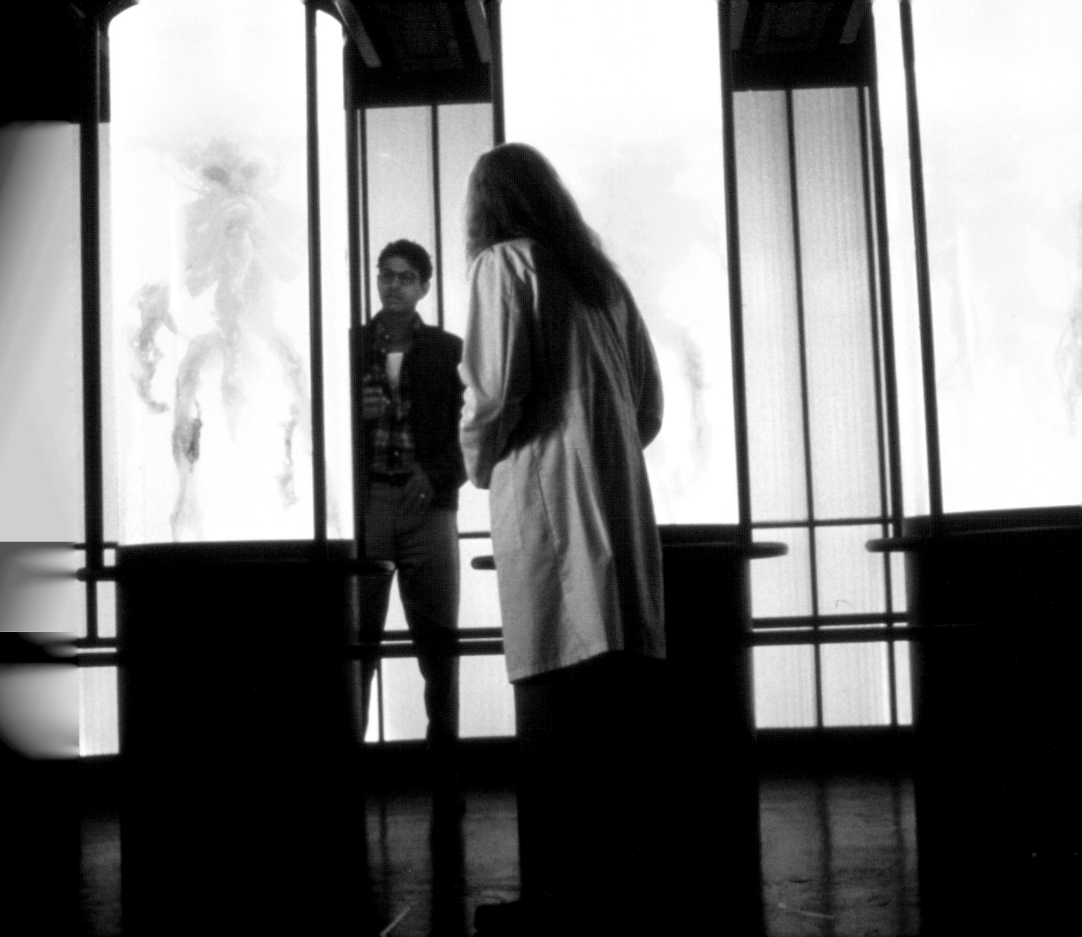

THE ALIENS

After destroying Earth's major cities, the actual aliens themselves needed to be just as intimidating and formidable as their leviathan spaceships. Even though they only appear in a handful of scenes, the creatures had to be a believable adversary. What Roland Emmerich and production designer Patrick Tatopoulos created was a design driven by logic, the same logic that applies to traditional human warfare: a body inside a suit of armor.

"It was Roland's idea to put one creature inside the other," explains Tatopoulos. "They have a biomechanical suit. The suit comes off and they're vulnerable; that adds character. Otherwise, why would they need the suit if they're still dangerous without it? The brain doesn't need to fight, it needs to be protected."

The first human to have a close encounter with an alien is Captain Steve Hiller (Will Smith), who brings the unconscious alien to Area 51 where it is autopsied by Dr. Okun (Brent Spiner). It breathes oxygen, explains Okun. Is affected by hot and cold just like us, has eyes, ears but no vocal chords. The biomechanical exterior is opened up to reveal the fragile insect-like alien within.

"The alien is basically folded into the head of the suit," continues Tatopoulos. "The arms and legs are independent. The arms don't fit into the arms and the legs don't fit into the legs like a costume."

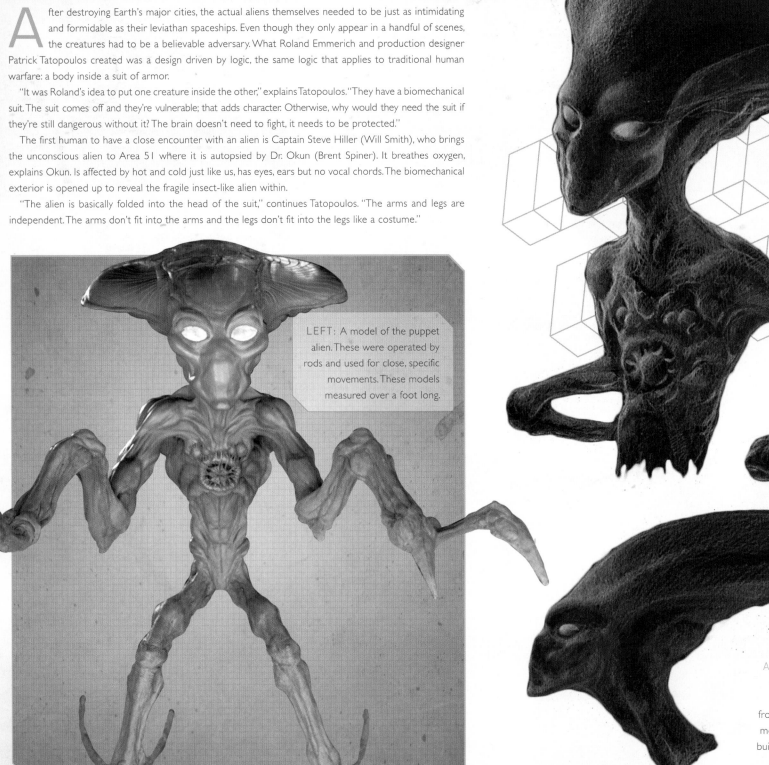

LEFT: A model of the puppet alien. These were operated by rods and used for close, specific movements. These models measured over a foot long.

ABOVE AND RIGHT: Concept art of the aliens, compared with a finished film still. An alien torso and arms were built for a puppeteer to operate from inside. Mechanical legs and a separate full-size model were also created and radio-controlled. The build was made from silicone and a covering of K-Y jelly provided the slimy shine.

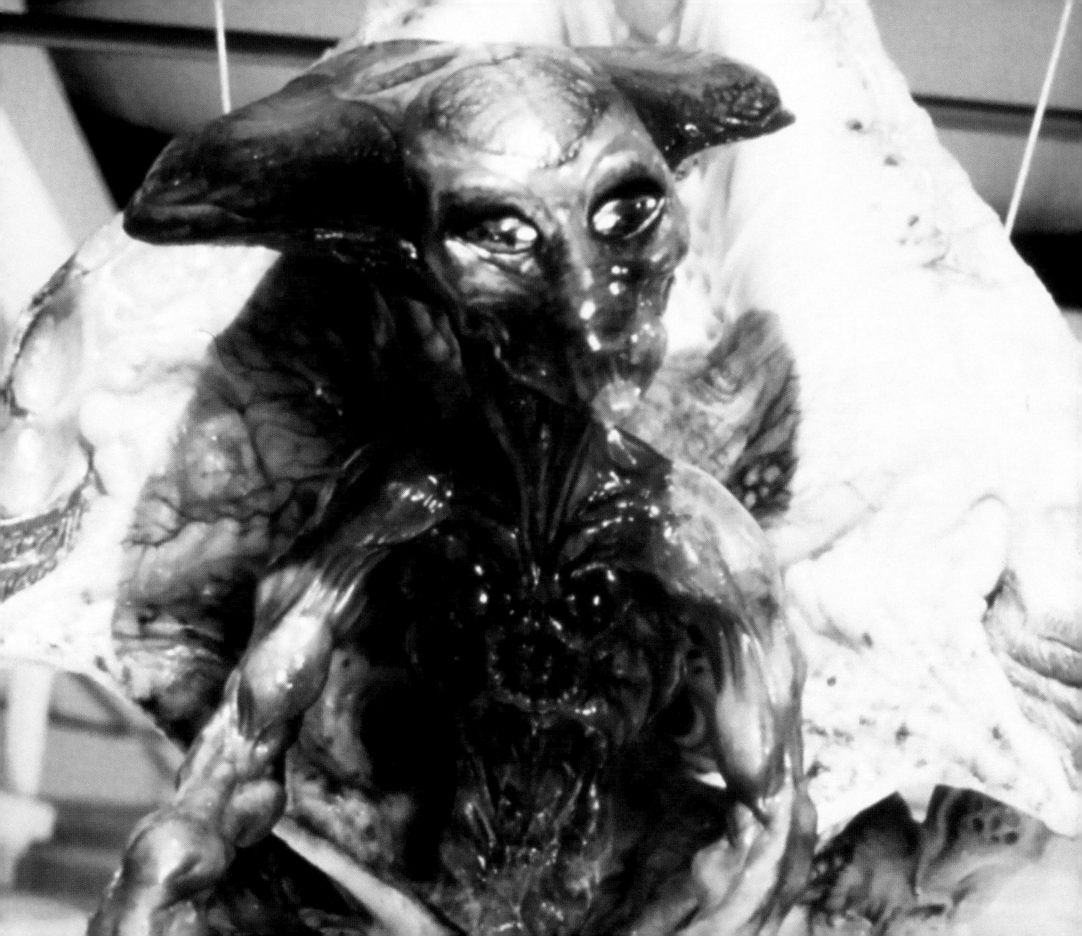

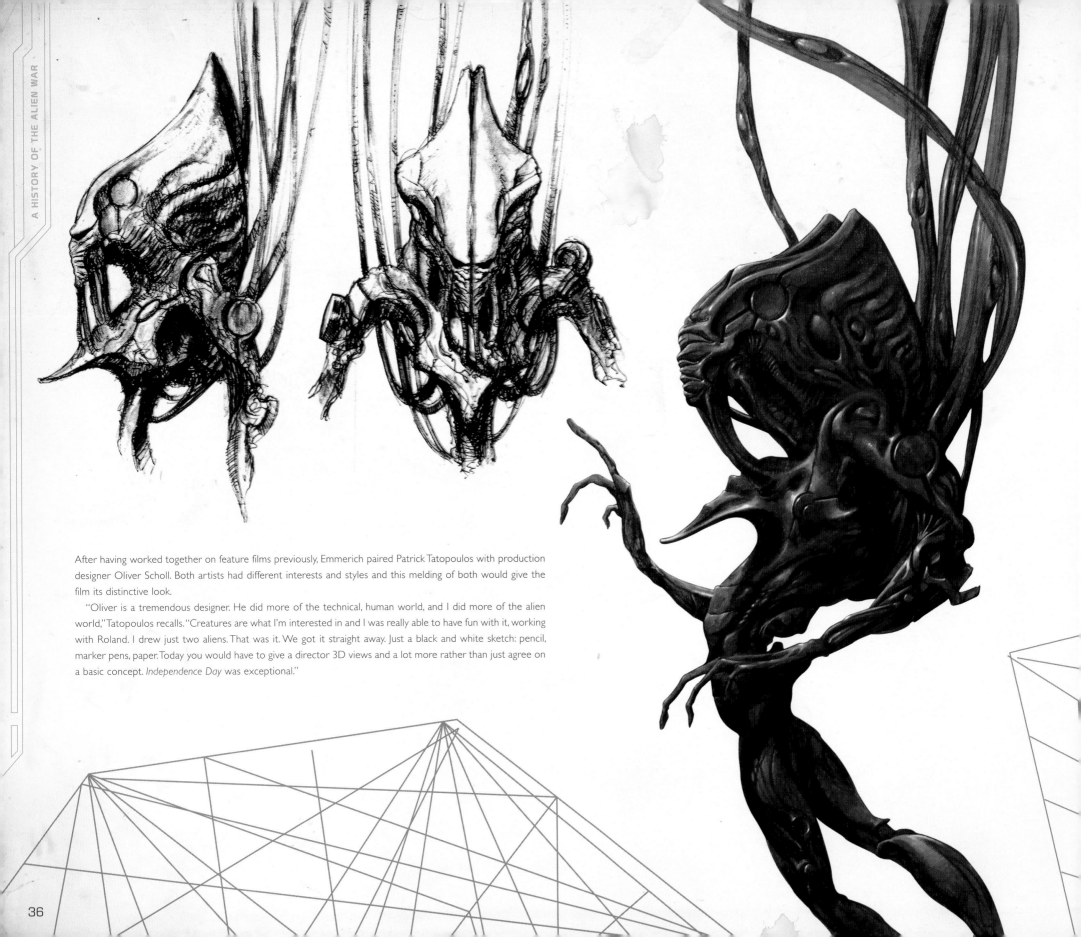

After having worked together on feature films previously, Emmerich paired Patrick Tatopoulos with production designer Oliver Scholl. Both artists had different interests and styles and this melding of both would give the film its distinctive look.

"Oliver is a tremendous designer. He did more of the technical, human world, and I did more of the alien world," Tatopoulos recalls. "Creatures are what I'm interested in and I was really able to have fun with it, working with Roland. I drew just two aliens. That was it. We got it straight away. Just a black and white sketch: pencil, marker pens, paper. Today you would have to give a director 3D views and a lot more rather than just agree on a basic concept. *Independence Day* was exceptional."

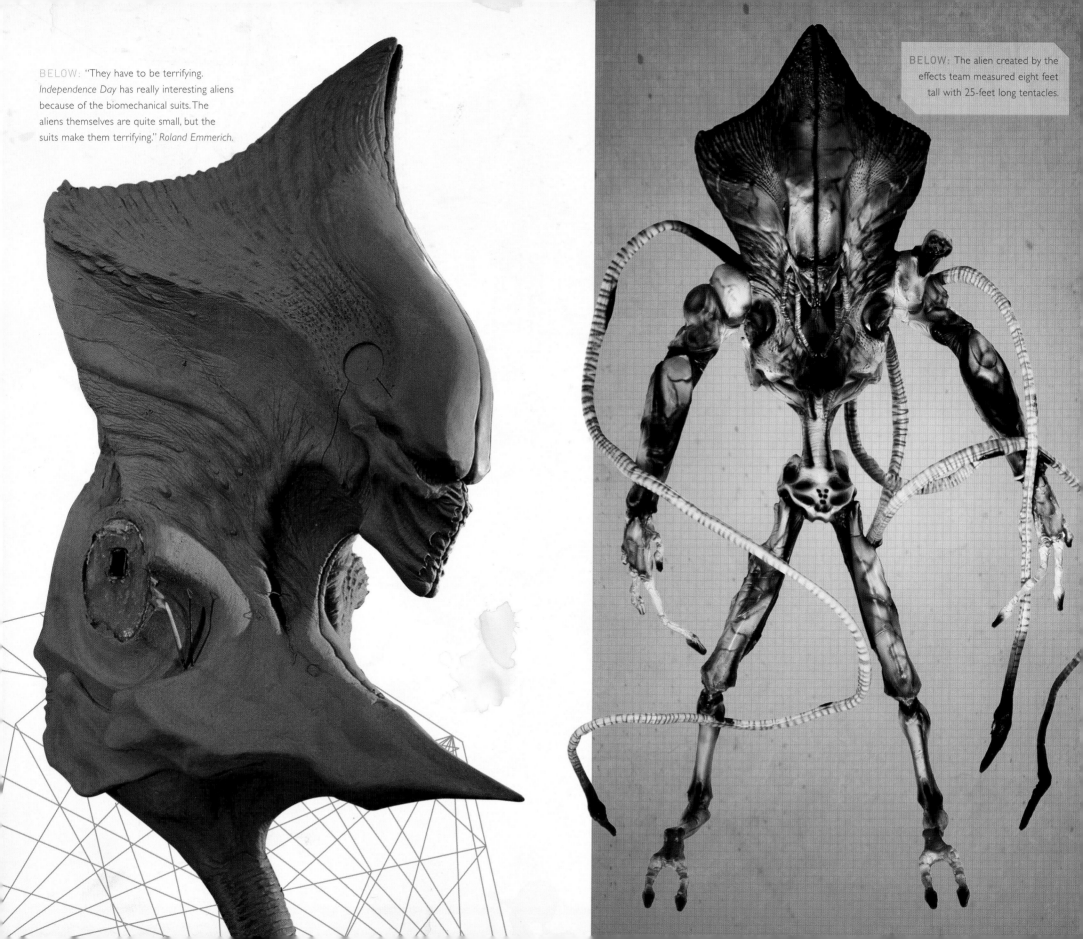

BELOW: "They have to be terrifying. *Independence Day* has really interesting aliens because of the biomechanical suits. The aliens themselves are quite small, but the suits make them terrifying." *Roland Emmerich.*

BELOW: The alien created by the effects team measured eight feet tall with 25-feet long tentacles.

THE DESTROYERS

"In old sci-fi movies, why are the spaceships always so small when they come to Earth? If you travel across the universe you wouldn't do it in a small craft. If you had this technology and were hostile you would come in a huge craft to look aggressive, to make us think: How can we ever beat them?"

This was the question Emmerich posed when creating both the story of the film and the incredibly formidable look of the heralds that arrive in Earth's atmosphere. The saucer is in keeping with the classic, recognisable shape of alien invasion movies in the 1950s, but here presented on a scale and with a level of detail audiences had never seen. To achieve the look, the effects team had to rely on practical creations rather than CG, and three models of different scales were built, including, on one shooting stage, a 26-foot diameter of just a segment of a destroyer.

"From a distance it looks very smooth because it's so huge," explains Scholl. "When you get closer you see all the detail and the texture, then you're really close and you give the texture a size that's insane then you know the overall size is much bigger. It's about trying to establish this hierarchy of scale to be able to read what you're actually looking at…that's kind of the trick. That was also the idea for the tower structure on the destroyer: to give it a front and a back because inherently a saucer doesn't have that, so where do you attack it, what's the focal point?"

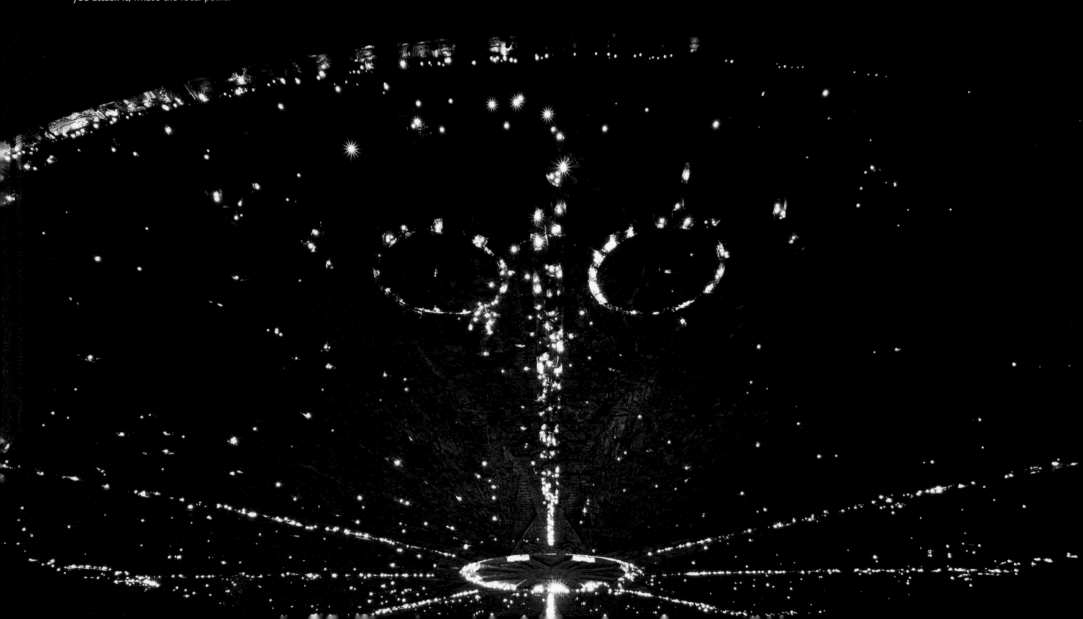

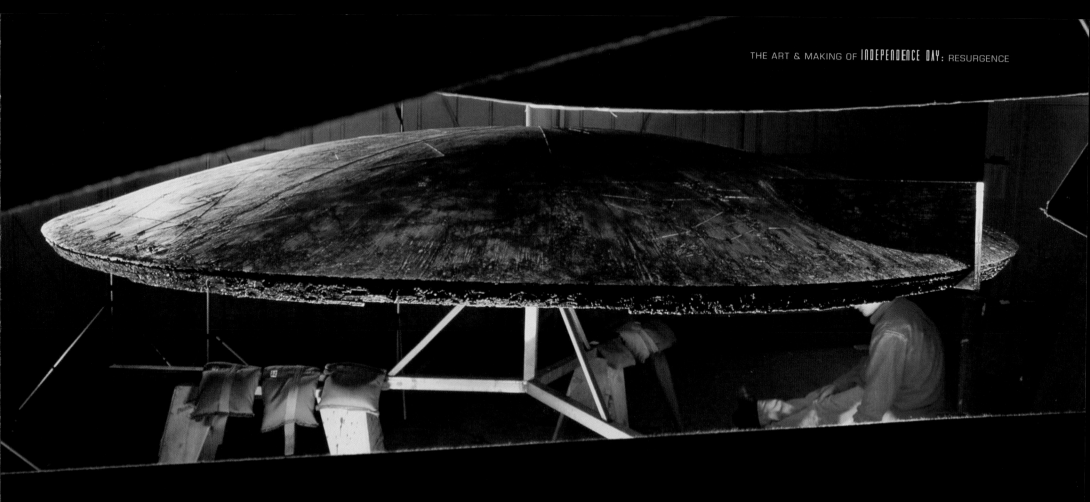

THIS SPREAD: The models of the destroyers, teeming with life and power, at once highly advanced but also worn and historic. Scholl explains how they created the heavily developed textures: "For the bottom layer the pattern was: Making it then putting it through a copy machine then copy and paste it so you can do a repeat pattern. It's really manual stuff...I think we had some photography matching that we did and a lot of it was hand-sculpted, carved into foam and then moulded and multiplied. Patrick [Tatopoulos] did an overall pattern on the bottom, for the look of the underside of the destroyer, that we kind of liked. And there was this thing in the middle which was supposed to be the big destroyer gun [the 'Schism'], so I did a little mock-up with foaming, moving panels, a layout of how it would open, what ar`e the different stages of the opening."

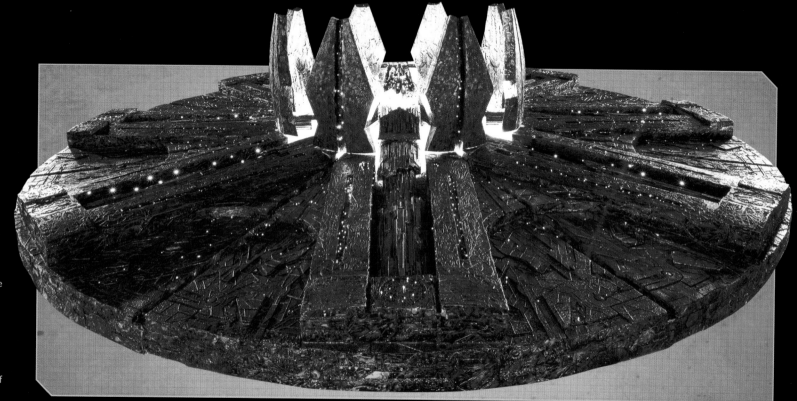

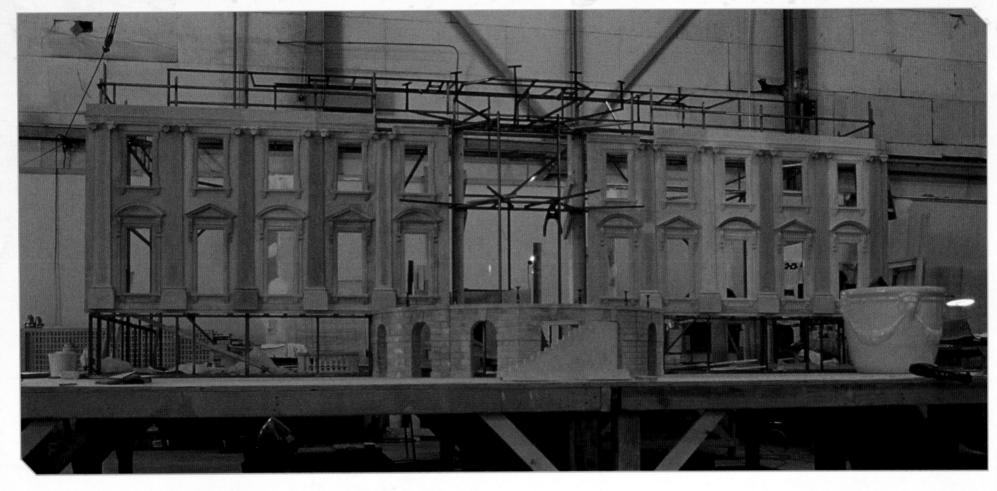

THE WHITE HOUSE

"There is something to be said about real sets that have substance. I think a White House model that gets blown up is still better than a CG White House being blown up," explains director of photography Karl Walter Lindenlaub. The residential section of the building and the Oval Office were working sets built in a 750ft long air hangar once belonging to Howard Hughes, but the exterior was an impeccably detailed five-foot tall, fifteen-foot wide model filled with dollhouse furniture. The model was used not only for effects work but also in scenes with actors, via in-camera trickery: "We did this huge forced perspective set-up for the White House," explains Oliver Scholl. "You could stand at a full-scale fence in the foreground and the ground is rising towards the back with the sight lines lined up and the perspective forced so by the time you are at the background where the White House is the whole thing feels like it is really there through the camera, if you're at the right angle."

The suspension of disbelief is what all storytellers depend on – but using highly convincing, inventive methods and special effects helps and, indeed, audiences the world over turned out to see blockbuster sequences brought to life through meticulously created tried and tested miniature work – just on the cusp of brand new effects technology that would soon dominate large scale filmmaking.

"The original ID4 was one of the last big visual effect movies to use miniatures," recalls visual effects supervisor, Volker Engel. "People can hardly believe when I tell them that at least 80% of the visual effects they see on screen are model-miniatures. They were created by model supervisor Mike Joyce and his fantastic team of specialists. Digital compositing was used to combine over 4000 elements that were shot in-camera on a stage, a lot of them with motion control cameras under the expertise of my co-Supervisor Doug Smith."

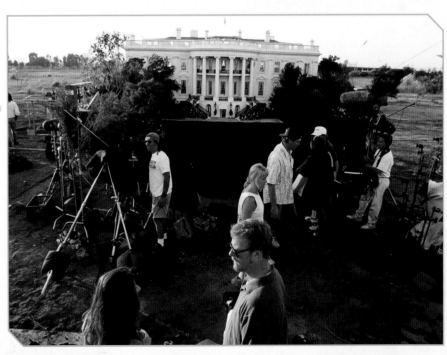

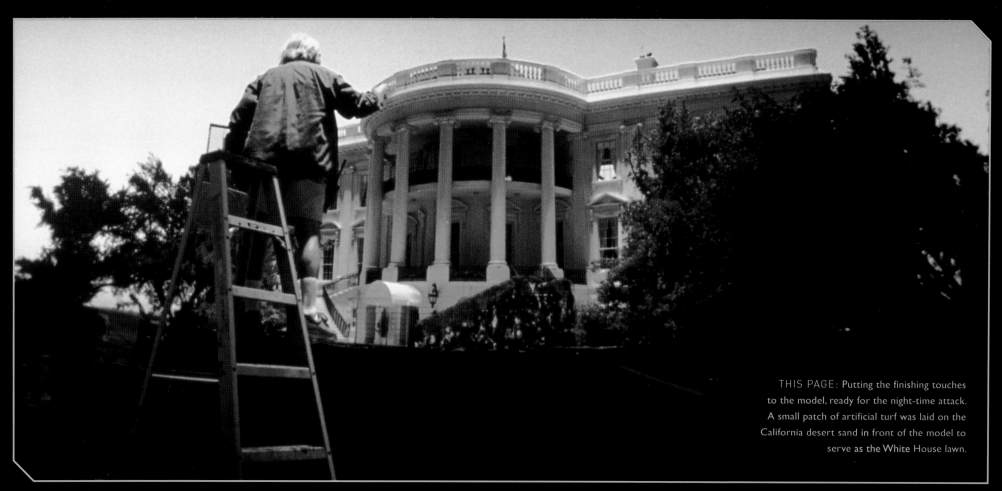

THIS PAGE: Putting the finishing touches to the model, ready for the night-time attack. A small patch of artificial turf was laid on the California desert sand in front of the model to serve as the White House lawn.

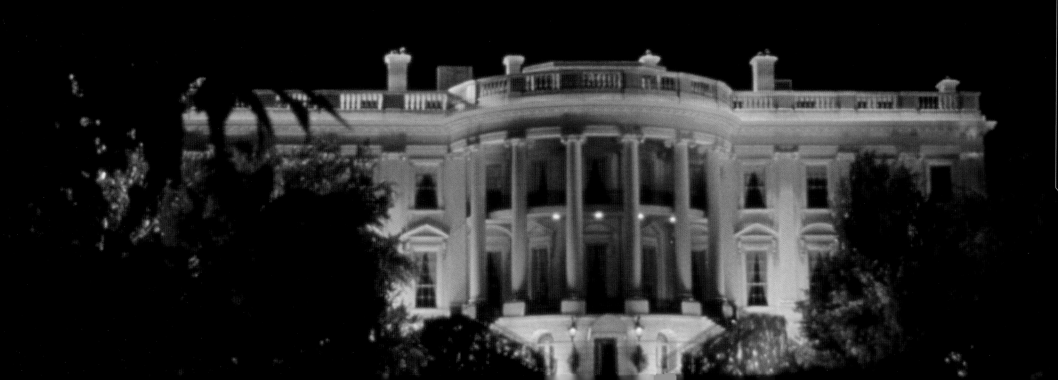

BLOWING UP THE WHITE HOUSE

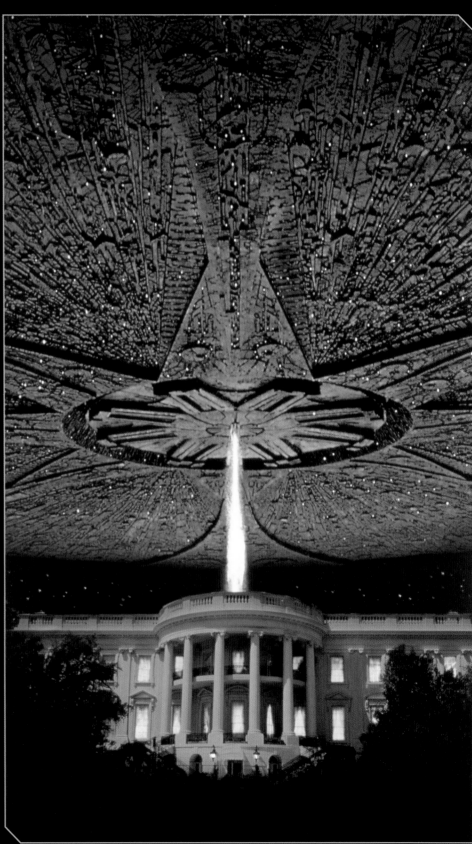

The centrepiece attack and the film's most famous moment is when the aliens destroy the White House. "We didn't realize it was going to be so iconic," recalls director Roland Emmerich. "Audiences cheered when they saw it!"

The miniature was fitted with more than thirty explosive charges and, as only one model existed, they had a single chance to capture the shot. In 1996, CG was expensive and less sophisticated than in 2016, and as Emmerich said at the time, "When you blow up a big model, there is nothing better than that on film… Fire, for instance, is very bad in CGI because it is so random and unpredictable." This meant the effects had to be produced in-camera and for the White House scene, nine cameras were set up to cover each angle.

While this audacious shot seems huge in scope, it was all achieved in miniature, with the effects teaming working with pyro technician and industry legend Joe Viskocil. Volker Engel worked closely with Joe (including sharing the Academy Award for Visual Effects with him) in achieving the landmark moment, as he explains: "We have a city destroyer on top of the White House, which was a miniature, and there are no augmentations in any way with CG, except with the beam [nicknamed 'The Hammer']. Just the beam coming down that was a computer effect. Everything else was all shot for real. Joe and I did some tests the day before just to get the timing right and we actually found out that the timing wasn't right. We shot a very small section of it – otherwise we would have blown up the whole thing and it wouldn't have worked timing wise."

The final sequence became the 'money shot,' so recognisable that the filmmakers were even invited to screen the movie in the real White House.

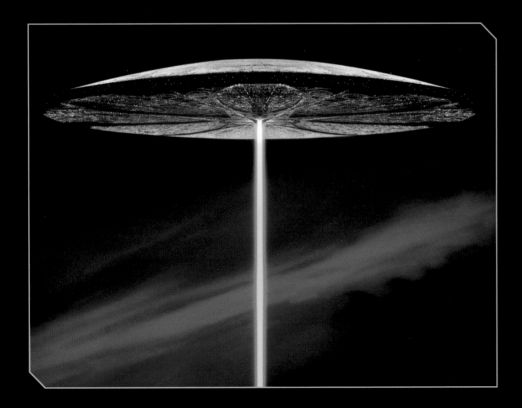

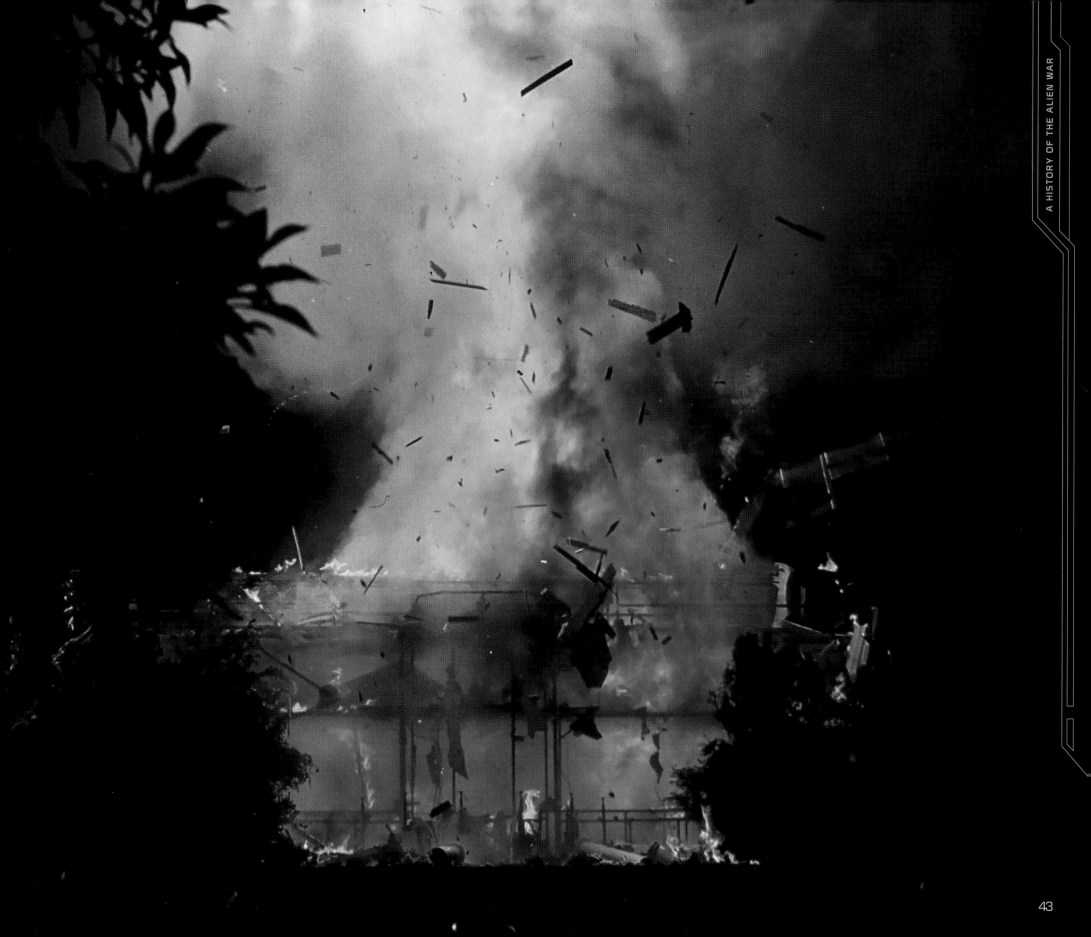

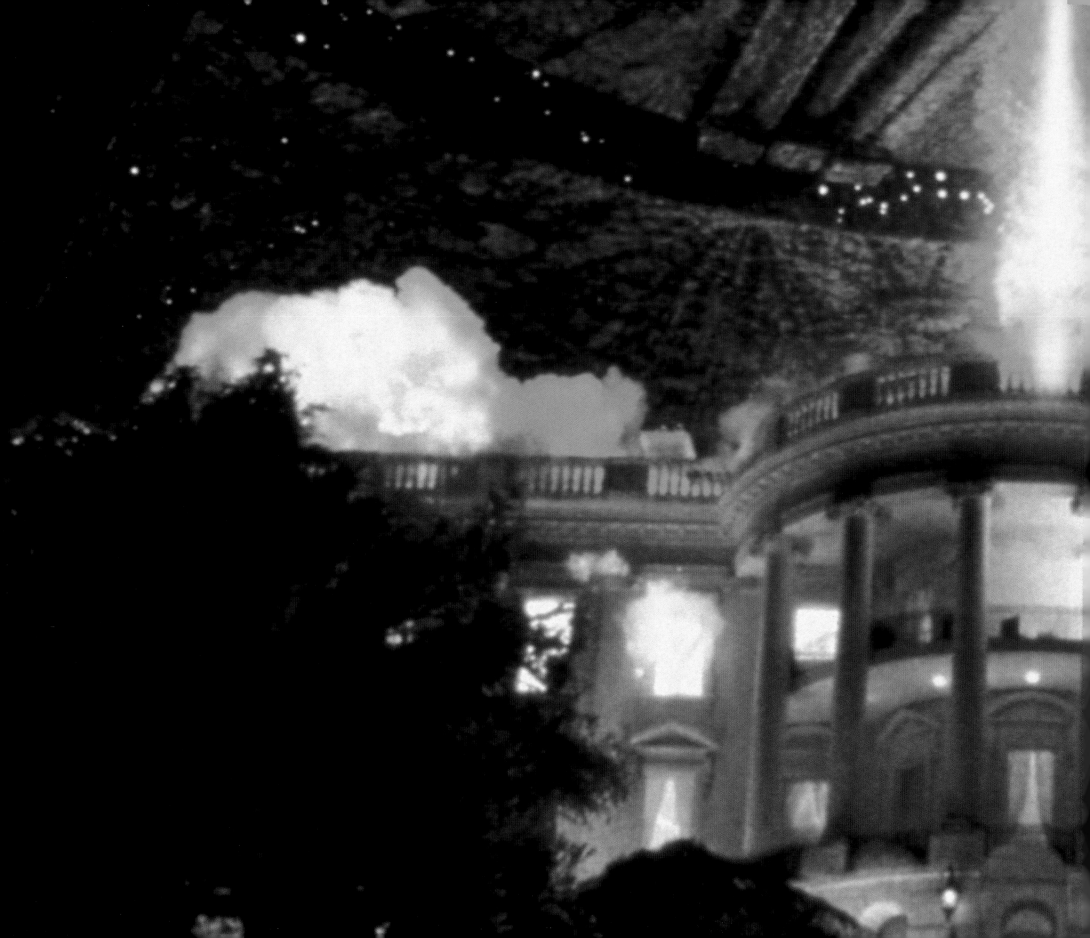

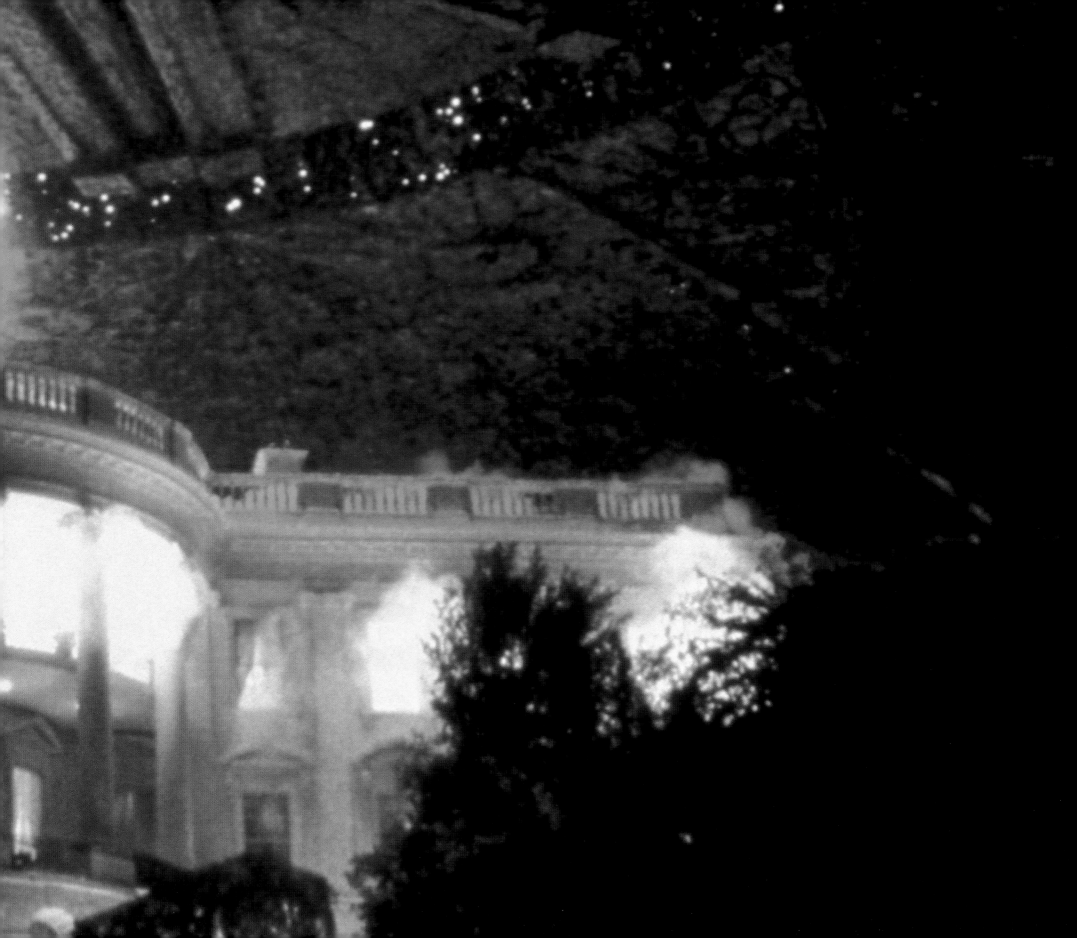

"TIME'S UP"

Levinson watches the countdown reach zero, and then, simultaneously across the globe, the aliens attack. Iconic buildings and structures, such as the Lincoln Memorial and the Empire State Building were all built in miniature, and rigged to blow. Los Angeles and New York streets were also created complete with accurate detailing, such as taxis, streetlights, and billboards. An office interior with desks, computers, and coffee makers was also readied in preparation for when the destroyers' wall of fire stampedes through the cities.

As with the White House explosion, the effects were achieved in-camera. To create the movement of the clouds of flame billowing through streets, Joe Viskocil had the idea of tilting the miniature sets 90 degrees and placing the pyrotechnics on the floor beneath, knowing that the fireballs would naturally want to travel upward, funnelled as if in a chimney. By setting the camera above the set and recording in high speed film but slowing down in playback, the result is the illusion of devastation wiping out metropolises.

In Los Angeles, many citizens, including Jasmine's friend Tiffany (Kiersten Warren) flock to the top of the US Bank Tower to welcome the aliens. They are the first to be annihilated. The close-ups of Tiffany and her fellow UFO enthusiasts were shot on a stage set, but the wide angles of the gathering was captured on location in what Karl Walter Lindenlaub remembers as one of the most logistically complicated sequences of the entire shoot.

"We shot that in one evening with two helicopters in the air and seven camera crews on different rooftops, but each rooftop had lighting rigs that we specifically put there so that we would film from the air and could actually see those people on the roofs. We had to come up with different ways to design lighting rigs for these rooftops, they had to be made safe, and they were rigged for two weeks. On the day, we had a sort of command station at the tallest building which, in those days, was the First Interstate Bank. On the rooftop we had a crew shooting actors and extras, and on the floors below we had some other cameras and some windows taken out, and then Roland had a console with video transmissions from each camera on these different rooftops. There had to be a video link via a satellite link so we could see what all the other camera crews were doing. We had a camera in a helicopter going around shooting, and then another camera on a helicopter that was like a police helicopter that was in the shot. All this had to be practised and co-ordinated and practised again, and then we had a window of twenty-five minutes where the sky still had a little bit of blue, but the city lights and street lights were on. We call that "magic hour," and in that period we had to shoot that sequence. It was really exciting."

THIS PAGE: The destroyers hover over New York and Los Angeles.
OPPOSITE PAGE: Stills showing fire engulfing downtown LA.
OPPSOITE CENTRE: "I have a cameo in the whole destruction sequence. You see a large office building from the outside, we cut inside and there's a guy doing some filing by some cabinets and they only shot a stuntman being pulled backwards. Roland asked, 'You never see him front the front? We need a shot of this guy reacting to the flames.' And so I said, 'It's time for my close-up, Mr. DeMille.'" Volker Engel

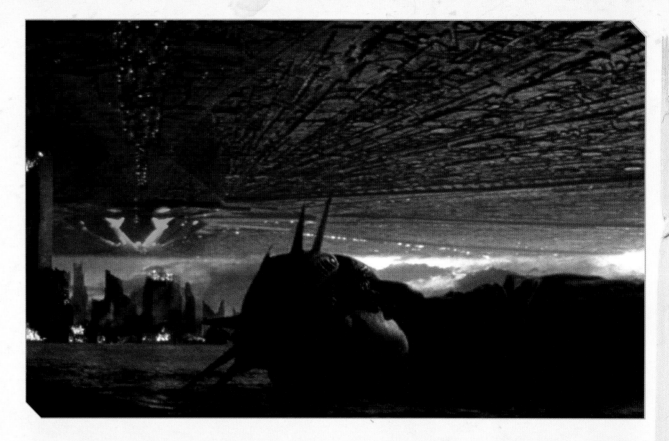

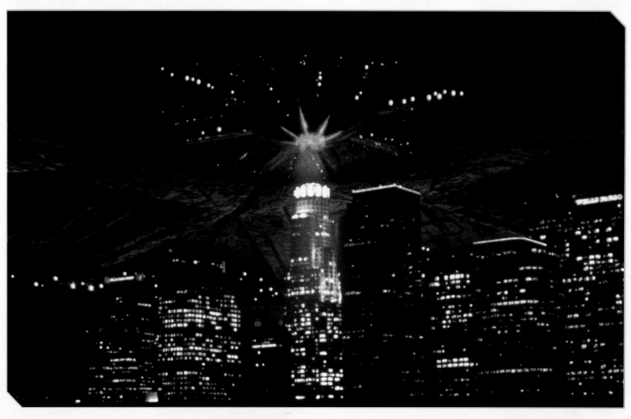

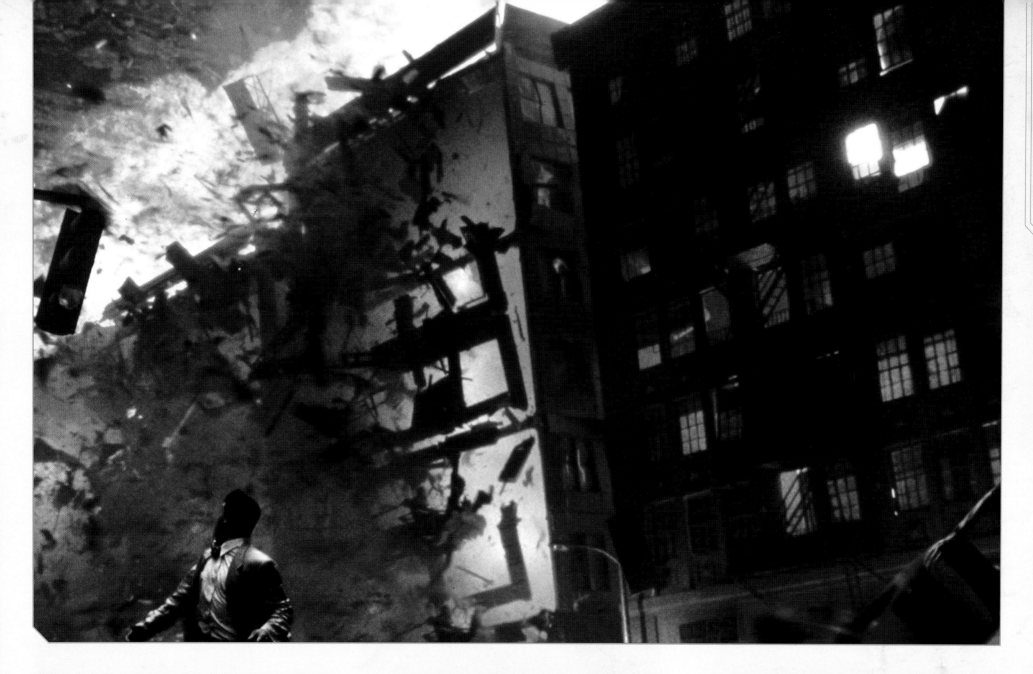

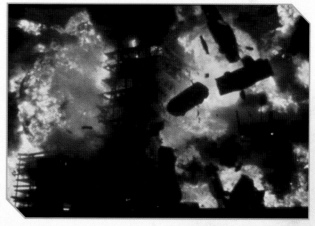

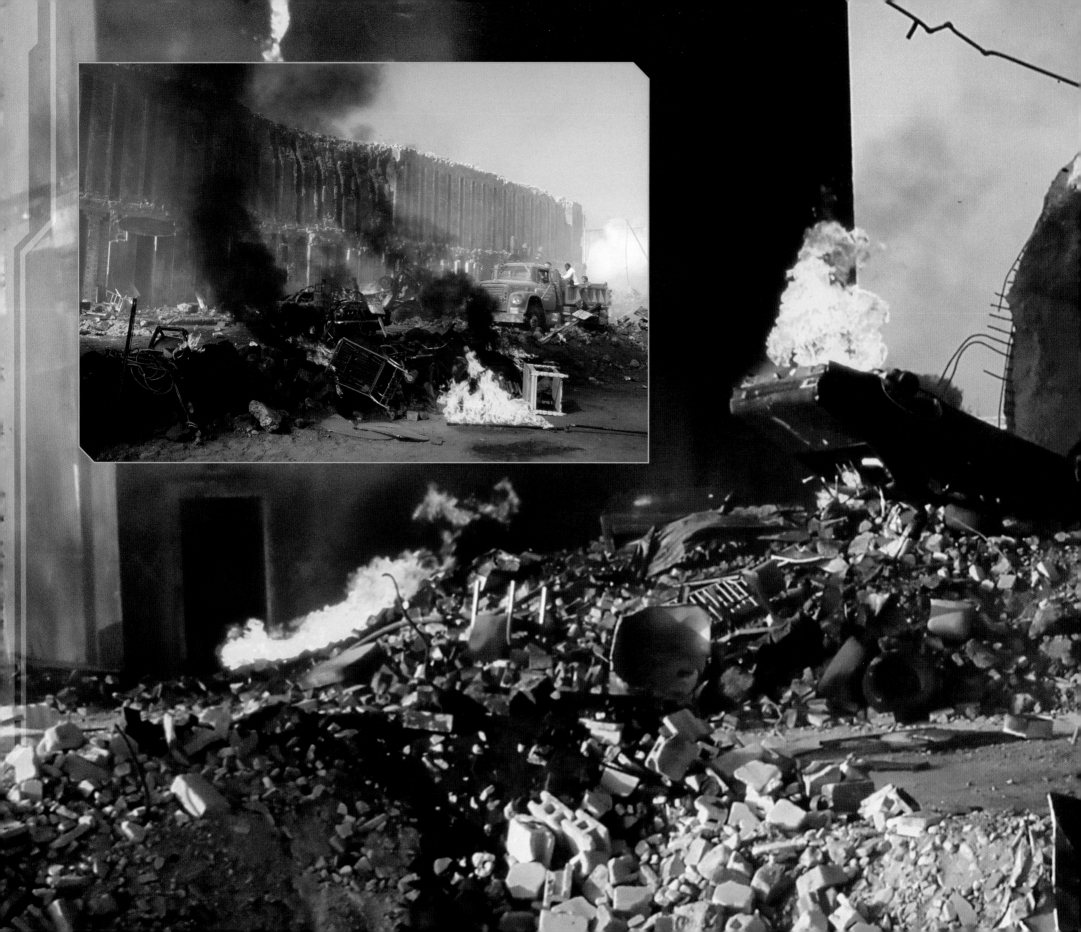

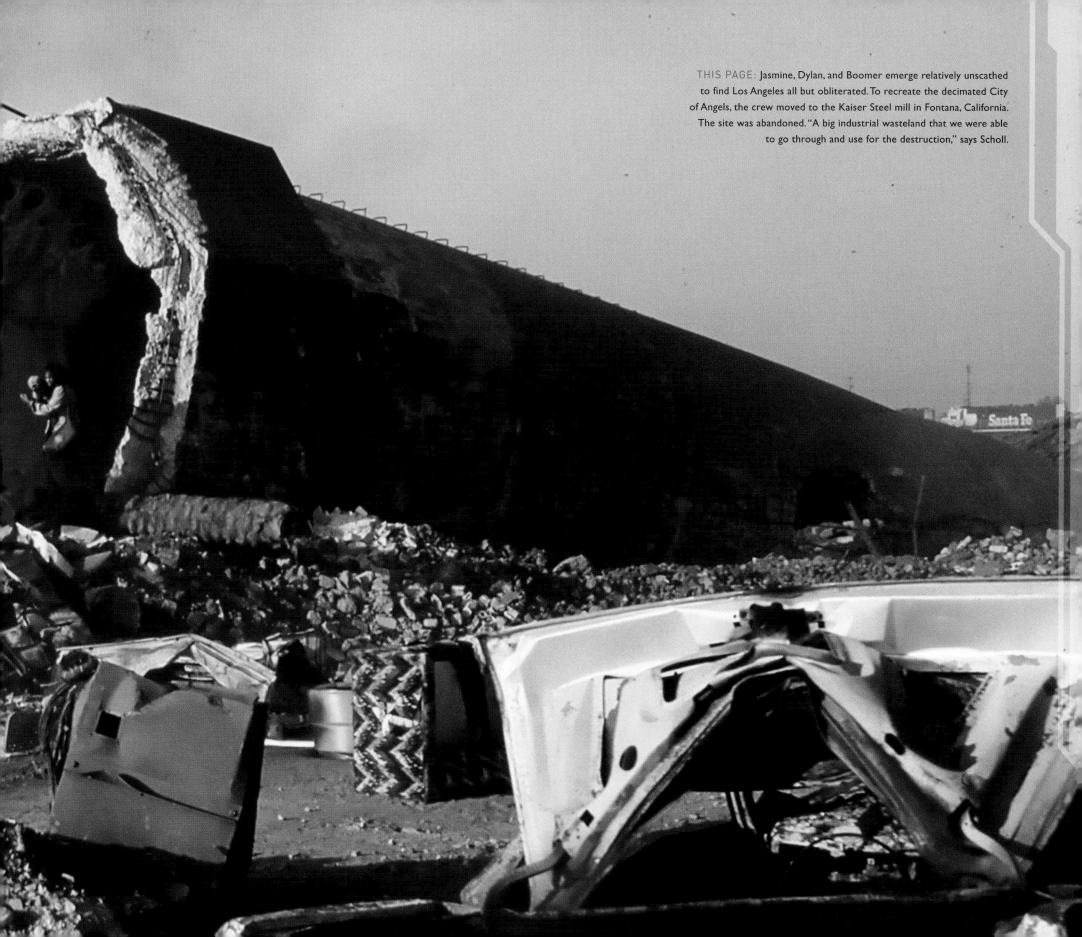

THIS PAGE: Jasmine, Dylan, and Boomer emerge relatively unscathed to find Los Angeles all but obliterated. To recreate the decimated City of Angels, the crew moved to the Kaiser Steel mill in Fontana, California. The site was abandoned. "A big industrial wasteland that we were able to go through and use for the destruction," says Scholl.

THE PHENOMENON

Producer and co-writer Dean Devlin describes the moment the idea for the film was born, an idea that is a perfect cinematic marriage of visuals and plot: "Roland said, 'What if tomorrow morning you wake up and enormous spaceships 15 miles wide were hovering over the 30 biggest cities in the world. Wouldn't that be the most momentous day in the history of mankind?'"

Patrick Tatopoulos elaborates on the visceral impact the image aimed to have on the viewer: "You'd never see the whole ship – it's too huge. Roland wanted the idea of looking out of your window and seeing that the sky has become mechanical. This set the tone for the whole of ID4."

'Foreboding' hardly does justice to the overwhelming images of ships wreathed in fiery cloud boring through the sky like a John Martin-esque vision of apocalypse. This effect was achieved in a water tank or 'cloud tank'. Thin metal pipes dotted with halogen lights and stippled with holes were lowered into the water, and paint was pumped into the pipes. "The paint spread out into the water," explains Volker Engel. "Depending on the choreography of the movement of the pipes, the color would take on different forms. It usually appeared cloudy."

This was matched with previously-filmed reaction shots of dozens of extras gazing up at what was then an empty sky. The visitors had arrived.

Once the phenomenon has been revealed as an attack, the remnants of mankind group together, fleeing the cities and waiting for an opportunity to strike back.

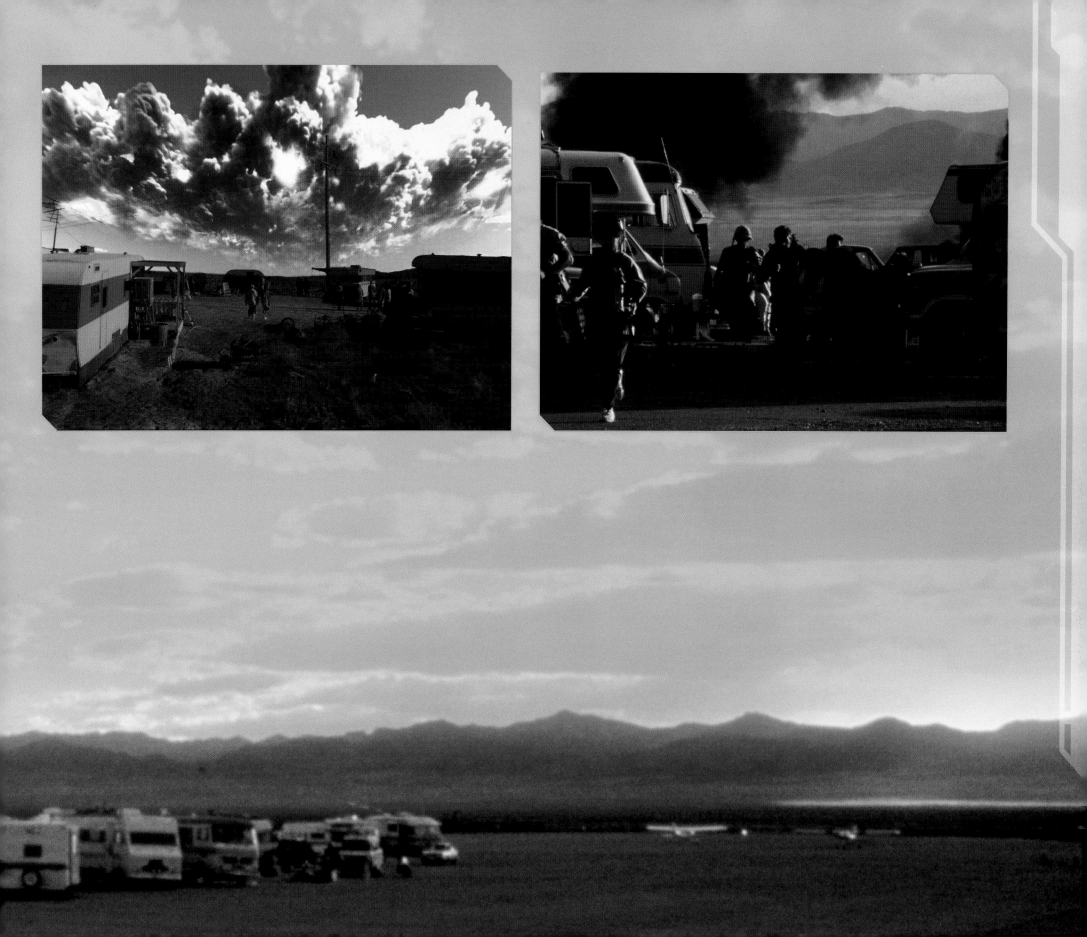

THE FAT LADY SINGS

While Hiller and Levinson Trojan-horse their way into the alien mothership to plant the virus that will lower the defensive shields, the pilots on Earth engage the attackers. The dogfights were filmed by the second unit, directed by Dean Devlin, using the genuine scale cockpit section, miniature planes in the background, and painted dioramas that could be quickly rotated to create the sensation of planes swooping and turning through the air. Actors were inside life-size prop planes being rocked back and forth by a 'gimbal.' The desert beneath was recreated in detail and in the correct scale against the 15-feet diameter destroyer model hovering on a rotating pylon above.

To convincingly portray hundreds of attacker ships versus the fighter planes, some minor, albeit cutting-edge, CG elements were harnessed, as Engel details: "The CG elements were really only on a cut by cut basis. Most of the time they were miniatures shot through motion-control, but there were one or two shots in there were we had CG planes that we finished very late in post production but that was then intercut with our pilots sitting in the cockpits. There's never a composite in there. It's either all live action or we're cutting to a wide shot with some CG planes. In the dogfight it's all motion-controlled miniature planes, not CG planes. Then only for the alien attackers, you have a swarm of 100 of them – that was CG. But the moment you feature them a bit more prominently and you have six or seven in a frame, they were all shot separately as motion control miniatures. It was still the time when it just took forever to get some CG images rendered. The whole CG department was six people and we hired another company for super wide shots under the city destroyer: When you see these flocking patterns of the dogfight from really far away, and you have tiny attackers – they came up with the software that was basically simulating that behaviour."

The skies become home to graceful aerial chaos and guiding the pilots on their way to mankind's greatest battle were the words of President Whitmore, uniting and inspiring his countrymen – and creating one of cinema's most famous rallying cries: "Good morning. In less than an hour, aircraft from here will join others from around the world and you will be launching the largest aerial battle in the history of mankind. 'Mankind.' That word should have new meaning for all of us today. We can't be consumed by our petty differences anymore. We will be united in our common interests. Perhaps it's fate that today is the Fourth of July, and you will once again be fighting for our freedom. Not from tyranny, oppression, or persecution, but from annihilation. We are fighting for our right to live. To exist. And should we win the day, the Fourth of July will no longer be known as an American holiday, but as the day the world declared in one voice: 'We will not go quietly into the night! We will not vanish without a fight!' We're going to live on! We're going to survive! Today we celebrate our Independence Day!"

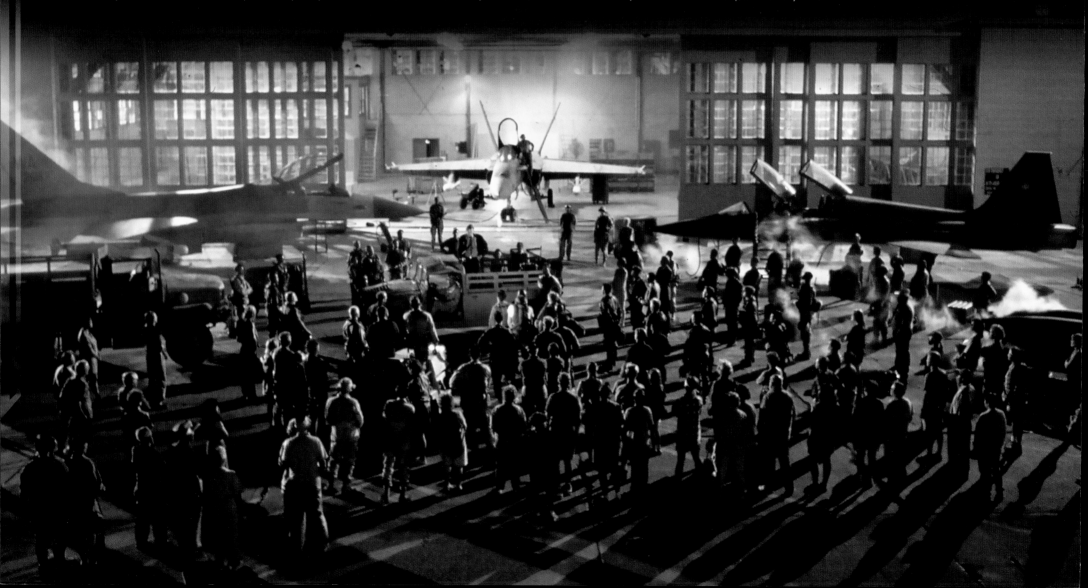

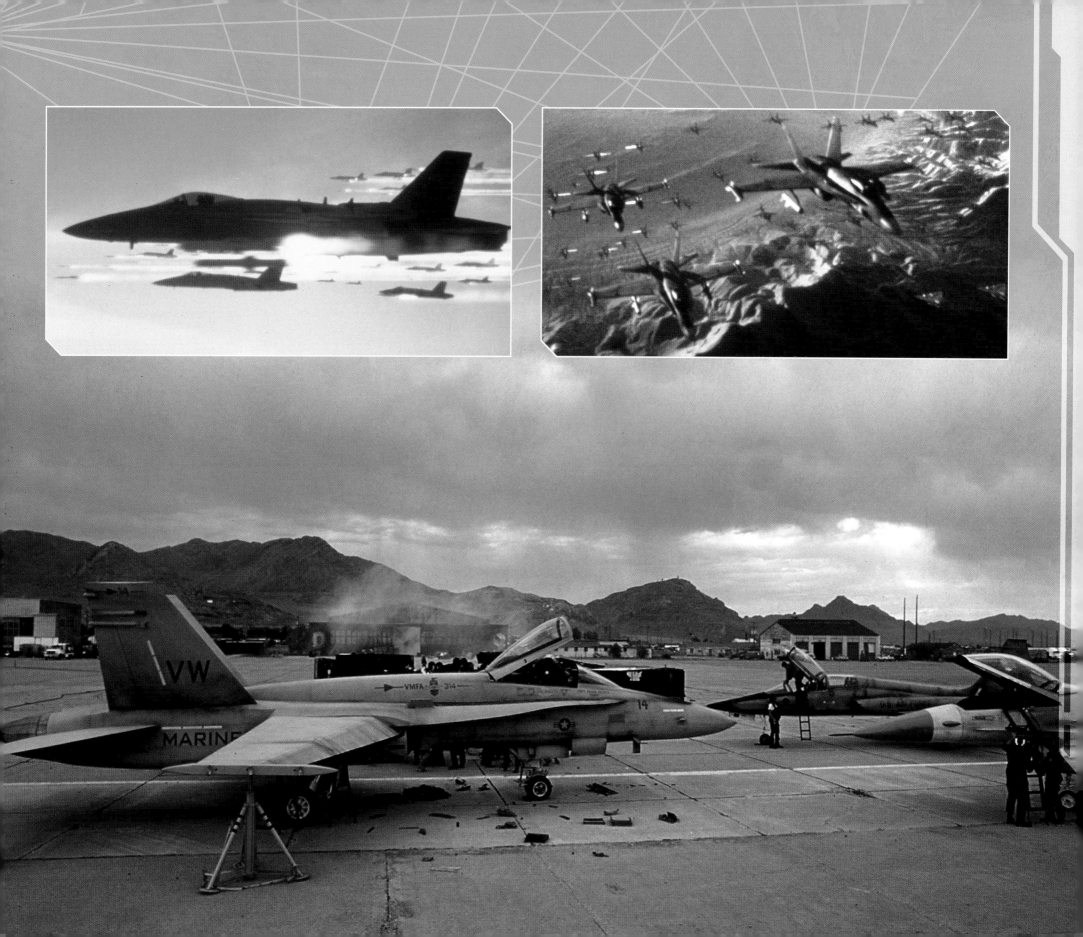

EARTH

AFTER THE INVASION

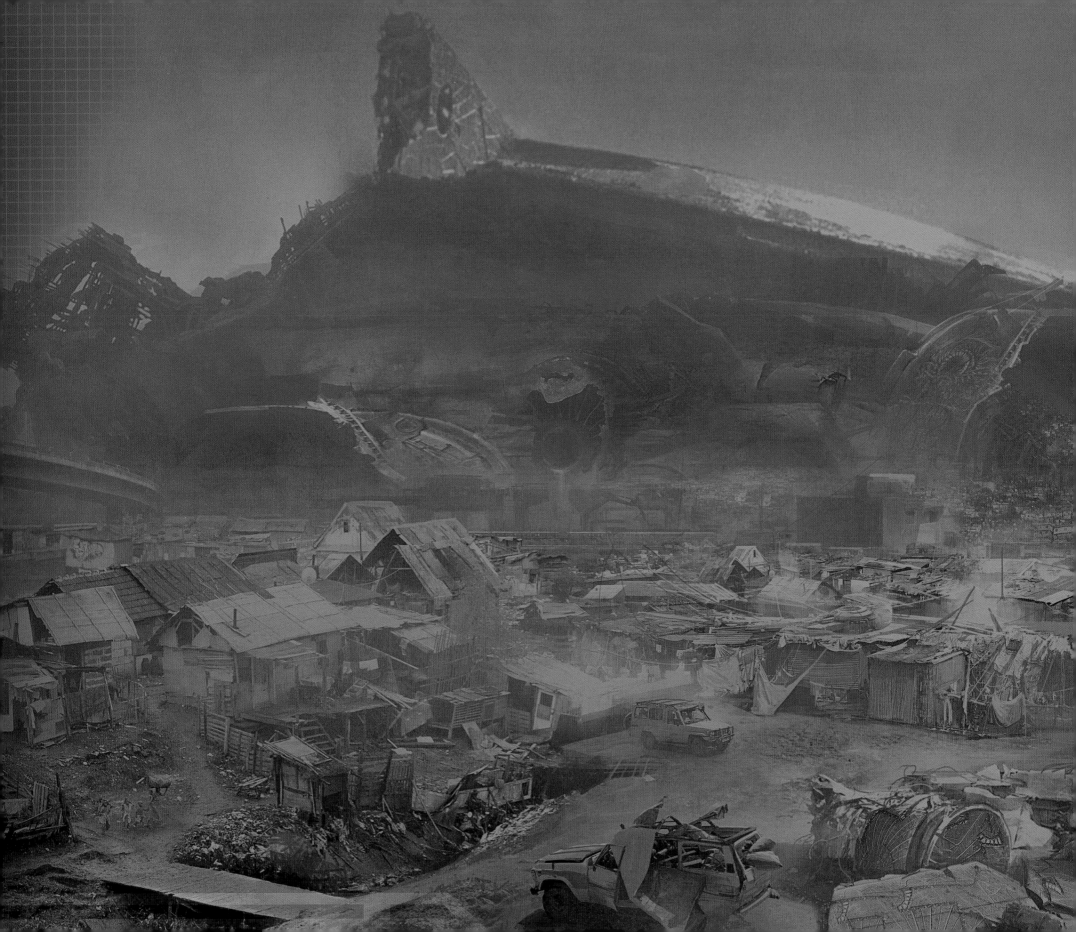

DAVID LEVISON

EARTH AFTER THE INVASION

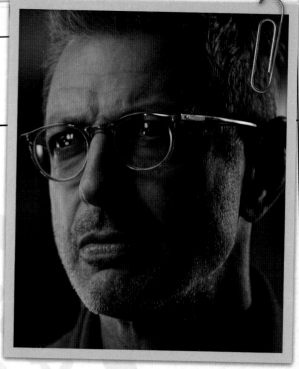

"And on the five millionth day, Noah and the gang disembarked from the boat, rolled up their sleeves, and got to work. They rebuilt."

I may be misremembering my Torah slightly, but what we have here is the Earth decimated and a few survivors working together to improve the world, to try again – to make it a place we can be worthy of. I'm not trying to claim that we were on a mission from God – to do that would be disrespectful to the billions who died in July 1996. And as for God? I know what my father taught me: don't believe what those in charge tell you.

But what we were left with on the 5 July 1996 was a planet that needed fixing and a future that needed making. It was up to those of us left to do exactly that.

We knew very little about the aliens. Thanks to accidentally stumbling upon their signal and then peeping inside their mothership, I knew something, therefore I became the expert. We began harvesting their technology, picking through their downed ships to see what we could use. Their equipment was far beyond anything we had on Earth. All their craft used anti-gravity and their weaponry has its own extremely potent power source. It has taken us years to find a way to stabilize and apply these mechanics to our own engineering. I worked with the research crew at Area 51 and it's a pity that Dr. Okun has not been able to participate. I know he would have found it, in his words, "exciting." After his encounter with the alien, we all thought he was dead but he has lain in a coma since 1996. He has been cared for and we hope to one day show him the world we have made.

And what a world it is.

For the first time ever, EVER, mankind has put aside their squabbles and we are working together. Border disputes, religious struggles, international warfare – it has all faded into the background in the name of protecting ourselves and our world. "If we don't end war, war will end us" is what H.G. Wells said in 1936. We now understand, finally, that we are stronger together. It's just a shame that it took the deaths of untold countless to educate us.

Cities that were nothing but rubble on 5 July 1996 are restored and functioning better than ever. It would have taken decades to rebuild New York, LA, London, Paris, but the alien tech sped up the process immeasurably. In just a few hard-working, difficult, but successful years the Eiffel tower stands tall again. We have our White House back. In Dubai there is something outrageous called the Burj Khalifa; tallest building in the world, over 2,700 feet. I'm not going up there. I'm sure it's lovely. It has been a productive, optimistic time. Optimistic? I may be using that word a bit freely. Certainly we feel stronger than we did and every year that takes us further from 1996 helps me sleep a little better. But the shadow of those days still looms. No one says it, because to say it would break the spell and the feeling that everything is going to be fine.

Sometimes, when the day's work is done and everyone has gone home, when it's quiet and I'm alone, I listen to the signals our new satellites are transmitting. I listen just like I did in 1996. I wait to hear something that shouldn't be there. As I close my eyes and wait, there is one thought that keeps repeating: Are we living on borrowed time?

I put it out of my mind and get back to work.

I'm able to do such things as listen to the satellites whenever I like because somehow I've found myself in what people who care about these things call A Position of Power. I was rewarded for my help in 1996 (as if you fight for your home and your loved ones for a reward) with the burden of responsibility. In the days immediately following the war it was unanimously decided that we create the Earth-Space Defense (ESD), an initiative that would prepare us in the future for any more unwelcome visitors. I worked closely with my (now) good friend Tom Whitmore on this as we both agreed that Earth needed to be prepared in case they ever came back. I dove into researching the alien technology and how we could use it for our own gains.

It has been a beautiful thing to witness a unified Earth, but it has not been without cost.

My wife, who became my ex-wife, became my wife again. And we were happy. After what we had been through, we knew what was important. Like the world at large, we were better together than apart. Despite my long hours at the ESD, despite her devotion to her career, despite my father's constant nods and winks and encouragements, we made it work. We had five good years together, and only one of those was spent with the cancer that took her from me. It's ironic that we may have never reconciled if it had not been for the alien attack – how anything can come from that much carnage. But that has surely been the lesson of all of this: How we can keep going, keep hoping and keep trying. Connie was lost, but I keep going; one day I'll be lost, but I'm pretty sure my father will still keep going.

After many years of work our defences began to take shape. We established a Moon base, run by the wise and extremely competent Commander Lao. Less than 50 years after mankind first set foot on la lune we have a permanent settlement. I try not to go there if I don't have to; nice view, but Steve's piloting never did me a lot of good (apart from when he's saving my life). Always made me smoke a cigar as well.

As I write this we're also working on our bases on Mars and on Rhea - one of Saturn's moons. The cannons we're setting up utilize the same plasma technology as the destroyer ships used on our cities. It has taken us years to perfect this system and control the immense amount of heat that it generates. In both the weaponry and the hybrid alien-human ships we've created, containing the power has been the challenge. Tom and I were adamant that nothing be used with a human subject until it was safe to do so.

But by 2007, Tom had served his terms as president, and Vice-President Bell stepped up. Bell and his aide Tanner pushed and pushed our research to progress faster and achieve the impossible. I resisted as much as I was able, but when the hybrid ships were announced for human testing there was nothing more I could do. Steve knew they weren't ready, but what he also knew was that if he didn't fly it, someone else would.

He was right. It wasn't ready.

I was there when the plane malfunctioned. So was Jasmine, so was his stepson, Dylan, so was the whole world, watching as one of our greatest heroes took his last flight.

I don't blame Bell and Tanner. They did what they did out of fear, scared that the aliens would come back at any moment. It was their own insecurities that took advantage of Steve's bravery.

Actually, I do blame them. I lost my best friend, and I have a final unsmoked cigar to prove it.

As a result I did what I could to make sure that such a tragedy and travesty could not happen again. I fought for the position of director of the ESD. It means I now have authority over the research and testing of equipment, but I have a lot less time to play chess.

The future is looking better than the past does: Jasmine and Steve's son, Dylan, has grown up to be a brave, resourceful, and caring man who is every bit the pilot his father was. Patricia Whitmore has the grace, intelligence, and nobility of both her parents. Speaking of which, Tom has had a difficult few years. More than any of us, he is haunted by the War of '96. The last time I saw him he was distracted, broken, but fighting

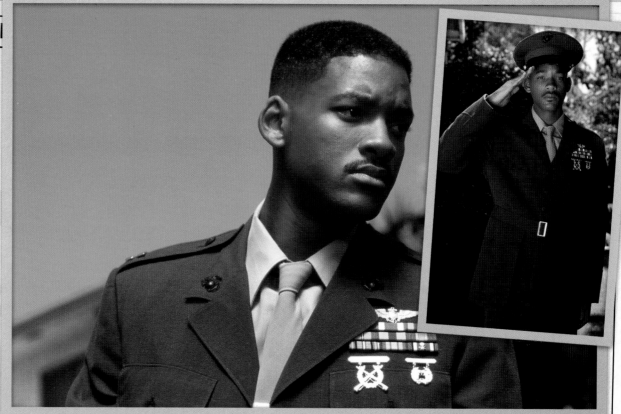

"I LOST MY BEST FRIEND"

whatever he is fighting every day showed me he is still the brave man I remember.

We live in a world now that feels very much like the future we envisioned back in the mid-20th century. Impossible technology, living on the moon, 'laser' guns. That said, I still need to wear glasses and I still have to remind people to recycle.

It's not Utopia, but we're getting there.

As I write this, as I recall everything that's happened over so long, I think about how much older we are, and the world we're trying to make and defend for the next generation. I think about my grandchild-less father and how I haven't seen him in so long a time that it would shame me to write it down. But that is not entirely my fault; well, it is my fault that I agreed to go to a book signing with him to promote his outrageous memoirs, but it is not my fault that he tried to perform a recital of The Beatles' 'All You Need is Love.' "John Lennon," he said, afterwards with a distinct whiff of déjà vu. "Smart man. Shot in the back. Very sad." That was when I left.

It is incredible to me that we are now just days away from the 20th anniversary of the attacks. It would be the truth if I said I am not where I was once expecting to be at this point in my life. How do we mark this anniversary? It would be wrong to celebrate, although we have much to be proud of.

I won't be in DC at the memorial event, I won't be at a barbecue or with family. I will be working. In The Congo. That is the only place on Earth where the aliens landed a city destroyer and disembarked. What followed was a gruelling one-year ground war with African rebel soldiers. There's been reports of some activity there and my inquisitive mind is wondering if it is in any way linked to something I noticed when the mothership went down in 1996: a power surge from the ship's frequency.

It could have been nothing.

It could have been a distress call.

It was probably nothing.

I have to believe that we are ready and prepared now for anything that may come. That we didn't survive through thousands of years, plus another twenty that we almost didn't have, for nothing. We are stronger, we have evolved. I turn to Herbert George Wells again: "Adapt or perish, now as ever, is nature's exorable imperative."

But it occurs to me that evolution does not apply only to those on Earth.

CLASSIFIED

CHARACTER PROFILE

 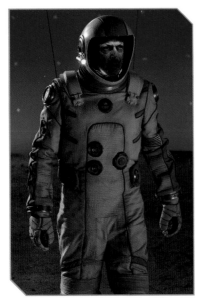

DAVID LEVINSON

JEFF GOLDBLUM

Much has changed for David in 20 years. He is now Director of the Earth-Space Defense (ESD) and has committed himself to studying alien life and culture, incorporating their technology into our own weapons and equipment. But despite this added pressure, David himself hasn't changed.

"He's always had a lot of potential," Goldblum reflects. "The crisis 20 years ago brought out a new part of him. His father always thought he was underachieving, but he was always a person of romance and character and scientific integrity and wild curiosity, and he's that same person."

"Of course in that 20 years he's been given the job of being a director of the Earth-Space Defense," Goldblum continues. "So there's lots for him to do and a big responsibility and it's a weird position for him to be in. He's essentially the same person and just as inflamed with romance and that poetic love for the planet and people and the wild curiosity."

Whilst he is as intellectually active and fulfilled as ever, it is David's personal life that has suffered. He hasn't seen his father in a long time and his wife, Constance

(who he remarried) died from cancer. Following their world-saving journey into space, David and Steven Hiller became best friends, but with Steven's untimely demise, David is forced to do what the world at large has been striving for: grieving and rebuilding.

Resurgence is a reunion for much of the cast and crew, as well as an opportunity to revisit the beloved world of *Independence Day* with new technology, ambitions and inspirations, as Goldblum explains, "I think it's bigger, it's much bigger...sets the like of which I had rarely seen – very big, elaborate, kind of beautiful art pieces. Roland Emmerich 20 years ago was the sweetest of all guys and passionate, and the same now – even more so. I think he's even deeper, more soulful and humanistic and loves telling these stories about love, essentially, and connections between all peoples of Earth. And he's a great storyteller. Dean Devlin said to me that he knows that for one reason or another Roland has a conspicuous fire in his belly about this project. He's just on fire about it. And that was my experience of it. We worked these 16-17 hour days regularly and he was the driving force, the happy General of the whole effort. It was very thrilling."

CHARACTER PROFILE

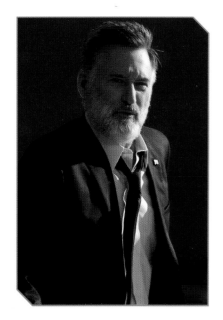 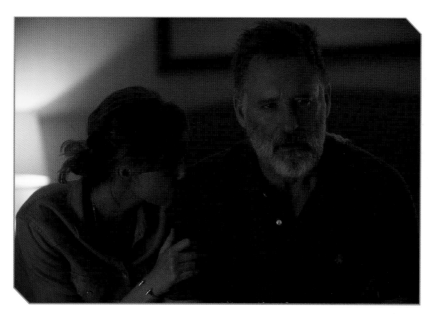

THOMAS J. WHITMORE

BILL PULLMAN

The years have not been kind to the former president. During the 1996 war, the alien captured by Steven Hiller almost killed Dr. Okun and created a telepathic link between the alien race, Okun, and Whitmore. The residual effects of which have made the president a shell of the man he once was. When we meet him in *Resurgence* he wakes up screaming from a nightmare – visions of a second, even more terrible attack.

"My character has undergone a big change," explains Pullman. "As President he enjoyed a lot of attention from the world for having led to the defeat of the invading aliens. And he somewhat becomes compromised by the fact that his mental condition has been destabilized by these recurring visions of dread and angst that they're going to come back and it's going to be worse than ever. So you find him at the beginning of the second one in a very different condition than the first President Whitmore. It's almost like he has PTSD."

Replaced in office by President Lanford (Sela Ward), Whitmore is now watched over by his daughter, Patricia (Maika Monroe), and secret service agent, Travis (Gbenga Akinnagbe). "He's been somewhat sequestered off," Pullman continues. "His daughter in particular wants to keep him out of the public eye so that it doesn't get embarrassing for him and others."

The bond between Whitmore and his daughter (his "munchkin") was a key, tender relationship in the first movie and one that continues through *Resurgence*. Having a daughter of similar age himself, Pullman was able to relate to the paternal side of Whitmore and the co-dependence of his family: "When I made the movie I think my daughter was about six, seven, and now Maika Monroe is my daughter and she's in her twenties. So it was a very natural thing to suddenly encounter her… The idea [is] to have someone very real I'm protecting, trying to think about how at some point I can't be a good guy to her because I'm so on the ropes with my own battles, and it's through her that I start to make my turn. It's the encounters with her that really remind me of what it is I need to do."

In movie terms and real-life terms, the two decades that have passed have given the characters and actors a genuine sense of the passage of time. It was inevitable the story would continue, the lives of the characters would continue, it was just a matter of when and how. "The sequel was always a matter of waiting for Roland's conviction that he could do it in a way that would be as inspiring for him and us as the first one was. Once he'd really gotten in gear for it, it was an easy thing to want to come back to do. As an actor I feel a little bit like the character [feels]… The first event happened and I always knew they would come back."

CHARACTER PROFILE

JAKE MORRISON

LIAM HEMSWORTH

An orphan, whose family was killed in the 1996 invasion, Jake is self-sufficient, independent and someone who trusts his instincts. "He's got a bit of a chip on his shoulder," explains Hemsworth. "He's kind of looking for some revenge and he's an impulsive young guy. He's a good guy, but I think he doesn't quite think things through sometimes."

His combination of confidence and recklessness leads to clashes with authority. While he acts with the best of intentions – such as saving the life of a friend- this can mean going against the wishes of his superiors, like head of operations on the moon base, Commander Lao. Jake's early career ambitions to be a fighter pilot were derailed and he now works on the base with his best friend, Charlie, lugging space weapons around using his moon tug.

"It's not quite the most exciting job for Jake," explains Hemsworth. "He can be a little outspoken, he's always been kind of the underdog…and I think he's jealous of other people's positions, Dylan in particular, him being kind of the golden child and always feeling like he was given everything [whereas] Jake really had to fight for the things that he's had."

And what he has is a loving relationship with President Whitmore's daughter, Patricia, and the trust of David Levinson's character. When David says he needs to investigate the wreckage of a mysterious ship on the dark side of the moon, it is Jake who helps him, going against the orders of his superiors and the President.

In his moon tug and, later, co-piloting an alien craft, Jake plays a key role in the major action sequences, including some very 21st century dogfights. "The jets are amazing, the tug's amazing. They're some of the most intricate, detailed sets I've ever worked on. The attack on the mothership was an exciting moment for Jake as it's the first time he gets back into a jet and they get overrun by the power of this alien invasion. There's a lot more of them and their technology is even more advanced now and they have the upper hand."

Realising such large-scale battles meant using CG and collaborating with Roland Emmerich, who had carefully pre-planned every sequence. "A lot of the stuff we've done on this has been on bluescreen and you really don't know what's going on and you're kind of talked through it. You have to trust that. Roland's one of the best directors in the world at doing this sort of thing. He has a vision."

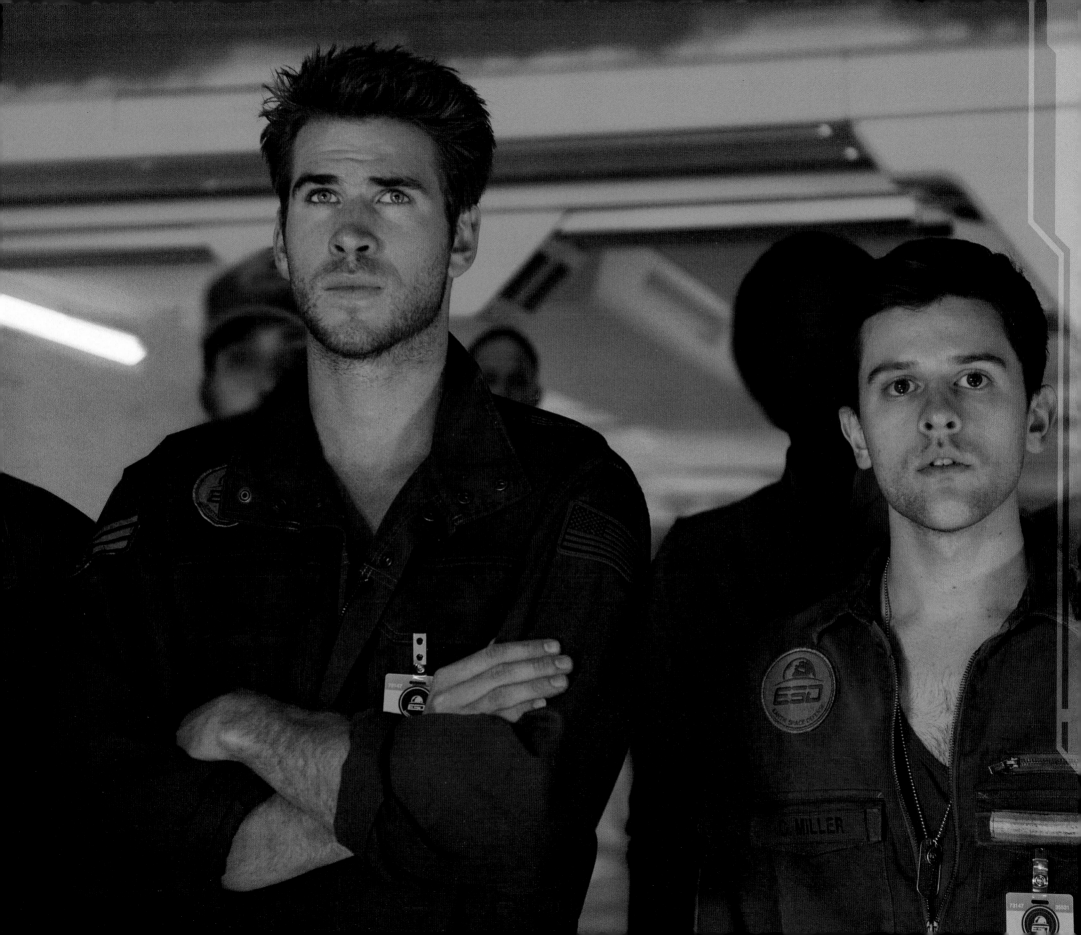

CHARACTER PROFILE

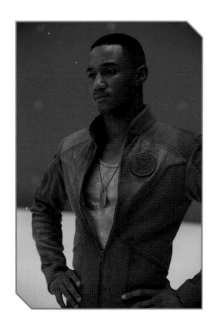

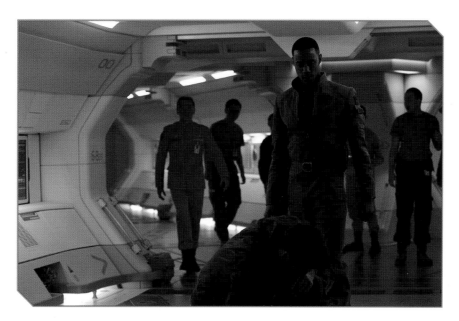

DYLAN HILLER

JESSIE USHER

Dylan was just a child when the aliens came to Earth in 1996. The fallout from those events took place during his formative years and the man he has become 20 years later is very much a product of those times. Growing up at the same time as Patricia Whitmore – both children of heroes – means they are almost royalty in the eyes of everyone else. Like his stepfather, Steven, Dylan went into the military and became a fighter pilot.

"A pretty good one!" as Usher puts it. "He just had a natural talent which is kind of what has led him to where he is now. He's a squadron leader and he's obviously a very talented fighter pilot. He's put definitely put the work in, for sure… A lot of the guys in the military look up to Dylan, and he has a good grasp of pressure and a good grip on the legacy. People will follow his lead."

Dylan, along with Liam Hemsworth's Jake and Maika Monroe's Patricia, form the new generation that continues the story of *Independence Day*. It was important to the characters and the audience that as they take the adventure into the future they also represent a link to the past. For Dylan and his mother Jasmine the intervening years has only made their bond stronger, a closeness that both actors worked on before filming even began.

"Vivica reached out to me when it was announced I'd been cast and said, 'I can't wait to meet my son!'" explains Usher. "So by the time I arrived on set it was like we already knew one another. She really prepared me for what was coming." When it comes to the characters themselves, "[they have] grown together. What they have had to deal with, they've dealt with together."

And what they have dealt with – and in some ways are still dealing with – is the untimely death of Steven Hiller. "His death is still fresh," says Usher. "It's still playing on the news and people are still coming up to me and saying, 'Sorry about your dad.' I kind of wish he was around to show me what to do."

Despite Dylan being the film's closest link to Steven and his taking the mantle of the 'heroic fighter pilot,' Dylan is no Steven Hiller-proxy. "He's not like him, but you do see similarities because of the situation he's in. Sometimes you can't help but draw links; he's such a legendary character, we'd be mad not to. People who know the first film well may notice little things and say, 'That's the sort of thing Steven would say!'"

As Usher describes him, "He is very much his own guy. A hero and I've never really played a hero before. It's great for me as an actor and for the character as well. It's fun!"

PATRICIA WHITMORE

MAIKA MONROE

In the first movie she was 'Munchkin.'' Fast forward 20 years and Patricia 'Patty' Whitmore has followed in her father's political footsteps and finds herself in a new and rebuilt White House. Where once she played in the halls of 1600 Pennsylvania Avenue, it is now her place of work, with Patricia acting as an aide to President Lanford. Patricia has worked hard to get where she is, taking her responsibility and authority seriously, taking the lessons learnt from her father but moving the Whitmore family into a new age. "She's definitely tough," Maika Monroe says of her character. "She's a warrior. I think she also has a very big heart, and you see a lot in this film, the relationship with her father, and she cares so much about her father and will really do anything for him."

Her father's legacy looms large, but the reality of Thomas Whitmore two decades on is a man who must be looked after and kept out of the public eye as much as possible. As her character says, "I want to remember him for the man he was, not who he's become." The world has grown accustomed to normal life again, but it is painful for her to see her father still tormented by the past. "I don't think that she thinks her father's crazy, but she's definitely concerned," explains Monroe. "In the middle of the film she actually starts listening to what he's saying and realizing, 'Okay, wait. Maybe there is a warning. Maybe he's on to something.'"

Aside from her father, the two most important people in her life are her love interest, Jake, ("the bad boy") and childhood friend, Dylan, a relationship which Monroe describes as "Not a normal childhood. They grew up in the limelight of these global heroes. And so they bond over that. It was not easy, and I think that not many people can understand what it's like, the pressure and the reality of having these huge war heroes as their parents. So, seeing the bond and the friendship there is really special."

The majority of Resurgence sees Patricia separated from both Jake and Dylan as the aliens rain down chaos upon the world. By far the biggest production Monroe had worked on up to that point, interacting with this science-fiction world was a combination of hugely realistic, sophisticated sets and cutting edge visual effects: "I'm used to the indie world, that's much smaller than this. This is huge. When you walk onto these sets, especially the shuttle bay, it's unbelievable. I mean, it's real." She continues, "We're using this system called the N-cam, and so we're able to see in real time a lot of the CGI, the aliens, explosions. We can come back and watch playback and see, where I'm running away from basically nothing, a blue screen, and then they're putting in the alien, and it is so cool."

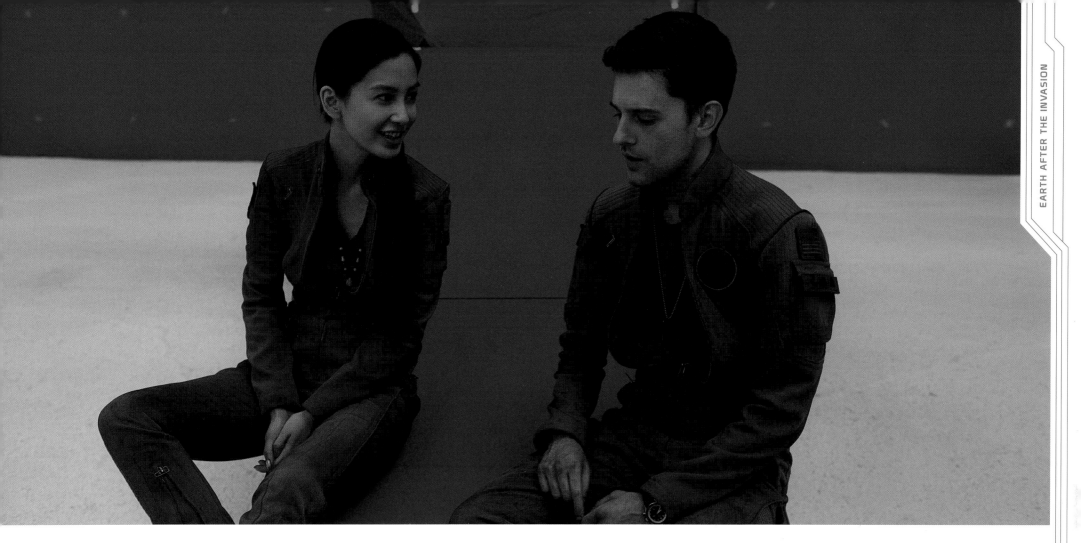

RAIN LAO

ANGELABABY

I f the original *Independence Day* can be broadly described as North America's response to the alien attack, then *Resurgence* is unquestionably the world versus the invaders. The scale this time is global and features a large ensemble of multinational characters.

A key new addition to the crew is the fighter pilot superstar, Rain Lao, played by real-life superstar Angelababy. Her character is Chinese and the niece of Commander Jiang Lao (Chin Han), who oversees the moon base, and raised her after her parents were killed. Somewhat of a celebrity – and extremely sought after by Jake's best friend Charlie – she is nonetheless a professional who takes her responsibility seriously, as the actress describes her: "a tough girl."

It is Angelababy's first foray into Hollywood and first effects-driven sci-fi film, and the challenge for her was bringing the scenes to life. This required a highly focussed imagination and trust in her director: "Their technology is pretty awesome," she says, "because every time before we started filming, Roland would show me a pre-viz on a monitor and he would explain the scenario. Especially when you are acting in front of a blue screen, it would definitely help a lot because you would realize, oh, the airplane looks like this…You need imagination to perform in front of a blue screen."

Realising this massive world, from the scope to the tiniest details, is an almost overwhelming undertaking and one that she watched Emmerich keep control of and guide each element. He always had an answer for whatever questions she posed. "I think Roland is a genius director. He has so many pictures of the future, so many secret weapons and so many details about aliens. Maybe he is from space."

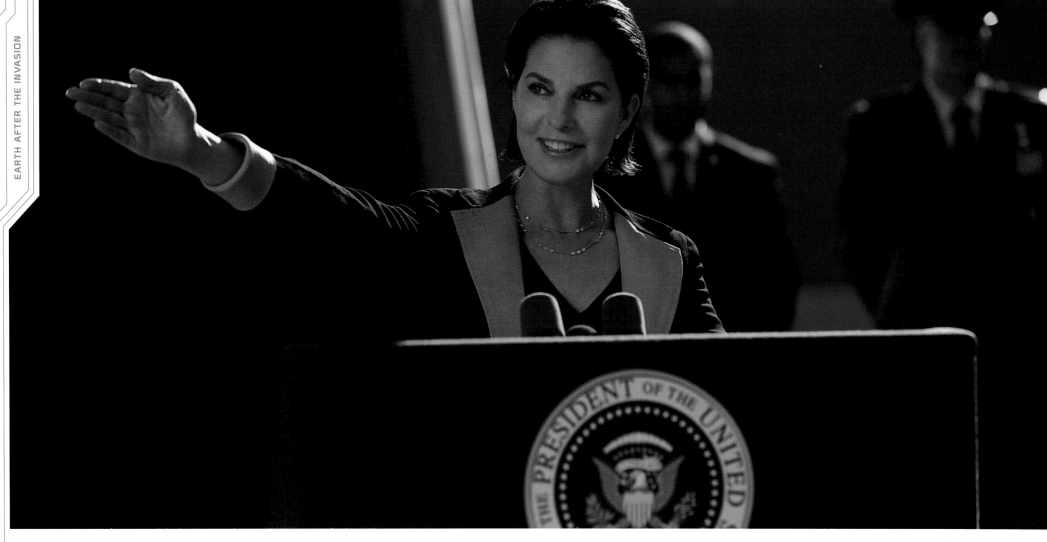

PRESIDENT LANFORD

SELA WARD

Thomas J. Whitmore was a calm, even-tempered, and humble president. Twenty years and some changes in administration have brought us President Lanford, who is, as Roland Emmerich puts it, "a southern belle. A feisty lady with a southern twang. She's a great president!"

A new character to the franchise, her backstory is of course affected by the events of 1996. After losing all her family in the war, she is hardened, tough, and determined to lead the country with conviction. With the majority of the world beginning to believe the traumatic days are long gone and never to return, it is Lanford's ambition to move away from the ESD, from defense spending, and push the country forwards. It is a different type of world now, a different

type of United States, with a suitably different president. "She's very decisive," is how Sela Ward summarizes her. "She has to be. She's not afraid of using force… in terms of leading the country, in terms of her decision making. A lot of strength and really not afraid."

Ward raises the point that so many characters were made orphans by the first confrontation; it is something the nation and global community as a whole had to face in their own individual ways.

"When you're playing a character with these circumstances you definitely want to include the emotionality of what it's like to have lost all the people you loved. The toll that that takes, the way that it hardens you and makes you more resilient and ferocious inside. So I think that's what makes her such a strong President. And she has nothing to lose."

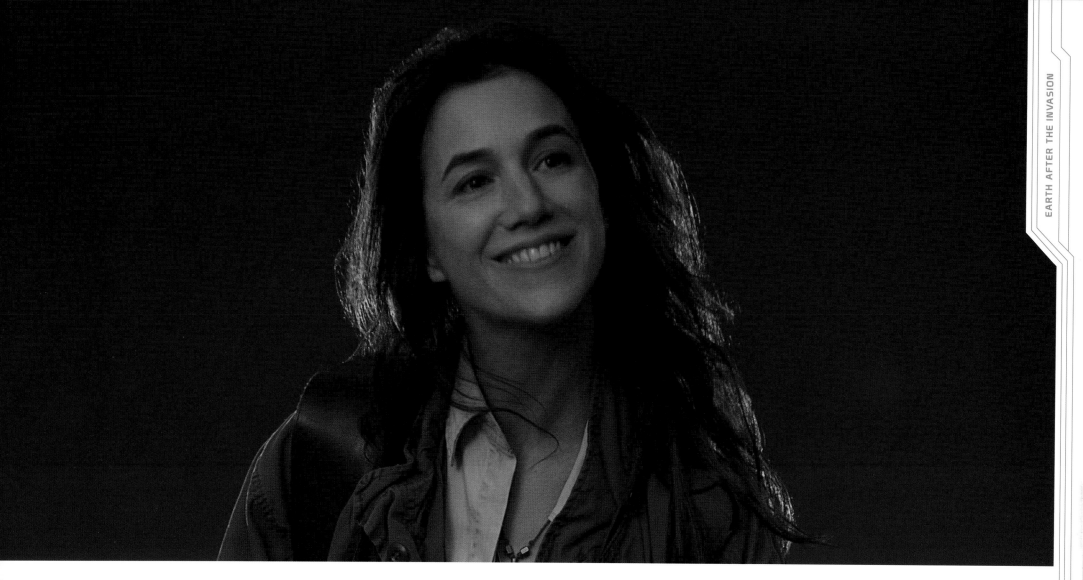

CATHERINE MARCEAUX

CHARLOTTE GAINSBOURG

An actress not known for Hollywood work, Resurgence is Charlotte Gainsbourg's first blockbuster. A truly multinational cast of characters, her role shows how the whole world is affected in times of crisis, and inquisitiveness and survival is not a national concern, it is a human trait.

When we meet her, she is investigating the "alien psychic residual;" visions affecting certain of those who came into close proximity to the first wave of aliens. Catherine has travelled round the world studying the images these people are describing, and which will prove crucial – and surprising. As in the original film, the scientific aspects of warfare are just as important as the firepower.

"I haven't done these films before," Gainsbourg specifies. "The technology of all the surroundings is completely new to me…it's a strange balance between what you could imagine with that kind of a scale. I would have imagined very technical and quite cold, and it's completely the opposite. It's not that big. It's very human."

From a production standpoint as well as narratively, the writers are keen to always bring out and highlight the human aspect. Between the action sequences in both films are extended scenes of characters in dialogue, exploring ideas, and personalities. This interaction is key, and for Catherine her main point of contact and closest companion is David Levinson.

"They've had some kind of love story together and he hasn't called me back, and so I'm a bit pissed at the beginning when I see him. Again, I know I'm going to see him, but he has to, in my mind, he'd have to apologize…I think she's a very passionate but also quite a strong character with beliefs, the opposite of David, maybe, in the sense that she observes people and he observes technology and aliens."

Gainsbourg brings a European style, emotion, and worldliness to the role, or, as co-star Jeff Goldblum puts it, "She is a wildly special person and actress, and I couldn't have been more thrilled with the precious moments that I spent with her. She's really spectacular."

In the years since the aliens were defeated, mankind pillaged the alien technology, harvesting it for our own means. After two decades work by David Levinson and the Earth-Space Defense (ESD), new equipment has been created to help humanity not only rebuild civilization but to protect it.

The ESD is in the process of establishing outposts throughout the galaxy to defend Earth from the return of unwelcome visitors. The furthest is on Rhea, one of Saturn's moons; the second is on Mars; the first fully functioning base is on Earth's moon. It is the last line of defense before Earth.

The first film opens with the alien spaceship passing over the moon so it is a significant location for both films. The moon base is under the authority of Commander Lao, and the potential and constant threat of the aliens has all nations working together, as Emmerich explains: "What happens if in the post war…they know that the threat is coming back? Which would unify the Earth…there would be no Chinese or Americans or Germans or French, there would be only humans."

turn, swivel, and target

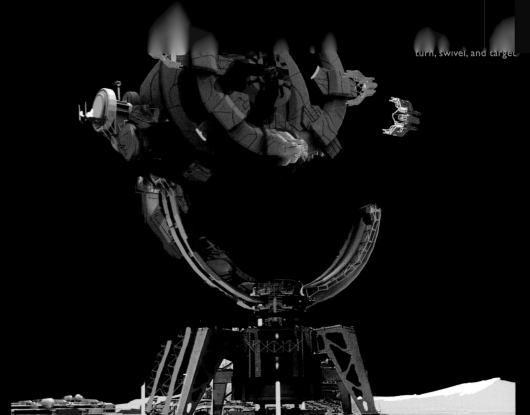

BELOW: 3D models of the space cannon.

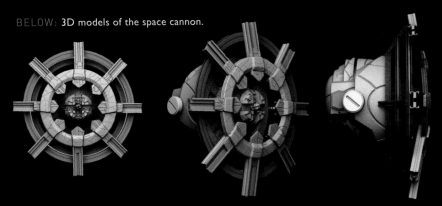

BELOW: Rough sketches showing overhead views of the huge base, the Earth just visible beyond the horizon.

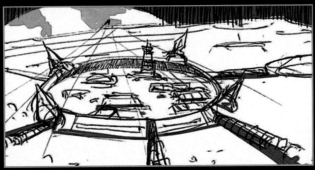
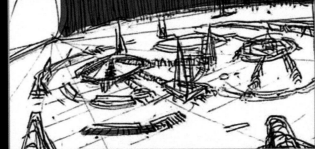

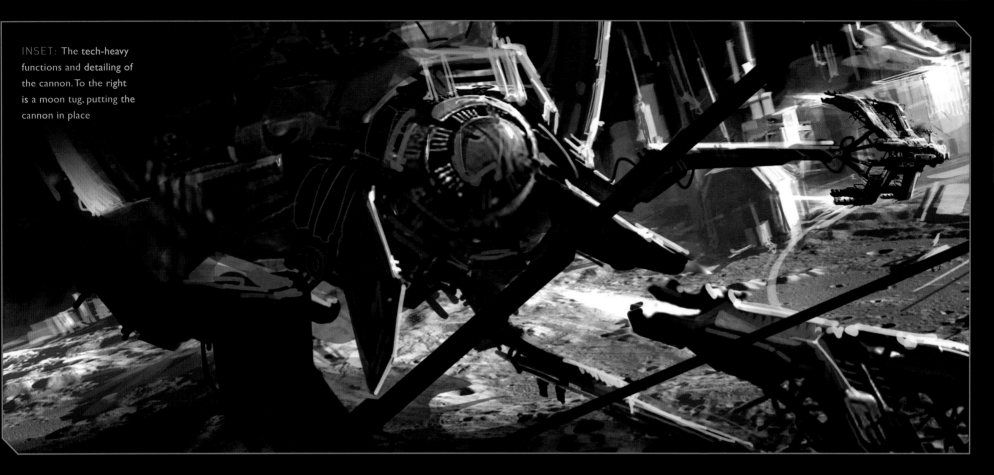

INSET: The tech-heavy functions and detailing of the cannon. To the right is a moon tug, putting the cannon in place

As with all the weaponry and equipment in the film, it was important that as impressive as it may be it should not be fantastical. It should be logical, not magical.

"I think we're a pretty grounded group," production designer Barry Chusid says of the design process. "And we're always bound by issues of gravity…. I think the approach that I always took was: we're colonizing the Moon, there's aliens, there's spaceships, and anything that we can do that grounds it and makes it feel like it's a part of our everyday life then let's keep that stuff as real."

"We started really practically," Chusid continues, "We looked at the history of designs for the Moon and we looked at some of the futuristic stuff that architects were looking at doing on the Moon. And then we built it in a very pragmatic way. They would need to eat, they would need to have solar panels or something that would create energy for them, and I thought, 'Okay, how can we build a world that surrounds all the stuff that we need for our shuttle base and our control towers and our dormitories? And we sort of just built around that: if you were going to do it, what would it look like?"

BELOW: Detailed and beautiful concept art showing the huge spread of the base.

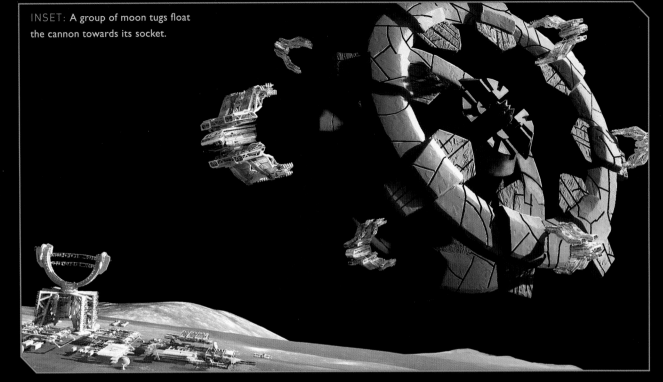

INSET: A group of moon tugs float the cannon towards its socket.

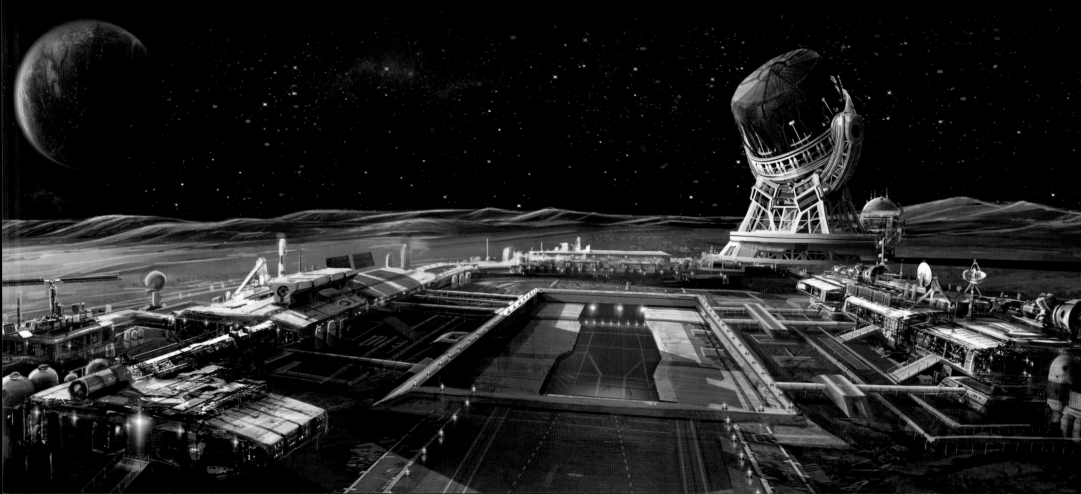

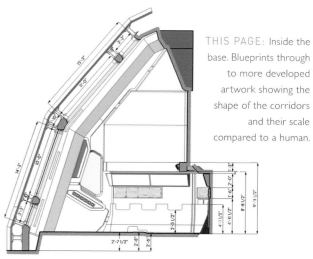

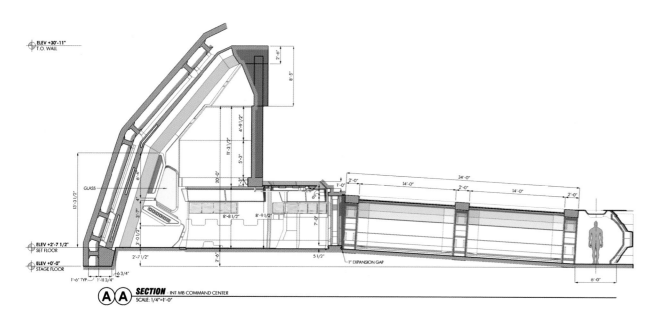

THIS PAGE: Inside the base. Blueprints through to more developed artwork showing the shape of the corridors and their scale compared to a human.

SECTION - INT MB COMMAND CENTER
SCALE: 1/4"=1'-0"

SECTION - INT MB COMMAND CENTER
SCALE: 1/4"=1'-0"

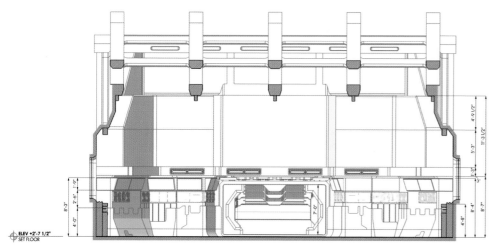

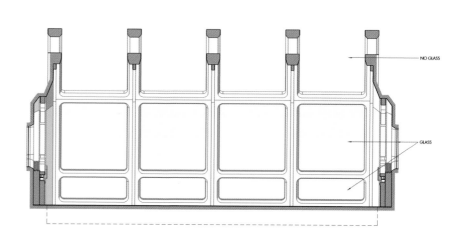

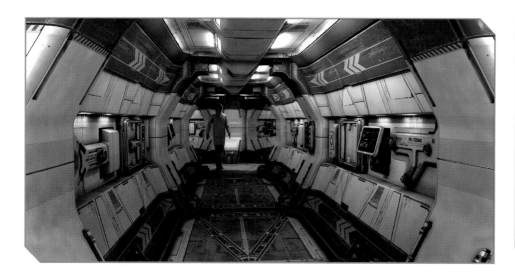

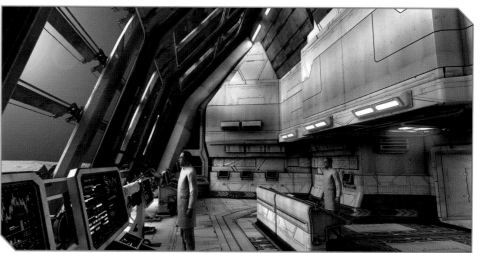

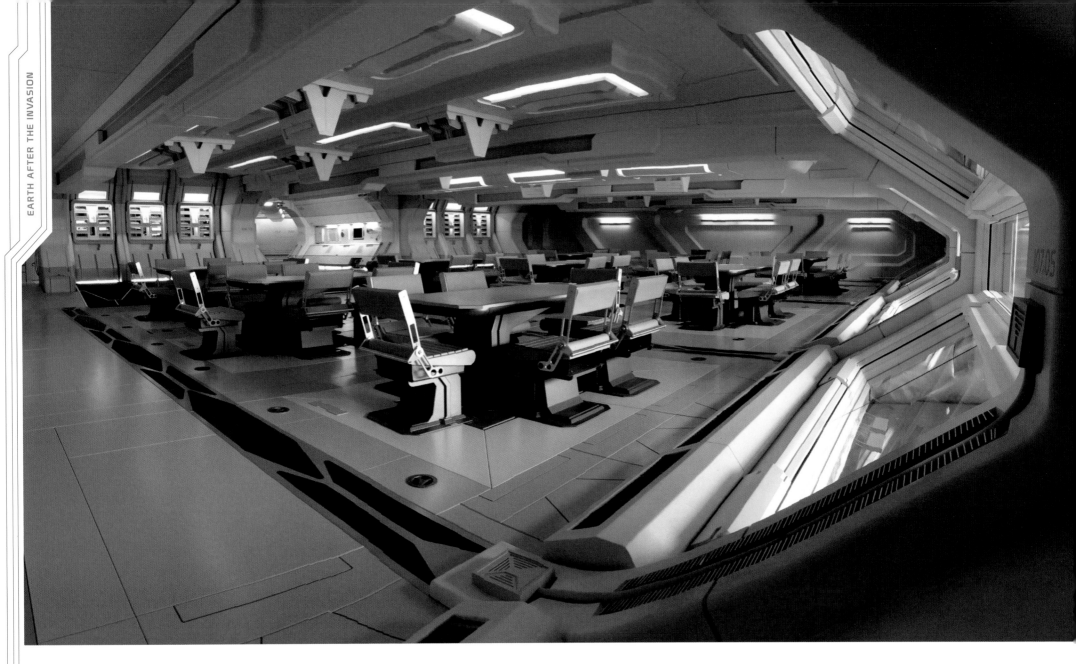

The world created in the film has to feel tangible. The scale, design process, and build process may be immense but it is all crucial to creating a world that audiences can relate to, that feels like it has weight and matters. Producer Larry Franco understood how dedicated the filmmakers were to establishing a sense of place and the narrative, which meant building sections of the base to shoot in and for actors to move around in: "It had to be there, it's part of the story," says Franco. "It has to be a moon base, it has to look spectacular, it has to be great... it can't just be some cardboard on the walls, it has to be something that you can actually touch and feel and be in."

Volker Engel won an Academy Award® for his visual effects work on the first *Independence Day*, and joined *Resurgence* as co-producer.

He understands firsthand how important the effects process is, but also that as much as *Independence Day* is remembered for its groundbreaking scenes of destruction, any decisions on a film should only ever be in service of communicating the story. "You get a lot of mileage out of something when you build it for real," says Engel. "And this is a good example for other decisions that are being made. You could for example ask yourself, 'On the moon, we're gonna have a gigantic hangar. Are we building a piece of it?' Obviously we cannot build this huge hangar that's sort of half a mile long or something like that. That's for sure, but it does make a lot of sense to build one whole wall of it and then two partial side walls, because Roland's very clever when it comes to that; he knows exactly where he has to position his camera to get the most out of a set like this."

TOP LEFT: A set photo of the canteen.

TOP RIGHT: "The sets are...all there to support the narrative, the story, and if they visually tell that story and Roland's able to tell that story then we're proud of them." Barry Chusid, production designer.

BOTTOM LEFT: "It was great to have something that people touch...it was real." Larry Franco, line producer.

BOTTOM MIDDLE: A cabin area. Much of the staff are on long term 'tours of duty,' like Jake Morrison and communicate to their loved ones via satellite link.

BOTTOM RIGHT: A cabin area. Much of the staff are on long term 'tours of duty,' like Jake Morrison and communicate to their loved ones via satellite link.

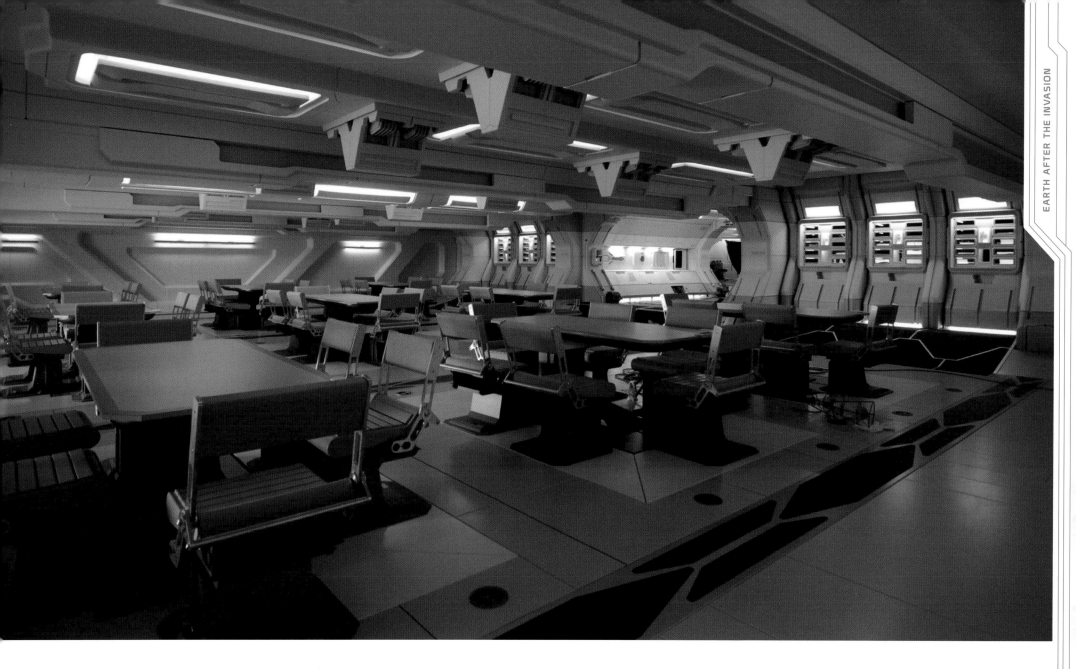

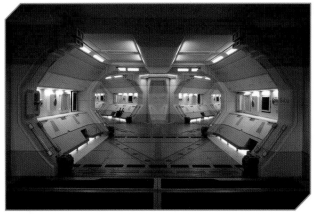

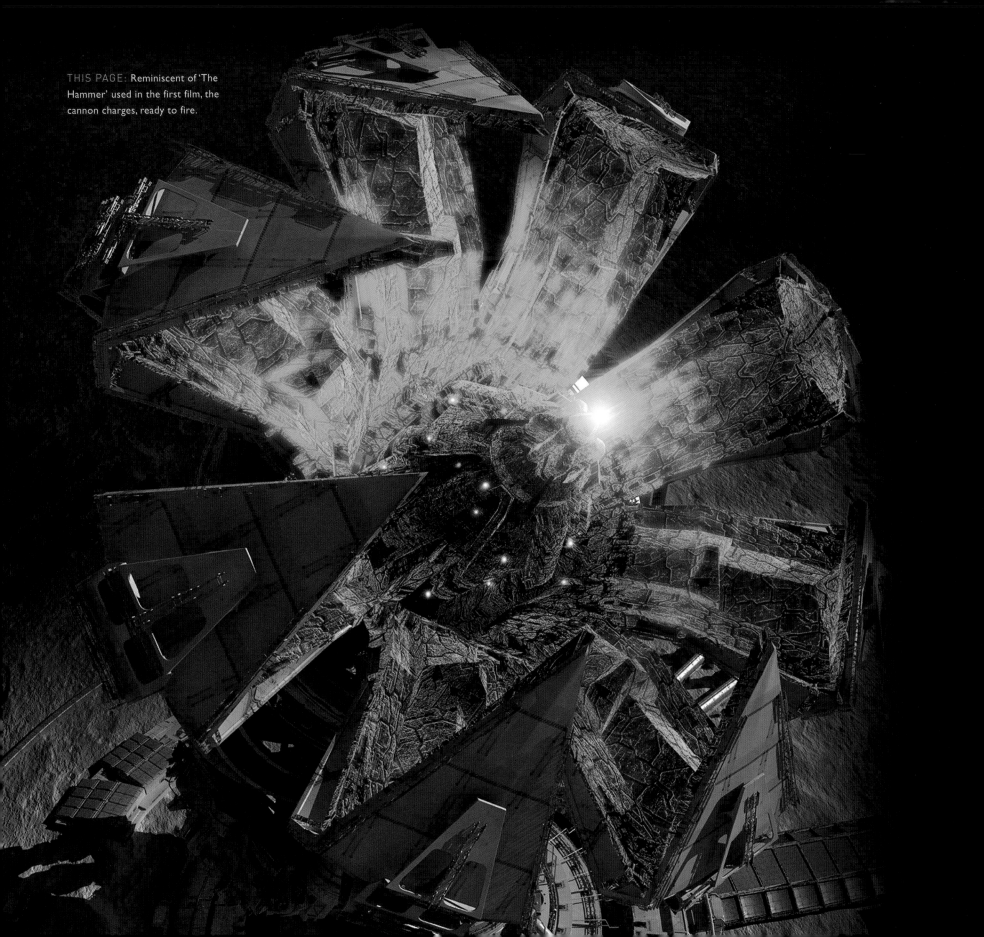

THIS PAGE: Reminiscent of 'The Hammer' used in the first film, the cannon charges, ready to fire.

MOON BASE CANNON

Using the advanced technology from the aliens, the moon base is readily accessible from Earth, and is a permanent base for those monitoring the solar system for unusual activity. Jake Morrison is stationed there and is working to get an enormous cannon in place, a cannon, according to concept artist Johannes Mücke, approximately as big as "Trump Tower, in diameter."

As another bridge between the original film and Resurgence, updating familiar aspects, the cannon is based on the central weapon in the city destroyers during the first invasion. Similar ones are in the process of being placed on Mars and Rhea. The weapon is brought up to modern day, with some science fiction additions and size upgrades, or, as vehicle designer Mark Yang describes, "Imagine our technology 30 years into the future thanks to the alien technology. There's no need to worry about shielding from radiation, or being able to regenerate power; the alien tech takes care of a lot of that, but how we interface with the tech is very similar."

Positioning a gigantic weapon on the moon is a big enough idea in and of itself, but Emmerich was passionate that the idea be as impactful when audiences see it on the big screen. Mark Yang reflects that "Every time we designed something, Roland was like, 'Way bigger, way bigger; much, much bigger!'"

THIS PAGE: Reminiscent of 'The Hammer' used in the first film, the cannon charges, ready to fire.

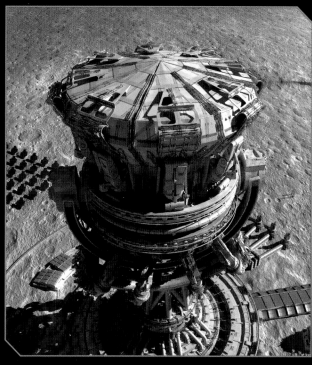

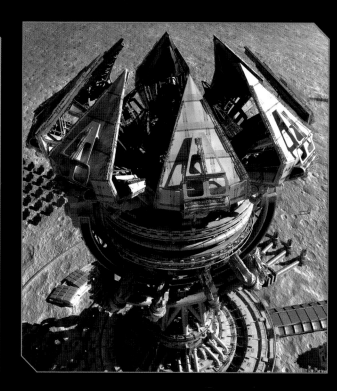

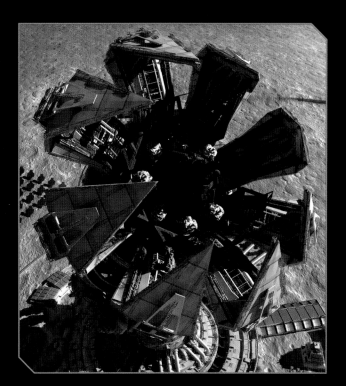

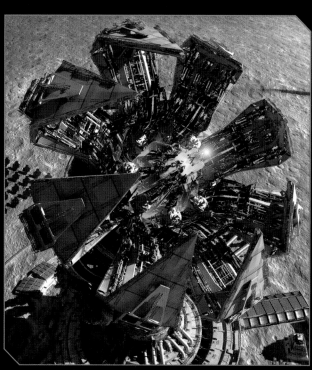

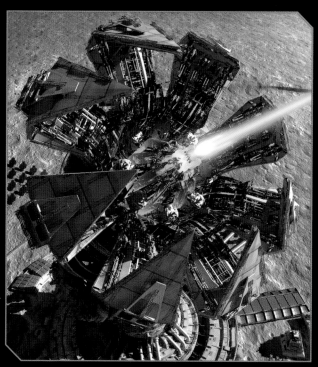

EARTH TECH
MOON TUG - EARLY CONCEPTS

For hauling around the massive equipment needed on the moon base – most importantly, the cannon – Jake Morrison uses the moon tug, a machine that doubles as both a ground and aerial vehicle. Described by everyone in the production as a "space forklift," it's a hands-on and purpose-built piece of kit that ends up being crucial to the story for Jake and his friends when the aliens return. Being such a centerpiece, Emmerich, his artists, and his builders spent a great deal of time getting the look and movement correct.

"Form follows function," explains production designer Barry Chusid, "because it has a very specific task… We wanted it to feel very natural and just like, 'Well, of course that's what it would look like.' If you had to move a cannon onto the Moon then that's the vehicle you'd use to do it."

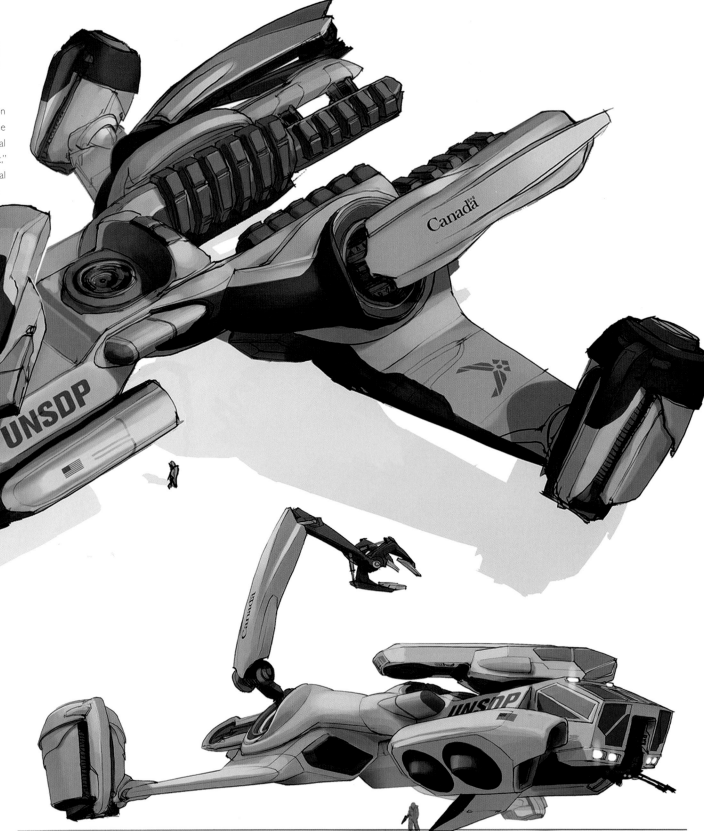

ABOVE: An early concept piece showing a much more plane-like, weaponized machine.

RIGHT: Alternative design showing an insectoid version with its mounted machine gun.

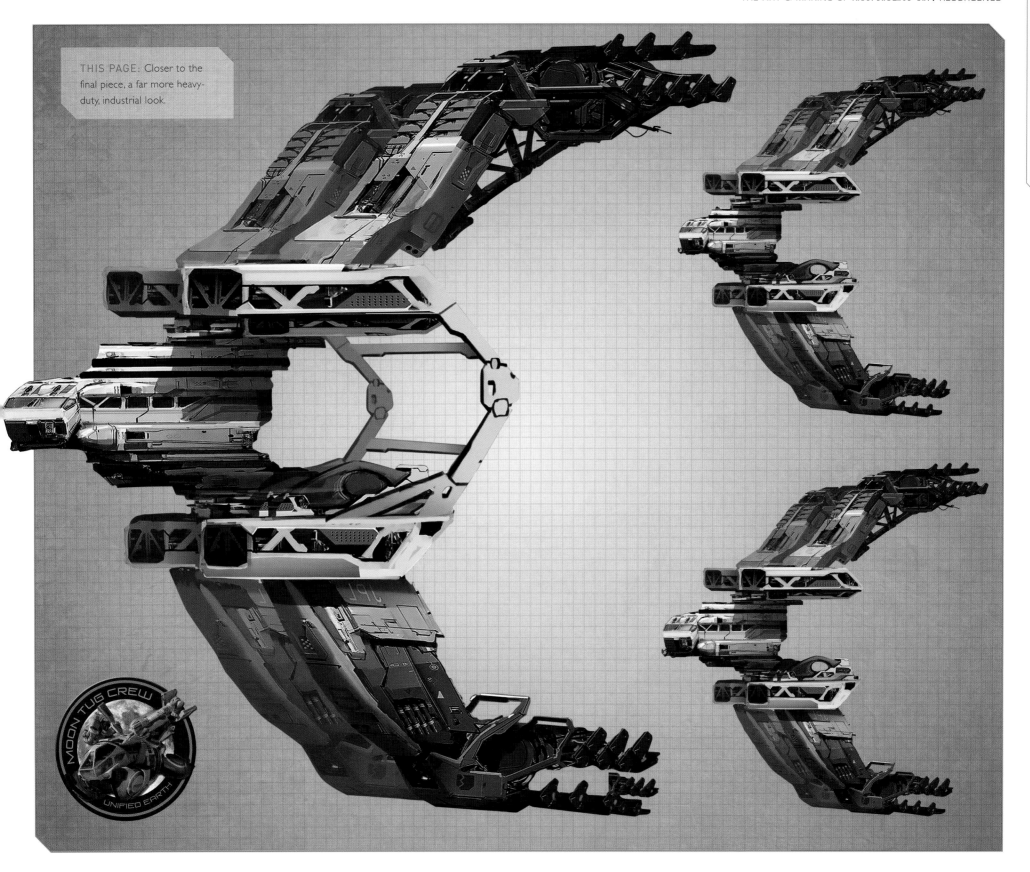

THIS PAGE: Closer to the final piece, a far more heavy-duty, industrial look.

MOON TUG CREW
UNIFIED EARTH

MOON TUG - FINAL DESIGN

The practicality of the moon tug is of the utmost importance to keep the human element intact. Once the technology becomes too impossible then it is inseparable from the alien world. The function of each piece of the tug was discussed and designed.

"It has two big long clamps in the end and they're all with hydraulic pistons," is how Johannes Mücke describes the inner and outer workings of the space forklift. "These hydraulic pistons can grab whatever you want to, so it's not a wagon behind a lorry, but like a giant hydraulic piston system. Essential is that it has a ring in the middle. And no ship like that has ever had it. We want the arms to be able to grab everything, so let's put a ring in the middle so the arms can rotate freely around the Moon Tug and we get a super strong design-driving element. That, I think, is what really drove the Moon tug to where it is and proved again that once you come up a functional explanation or something that makes sense to Roland, he's in. If it's an imagined reason it's fine, too, but if 'it kind of looks cool' it doesn't count. You will never be able to sell that to him."

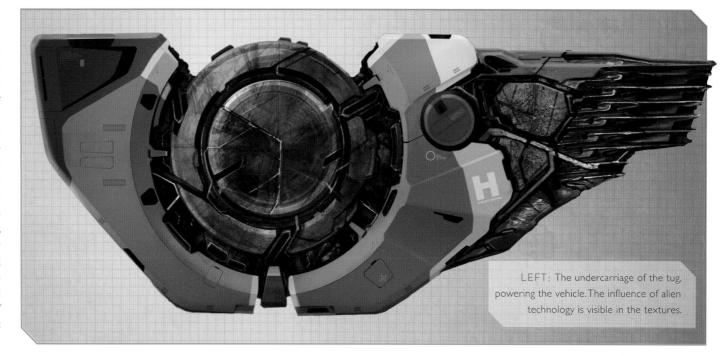

LEFT: The undercarriage of the tug, powering the vehicle. The influence of alien technology is visible in the textures.

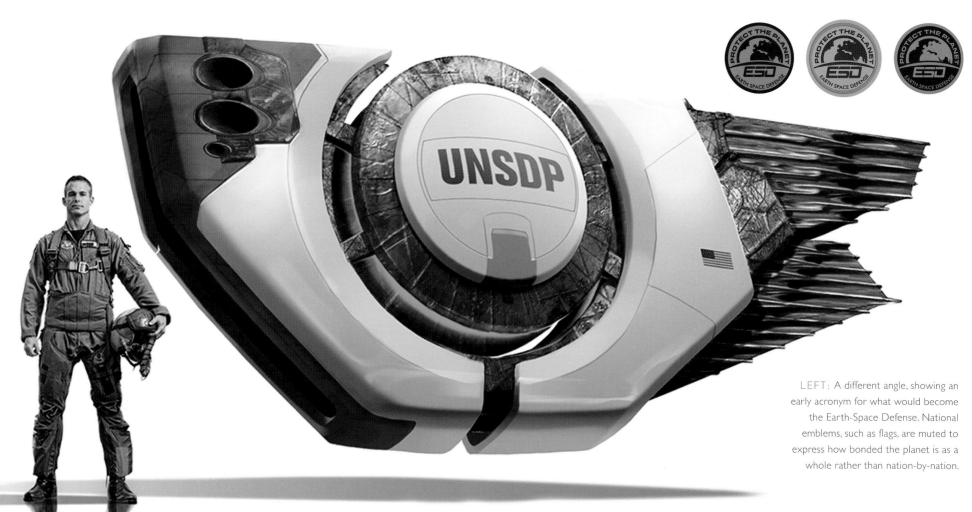

LEFT: A different angle, showing an early acronym for what would become the Earth-Space Defense. National emblems, such as flags, are muted to express how bonded the planet is as a whole rather than nation-by-nation.

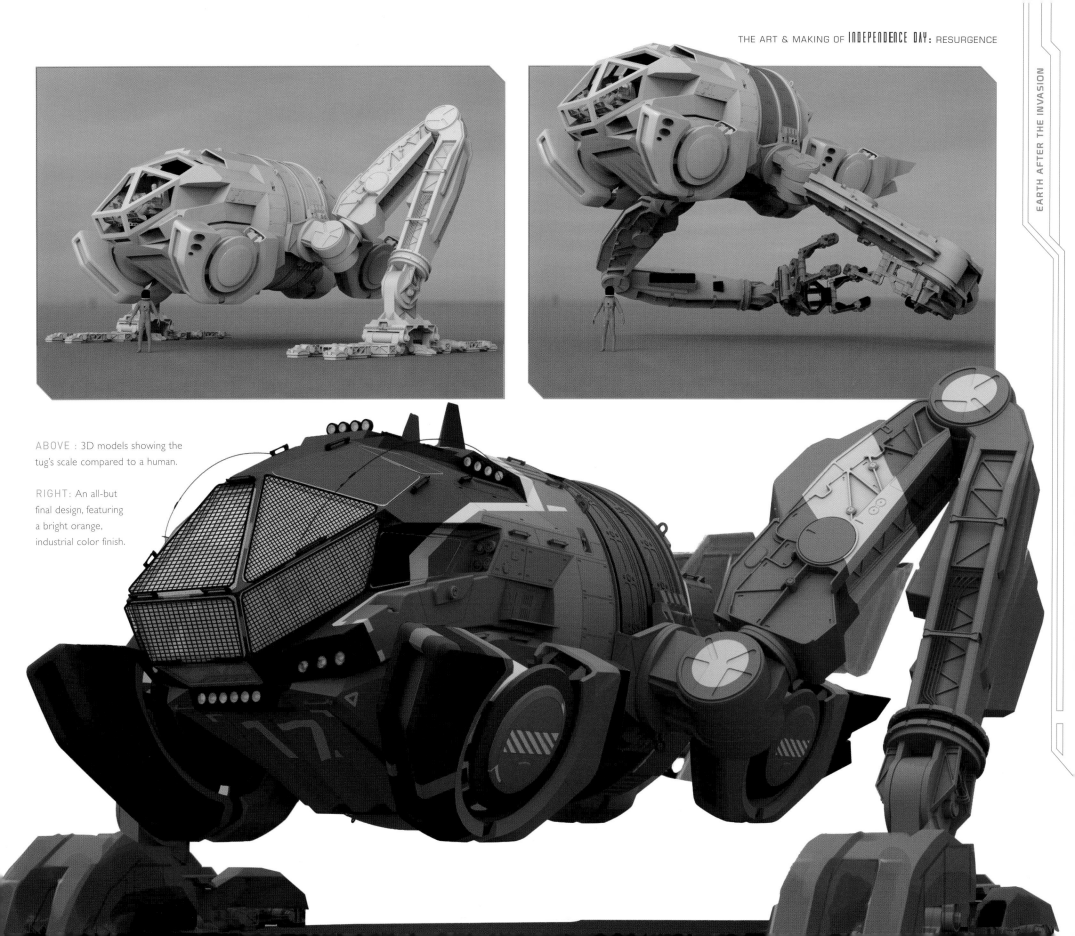

ABOVE : 3D models showing the
tug's scale compared to a human.

RIGHT: An all-but
final design, featuring
a bright orange,
industrial color finish.

TOP LEFT: The cockpit from the prop version that actors could actually interact with. Bill Pullman recollects: "It was really decked out, and every button I touched worked and lit things up. A different experience."

TOP RIGHT: Form follows function because it has a very specific task. If you had to move a cannon onto the moon then that's the vehicle you'd use." Barry Chusid.

BELOW LEFT TO RIGHT: "It has two big long clams in the end and they're all working with hydraulic pistons. This piston system can grab whatever you want to. It has a ring in the middle so the arms can rotate freely...once you come up with a functional explanation or something that makes sense for Roland, he's in." Johannes Mücke, concept artist.

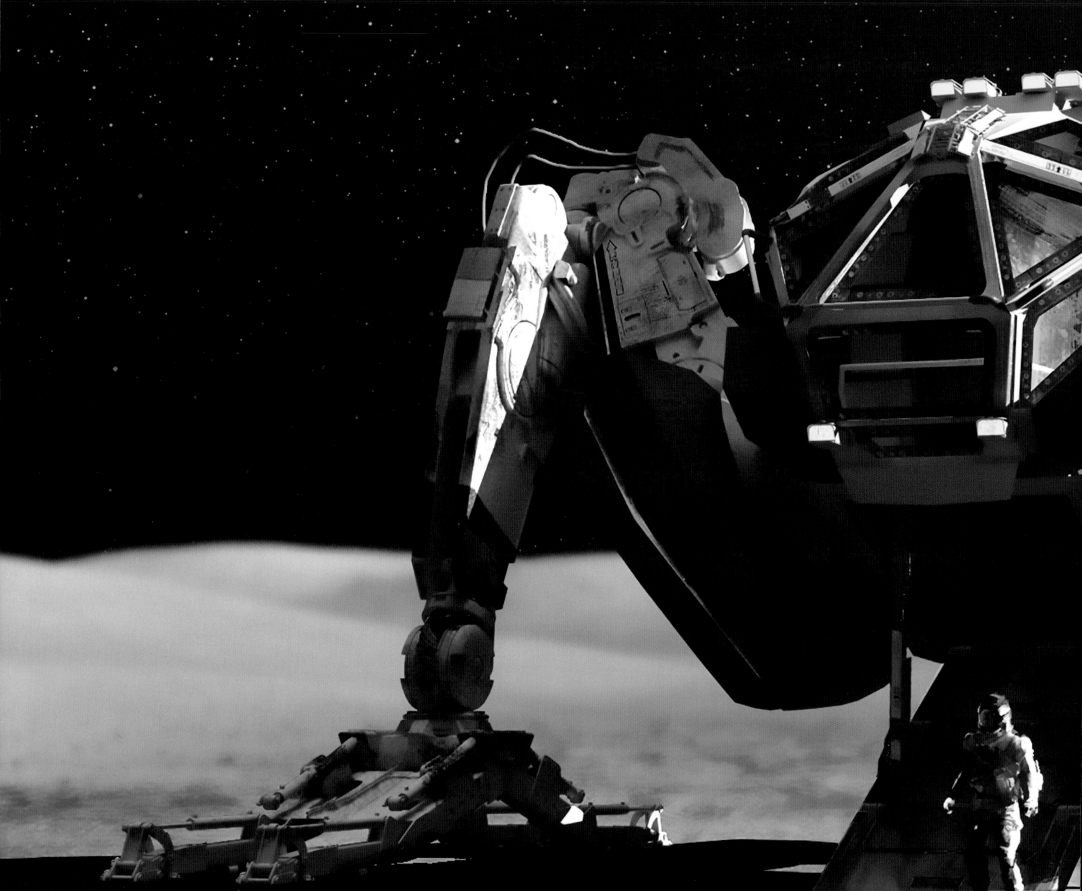

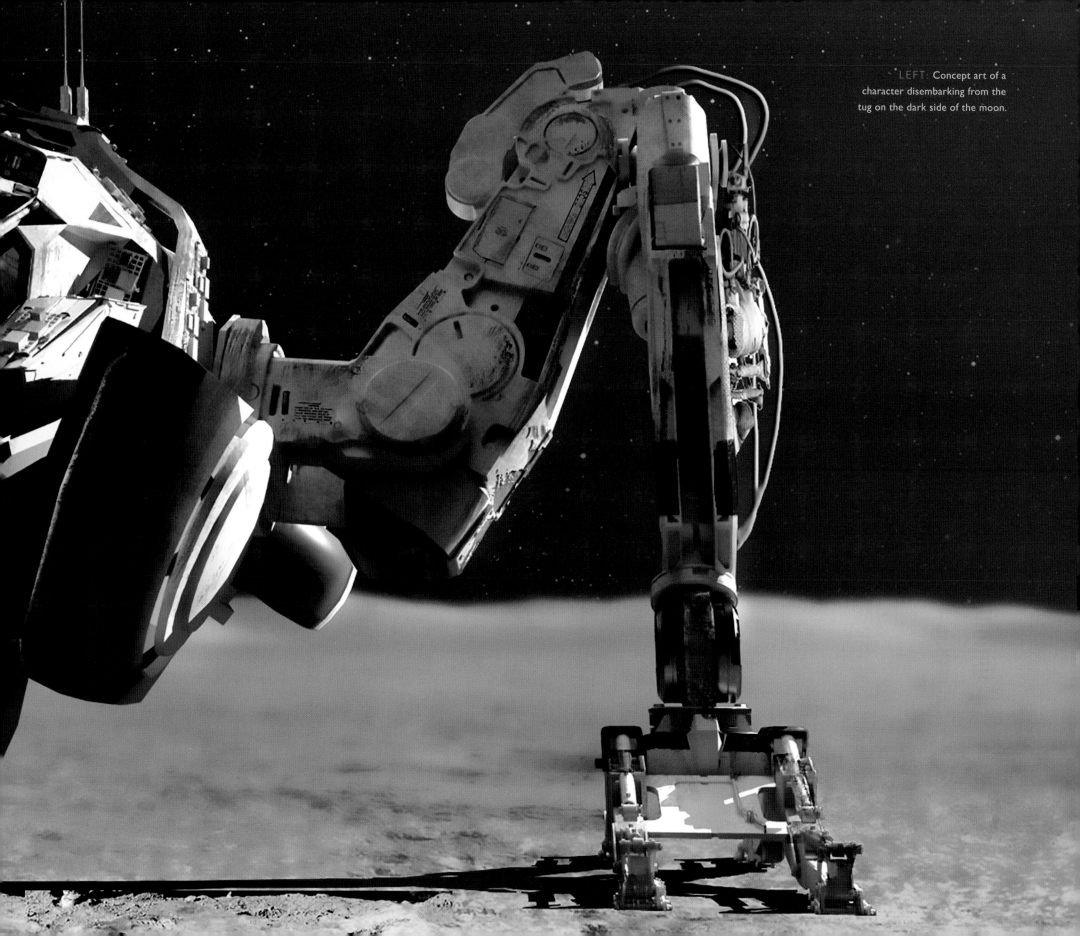

AIRCRAFT

The 2016 of the film is a recognisable world. As well as the major advancements brought on by using alien technology, there are still vehicles and weaponry that are clearly human with a slight upgrade. These serve as a bridge between the aesthetic of the first film and *Resurgence,* in particular the F-18 jets.

For creating the less fantastical transport, the designers took influence from existing aircraft. Vehicle designer Mark Yang worked closely with his director and the head of the art department. "Every design that we produced Roland has essentially asked 'How can this be real?' and put great emphasis on how something like this can be believable. At the same time we have pushed designers because we want people to connect with it and feel that it's up to date, but at the same time you always bring it back, you always make sure it's something that people can hold, that is tangible, it's not just this flying orb or a laser cannon. It's just constantly being interfaced, constantly being challenged – it's good working with someone like Roland who really appreciates the science."

RIGHT: Artwork very much grounded in contemporary aircraft, even bearing NASA branding.
BELOW: Showing the anti-gravity technology in action, the subtle infusion of blue lighting revealing alien upgrades.

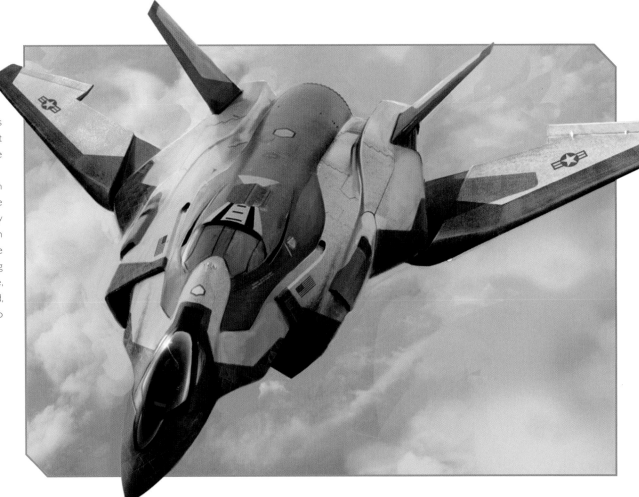

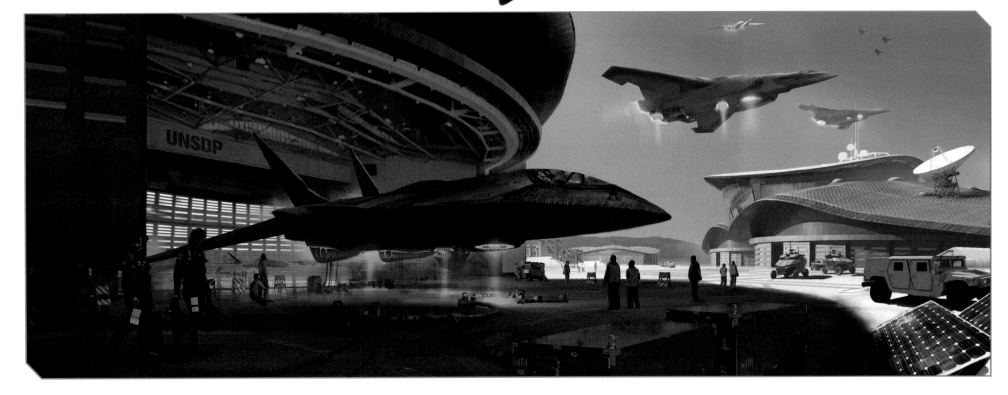

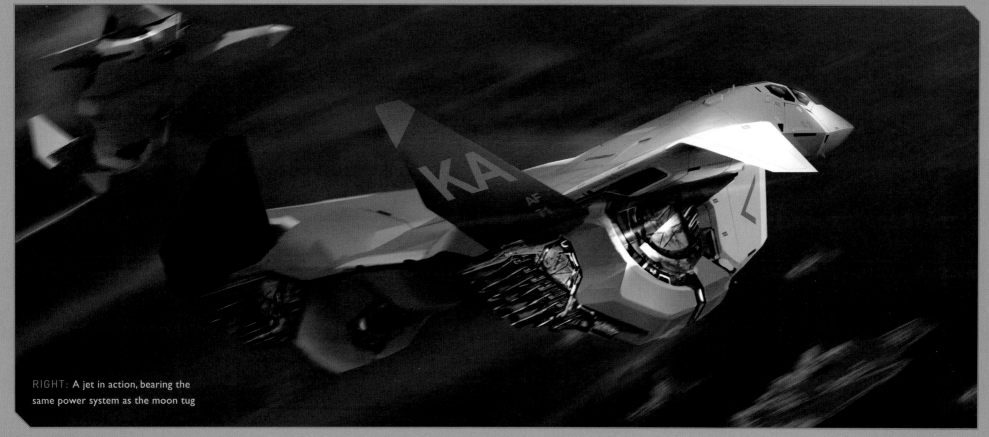

RIGHT: A jet in action, bearing the same power system as the moon tug

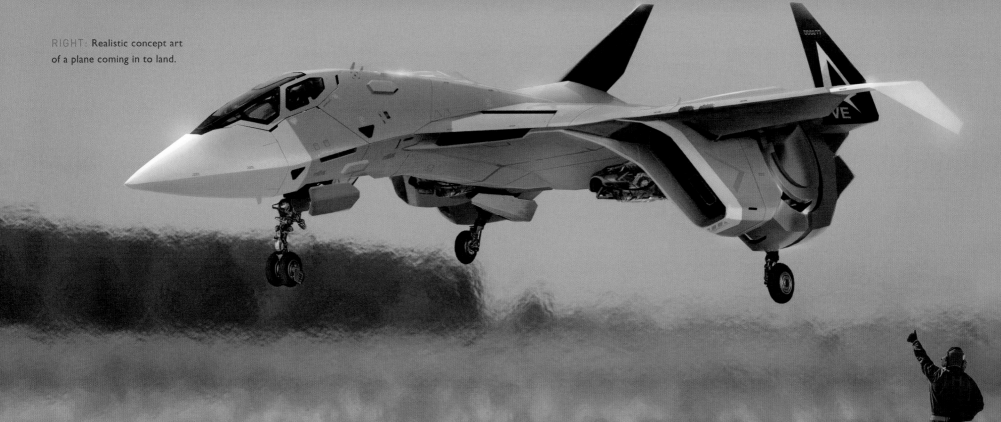

RIGHT: Realistic concept art of a plane coming in to land.

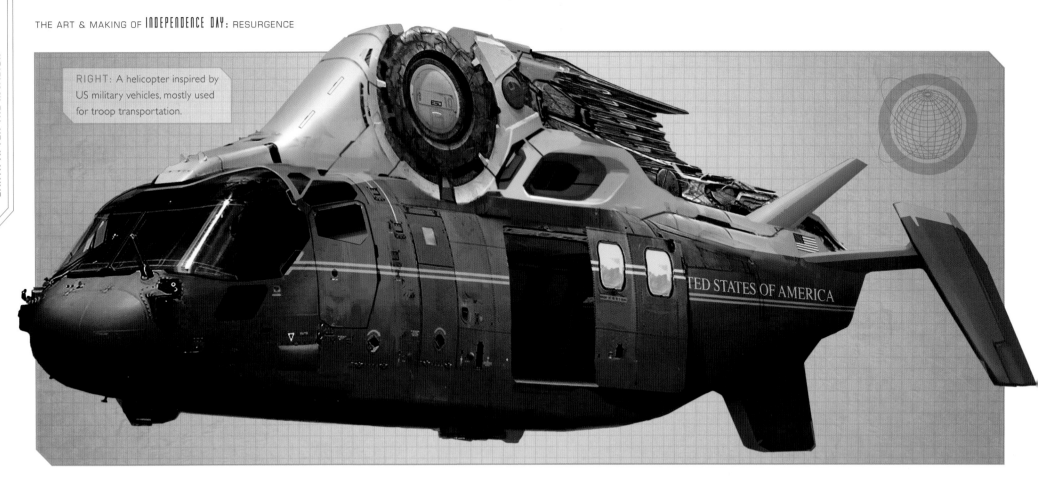

RIGHT: A helicopter inspired by US military vehicles, mostly used for troop transportation.

HYBRIDS

Along with the defensive equipment in orbit and on the moon, mankind has also melded alien and human technology to create hybrid fighter jets. In the film, these have taken years to perfect and much trial and error to find a way to harness the immense amount of energy powering the planes. The aliens grow their technology, whereas the ESD must do their best to replicate and adapt it. For the vehicle designers working on the concepts, how it worked took priority over how it looked.

"The alien engines can do so much more than we can conceive of," Mark Yang states. "If you look at the original movie the aircraft can go straight up and straight down, things that we can't do – anti-gravity – and a lot of what this hybrid fighter does is actually control the abilities. We're not able to grow the alien tech, we're able to make use of it, so a lot of what the human interface is, is to control the tech, and to keep it in check. It generates a lot of heat, for every single aspect of the weapons, so if you look at the plane, a lot of the design is just to cool it and to keep it operational, and I think because of that – compared to the alien counterpart – it's not quite as refined, but it is something we're able to use in a more creative way, a technology that humans had never had before.

RIGHT: A scene depicting a hybrid helicopter swooping through a rebuilt and revamped North American city.

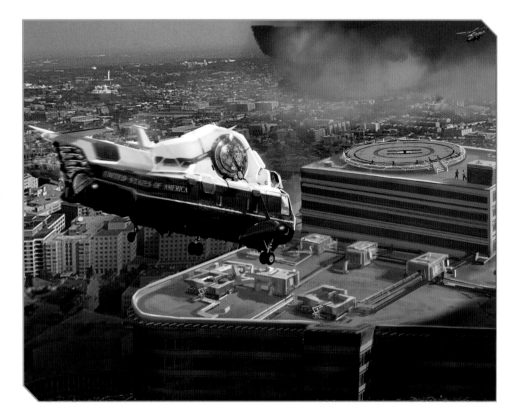

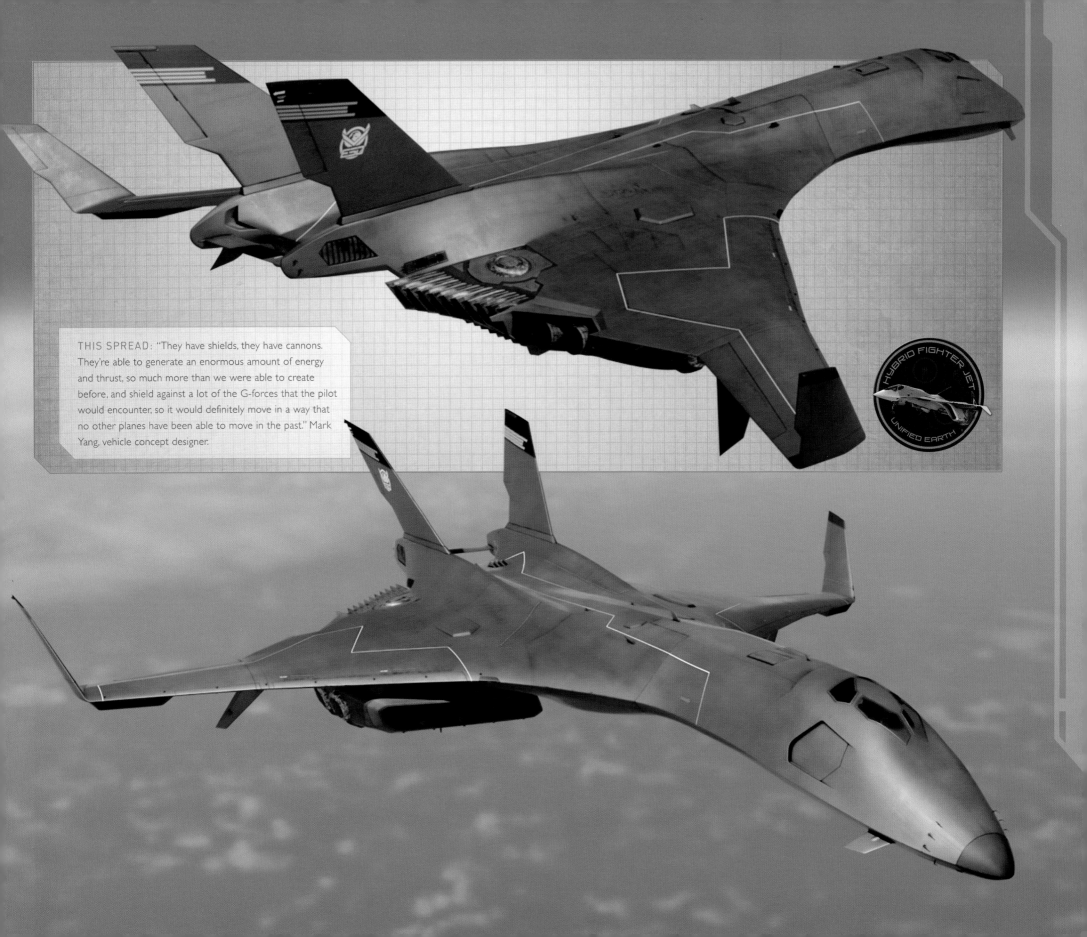

THIS SPREAD: "They have shields, they have cannons. They're able to generate an enormous amount of energy and thrust, so much more than we were able to create before, and shield against a lot of the G-forces that the pilot would encounter, so it would definitely move in a way that no other planes have been able to move in the past." Mark Yang, vehicle concept designer.

HYBRID FIGHTER JET
UNIFIED EARTH

AREA 51

The once-secretive Area 51 is now the nerve center for human defense and research into the otherworldly nemesis. It serves as a hangar for the hybrid planes, a testing area for all the equipment, and again offers survivors sanctuary when the attack comes.

Independence Day used practical effects and elements of cutting edge technology to stunning, groundbreaking results, and Resurgence likewise uses CG to bring the sets and sequences to life. Filming took place primarily in ABQ Studios, New Mexico, on some of the largest stages in North America, including one of 48,000 sq feet. In addition to this, the production department were able to recreate Area 51 facades in an abandoned solar panel producing factory also in New Mexico.

Production designer Barry Chusid describes the how and why of Area 51 in 2016: "Basically [humanity has] pooled all our resources and we're going to fight aliens, should there be another attack. And rather than fighting each other and rather than dealing with who's going to emigrate who to what country, we're now basically going to embrace each other and say let's get together, and one of the hubs for that is Area 51. Area 51 has basically been redesigned, re-thought. It's bigger and better and has this hybrid technology introduced to it, so it becomes this place where if necessary we can defend ourselves."

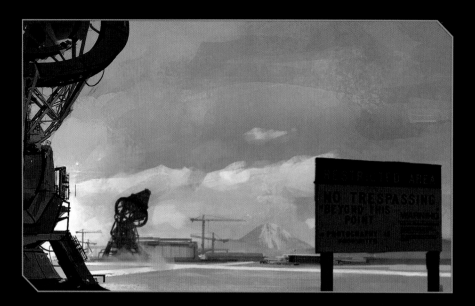

TOP LEFT TO RIGHT: With the 20-year gap between films it was important to re-introduce setting and places to audiences, showcasing how they have been updated. These images show a greatly expanded Area 51, complete with cannons and a vast hangar to house, land, and maintain the hybrid fighters.

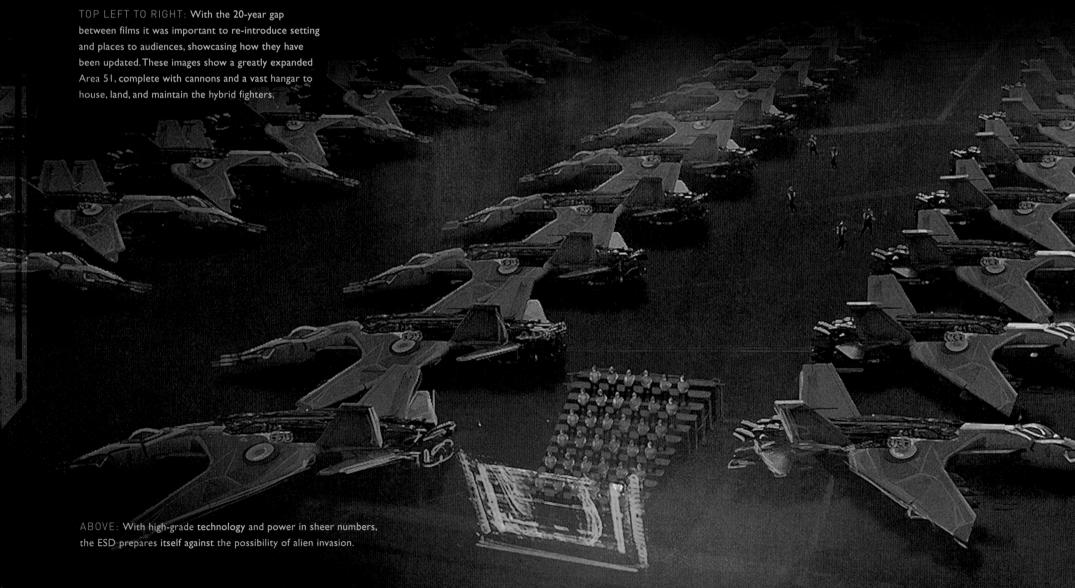

ABOVE: With high-grade technology and power in sheer numbers, the ESD prepares itself against the possibility of alien invasion.

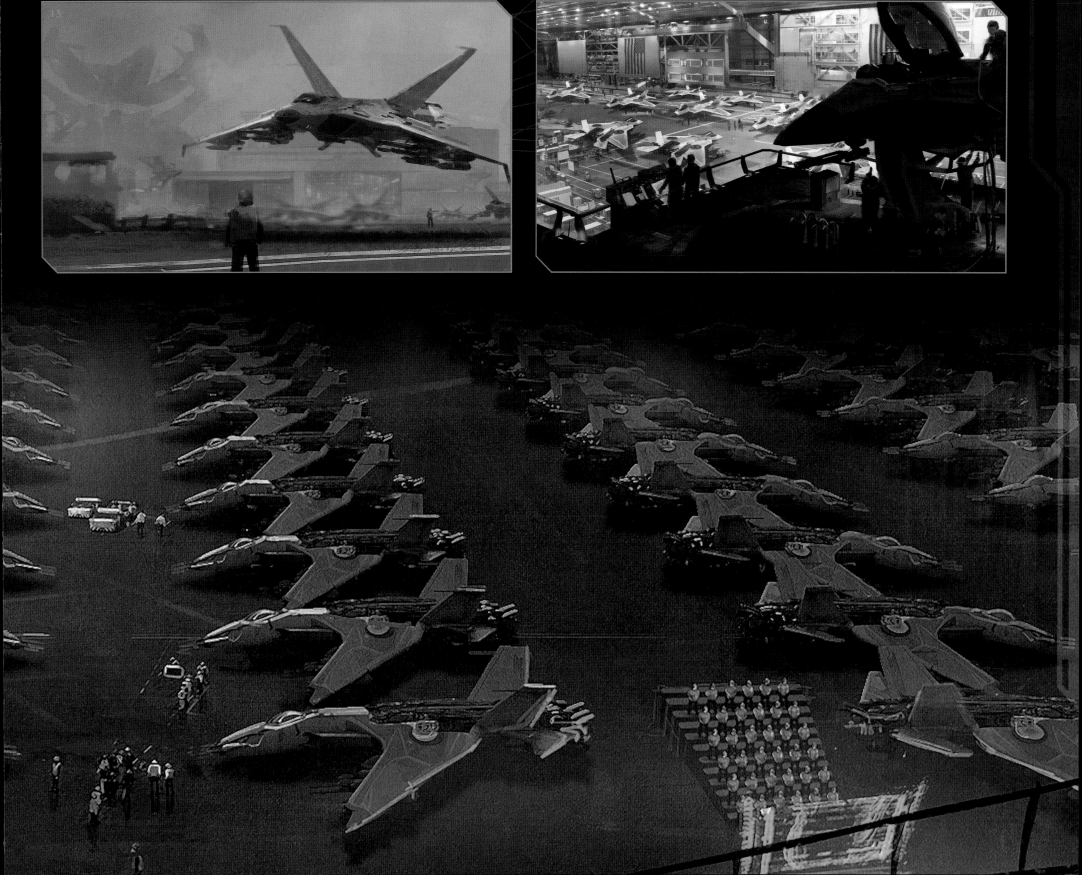

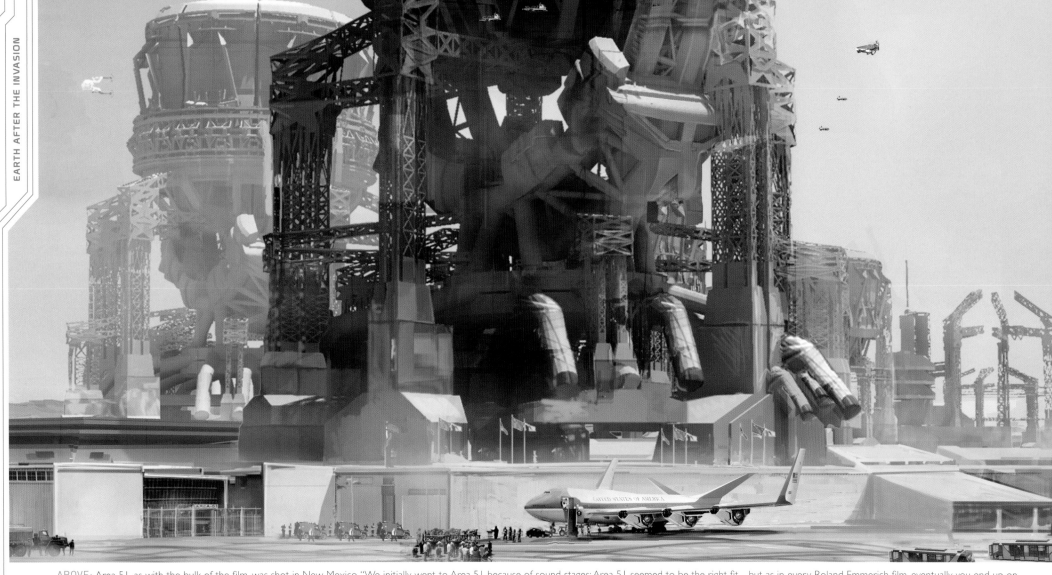

ABOVE: Area 51, as with the bulk of the film, was shot in New Mexico. "We initially went to Area 51 because of sound stages; Area 51 seemed to be the right fit…but as in every Roland Emmerich film, eventually you end up on a stage because, for lack of a better word, he's such a control freak. If he never ever has to shoot a single day under God's sun he will be very happy. He can control it. It's magic now all day long." Carsten Lorenz, line producer.

It is armored and equipped with more of an arsenal than the original Area 51 ever was, including a "tripod gun that the humans use to defend Area 51 and various other bases," says Mark Yang. "It's essentially a good thirty feet tall, it's massive, and together you can jump into like an anti-aircraft gun, and it's based on the alien/human tech. It has a very similar look to the handguns that we were able to re-create from alien technology that the humans were able to get."

BOTTOM LEFT TO RIGHT: With eerie echoes of thew original film, an alien is loose in containment; presenting the hybrid fighter for the first time; pilots scramble and put their jets to the test.

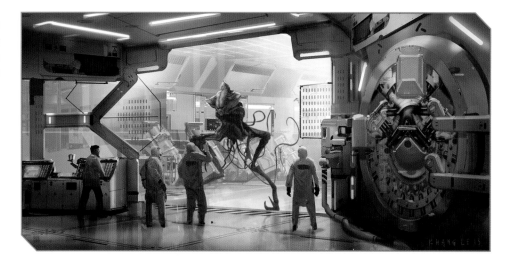

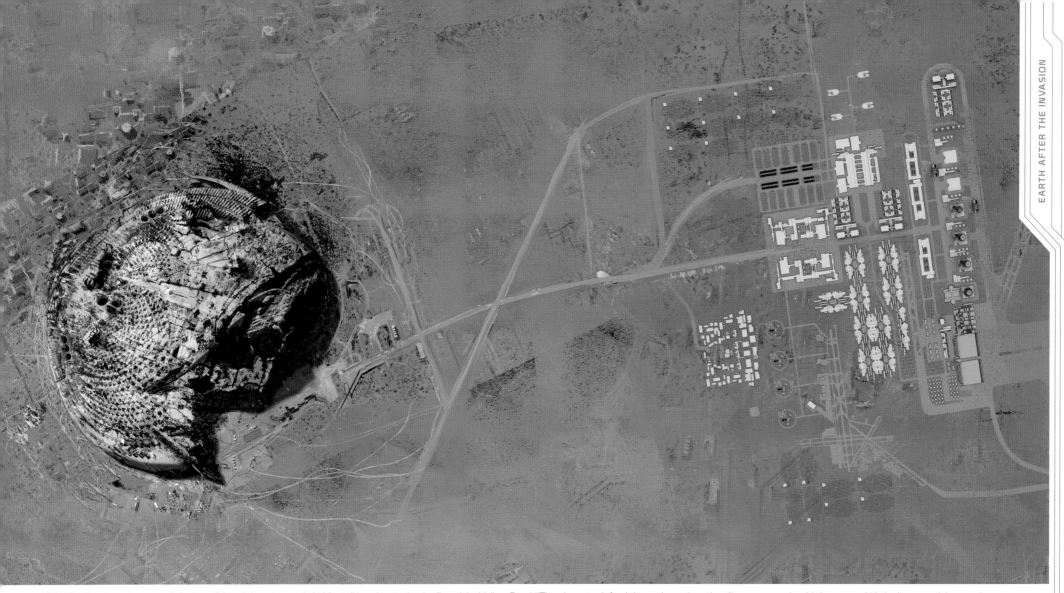

ABOVE: Overhead imagery of the Area 51 and desert sprawl. "We're talking about a bunker," explains Volker Engel. "They have to defend themselves when the aliens come – should they come. We had our model supervisor come down and we said, 'Come up with something based on bunker images that we've seen that probably date back to World War II. And so he took all of Area 51 and put this bunker design on the outside of these buildings.'"

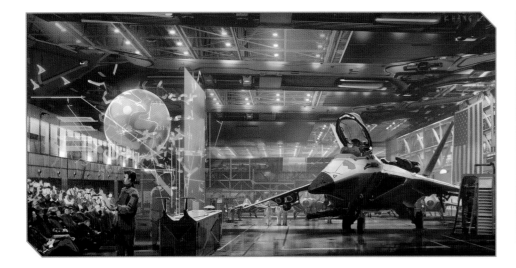

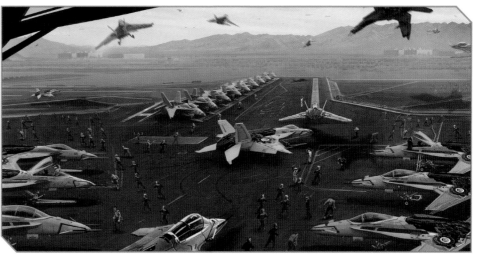

93

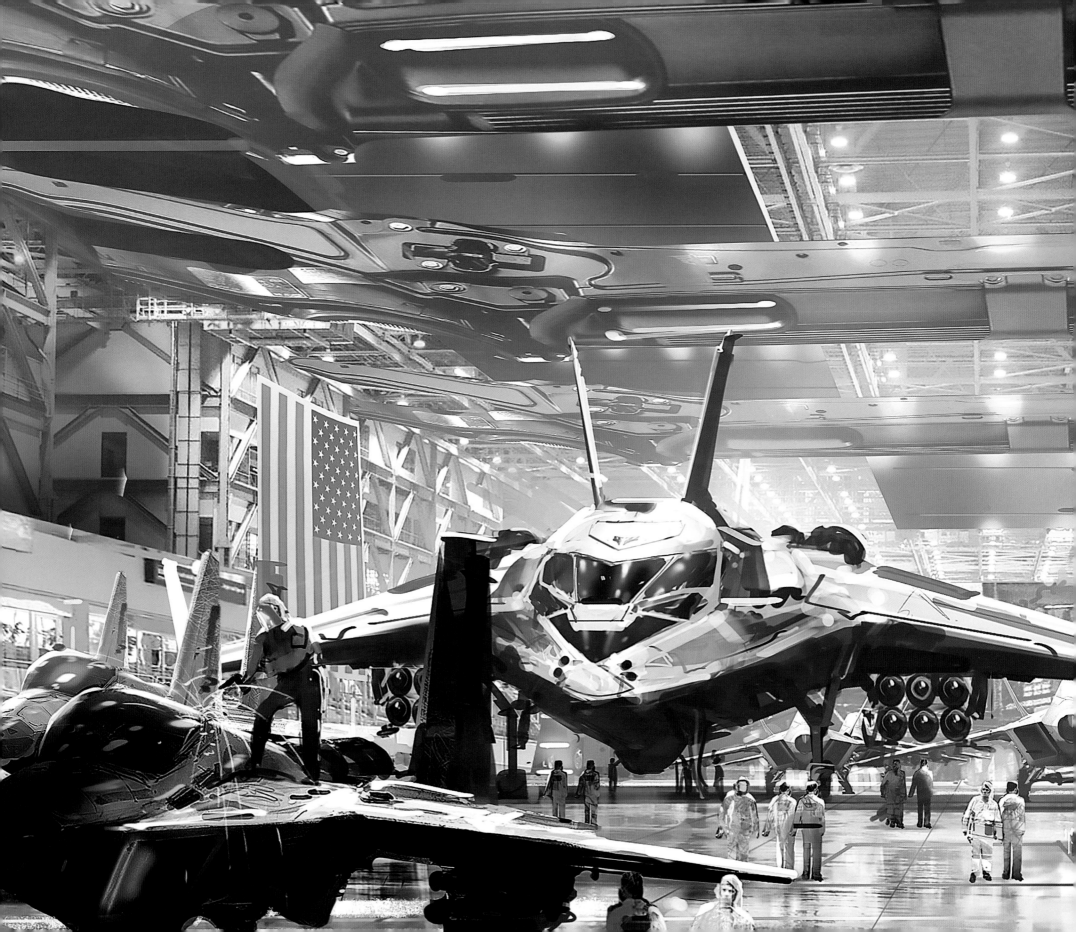

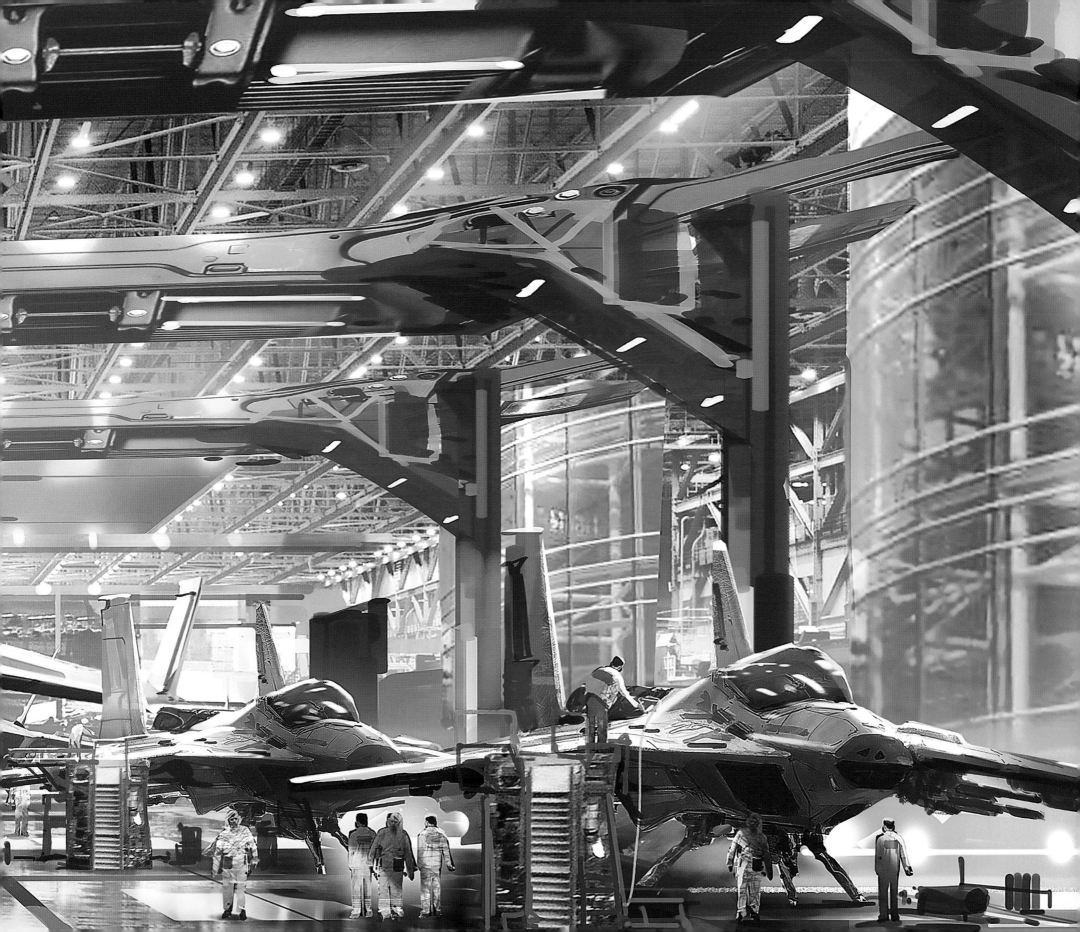

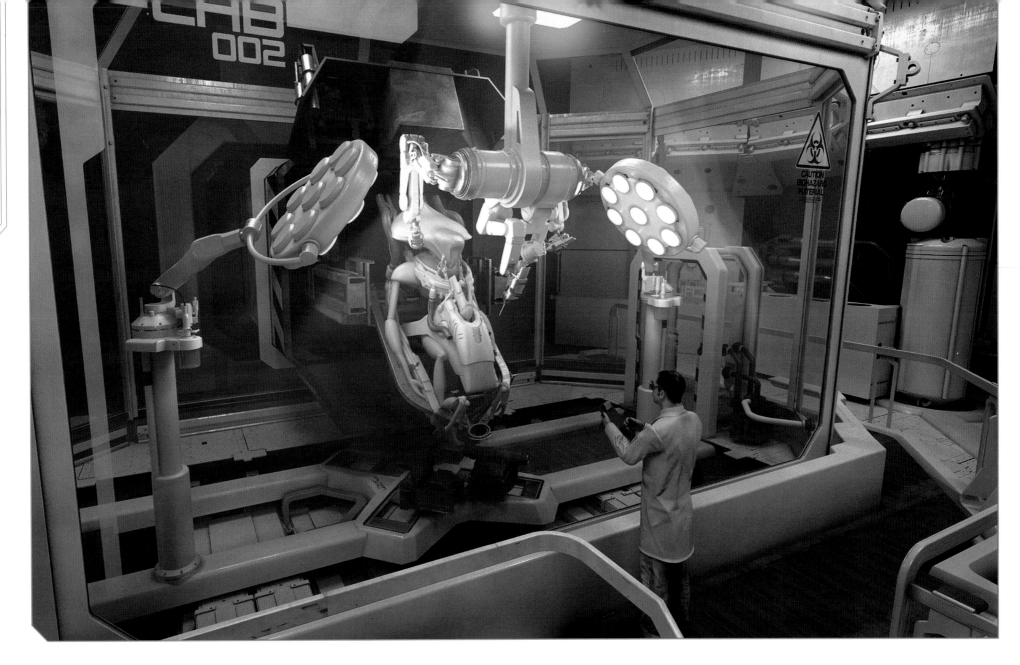

THE ALIEN PRISON

Control is crucial, not only on a big-budget movie production but for the characters in said production: What they don't understand, they fear and want to control. So to better understand the aliens, mankind took drastic steps.

"We're also housing the aliens from the first movie in Area 51," reveals Chusid. "We've built underground into our Area 51 so we can have them. The thinking was, opposed to them being in giant test tubes with wires coming into their heads and they're floating in liquid – which is a great image but we've seen it before – it was the idea that there's a fear factor built in: We're humans we're still afraid of them and yet at the same time we've conquered them, at the same time we want to study them. We want to depersonalize them. So they're in cellblocks. We don't necessarily want to touch them or interact with them, so there's this mechanical system. They're another matchbox that you can grab, bring into your observation area, observe under controlled conditions, then put them back in their box and then back in their cell. It feels more like a factory than it does a prison or a laboratory."

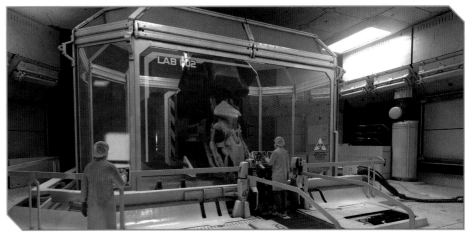

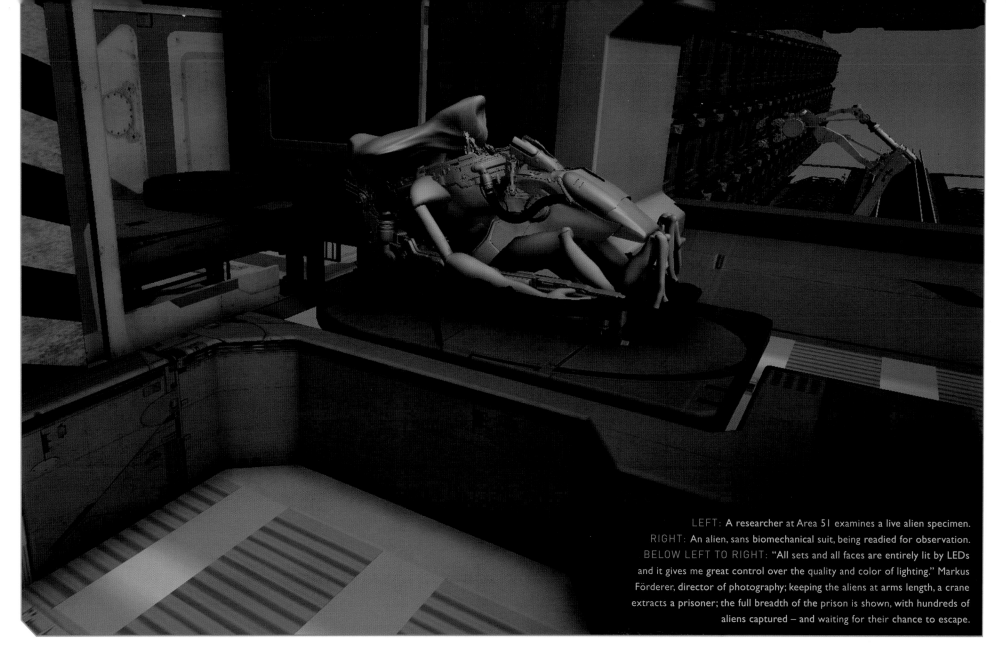

LEFT: A researcher at Area 51 examines a live alien specimen.
RIGHT: An alien, sans biomechanical suit, being readied for observation.
BELOW LEFT TO RIGHT: "All sets and all faces are entirely lit by LEDs and it gives me great control over the quality and color of lighting." Markus Förderer, director of photography; keeping the aliens at arms length, a crane extracts a prisoner; the full breadth of the prison is shown, with hundreds of aliens captured – and waiting for their chance to escape.

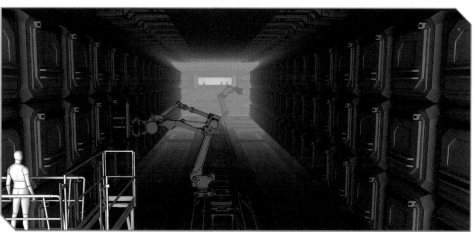

THE AFRICAN GROUND WAR

When we first meet David Levinson in 2016, he is travelling into the African savannah to investigate reports regarding an intact destroyer ship. This location is the only site where the aliens actually landed (for reasons initially unknown) and engaged the African rebel soldiers in a ground war. Levinson arrives – accompanied by a constant thorn in his side, accountant Floyd Rosenberg (Nicolas Wright) – to find psychiatrist Dr. Catherine Marceaux (Charlotte Gainsbourg), with whom David shares a romantic history. Together they meet the leader of the African rebels, Dikembe (Deobia Oparei). Dikembe tells them how not only has he been experiencing disturbing visions, but the derelict ship has started to come back to life.

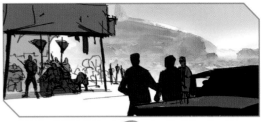
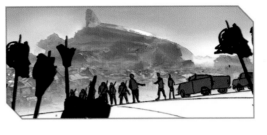
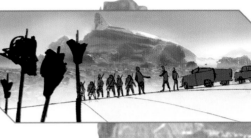

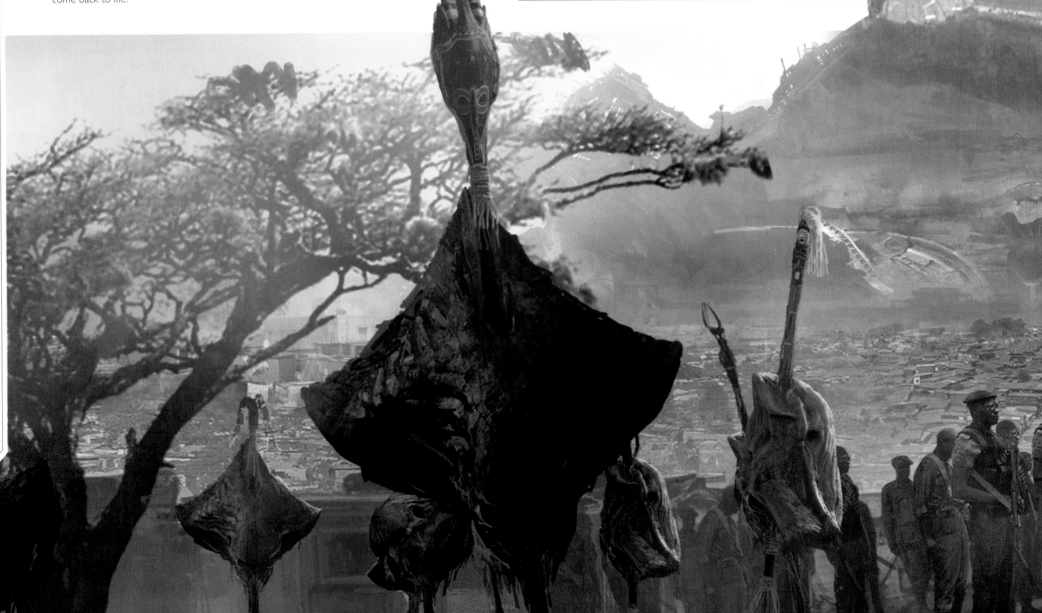

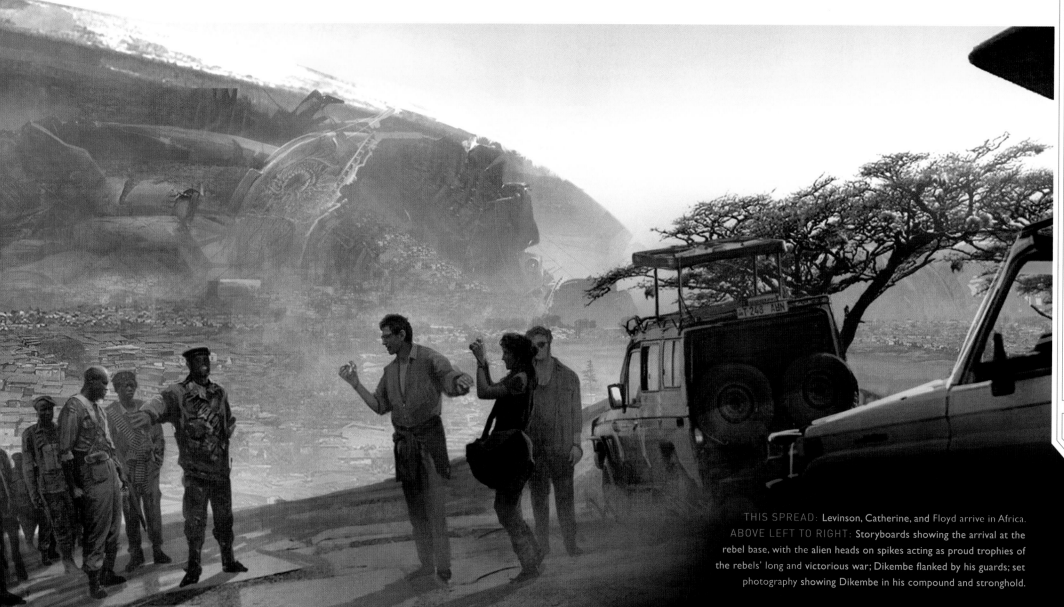

THIS SPREAD: Levinson, Catherine, and Floyd arrive in Africa.
ABOVE LEFT TO RIGHT: Storyboards showing the arrival at the
rebel base, with the alien heads on spikes acting as proud trophies of
the rebels' long and victorious war; Dikembe flanked by his guards; set
photography showing Dikembe in his compound and stronghold.

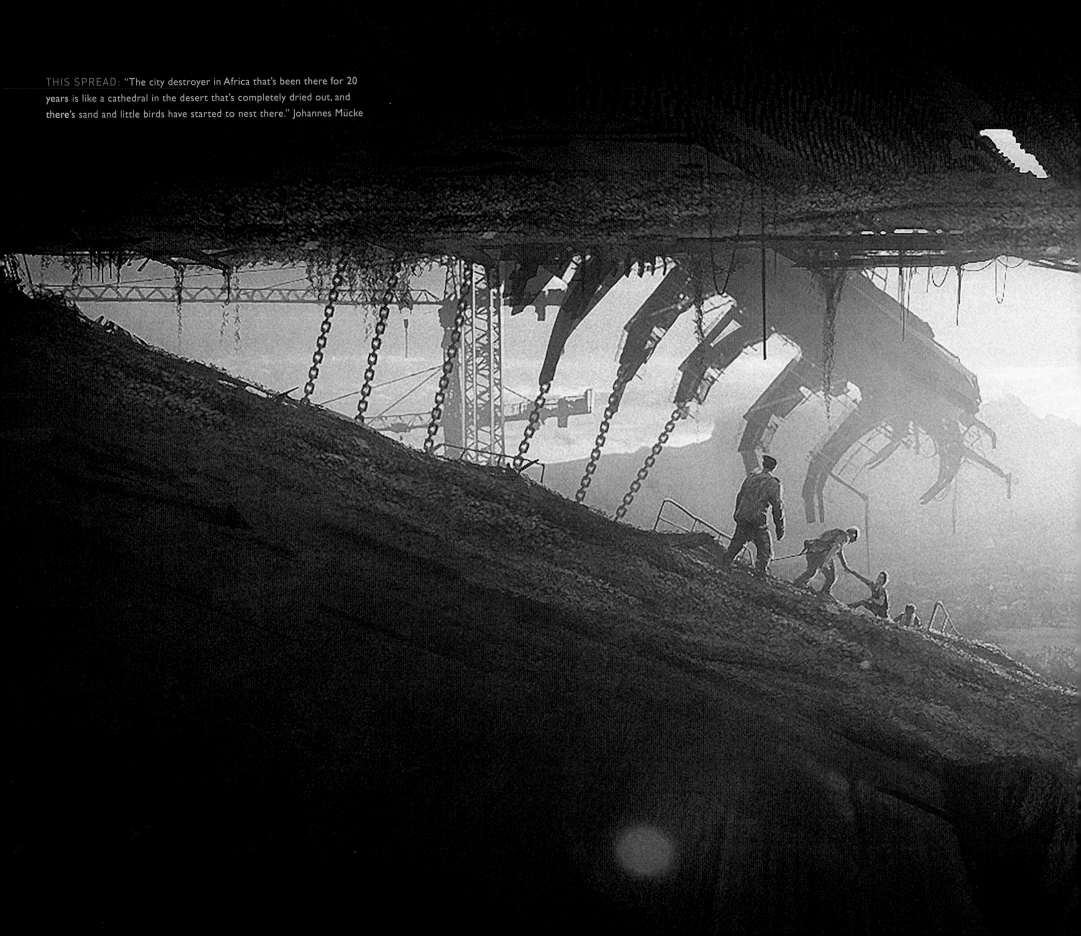

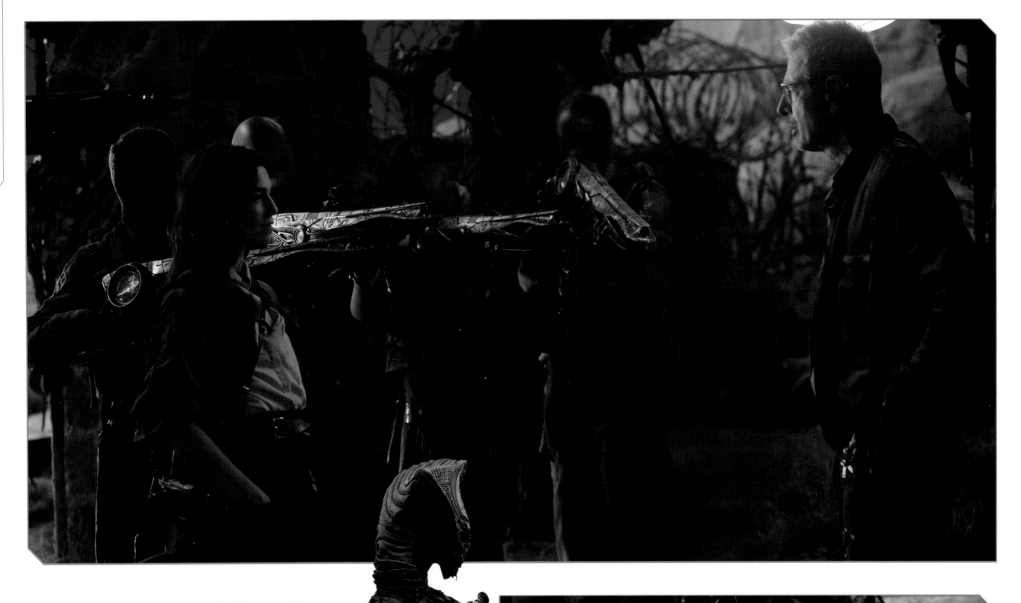

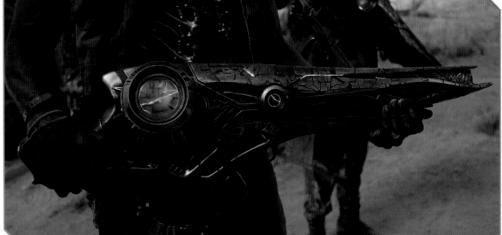

The city destroyer in Africa that's been there for 20 years," explains concept artist Johannes Mücke, "it's like a cathedral in the desert that's completely dried out and there's sand, and little birds have started to nest there and maybe a lizard or two has found their way up there."

The ship has opened up, unfolded itself like a flower, and is perched on its legs or 'petals,' revealing more about the old spaceships than ever realized and hinting at what is still to come. "We're introducing the idea that the aliens always had these feet but never used them, so we used this old city destroyer over Africa and gave him feet," Mücke continues. "Roland told me, this is super important. This disc standing on feet is going to be a foreshadowing of what's going to happen to the earth. Everyone has to understand this."

THIS PAGE: The African survivors have made totems of the aliens they bested and co-opted their blasters.
OPPOSITE: Africa was brought to life on location in New Mexico.

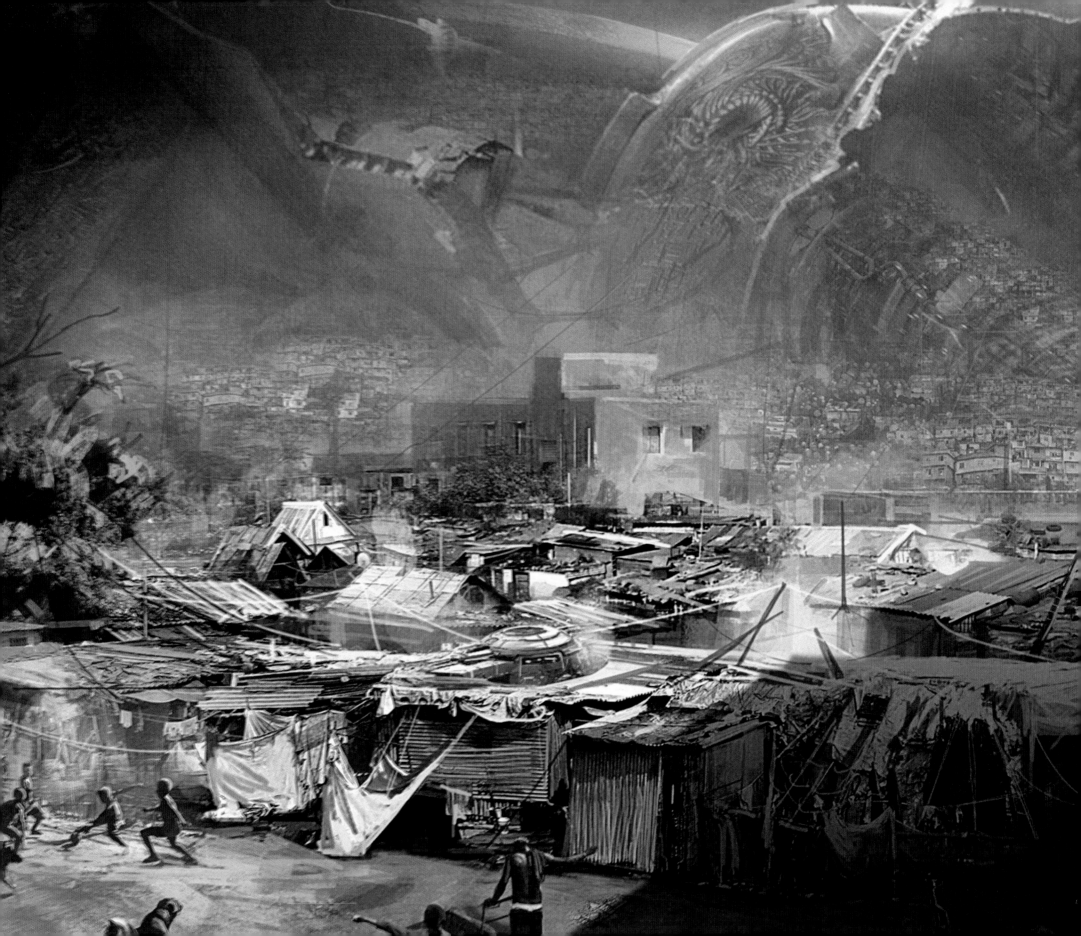

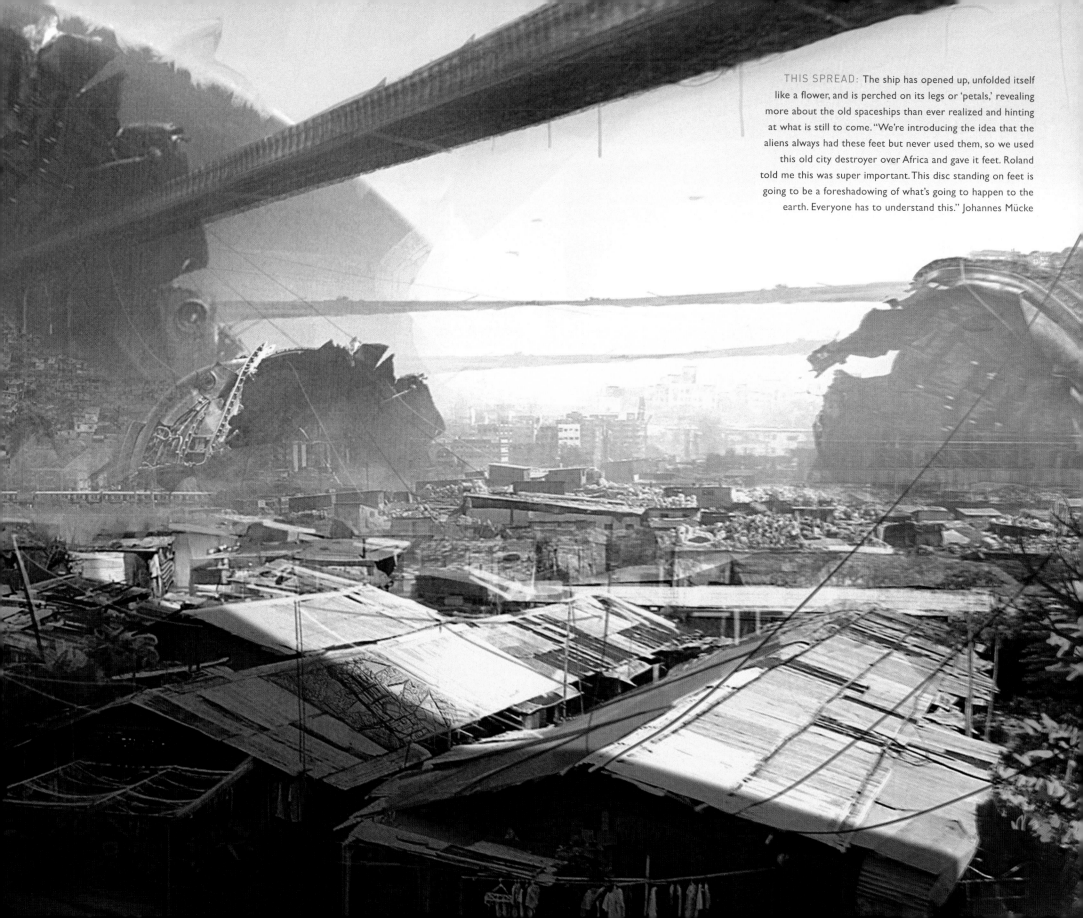

THIS SPREAD: The ship has opened up, unfolded itself like a flower, and is perched on its legs or 'petals,' revealing more about the old spaceships than ever realized and hinting at what is still to come. "We're introducing the idea that the aliens always had these feet but never used them, so we used this old city destroyer over Africa and gave it feet. Roland told me this was super important. This disc standing on feet is going to be a foreshadowing of what's going to happen to the earth. Everyone has to understand this." Johannes Mücke

THE AI SHIP

The first major catalyst for the story is the forming of a black hole near Earth's moon. Through this black hole emerges what's described in the script as a 'sleek, teardrop-shaped' craft. It does not appear to be armed but its arrival on July 3rd 2016, so close to the anniversary of the first attack, causes panic and confusion. Despite the warning of Levinson to not greet it with aggression and despite the UK and Chinese leaders voting likewise, President Lanford engages. The moon cannon shoots down the visitor. What Levinson discovers when he investigates inside is a single passenger: a form of AI – bearing a warning.

Creating a brand new ship, one that is both mysterious and beautiful – and linked to the visions Whitmore, Dikembe, and Okun are seeing – became one of the hardest tasks for the art department. Johannes Mücke describes it as: "the biggest nut to crack. The sphere with the horizontal slot. And the AI as well, it's this sphere with the circle. First off, you start to over-think it because it's too simple. I think that's what it is. This is how Roland works, he's really – this is what his success is, too – he distils all the nonsense away to come to the core and present the core undisguised to the audience for them to get the picture."

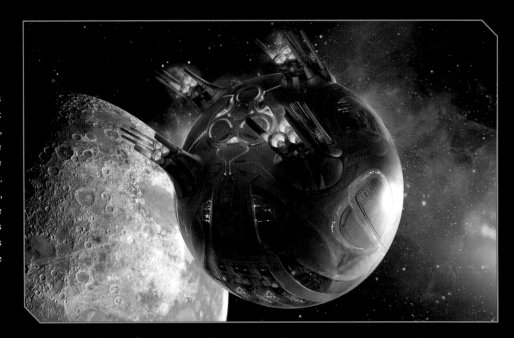

ABOVE RIGHT: Concept art showing the ship powering through our solar system.
RIGHT: David Levinson comes to investigate the crashed ship on the dark side of the moon

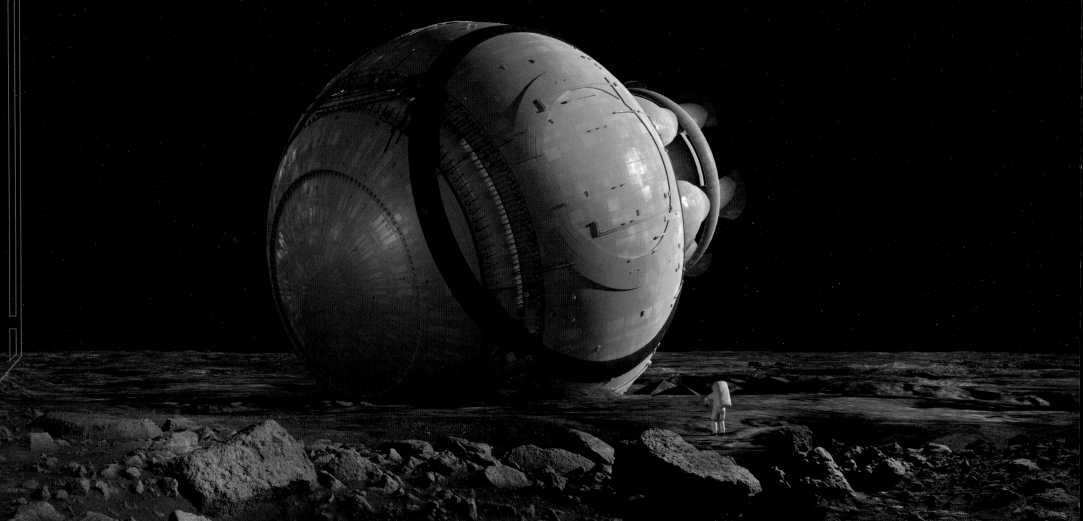

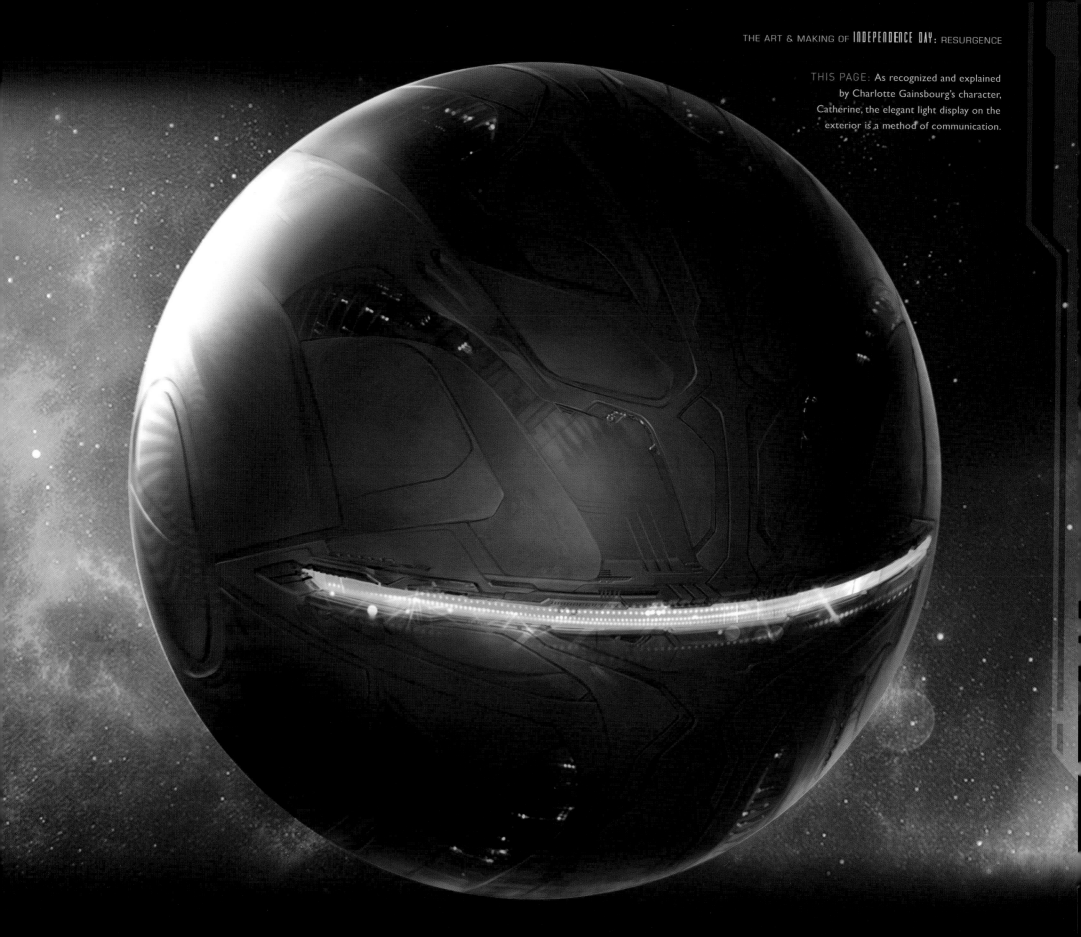

THIS PAGE: As recognized and explained by Charlotte Gainsbourg's character, Catherine, the elegant light display on the exterior is a method of communication.

THE AI SPHERE

When Levinson and Jake examine the crashed ship, it opens to reveal a sphere, housing an incredible, alien artificial intelligence. It is then transported to Area 51 for further study.

As a creative endeavour, what *Resurgence* has offered co-writers Roland Emmerich and Dean Devlin is a chance to go deeper into the world they created, expand it, build upon it. In particular, the details and mysteries of the alien race.

"There's some back story that we resisted doing in the first one because what we tried to do in the first movie is not do an alien invasion movie, we tried to do it like a disaster film," remembers Devlin. "We really patterned it after the Irwin Allen movies, so in a way the less we knew about the aliens the better. So we wanted to just say really in that movie, they're like locusts – they come, they eat, they leave. That kept it very simple for the movie and it worked. But of course you can't write the other one and only have that, so Roland and I had a lot more information about where they came from, how they came to be. We always kept thinking, well, we'll just have that for us. So by having the sequel now we have an opportunity to exposit much more of the backstory of the aliens."

BELOW: The first concept of how the AI could display holograms and communicate its information to the humans.
BOTTOM: This is the design that was the potential basis for a piece to use on set, but was rejected as too retro. It was redesigned and the sphere was rendered in VFX

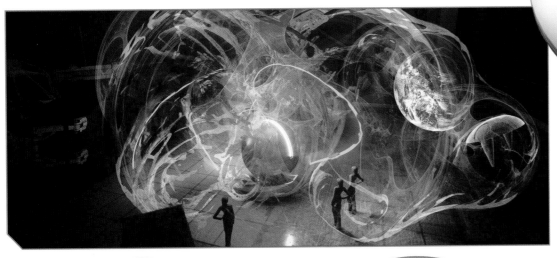

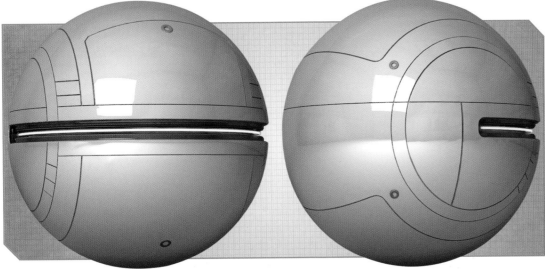

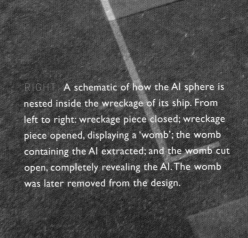

RIGHT: A schematic of how the AI sphere is nested inside the wreckage of its ship. From left to right: wreckage piece closed; wreckage piece opened, displaying a 'womb'; the womb containing the AI extracted; and the womb cut open, completely revealing the AI. The womb was later removed from the design.

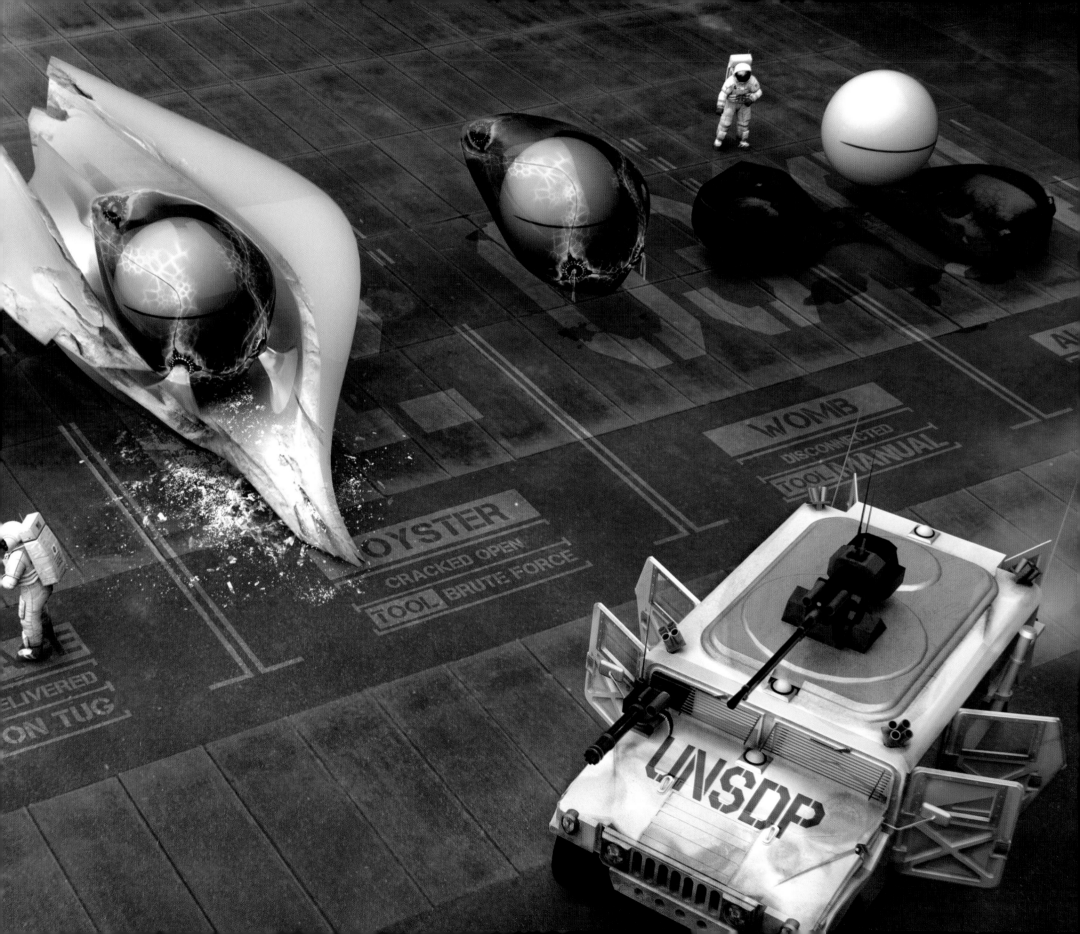

THE
RETURN
JULY 2ND 2016

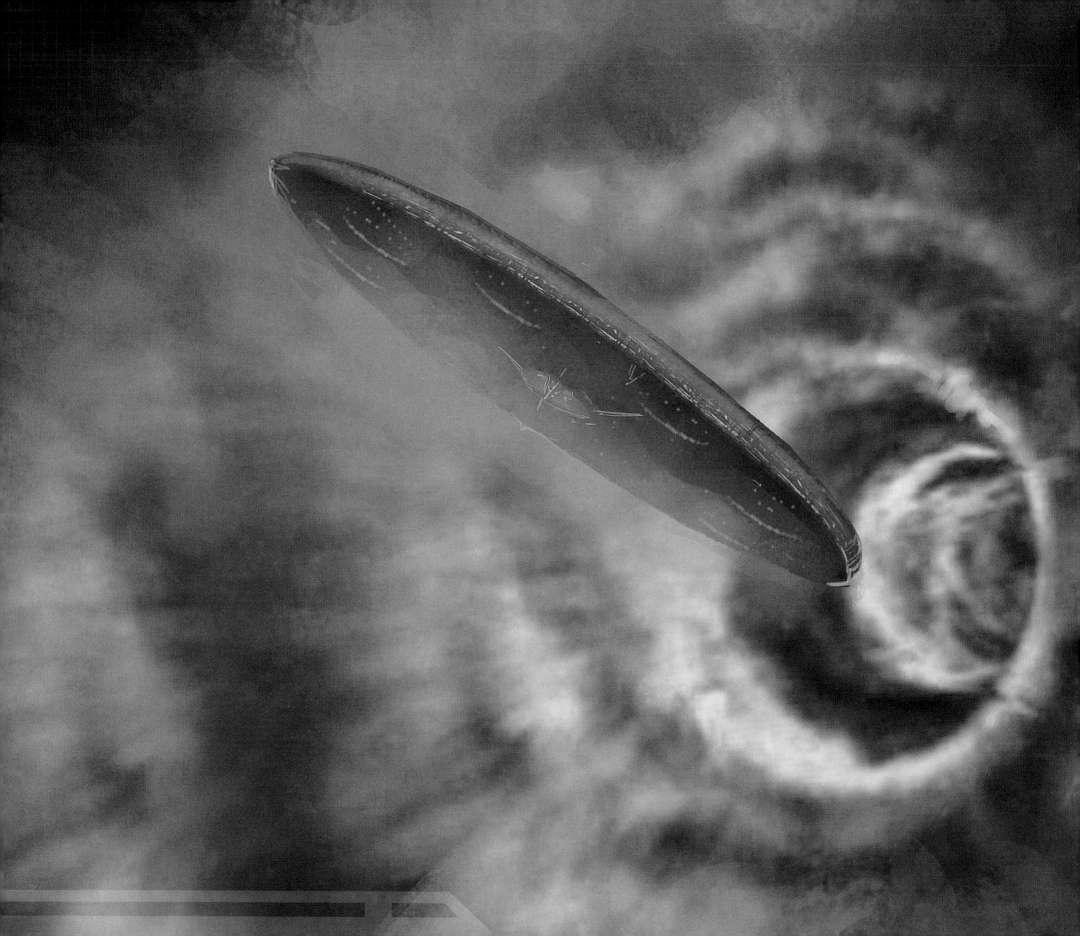

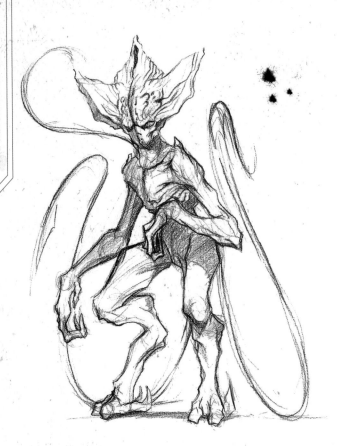

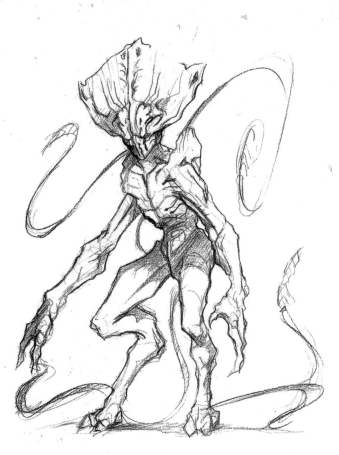

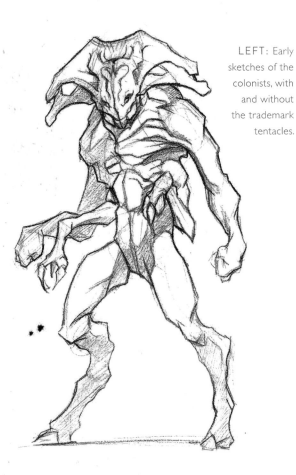

LEFT: Early sketches of the colonists, with and without the trademark tentacles.

THE NEW ALIENS

With the return of the aliens, the filmmakers were faced with a decision: To what degree should they keep a design through-line from the first film and how far should they reinvent the creatures? It was a challenge of taking the story to new places while maintaining the recognisable *Independence Day* look. The original alien designer, Patrick Tatopoulos spent two months on ideas, then the majority of the process fell to Aaron Sims, whose company specializes in creature design.

"The main aliens, the colonists, were the ones from the original movie," explains Sims. "We were starting to redesign them, just because they're from the 1990s so let's go further, make them more interesting. There was an evolution in just those characters alone to see if we wanted to change them, but we actually stuck pretty close to the original – just finessed them a little bit, heightened them.

"[In this movie] the colonists walk, and we changed a little bit of their feet and legs to compensate for that. That's probably where it's evolved because in the first movie, part of it was the technology wasn't there so you couldn't really do anything mechanically and it was creepier too if you didn't see them all the time and they were more in shadow. In this movie we see so much of them and we need them to not be vulnerable, there's something about having something that's standing taller than you right in front of you – that's very menacing. As opposed to just creeping and crawling around. We had to go into something that's more disturbing or identifiable in some ways as human."

INSET BOTTOM RIGHT: "The exo-skeleton with the body inside stayed. You create a world and the logic works. The character from the first one stays. That basis is rooted in the origin of the species." Patrick Tatopoulos
INSET BOTTOM FAR RIGHT: Concept designs of a more muscular nemesis.

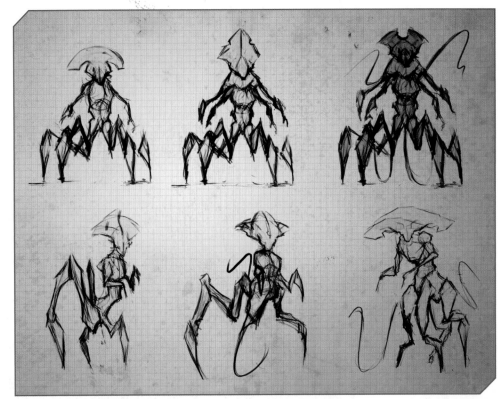

RIGHT: "The colonists with suit were 9-feet tall, then the little creature that came out was only 4-feet tall." Aaron Sims

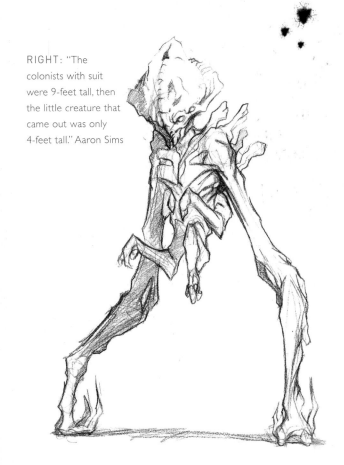
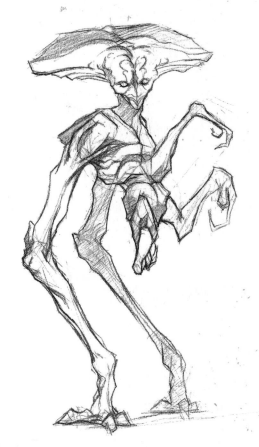
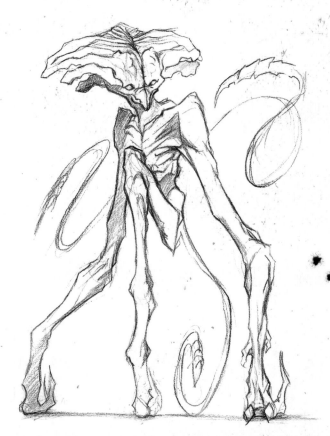

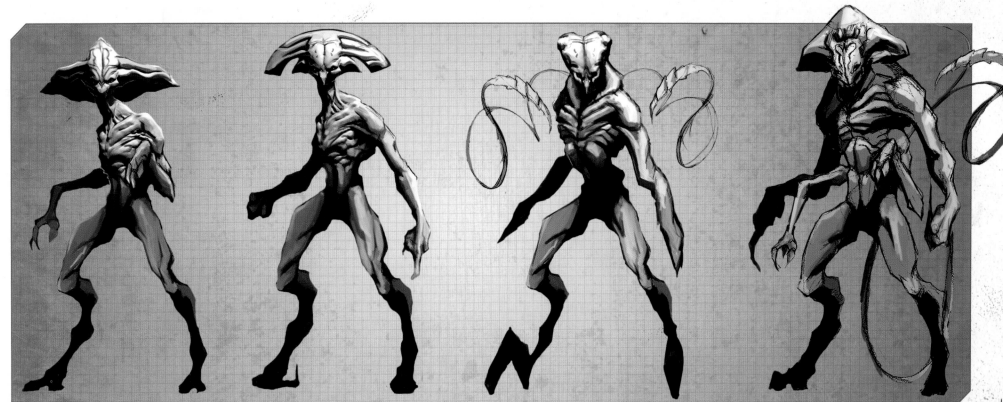

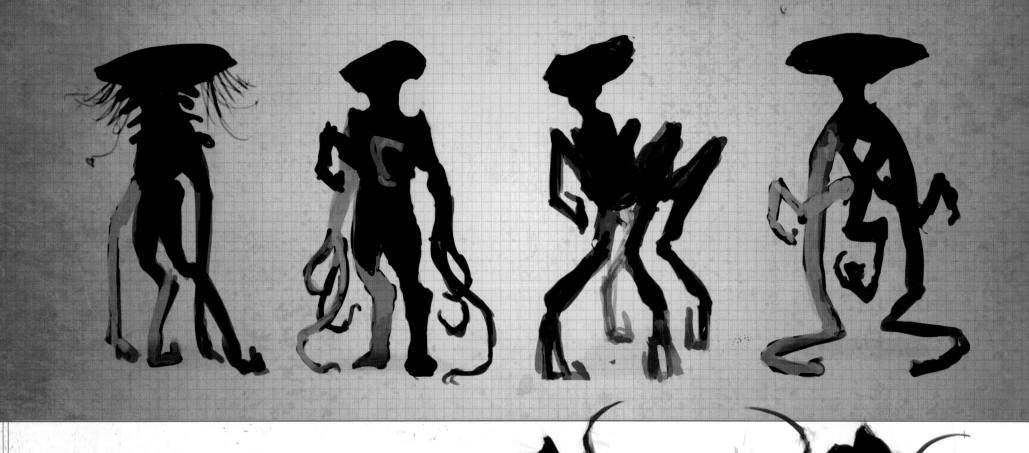

"It started off where we evolved and changed the original aliens, then Roland came back and said, why do we need to? Let's only change the things that make sense," recalls Sims. "The original one that Tatopoulos created, he said he didn't imagine it walking around, so it didn't feel like it had the base to walk on. It became narrower. So we actually widened it to create more of a balance for the body. With the inner one, we pretty much mimicked exactly what was done originally."

As these conceptual images show, it is a recognizable race, but from which only one subset appeared in 1996. There are more strange and terrifying variations to come.

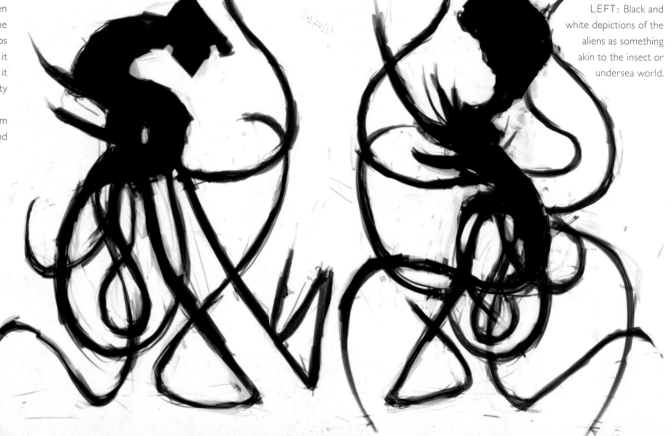

LEFT: Black and white depictions of the aliens as something akin to the insect or undersea world.

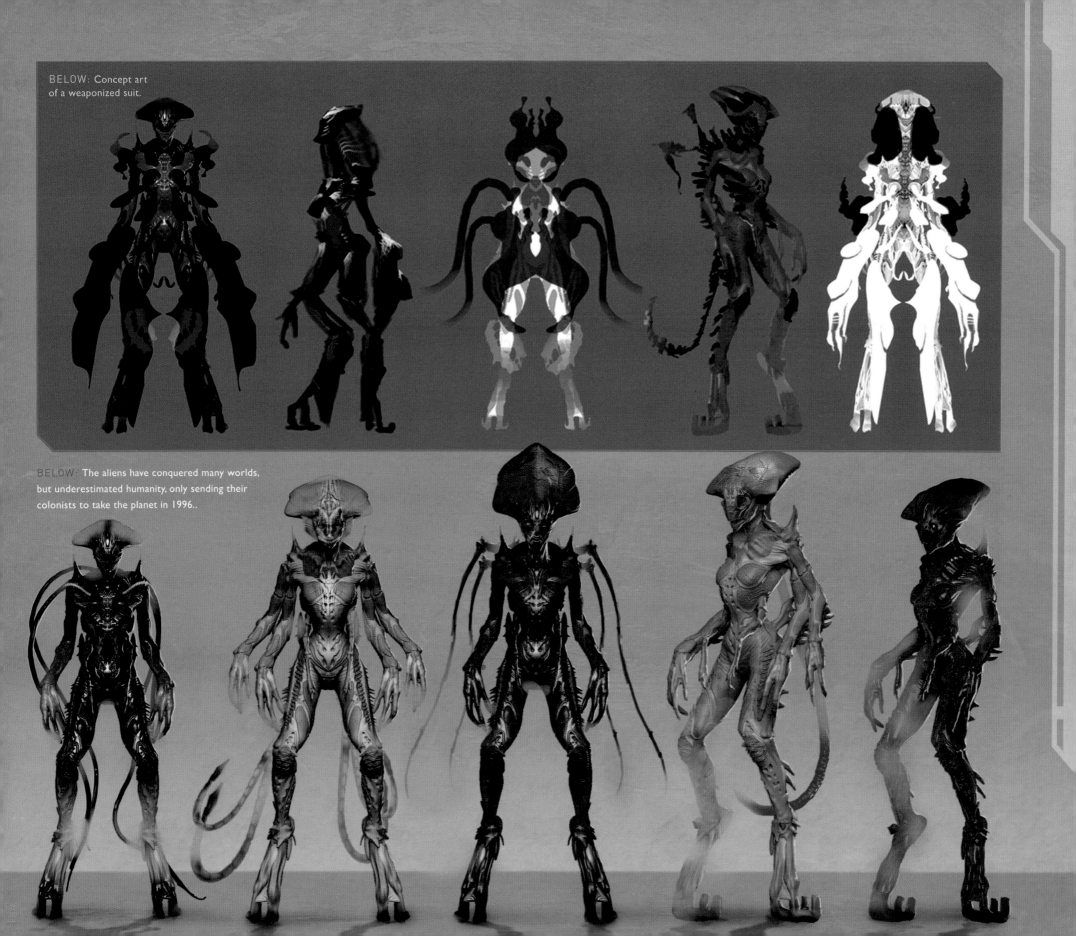

BELOW: Concept art of a weaponized suit.

BELOW: The aliens have conquered many worlds, but underestimated humanity, only sending their colonists to take the planet in 1996..

"I wanted to play with the creatures a bit," says Emmerich.

The aliens we meet in the first film are the smallest of the race. In Resurgence mankind finds itself facing soldier aliens, armed with blaster guns, who disembark from their ships, and engage in ground warfare. Now the attack comes from the sky and on the earth.

"There was many different design of the soldiers," continues Aaron Sims. "We did some that were bulkier, then some that were tall and lanky but were still menacing because even the thickness of their arm – they would appear tall from a distance but when they're closer to you their arms and legs are far bigger than ours. There's still a mass that comes with it. The torso was more of a long, thin torso that bent backwards and then we had all the tentacles that added another mass to it, too. The idea was they had to walk around like soldiers with their guns and feel somewhat familiar to things we identify as threatening. The soldier was 12 feet tall. It evolved because he was really big but you also wanted it to be a size that enabled the soldiers to enter rooms. If they get too big then they're beyond a scale that you could actually manage within a scene."

RIGHT: Concept art showing the angles of the creature and movement of the tentacles.

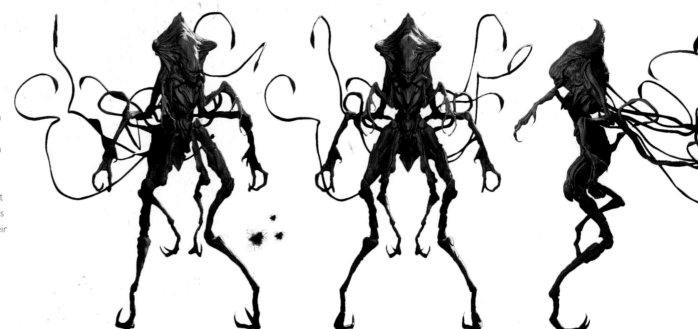

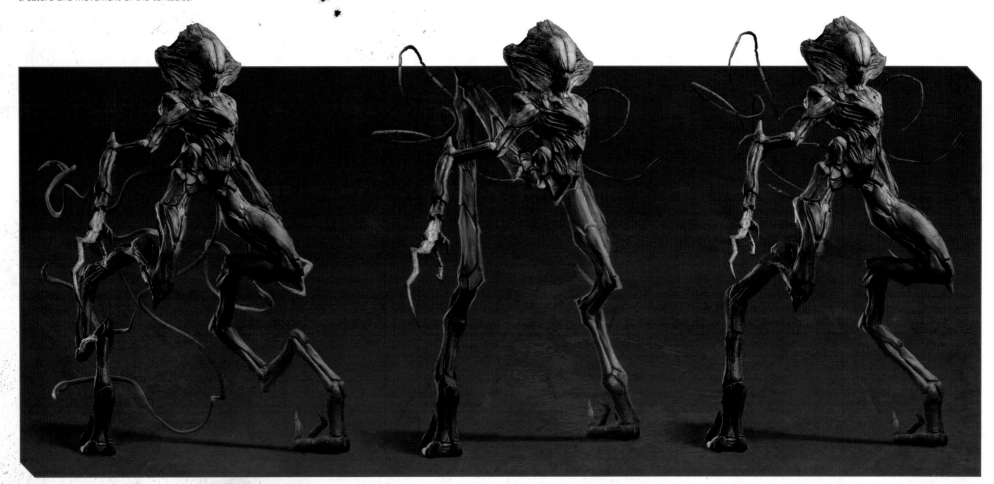

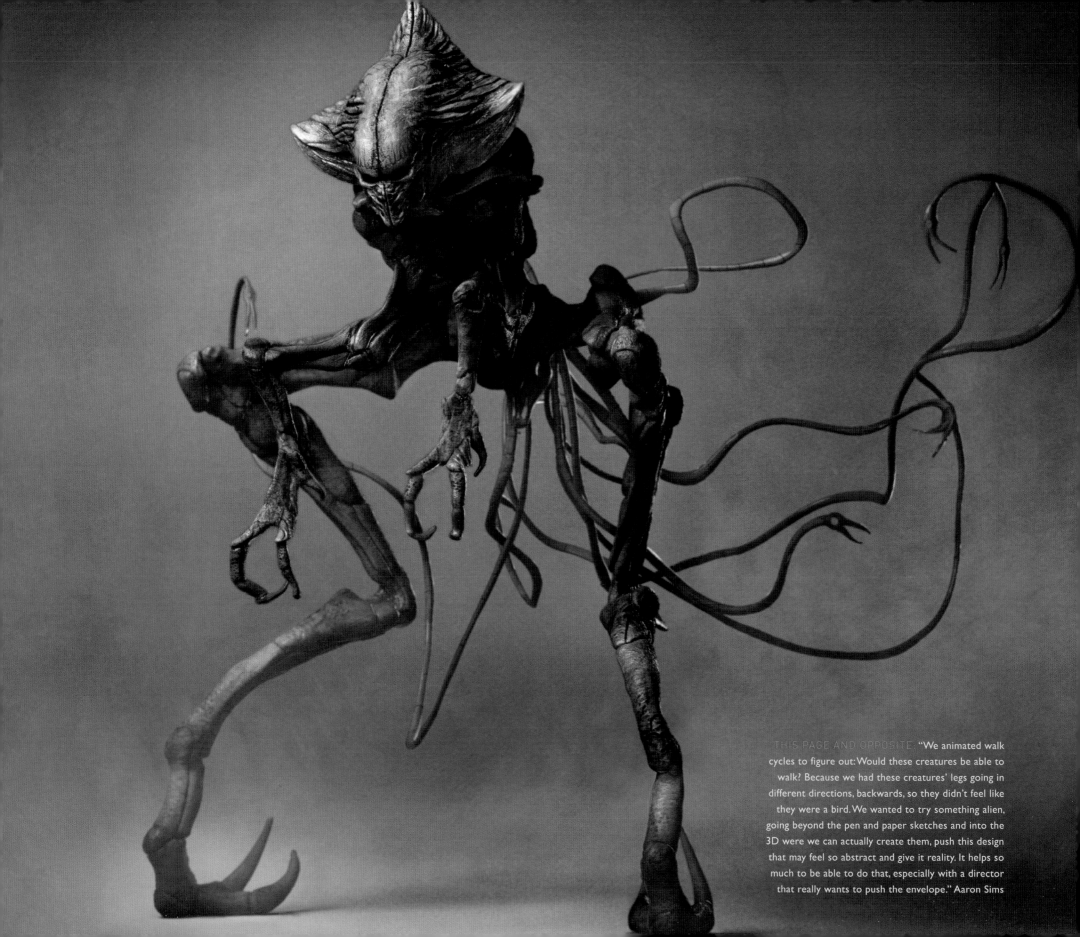

THIS PAGE AND OPPOSITE: "We animated walk cycles to figure out: Would these creatures be able to walk? Because we had these creatures' legs going in different directions, backwards, so they didn't feel like they were a bird. We wanted to try something alien, going beyond the pen and paper sketches and into the 3D were we can actually create them, push this design that may feel so abstract and give it reality. It helps so much to be able to do that, especially with a director that really wants to push the envelope." Aaron Sims

NEW ALIEN TECHNOLOGY

EARLY CONCEPT DESIGNS

A crucial revelation that explains the look of the alien hardware, why they landed in Africa, and also why they came back is that they grow their own technology. They shape and meld it to fit a purpose. This afforded the designers an enormous amount of scope to show subtly shifting patterns and changes to the core ideas.

"Everything is grown," Johannes Mücke details. "There's a lot of alien intelligence and alien AI to the way it grows, so it often looks quite mechanical as well. But we're really [trying] to convey that the aliens have this grown technology, and this is why we like to really have this quite organic look. [In the] cockpit you have some more mechanical things in there almost like blossoms. The chairs they have come out of the ground but they're not conventional cockpit seats; it's like they morphed out of the ground, they look like grown tree trunks." The designs on this spread were produced very early in the pre-production process, when the story beats were still being firmed up. They show the very different directions that dozens of artists took to showcase the alien '2.0' vehicles.

As with the destroyers in the first film, the facades on these ships are mostly in keeping with the solid, ominous, and oppressive aesthetic, but a few variations show a radically different aesthetic, with sharper lines and angles that seem drawn from the insect world.

"[After what happened last time] the aliens know. They have to be really careful; they have to send their biggest, strongest forces, so to speak," is how visual effects supervisor Volker Engel describes the second alien fleet. "A new generation of alien fighters". They are taking no chances in round two.

RIGHT: These very early black and white ideas were ultimately not used in the finished film.
BOTTOM: In a blink-and-you'll-miss-it moment, an alien troop transporter is visible in the original film when Levinson and Hiller make their escape from the mothership. For *Resurgence*, Volker Engel brought the idea back and even used the original model (courtesy of Oliver Scholl) for reference. Johannes Mücke worked on the carrier, following Emmerich's guidelines: "When Roland had me re-design the troop transporter he asked me to stay as close as possible to the original reference from *ID4*, so we only added a spine, re-designed the fin and underside and added some artillery."

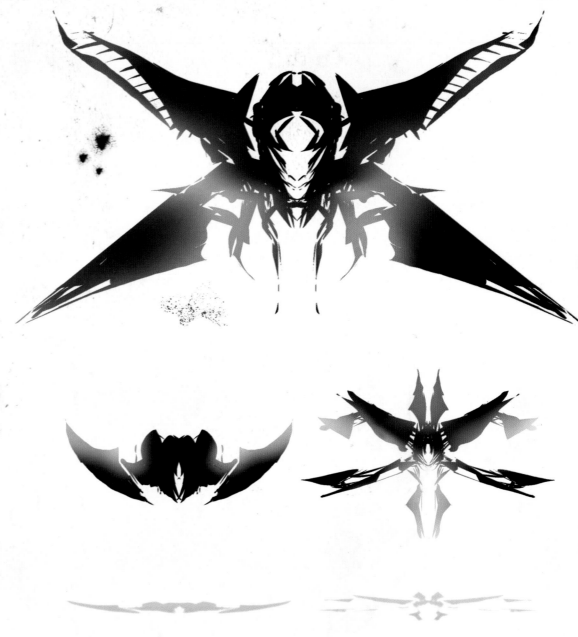

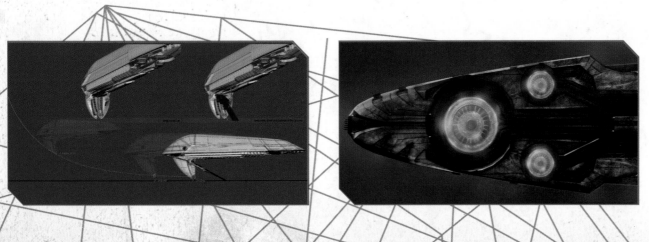

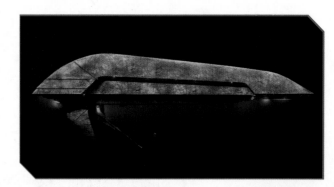

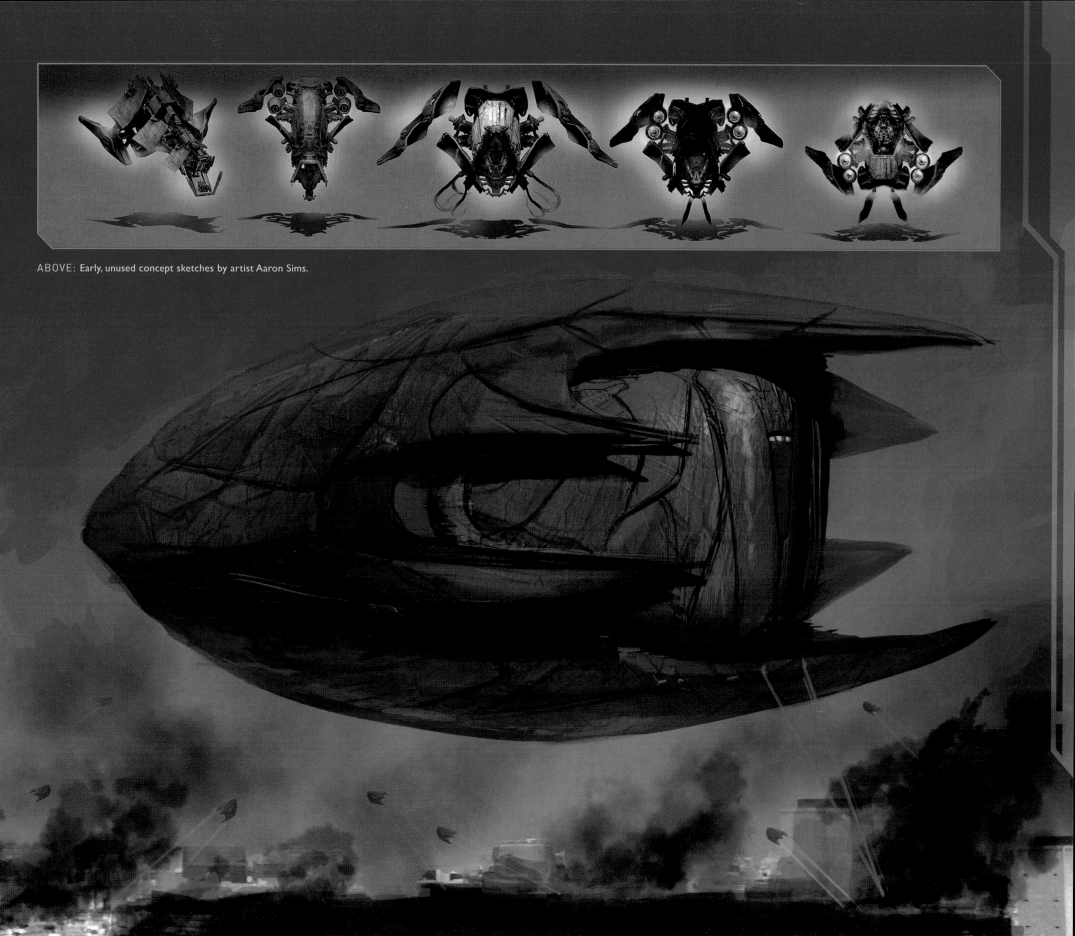

ABOVE: Early, unused concept sketches by artist Aaron Sims.

ATTACKERS

The ESD may have spent 20 years upgrading Earth's weaponry, creating a never-bettered arsenal, but it is soon overshadowed when the aliens return. They too have been busy.

The original attacker ships, swarming the skies, were an idea that hadn't been seen before in blockbuster sci-fi; the updated attackers needed to show how and why the story and look has moved on.

"The big challenge was not to get lost in admiration and respect for the first movie," is how Mücke describes it, "but to move it to another place, while it's really trying to maintain the language and the charm that the first one had.

"The pilots are sitting behind each other, and the lower one is the gunner and the upper one is the pilot. The gunner has two really big guns right next to him; he sees two gigantic guns right out of his little cockpit window, and he has the controls for them. The guns move. Then, halfway through flying, he realizes that on both sides over his shoulders are two more…the real badass things come out of the wings and he can see those too and understands, oh wow, I can shoot with these. That's the big fun sign. That's super fresh. I pitched it to Roland and he liked it, and so we're doing that."

BELOW: Various designs for the joystick the gunner uses to fire his standard weapon and also to trigger the giant wing guns. A life-size cockpit and joystick was built on set.

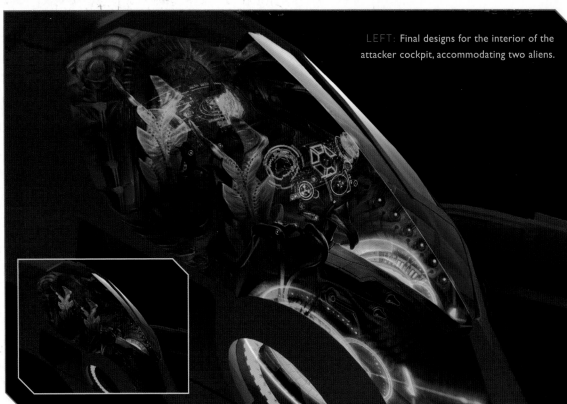

LEFT: Final designs for the interior of the attacker cockpit, accommodating two aliens.

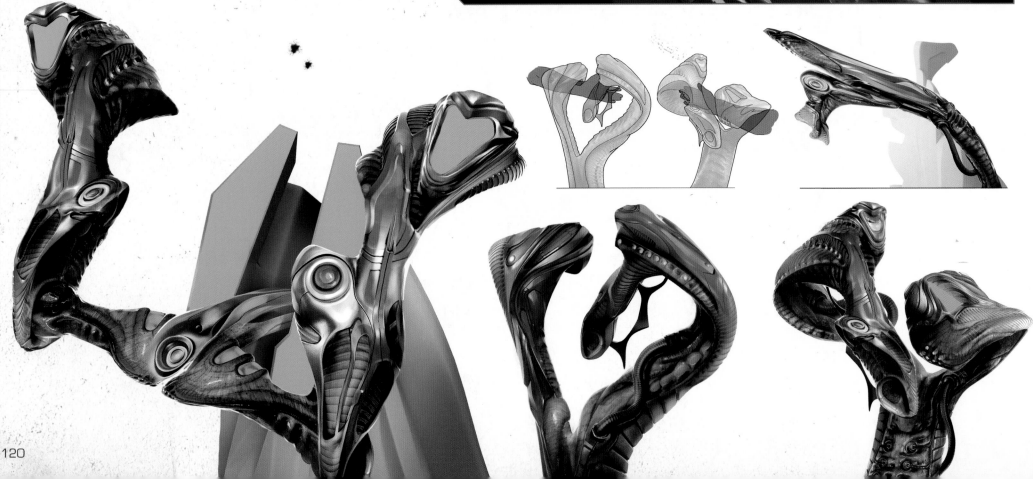

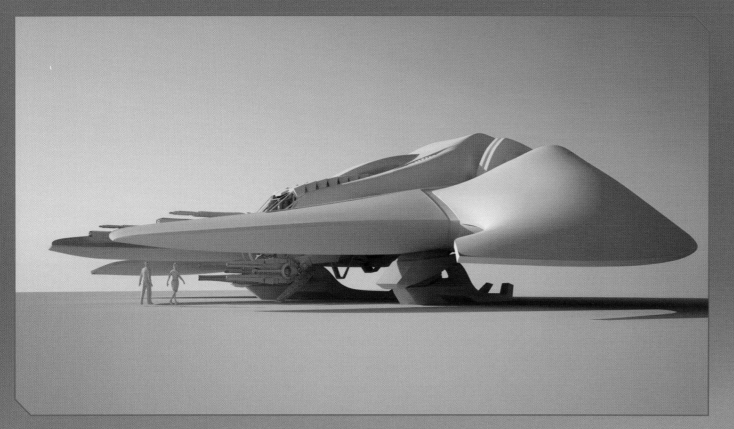

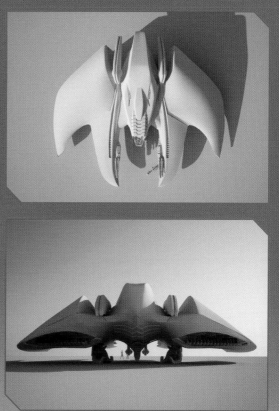

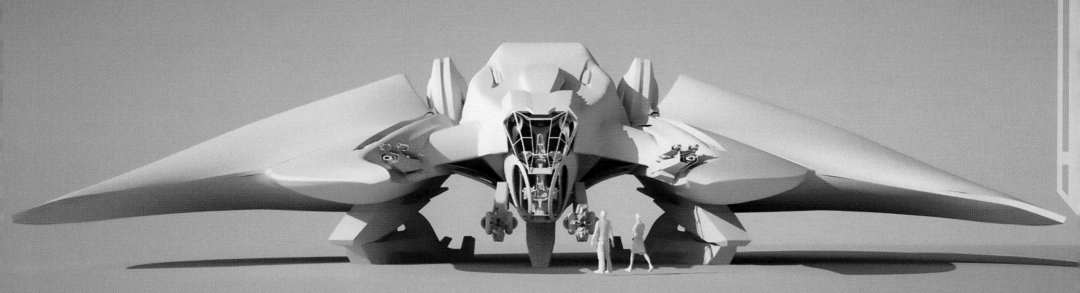

THIS PAGE: 3D models of the attacker, featuring an earlier version of the cockpit design and the final one used in the on-set prop.

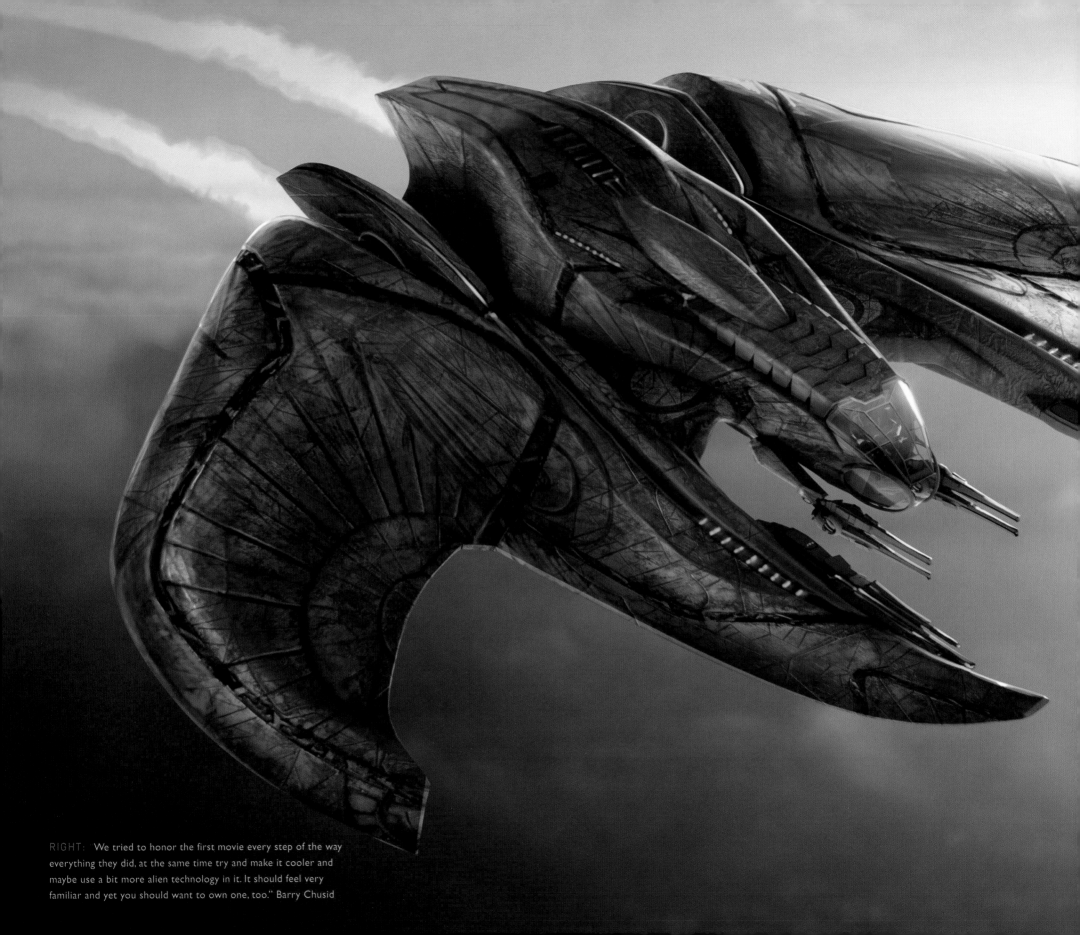

RIGHT: "We tried to honor the first movie every step of the way
everything they did, at the same time try and make it cooler and
maybe use a bit more alien technology in it. It should feel very
familiar and yet you should want to own one, too." Barry Chusid

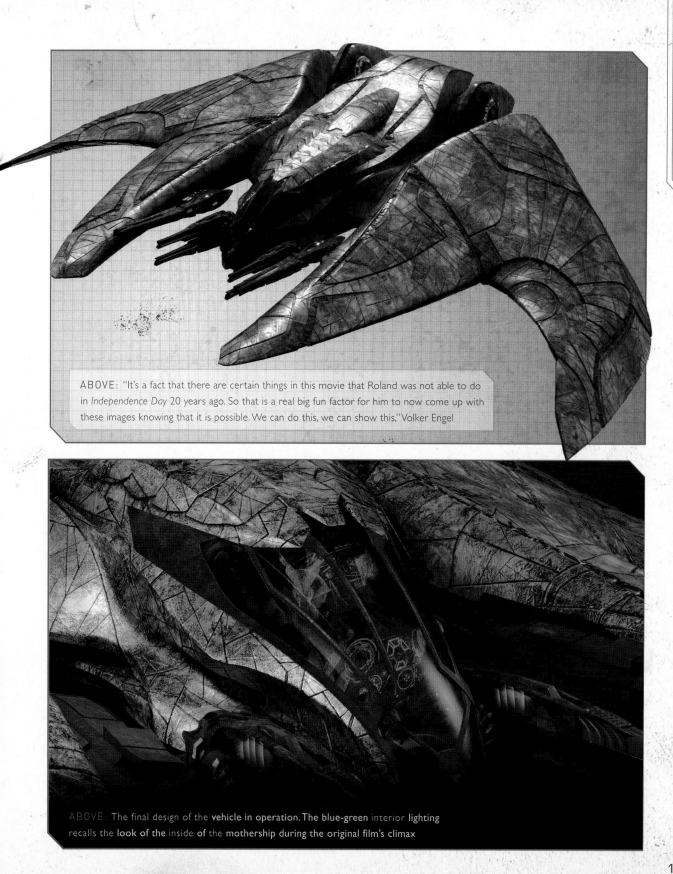

ABOVE: "It's a fact that there are certain things in this movie that Roland was not able to do in *Independence Day* 20 years ago. So that is a real big fun factor for him to now come up with these images knowing that it is possible. We can do this, we can show this." Volker Engel

ABOVE: The final design of the **vehicle in operation**. The blue-green interior **lighting** recalls the **look of the** inside of the **mothership during the original film's climax**

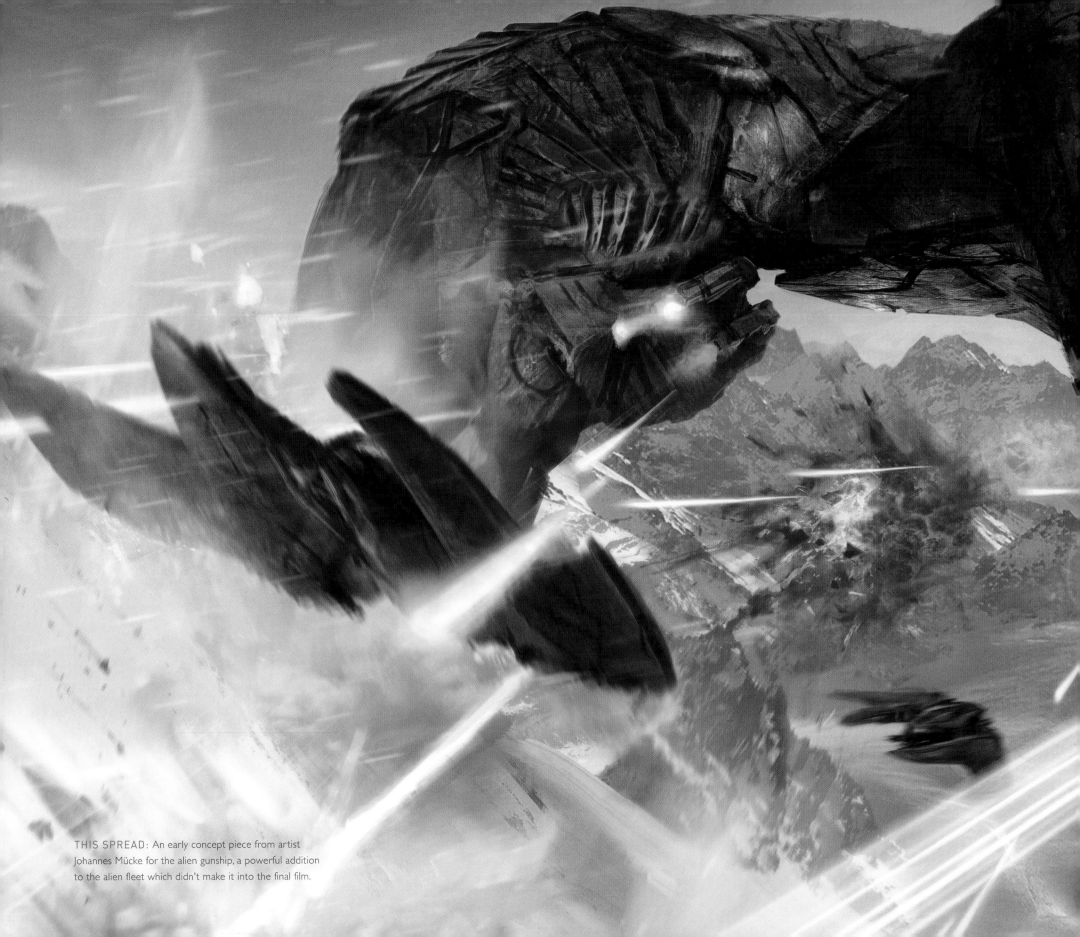

THIS SPREAD: An early concept piece from artist
Johannes Mücke for the alien gunship, a powerful addition
to the alien fleet which didn't make it into the final film.

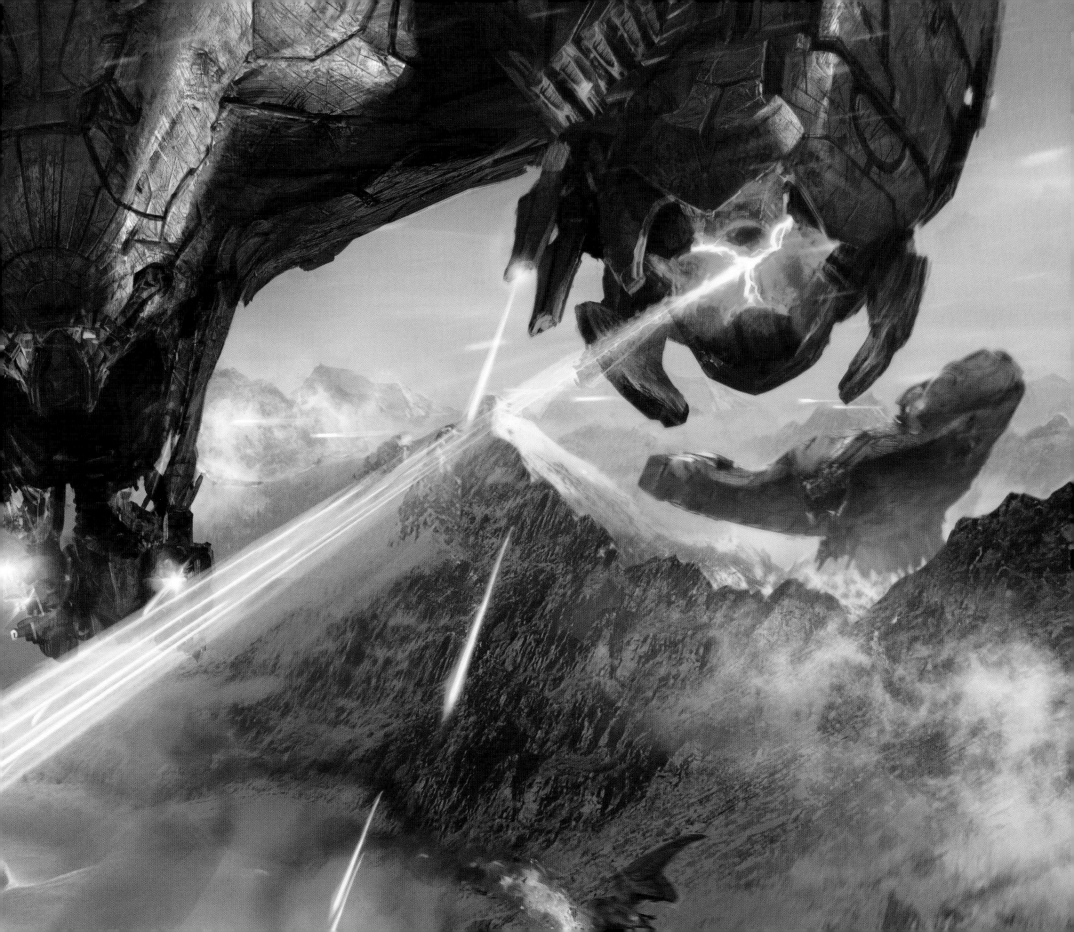

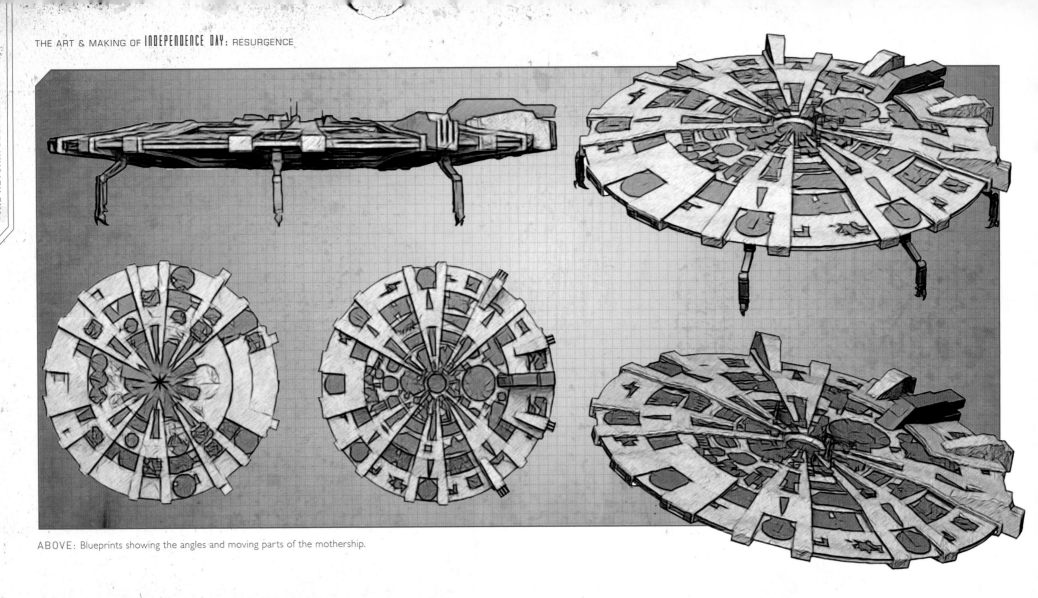

ABOVE: Blueprints showing the angles and moving parts of the mothership.

MOTHERSHIP

The centrepiece of the film is the arrival of the mothership. Warned by the shot-down Al ship, Levinson, Jake, and their friends are able to get to safety in the moon tug as the gigantic mothership destroys the moon cannon and crashes by the moon itself, obliterating the ESD base.

'Ship' is a misnomer, as a more appropriate description would be 'planet.' It dwarfs anything seen before. As Levinson describes it: "Definitely bigger than the last one."

The impact on both the audience and characters has to be suitably awe-inspiring and devastating. After waiting and wondering for 20 years, it's even more than we could have dreamed. Knowing full well the pressure to nail the design, Johannes Mücke collaborated closely with Emmerich, as he explains: "The mothership comes to Earth and comes over it. The way I designed it is then that these feet land on the Earth so it latches on and sits on the Earth. In the middle of the mothership there's an opening, with a drill. It shoots out plasma into the core of the Earth. It sucks out the magma from the core of the Earth and this magma gets into the mothership. It floods out through the legs to the feet, then the feet grow roots. You can suggest stuff to Roland and he loves it or hates it but we took as a reference, and pitched to him the way lava moves underwater, under cold water, where it instantly cools down and it really grows then it stops and the heat breaks up again and it keeps growing and growing. It looks amazing. They loved that. So this was our paradigm of how these roots dig into the earth, mainly in Washington, and then they start growing under the earth."

The mothership is meant to be intimidating and serve its purpose, so the impact has to be as immediate and clear as possible.

As Mücke explains, "Something that I've learned from Roland, which was such a great lesson, is that he believes in keeping it as simple as you can: The spaceship's a disc. He likes the most straightforward and simple idea you could have. It'll get super complicated by itself. If you start with a complicated thing, you'll have a Gordian knot, you'll have something like that which you'll never solve visually.

"You have a certain time to establish it with the audience," Mücke continues. "So have something really visually clear that nobody questions, then have your little complication that comes automatically along the way." The design of the mothership came quickly but soon arose the logical and physical question of how such a big ship would function.

"At one point we found out, okay, but it can only scratch the atmosphere with its underbelly," Mücke explains. "We'll never have this idea that it's completely inside the atmosphere because our atmosphere is such a thin layer. Roland had me redesign the whole thing so once it comes it has much more moveable features and it could really be like a cap over the Earth before the feet start extending. I had so many redesign passes to really cater to the sheer gigantic size of the mothership and how it's able to enter. Roland said it looks like – with the feet and it being so flat – it looks like a table on the earth."

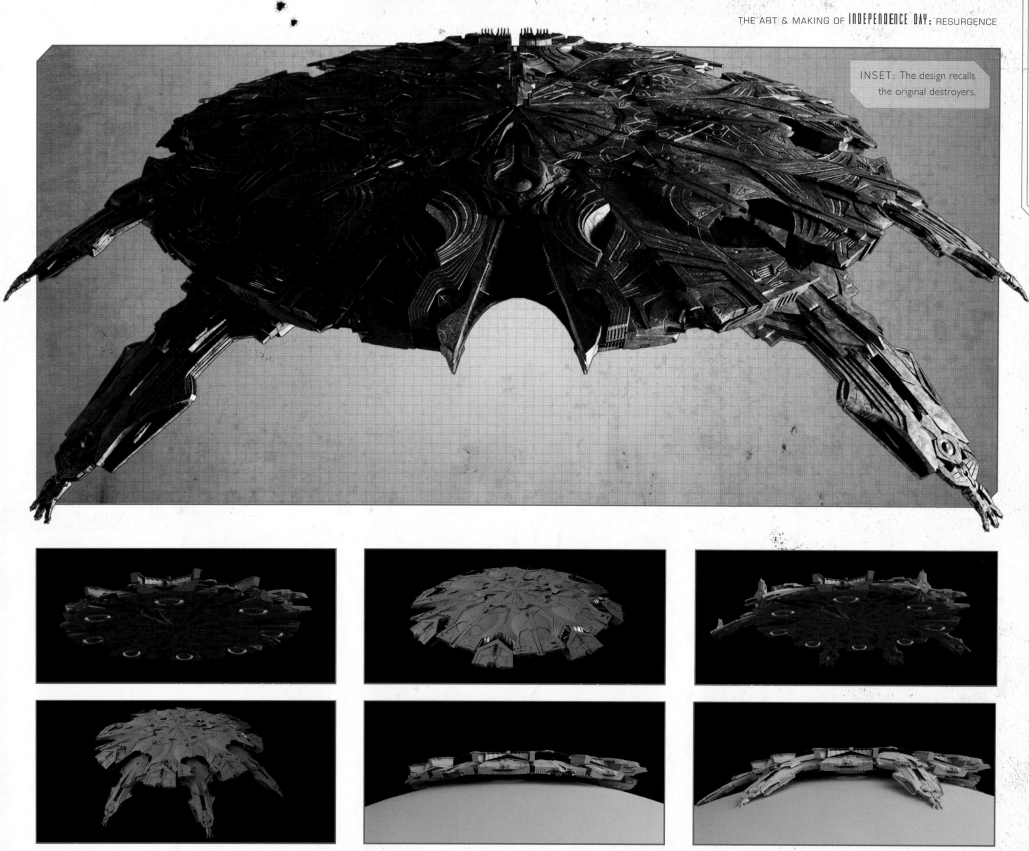

INSET: The design recalls the original destroyers.

ABOVE: "It's not amorphous but more parts are adopting to the curvature of the Earth. It comes in then parts come out, then other parts enclose. So many parts are moving that it really starts to be like a cap over the earth when it travels, and then the feet come and it hugs the earth." Johannes Mücke.

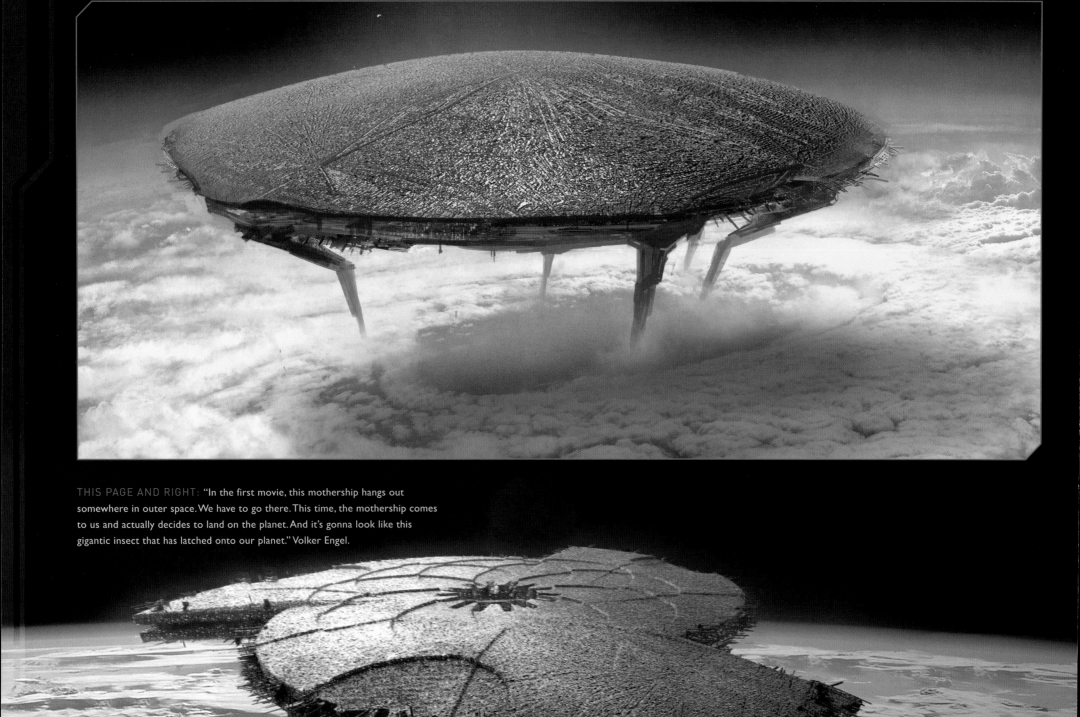

THIS PAGE AND RIGHT: "In the first movie, this mothership hangs out somewhere in outer space. We have to go there. This time, the mothership comes to us and actually decides to land on the planet. And it's gonna look like this gigantic insect that has latched onto our planet." Volker Engel.

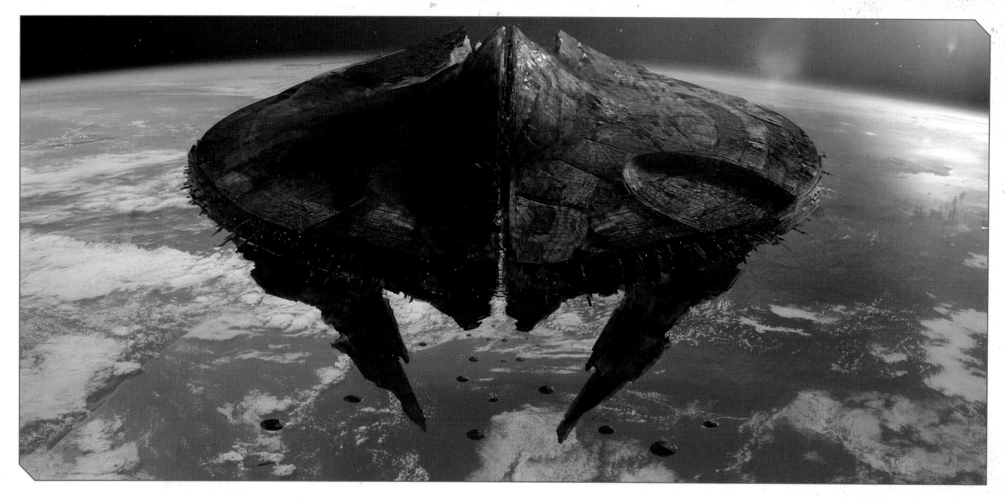

BELOW: Views showing potential ideas for the landing and latch the ship will make using its feet.

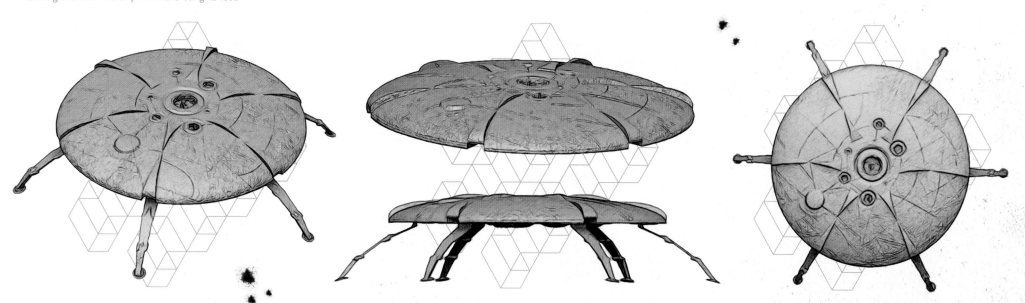

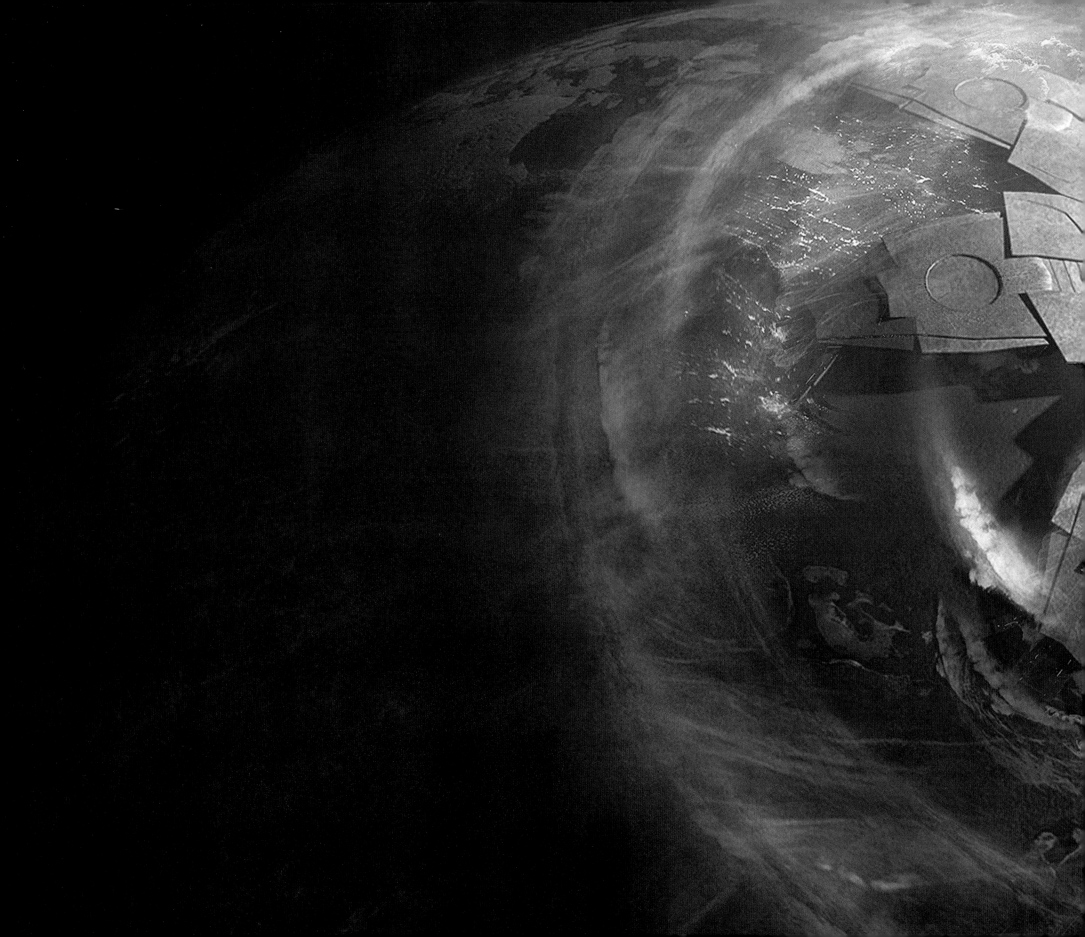

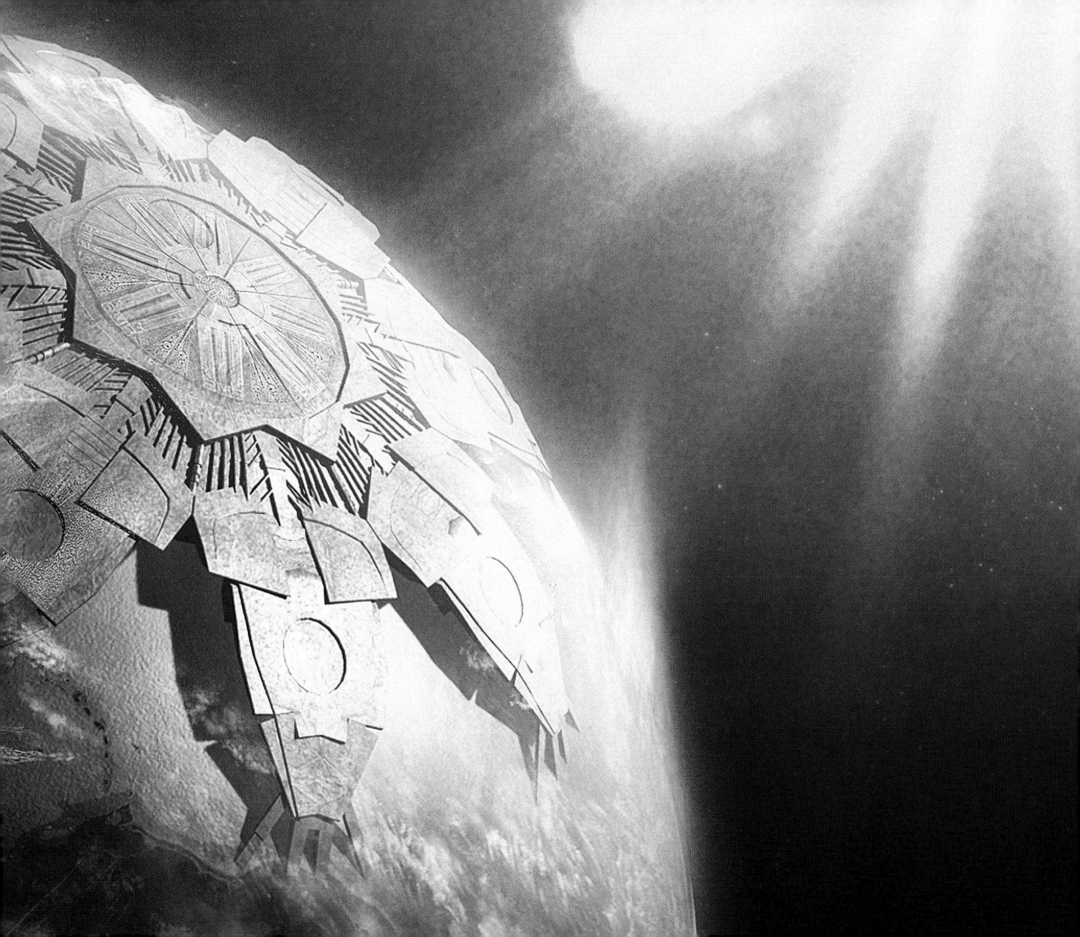

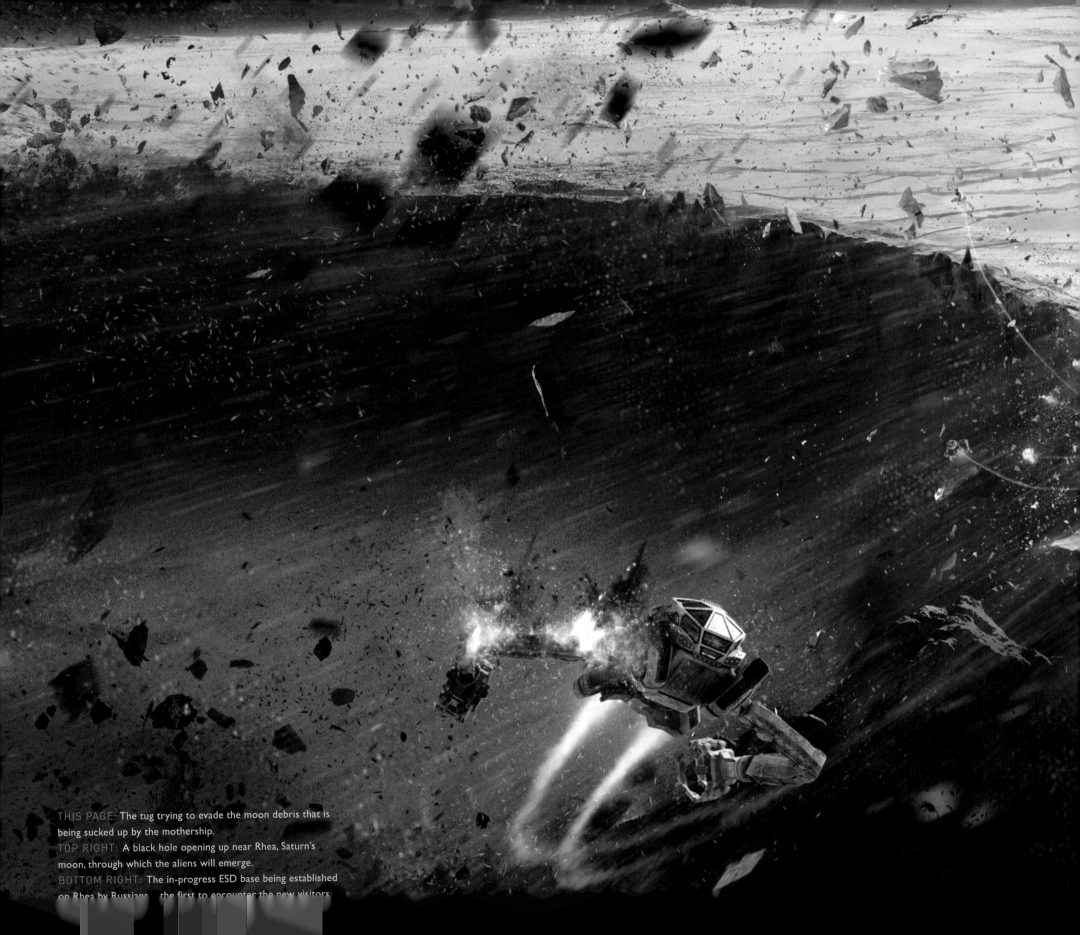

THIS PAGE: The tug trying to evade the moon debris that is
being sucked up by the mothership.
TOP RIGHT: A black hole opening up near Rhea, Saturn's
moon, through which the aliens will emerge.
BOTTOM RIGHT: The in-progress ESD base being established
on Rhea by Russians — the first to encounter the new visitors.

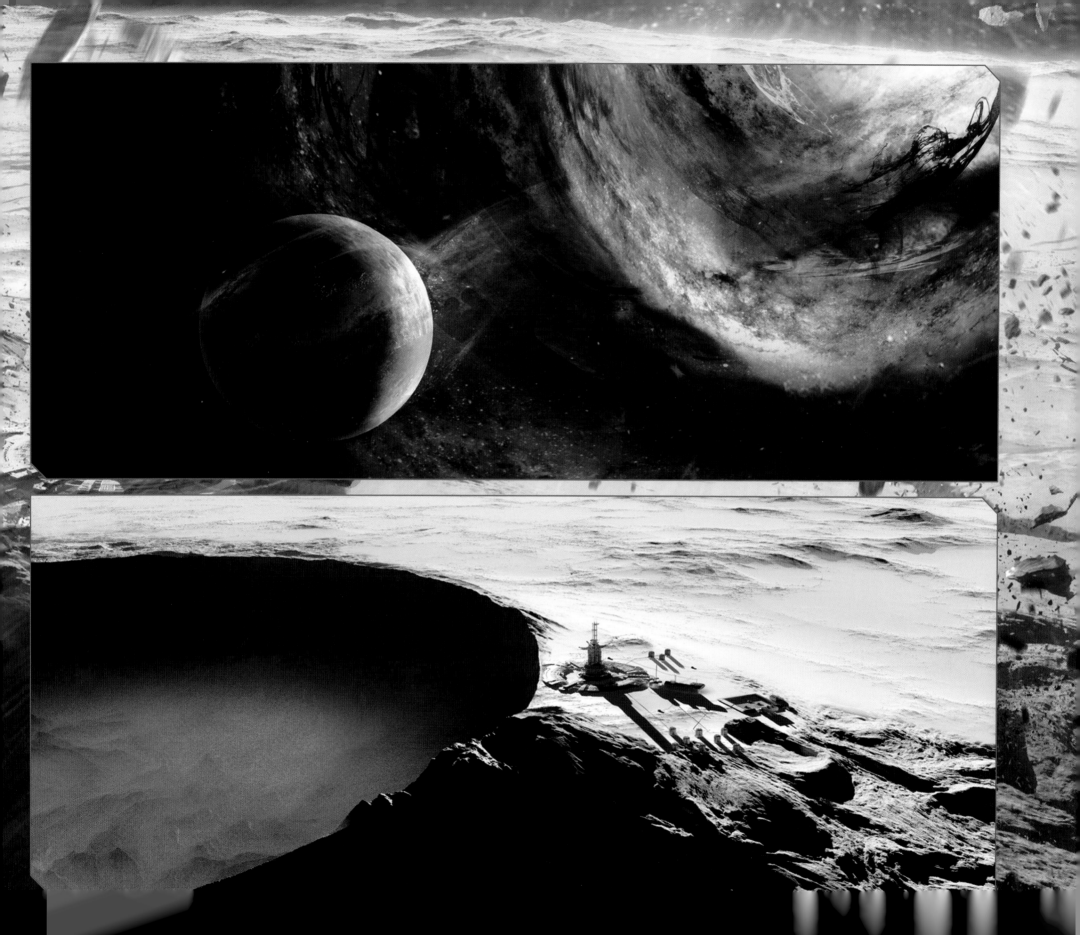

MOTHERSHIP LANDING STORY BOARD - BY ROLAND EMMERICH & JOHANNES MÜCKE

LEFT: The 'horns' appear on the top frame edge, and their shadow cast on the earth comes from the bottom frame edge.
RIGHT: Mothership approaches, threatening to pierce the earth with its horns (small dots are the ESD orbital cannons).

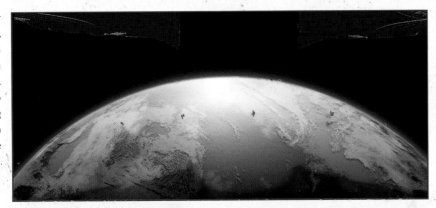
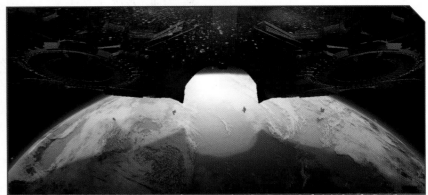

LEFT: Close-up of orbital defense cannons.
RIGHT: View from inside the tug of the giant cannon on the underside of the mothership.

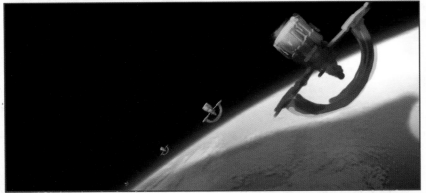
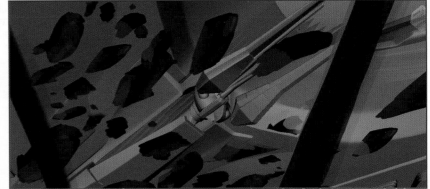

LEFT: The mothership brings out locks onto the cannons with targeting lasers.
RIGHT: Cannons obliterated.

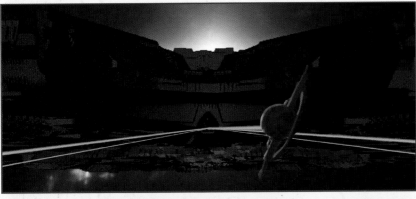
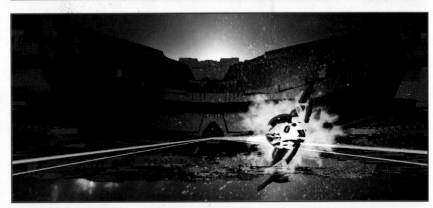

LEFT: All orbital defence stations are erased.
RIGHT: The front of the mothership starts burning and setting the atmosphere on fire as it enters it.

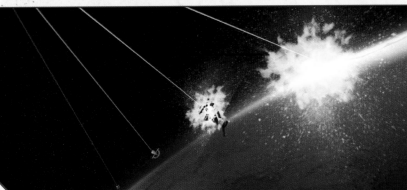
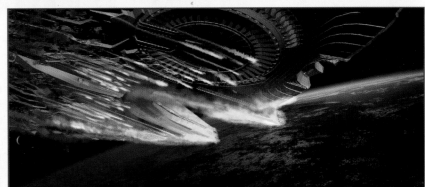

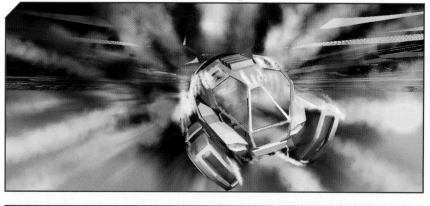

LEFT: Moon tug, amidst the hellfire from entry into the atmosphere.
RIGHT: View from moon tug: The moon debris disintegrates in fireballs.

LEFT: The thruster arms extend, appearing to hug the earth.
RIGHT: View from moon tug: The green rings are the thrusters that prevent the mothership from attaching to the earth by pushing itself away.

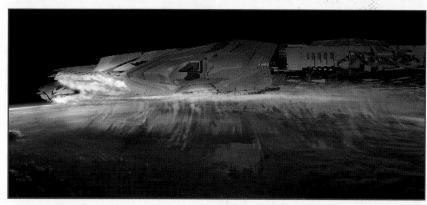

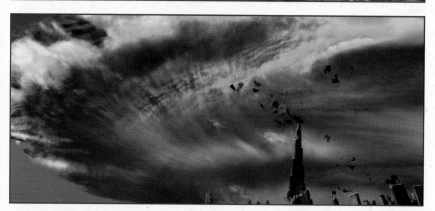

LEFT: The mothership starts sucking clouds and earth surface under its belly.
RIGHT: Dubai gets sucked into he sky of fire.

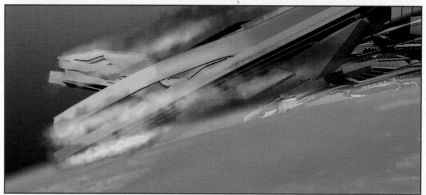

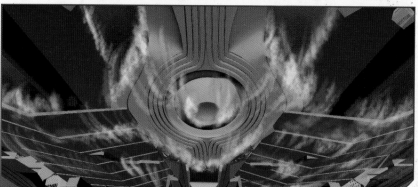

LEFT: The landing feet expand and create another atmosphere entry spectacle.
RIGHT: The glowing landing foot races towards the camera.

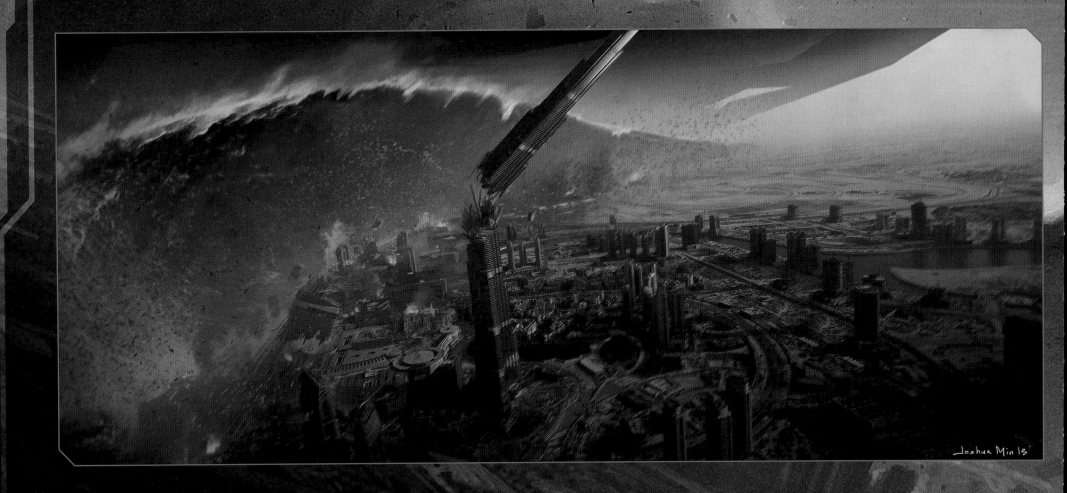
Joshua Min 13

THE DESTRUCTION
DUBAI

Dubai's **Burj** Khalifa is 829.8m tall. It has 163 floors. It took five years to build. In Resurgence it takes a matter of seconds to bring it crashing down.

When the mothership enters Earth's atmosphere, its own internal gravity sucks up the cities it passes over, creating a vortex, an artificial storm of chaos. Concept artwork, motion images, and extensive pre-visualization were all needed to create the sequence and understand the logic of how the ship's gravity counteracts our own.

"The idea is that the ship comes to Earth and we'd seen before how it cracks the moon in half," explains Mücke, "We want the audience to get the false impression that 'Oh my god, it's cracking Earth in half!' And then the first thrusters start really pushing towards the earth and when it scratches over the moon it picks up all the moon debris and the moon tug. When its first little part enters the atmosphere, you get this asteroid storm because there's this huge speed and all this moon debris is stuck under the moving mothership…So now we're with Levinson and the guys in the moon tug, we're caught between the underbelly of the ship and this cloud layer underneath, kind of in this middle zone where all this stuff that's being sucked up gathers. As we vacuum clean the top of the earth, starting somewhere in Singapore, it builds and builds and builds."

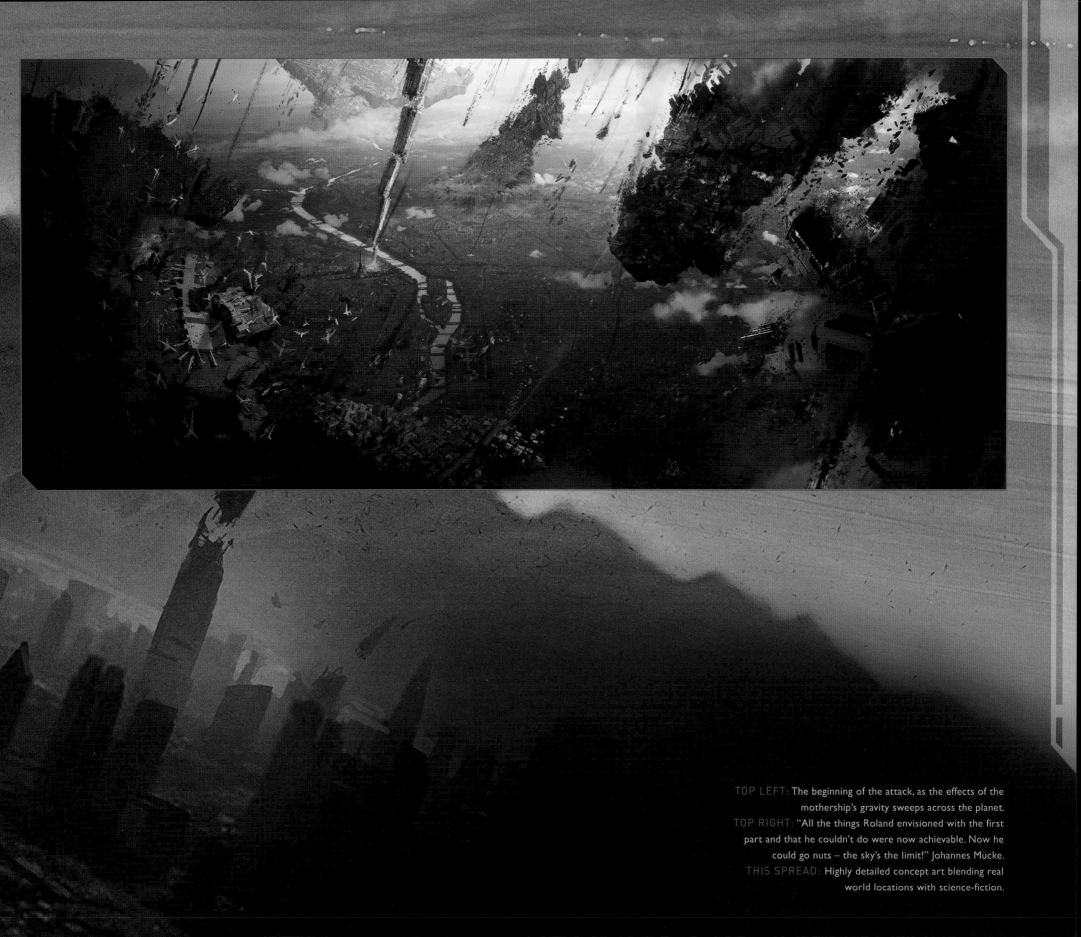

TOP LEFT: The beginning of the attack, as the effects of the mothership's gravity sweeps across the planet.
TOP RIGHT: "All the things Roland envisioned with the first part and that he couldn't do were now achievable. Now he could go nuts – the sky's the limit!" Johannes Mücke.
THIS SPREAD: Highly detailed concept art blending real world locations with science-fiction.

LONDON

The script describes it as an 'orgy of destruction.' The mothership begins to slow down, letting it start to descend to the surface of the Earth. It turns down its thrusters. The result? Everything that has been sucked up is released, causing south-east Asia to rain down on London and Paris.

David Levinson wryly observes that *what goes up must come down*. "It's the disaster movie to end all disaster movies," says Volker Engel. "But at the same time, this is much more of a science fiction movie that has a disaster sequence in it. We see buildings being ripped out of the ground and then coming down again. London and Paris are good examples and I might quote my favorite sentence in the whole screenplay when it comes to visual effects. It says, 'Dubai falls on Paris.' So this can only be a Roland Emmerich movie."

People around the world can only watch helplessly, completely overwhelmed, as the Millennium Wheel is toppled, and Kuala Lumpur obliterates Piccadilly Circus, and millions die.

The world is turned upside down.

RIGHT: People evacuate central London as national landmarks collide and a car smashes into the Shaftesbury Memorial Fountain in Piccadilly Circus.
BELOW: "So much more is possible now so Roland is just pushing everybody to really explore whatever's possible with modern technology and CG." Johannes Mücke.

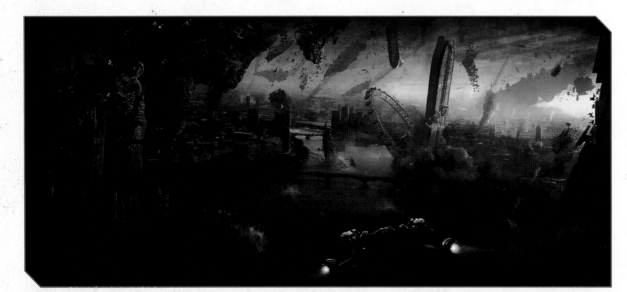

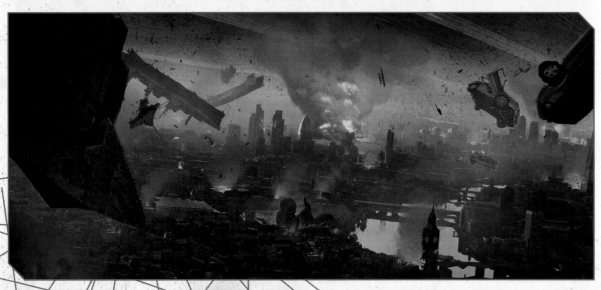

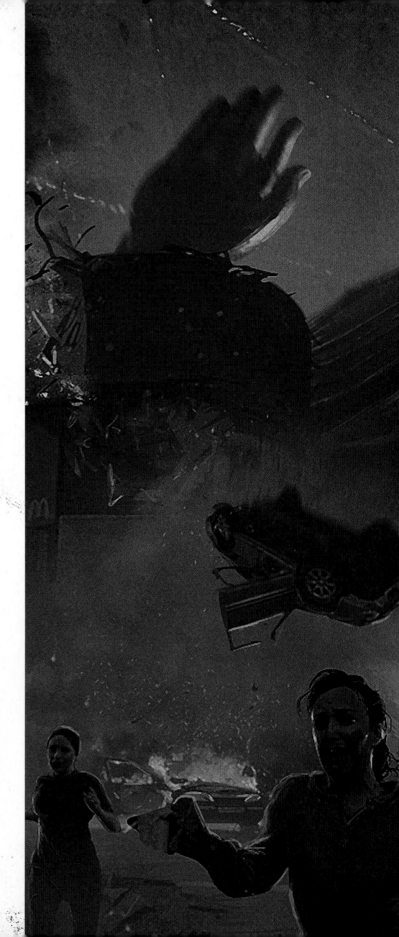

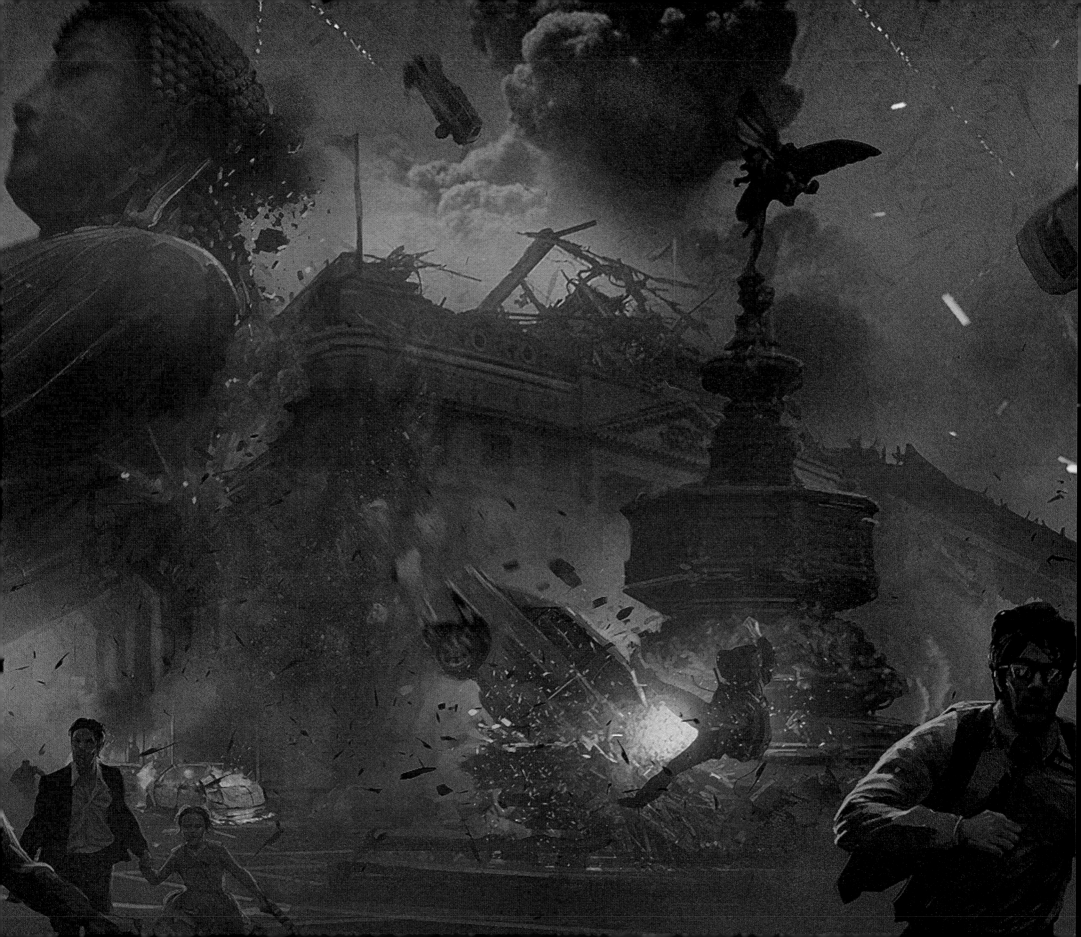

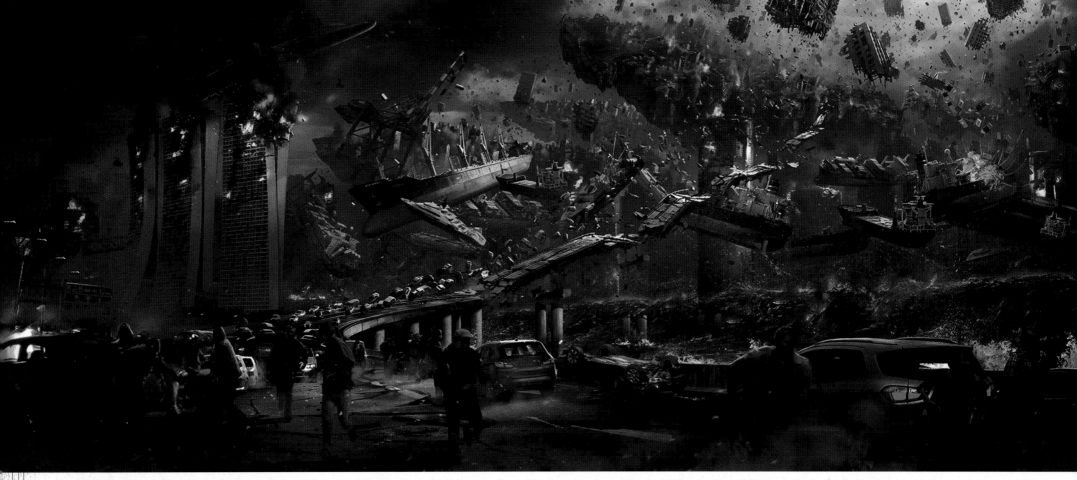

ABOVE: Singapore is whipped up into the mothership's vortex. BELOW: Austin, Texas, has been flooded by the tsunami caused by the Mothership. Part of this was built as a set for the shoot in Albuquerque.

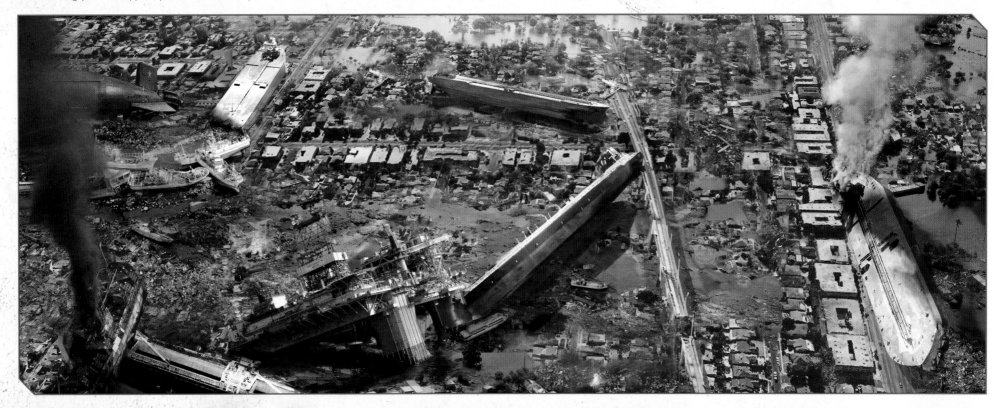

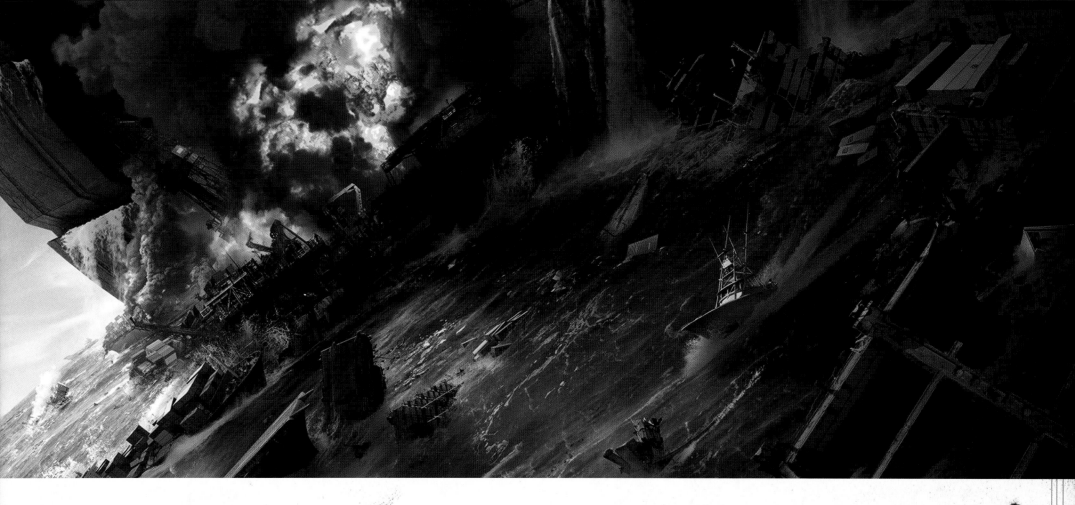

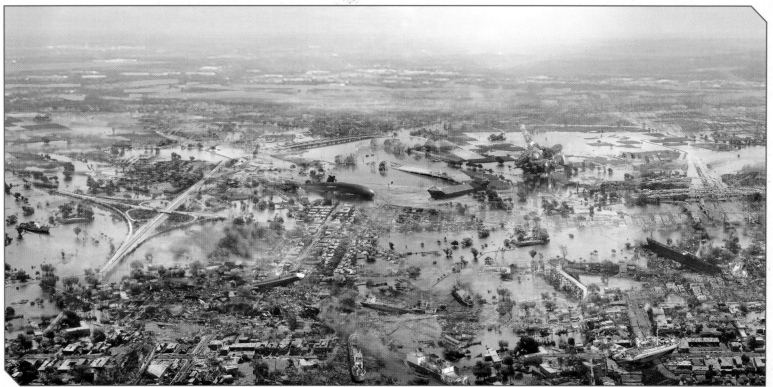

ABOVE: A piece of concept art presented to Twentieth Century Fox at the initial pitch meeting for the entire project. "The sixteen images that were created were really there to show the grandness of the movie," recalls Volker Engel. "Roland very deliberately picked a couple of these images to show that scope. And one example is the landing foot of the mothership hitting the water right in front of Galveston, Texas. It's something you could have never done with a miniature. It would have always looked like a bathtub no matter how large of a pool you would have built. It's got to be gigantic."

LEFT: Concept art showing the aftermath of the tsunami that hit Austin, Texas.

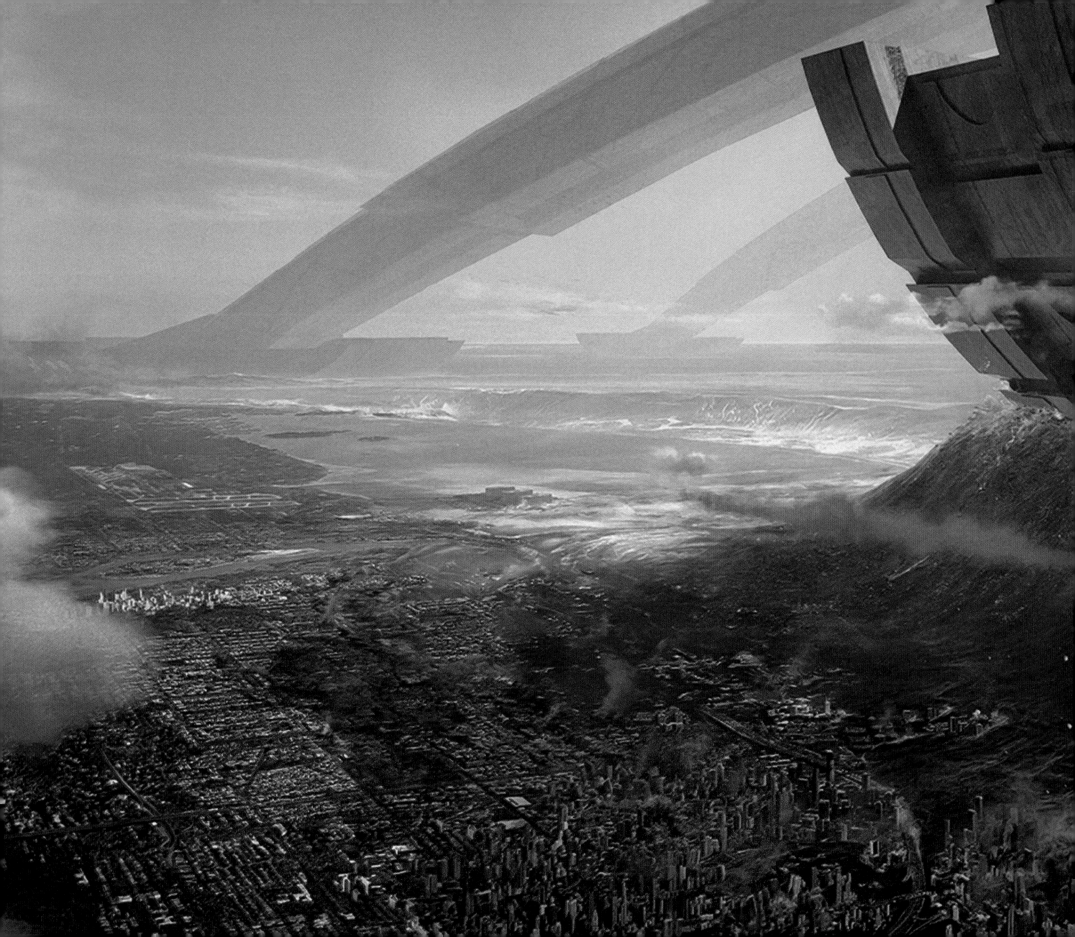

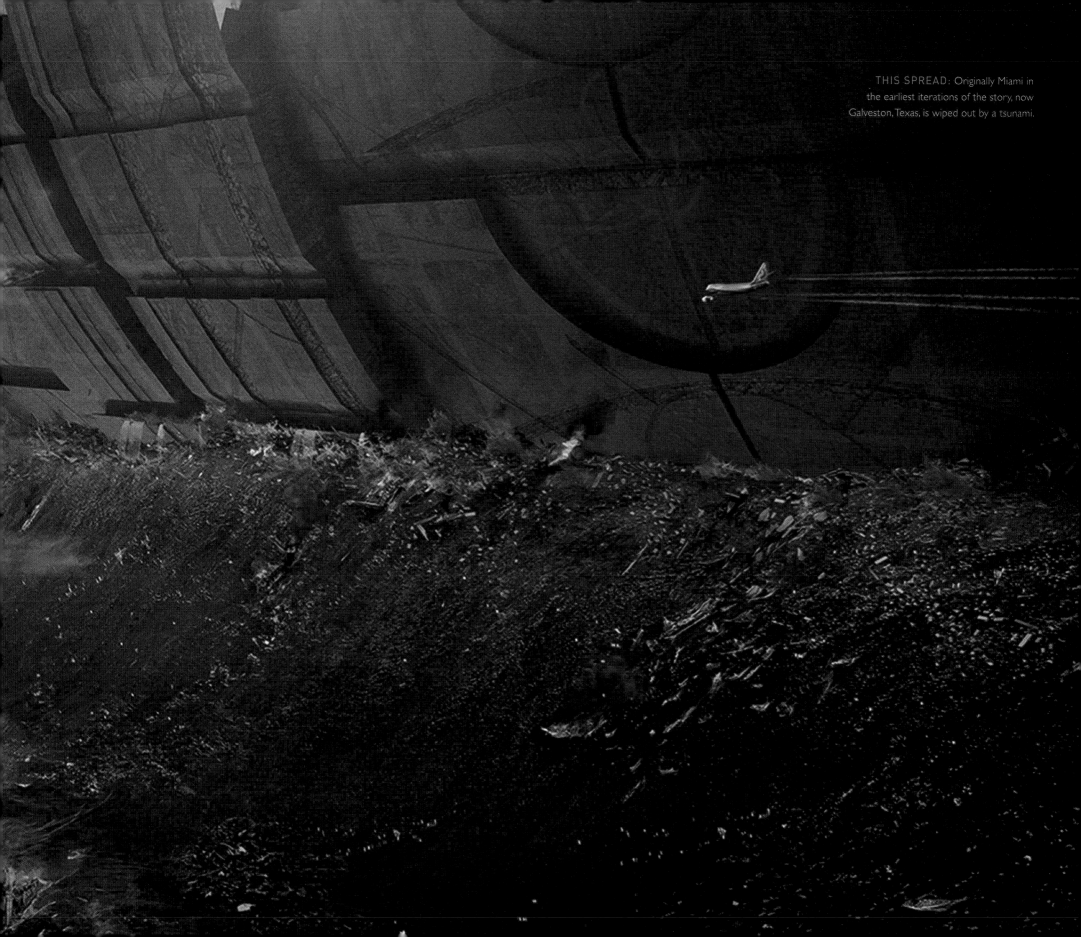

THIS SPREAD: Originally Miami in the earliest iterations of the story, now Galveston, Texas, is wiped out by a tsunami.

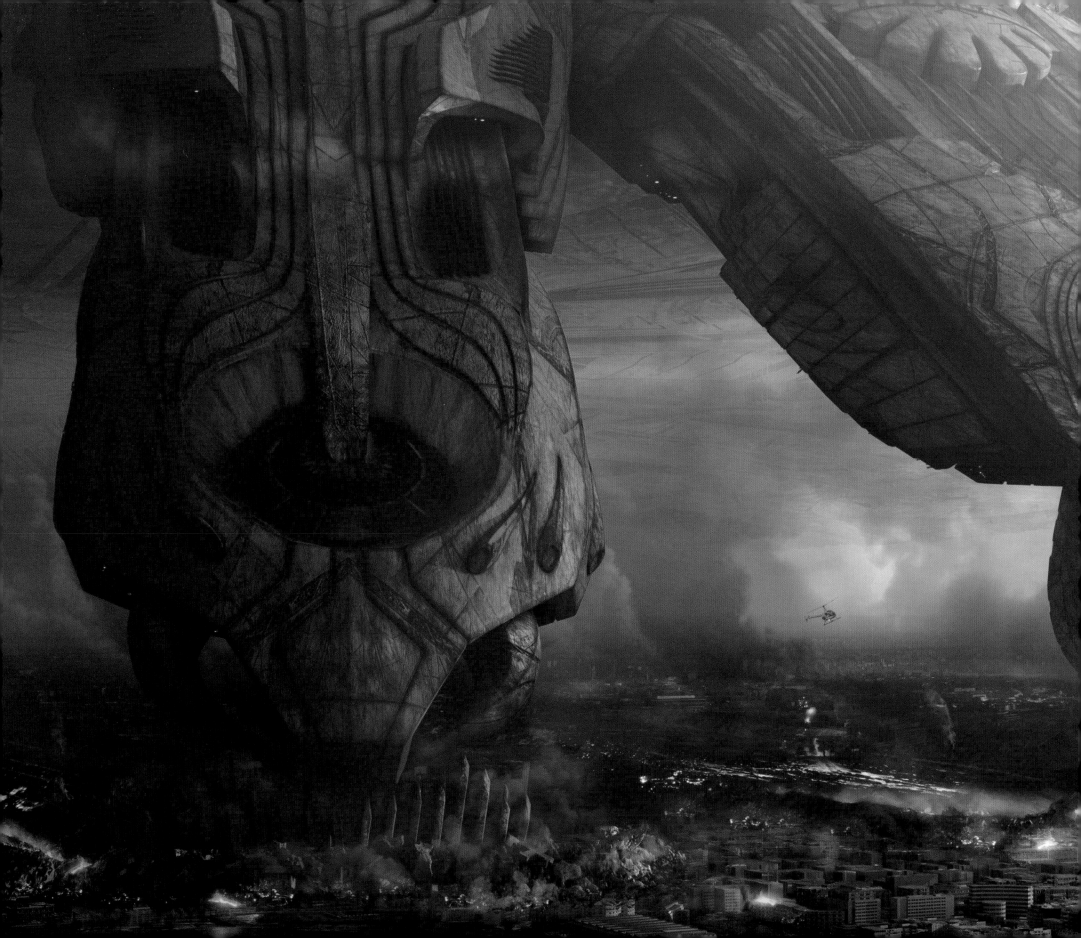

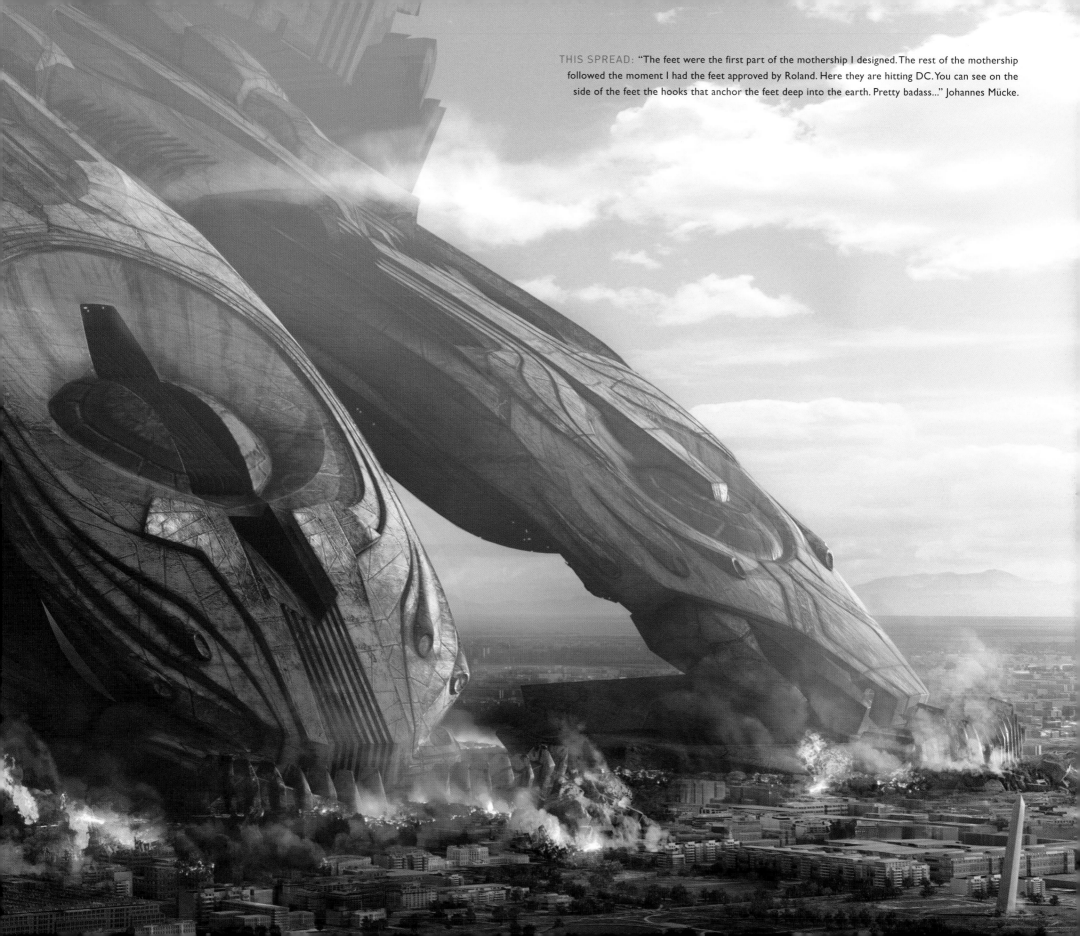

THIS SPREAD: "The feet were the first part of the mothership I designed. The rest of the mothership followed the moment I had the feet approved by Roland. Here they are hitting DC. You can see on the side of the feet the hooks that anchor the feet deep into the earth. Pretty badass..." Johannes Mücke.

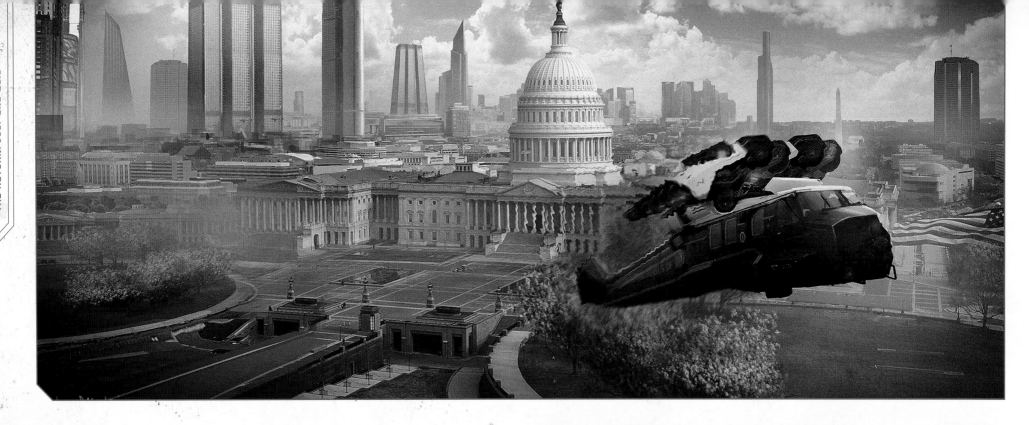

WASHINGTON

The climax of the mothership's arrival is when the one of its feet comes to a stop in the United States capital. The slightest mention of 'Independence Day' and 'Washington' brings the destruction of the White House to mind – it is a historic cinematic moment. *Resurgence* is well aware of the significance and chose to address it in the most direct – and audience-friendly – way.

Johannes Mücke describes his research for the design and how inspiration for the biggest ship came from the smallest insect. "I came up with an idea for how these feet would actually look. I saw microscopic images of the feet of a fly, which look so stunning. If you imagine those at the size they are in the movie it becomes breathtaking. Not only does it have an absolutely intricate and fantastic structure to look at, it's also super-logically built. It is made for the fly to latch on glass and walls and everything, plus little hooks on the side to grab onto a sphere. And we said, imagine that, the foot digs in the earth, grinds over Washington and then it smashes these gigantic hooks in, how about that? To that point in the script it was written, 'This time we do not destroy the White House.' That was kind of the joke, the foot stops just exactly in front of the White House. And Roland said, 'Okay, you know what we do: the foot smashes in, stops in front of the White House…pause…then out comes the hook…bye-bye White House!' He was so excited about that, like a little kid. I have just built a giant sandcastle and tomorrow I'm going to destroy it! It was hilarious, it was so fun to watch."

ABOVE LEFT: DC in a last calm moment after 20 years of peace.
ABOVE RIGHT: "When Roland was deciding where to place the second foot that would land in the US, he said it had to be Washington, for sure." Johannes Mücke.
BELOW CLOCKWISE FROM TOP LEFT: The mothership foot coming to a stop before the White House; the feet grinding through the earth as the ship slows; deep grooves cut into the land; an early version of the hook that latches on, here opening out; the size of the ship compared to the US capital; early concept art showing the foot sending out its ramp-like hook.

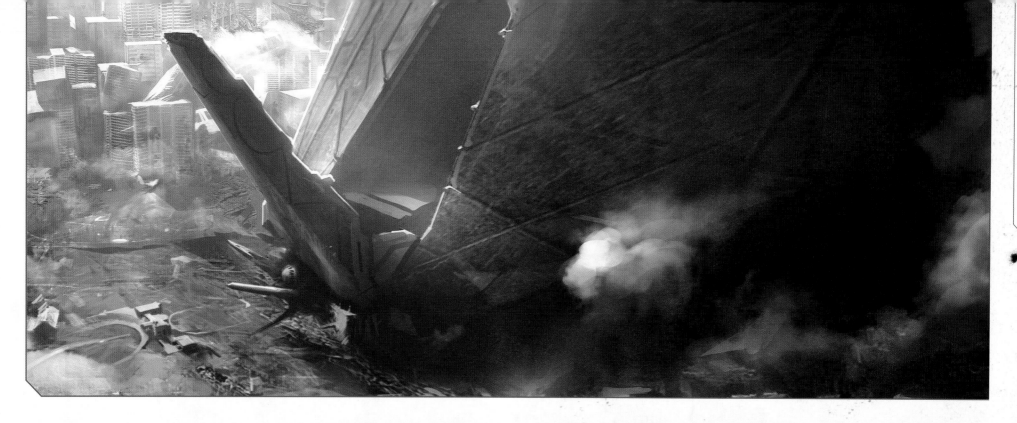

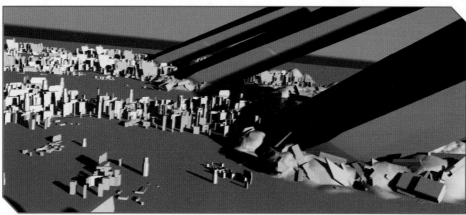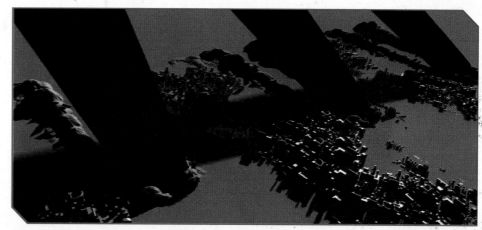

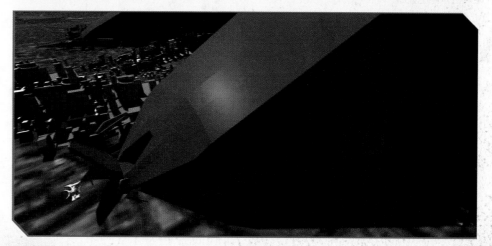

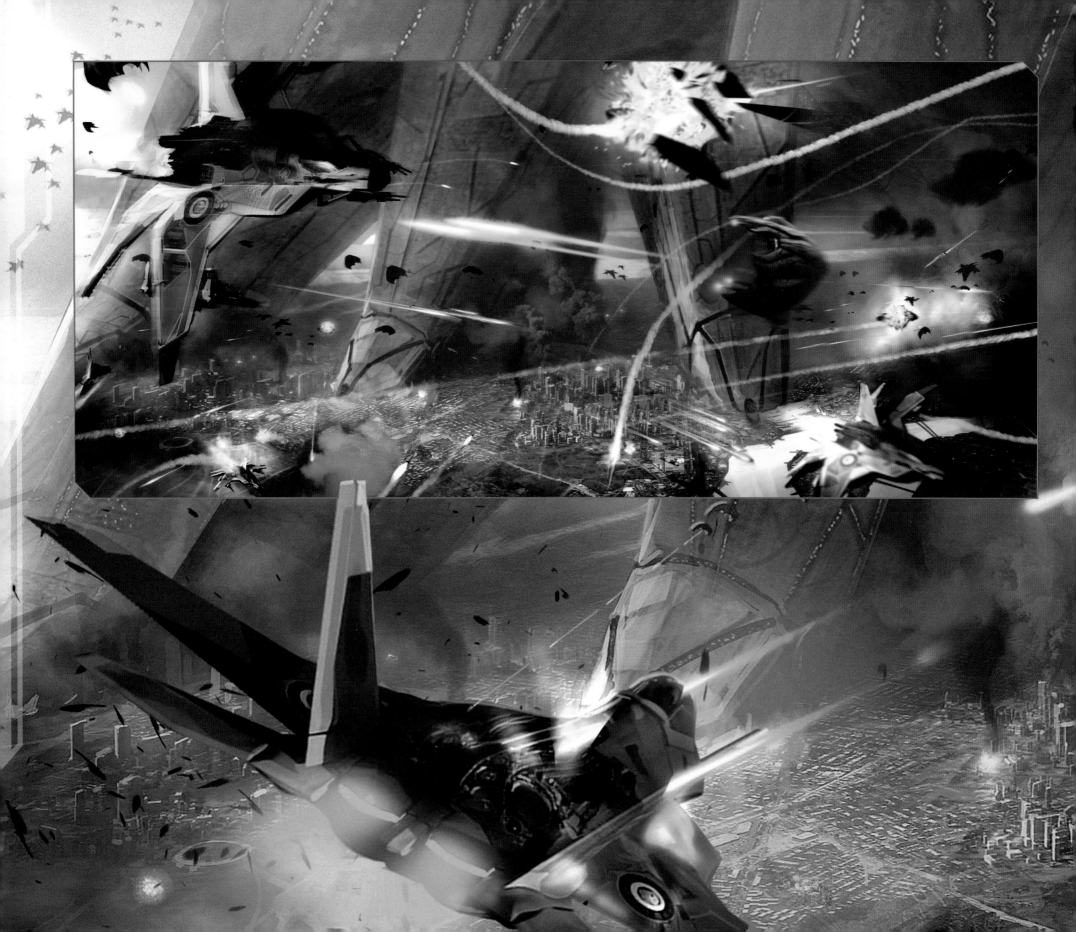

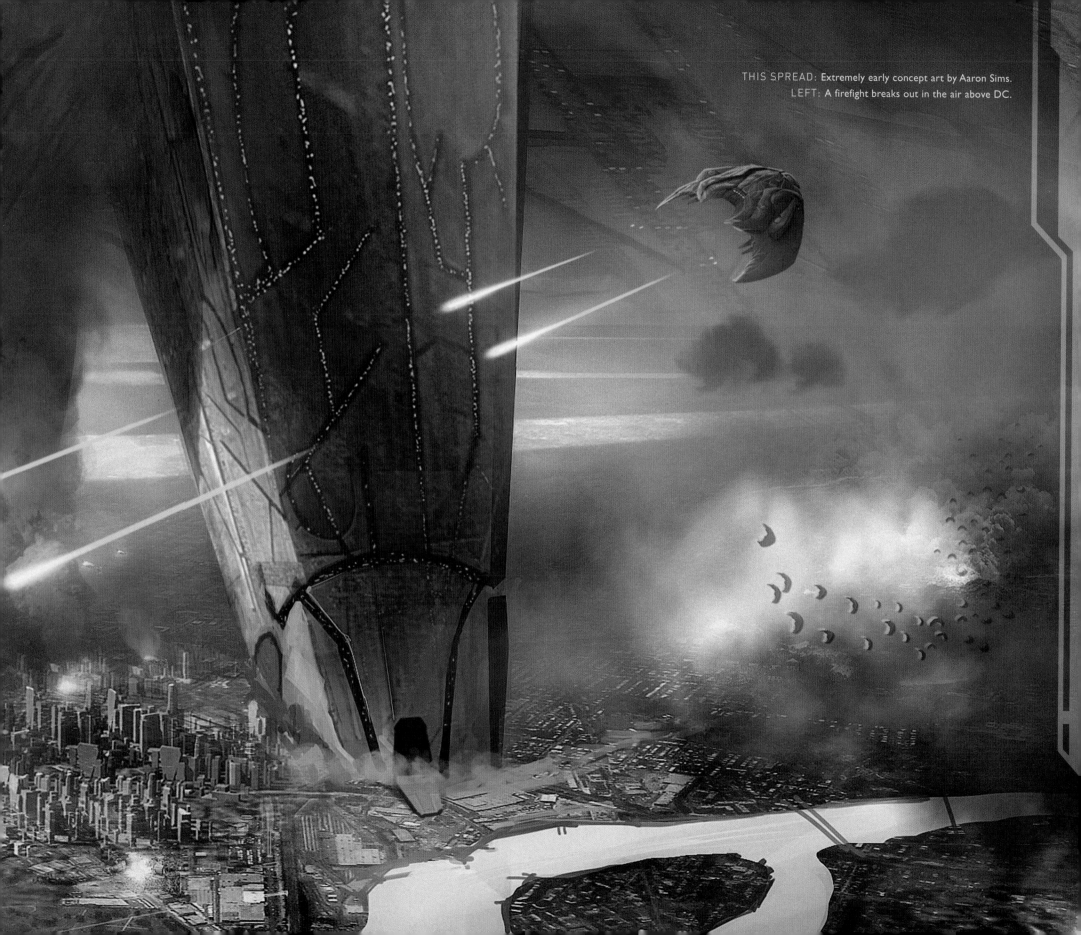

THE OFFENSIVE

After twenty years' preparation, the moment mankind hoped would never come has arrived. "The old generation has been telling the young generation: if you work hard, train, and learn, we can beat them. The young believe them – we can do this," explains Emmerich. "Then the aliens come back, overpower us, and make us the underdog all over again."

The rebuilt cities are gone, the new technology is all but ineffectual, but everyone is still there and still surviving. In the fallout from the attack, everyone regroups at Area 51, including Dr. Okun, who snaps out of his coma to rejoin the fight. He begins inspecting the AI brought to him by Levinson, while Jake, Dylan, Rain, and Charlie lead the counter attack on the mothership.

"They built a replica cockpit that had all the gadgets and switches a normal jet would have, but way more technologically advanced," remembers Jessie Usher. "I would fly this simulated plane with bluescreen all around, with [co-writers] Nick, James, and Roland telling me through the speaker system what's going on, and directing all the camera moves. We flip, we fly all around the world, barrel rolls, up into space, and the cameraman is there. We did a lot of rehearsals, then we got it down."

OPPOSITE: "The pilot inside the plane has a very comfortable interface, and it does have certain things in common with the modern F35 in that they can see certain information that relates to the outside of the plane." Mark Yang, vehicle concept designer.

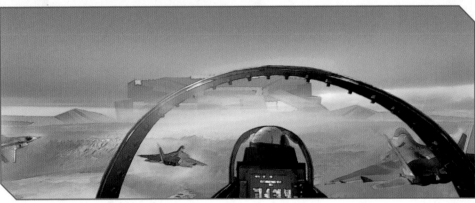

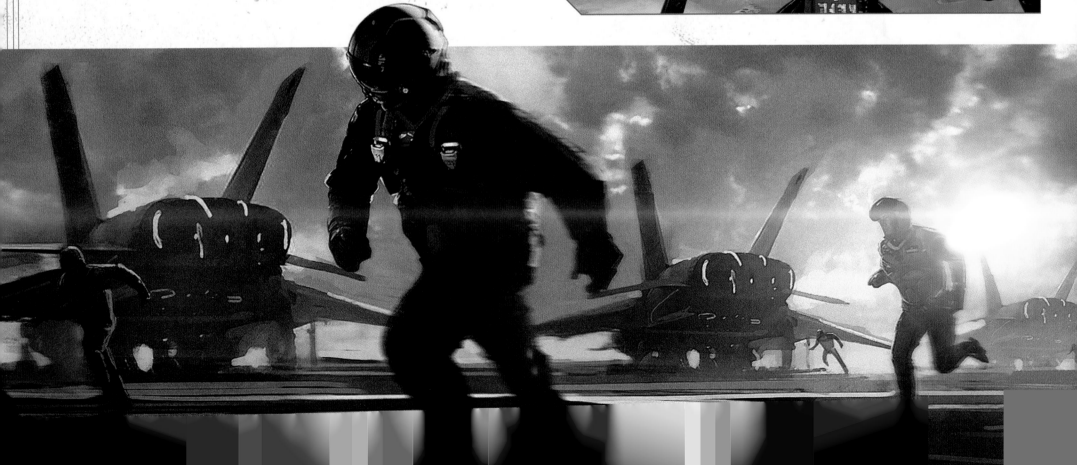

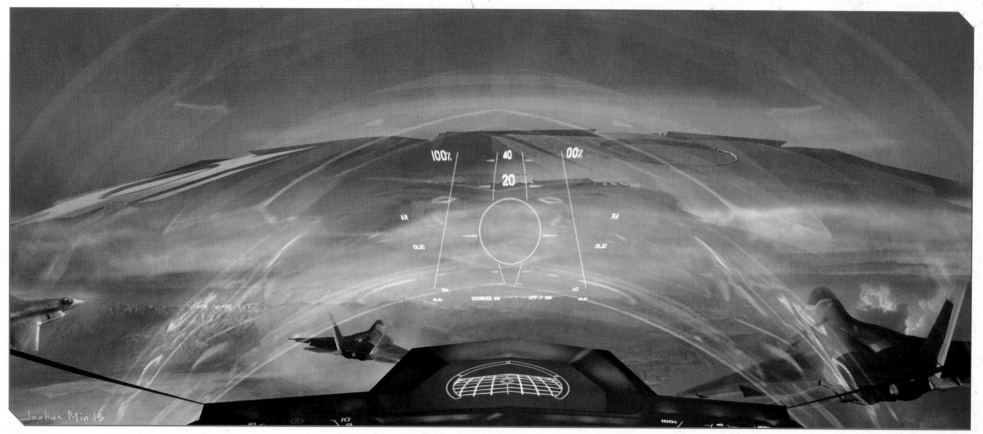

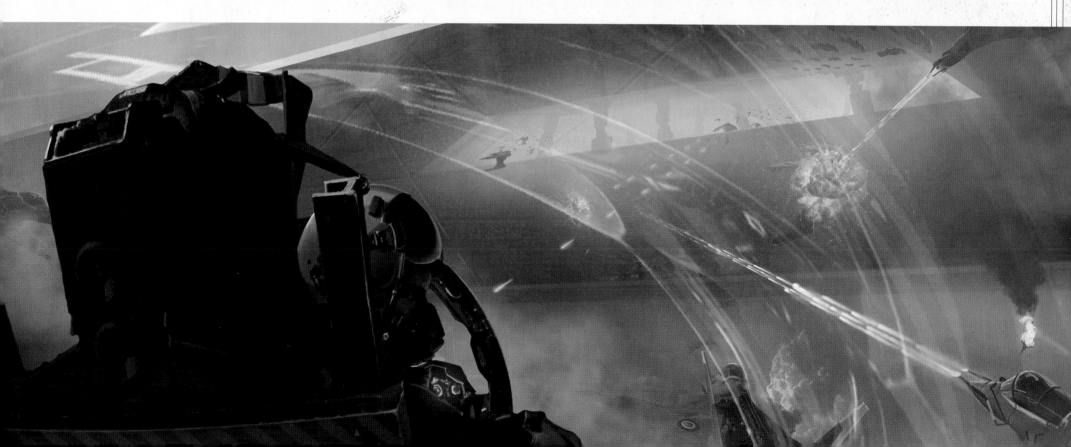

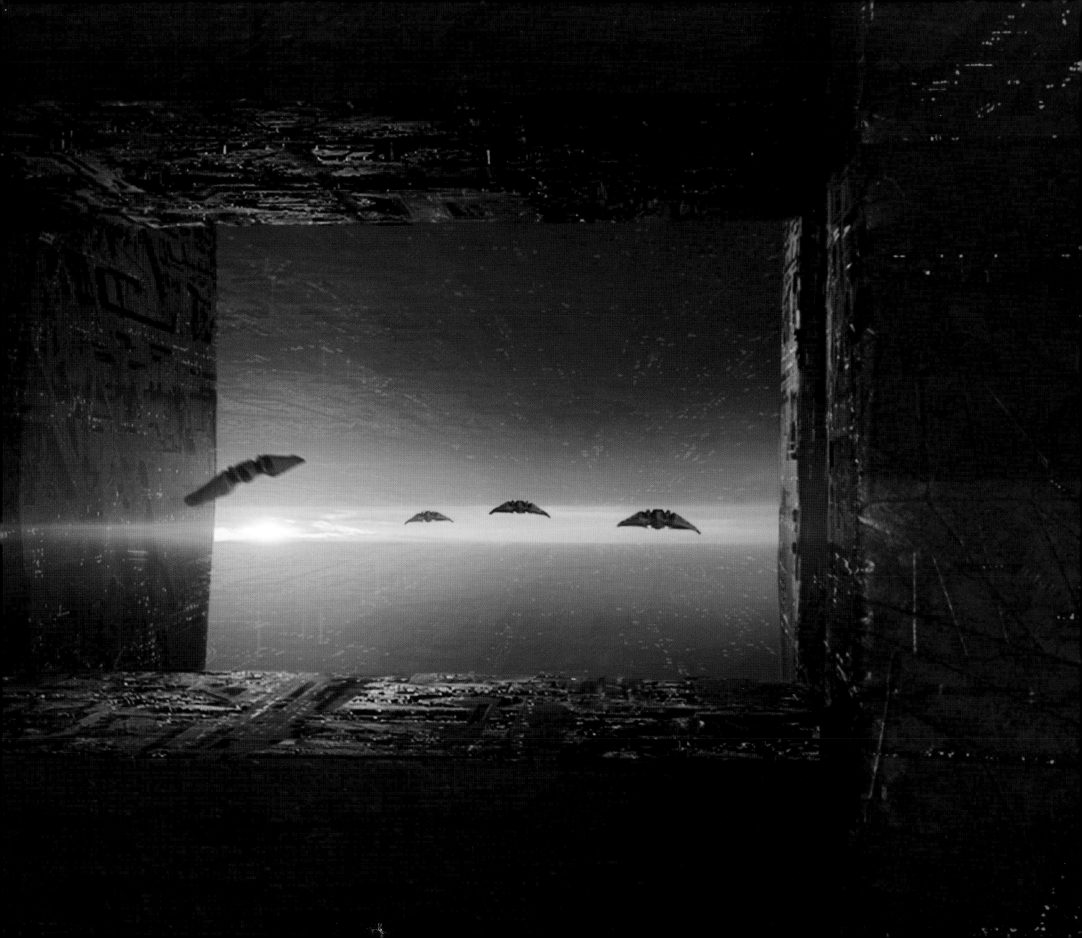

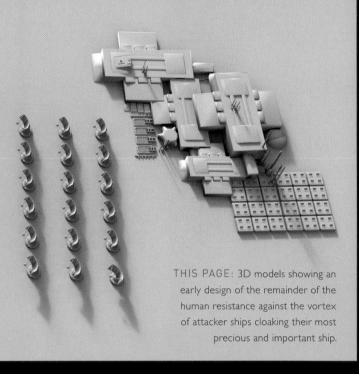

EARLY CONCEPT OF THE ATTACK

In two decades, the filming of aerial fights and action sequences has changed greatly, in both scale and technology. The counter attack leads to an incredibly high-altitude dogfight, with the human forces pushing the invaders all the way back to the mothership. Which is exactly what the aliens want.

"The attack on the mothership was an exciting moment for Jake," says Liam Hemsworth. "It's the first time he gets back into a jet and they get overrun by the power of the alien invasion… their technology is even more advanced now and they have the upper hand."

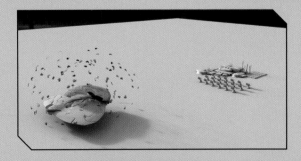

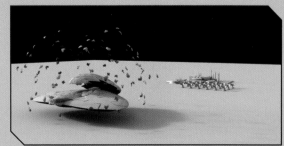

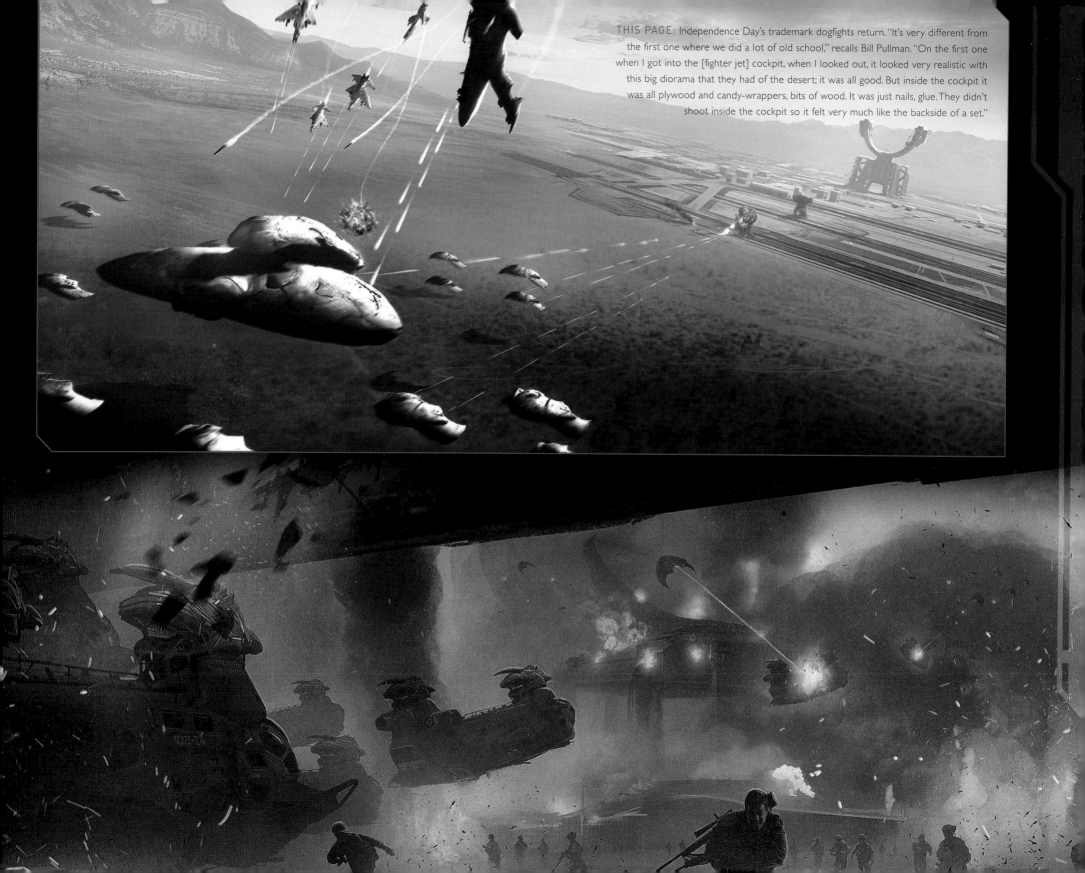

THIS PAGE: Independence Day's trademark dogfights return. "It's very different from the first one where we did a lot of old school," recalls Bill Pullman. "On the first one when I got into the [fighter jet] cockpit, when I looked out, it looked very realistic with this big diorama that they had of the desert; it was all good. But inside the cockpit it was all plywood and candy-wrappers, bits of wood. It was just nails, glue. They didn't shoot inside the cockpit so it felt very much like the backside of a set."

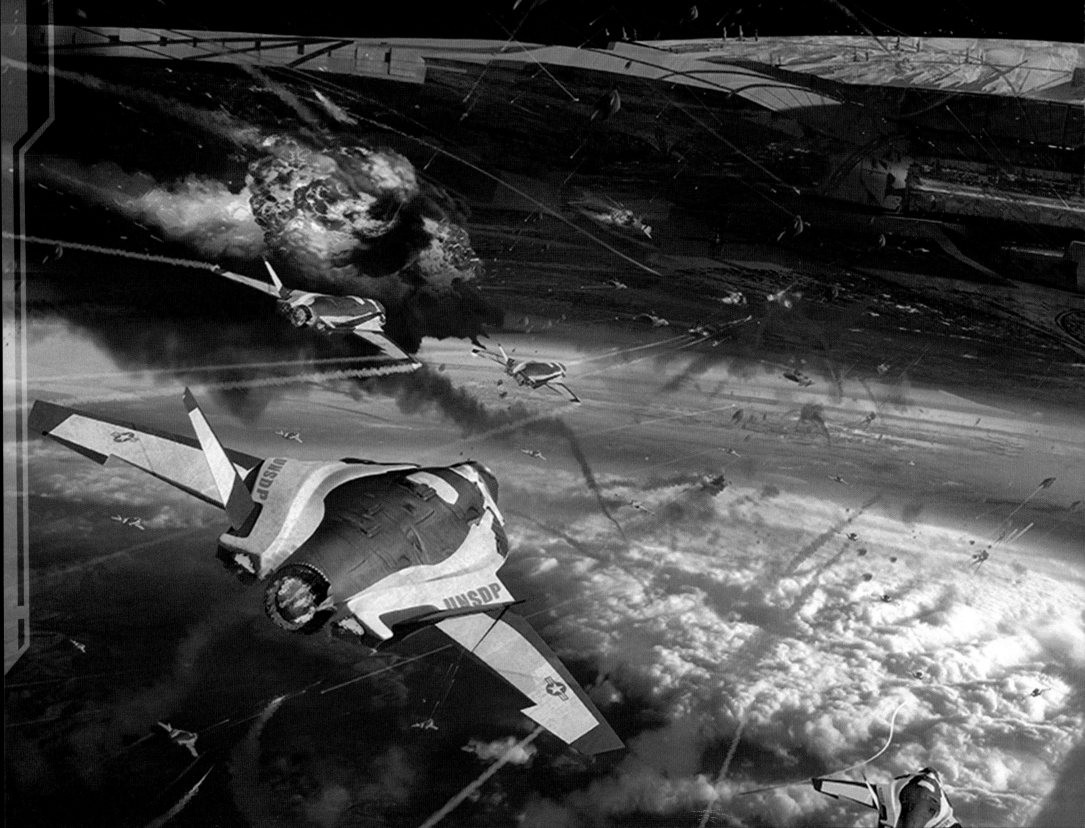

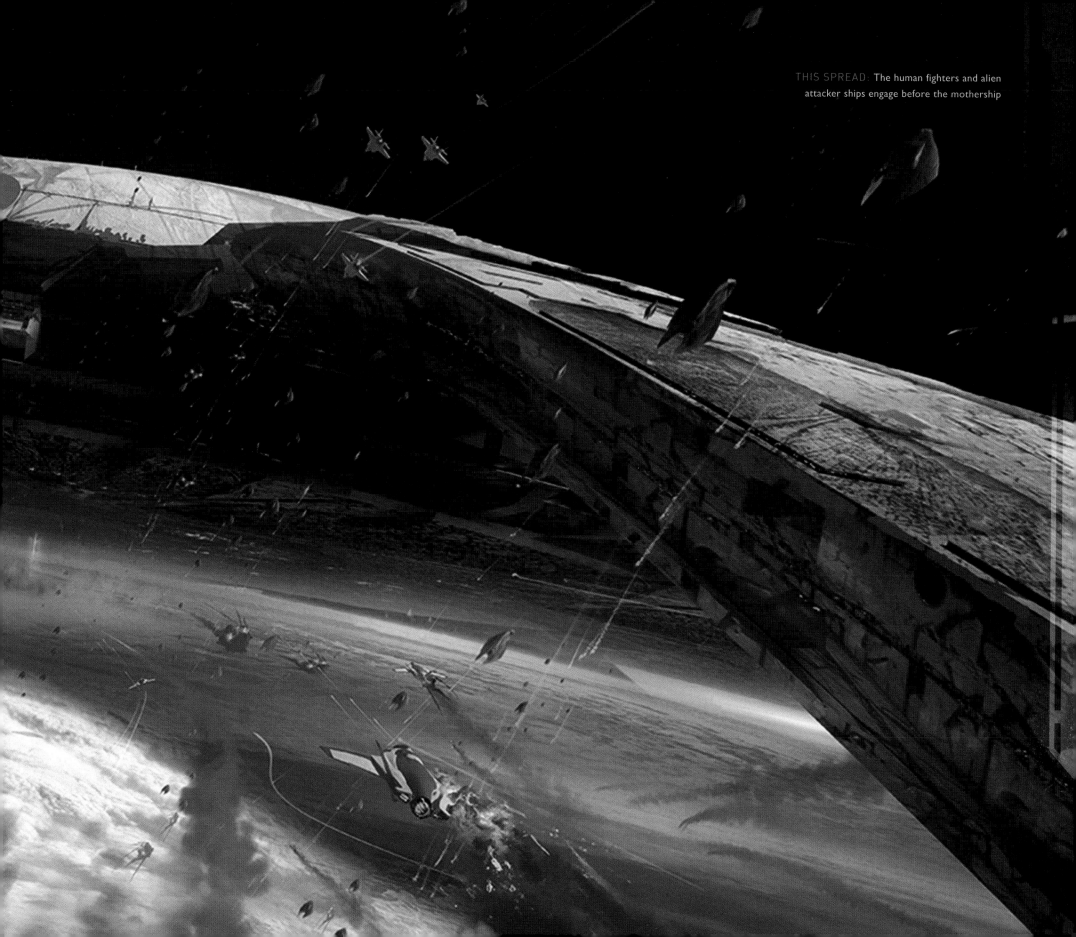

THIS SPREAD: The human fighters and alien attacker ships engage before the mothership

INSIDE THE MOTHERSHIP

When the ESD hybrid fighters find themselves in the depths of the mothership, that is when they also find themselves most vulnerable. Their trump card is quashed, and the downed pilots find themselves on the run in the strange, hostile heart of the alien craft.

The closest look yet at the alien life and environment, "a cathedral" is how Johannes Mücke describes it, hundreds of feet high. Whereas "really weird" is Jessie Usher's choice of words, with his instructions on how to perform when Dylan crash lands in a swamp neatly summarized as, "Go down, don't get found, crawl around, get scared." The habitat on the ground level is like a jungle, a tangle of weeds with beautiful but threatening flora, showing us a level of detail only hinted at previously.

"We went back and looked at the original area, which is this hangar where Will Smith and Jeff Goldblum's characters docked, and if you look down you get a kind of far away idea of what it can look like – kind of like you're standing on the edge of a cliff looking down a valley, but in this movie you actually get to go inside it," explains Mark Yang.

He continues, describing the focal point of the interior, which the characters must journey towards if they are to escape. "They're kind of like control towers, and they also have a lot of machinery that regulates the habitat. The towers are massive, like miles and miles into the air, and every one of those towers is essentially a base, like a mini Area 51 just stationed there. The characters have to climb up a tower and hijack a ship. It's a huge air-base with lots and lots of ships, some of them have gone off to shoot humans and some are still around, but within the base there's support staff and all these groups. You get to see what happens when they come across humans for the first time – eyeball to eyeball as opposed to the first movie where you see just one guy, you get to see a ton of aliens who see these humans running around their base, and they're just, like, 'What are they doing down there?'"

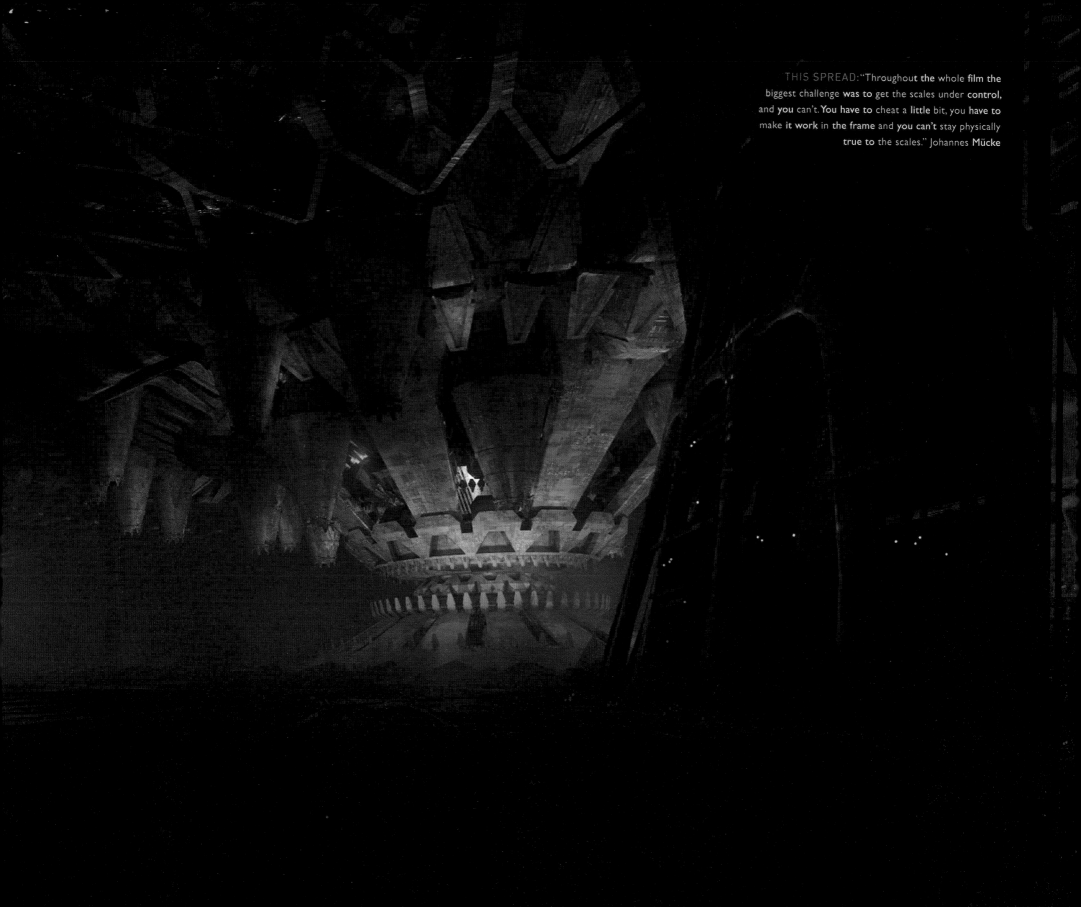

THIS SPREAD: "Throughout the whole film the biggest challenge was to get the scales under control, and you can't. You have to cheat a little bit, you have to make it work in the frame and you can't stay physically true to the scales." Johannes Mücke

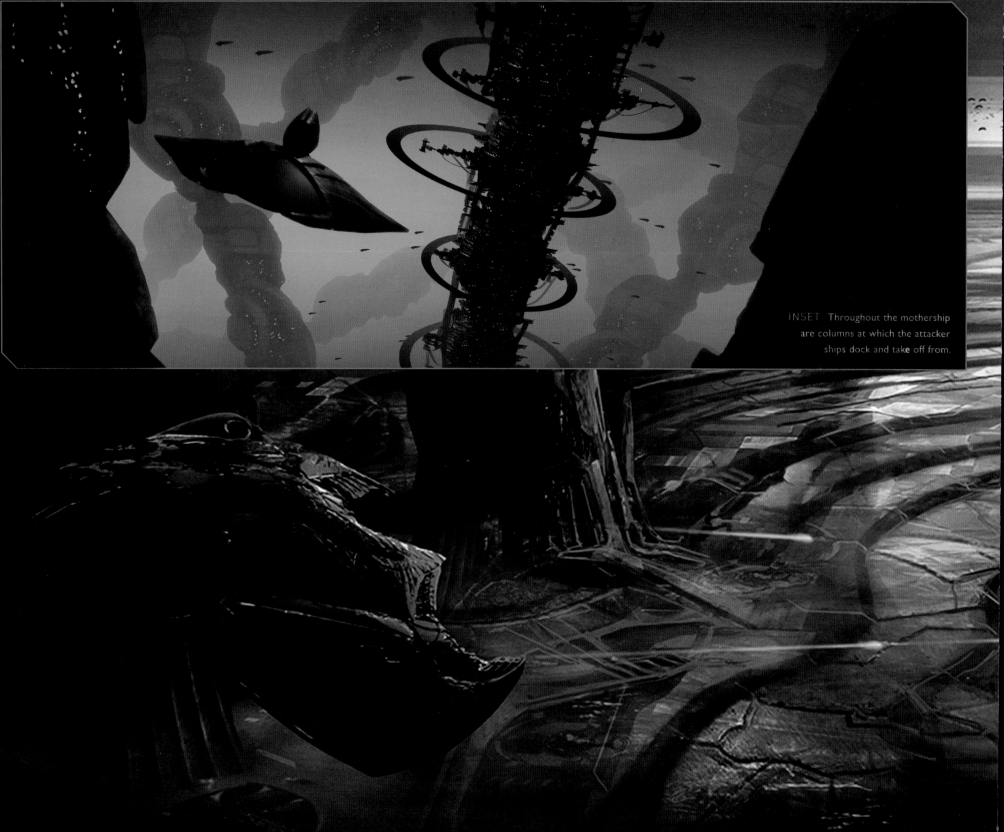

INSET Throughout the mothership are columns at which the attacker ships dock and take off from.

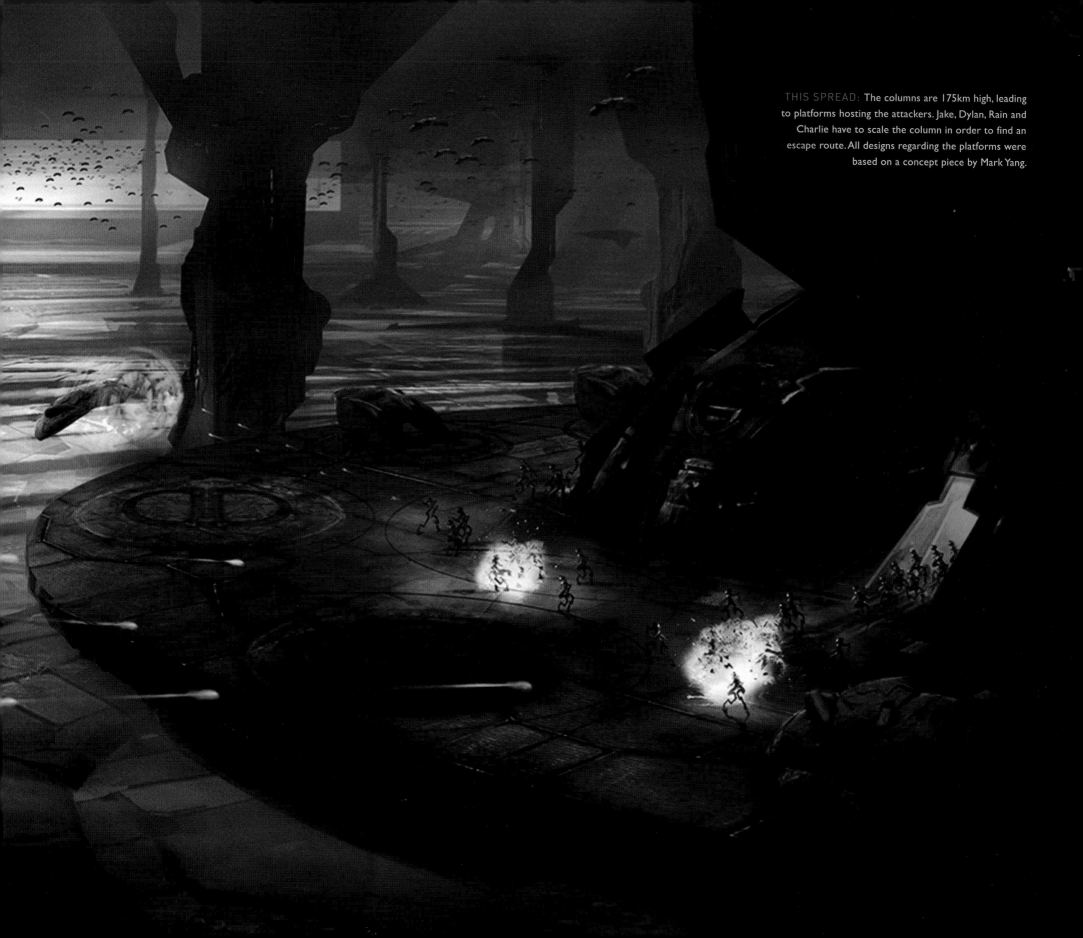

THIS SPREAD: The columns are 175km high, leading to platforms hosting the attackers. Jake, Dylan, Rain and Charlie have to scale the column in order to find an escape route. All designs regarding the platforms were based on a concept piece by Mark Yang.

ALIEN HARVESTER

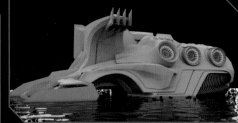

The mothership isn't really a ship; it's a world. All aspects of the alien civilization are present: military, social structure, transport, communications hubs, and the alien form of agriculture. As the aliens grow their own technology, they need to cultivate the crops, and eventually harvest it, ready to mould it for their uses.

Inside the mothership are giant fields where the plants grown. The harvester is a drone, not piloted, acting like a wheat harvesting robot. It is one of the first things the survivors encounter when they crash land. Unlike the actual aliens, the harvester isn't briefed to destroy the humans, but they may end up as collateral damage as this deadly machine slices through the fields.

"Our first design of the harvester was based on Steve Burg's sketches," explains Mücke. "I envisioned it as a super-menacing cutting machine with hundreds of blade – slightly inspired by a nightmare I had years ago. We later added the humungous trailer where the conveyor belt transports the greenery. Roland advised we make it as big as possible, his exact words being: 'You guys in Vienna never think big enough.'"

BELOW: After abandoning his hybrid jet and descending into the fields, one of the humans finds himself caught by his parachute on the harvester. He is just visible, dangling on the left of the machine.

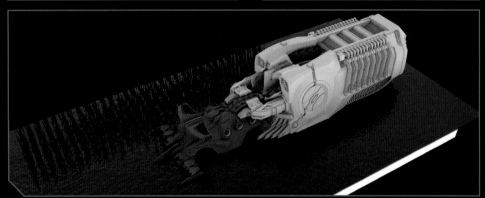

ABOVE: Variations of the harvester moving over the water, with and without a trailer catching the crops.

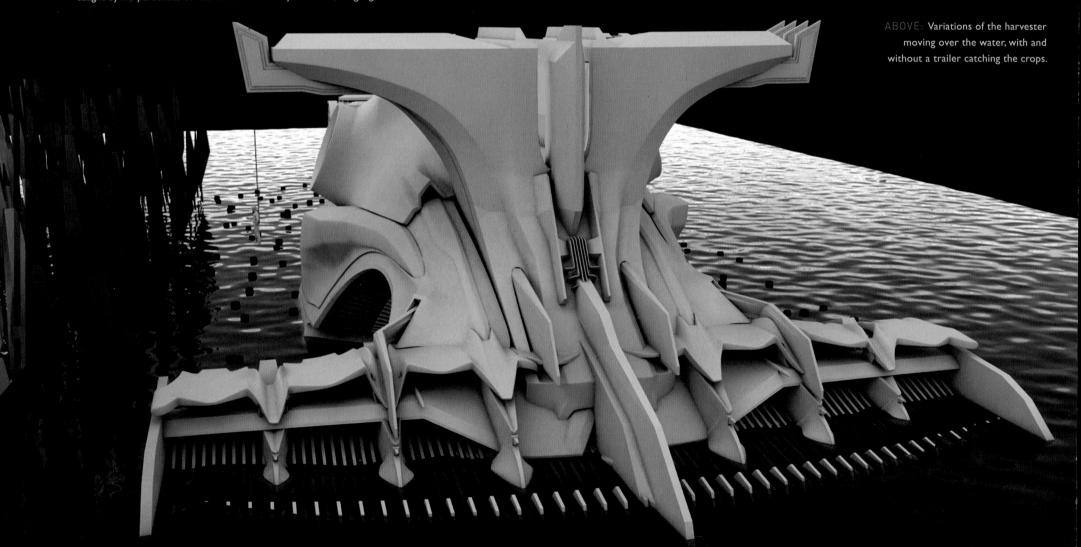

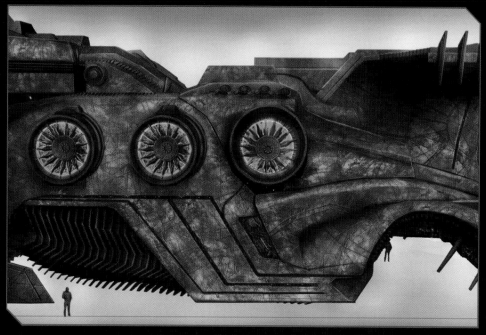

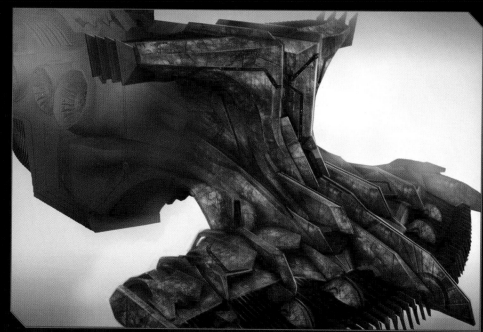

ABOVE LEFT: Scale drawing versus an average-sized man.
ABOVE RIGHT: The harvester has no wheels but moves forward with many slim, wave-like moving legs, like krill.
RIGHT: The large circle design on the side of the machine is a motif repeated throughout the alien technology.

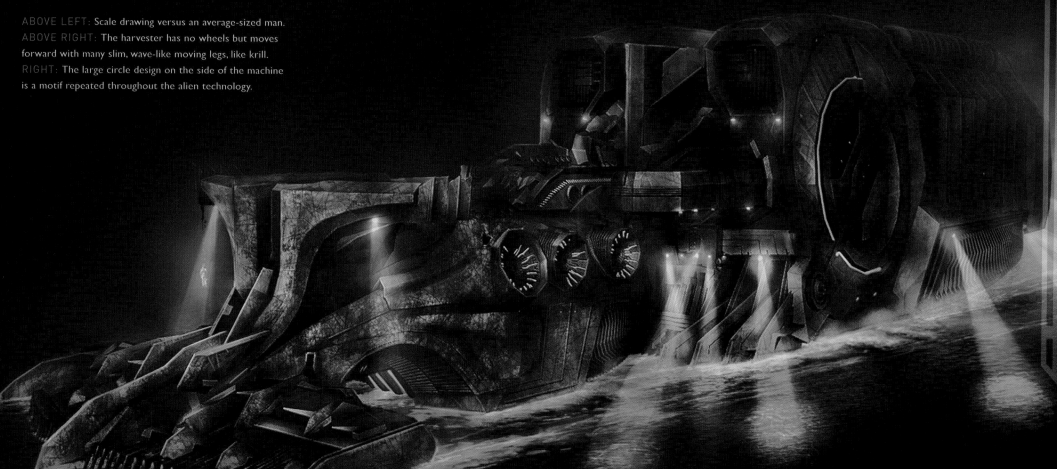

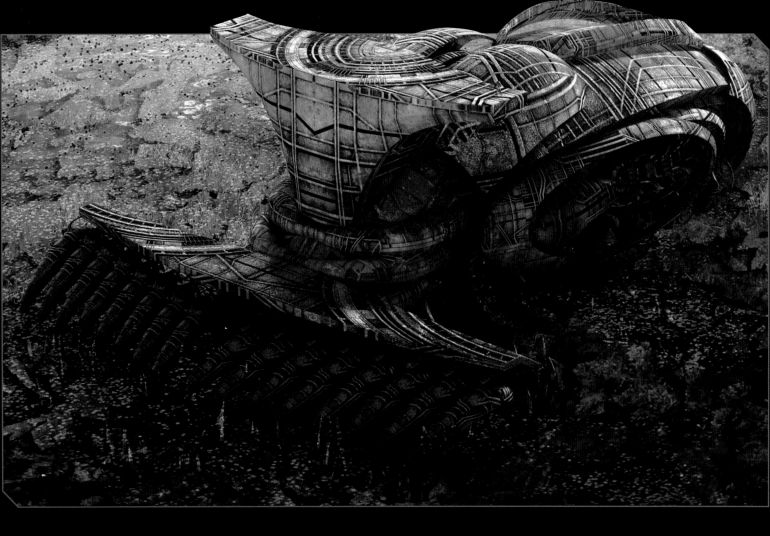

The harvester isn't an anonymous machine drifting through the scene without purpose; it provides a moment of drama and incident for the humans, and adds richness to the tangible alien world. Everything on screen in Resurgence has to earn its place there, nothing is superfluous or surface dressing.

"Once you come up with a functional explanation or something that makes sense to Roland, he's in," details Mücke. "If it's an imagined reason, it's fine, too, but if 'it kind of looks cool' it doesn't count. You will never be able to sell that to him."

And so it goes for the whole geography of the mothership interior. The craft needs to be the size it is to latch onto Earth and draw out the Earth's core. It needs to house a vast, functioning populace and accompanying technology. It needs to be big.

"The interior of the Mothership is as big as North America and you never realize that," states Mücke. "You talk about, okay, they're inside this ship and everybody has a feeling of how it will look. Then you realize, it's a planet. You're on top of a planet and can't see the ceiling. You have to wrap your head around that and make design decisions: okay, if it were true it would be like this, but let's find a way to make it work in-camera."

An integral piece that needed to be accommodated was the behemoth-esque ship belonging to the film's centrepiece villain: the queen. Within the mothership, and for literal and symbolic reasons placed right in the highest echelons, is her craft where she is based and protected. "It's like a ship's bridge," says Mücke, "except that it's detachable and flies on towards Area 51."

Aaron Sims elaborates: "Her ship is really just a disc. There's the big mothership then there's the queen's ship on the top and it pretty much mirrors a disc, a flying saucer. The inside is really dark, there's a hole in the bottom where you can go into it, that's how she leaves and how she gets into the ship. But it's basically a really dark, cavernous area with screens around it and her harness that helps her navigate and move around the entire inside of the ship. There's another part, in the ceiling, where her suit is, that opens up and the suit comes out and she gets into it. It's so dark inside there that it's mainly for you to see the alien screens, a little bit of her silhouette, and lights here and there, but the idea was to keep it dark, scary and menacing. You're not going to see that much detail inside. It's so big that there'd be atmosphere in there, haze, because of that fact that the size she is, her ship is almost like a small city."

For the majority of the film, the queen is bathed in shadow, revealing herself only at the film's climax.

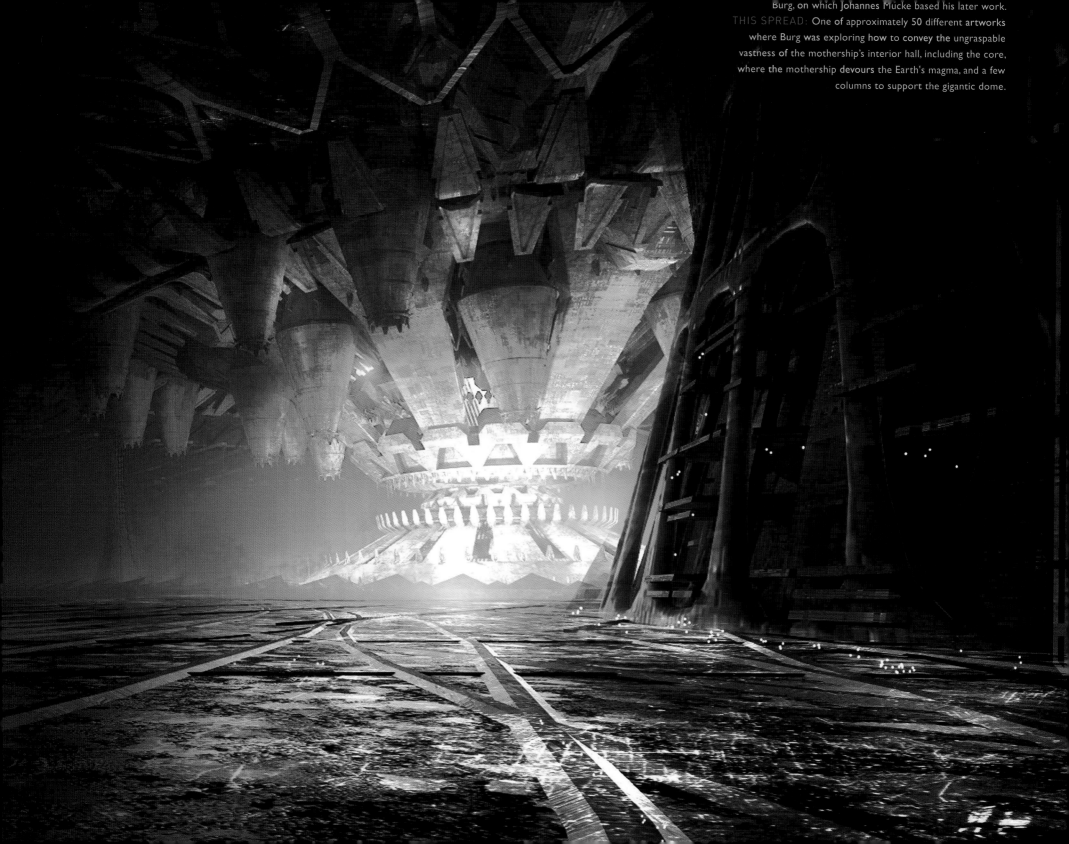

ALIEN QUEEN

The logic of the aliens resembling an insect social strata is followed to its terrifying conclusion: a queen. She has hunted across the galaxy to find planets like ours, which the aliens are methodically working their way through and draining of all resources. Our planet is the only one to have ever defeated them – inciting the queen to take matters into her own tentacles. In the colossal showdown it is her versus what remains of mankind, its resources, and willpower.

Looming at over 200-feet tall, the queen is the biggest by necessity. "She's the big, unique element of this film and the one that we went through so many iterations and so many variations," recalls Aaron Sims. "It came back to changing the design based on the story – what she had to do, what her purpose was. She's the queen and these are the soldiers. Like in the ant world, they all work based on her. Even how in the first movie, it was all connected to the big ship in space. Once they destroyed that all the other ones couldn't really function as they were all connected. So I think that was an overall theme, the way they all worked, the way that the aliens worked, followed her.

"We created egg sacs," continues Sims. "She was the one that was creating these aliens, she gave birth to them, so they're almost – it falls again into the insect world. There were a lot of designs. As much as that may not be incorporated into the final film because it wasn't as important story-wise, there was that aspect in the design of how her anatomy would look, having a big egg sac; how do you make that? How do you make that look different from anything else that's been done?"

Her presence, her form, her function, and the implications of her are visible immediately. The threat she poses is clear, and if mankind is going to survive, bringing down the ship isn't going to be enough this time.

THIS SPREAD: Concept art showing the queen within her ship, and meeting terrified humans.

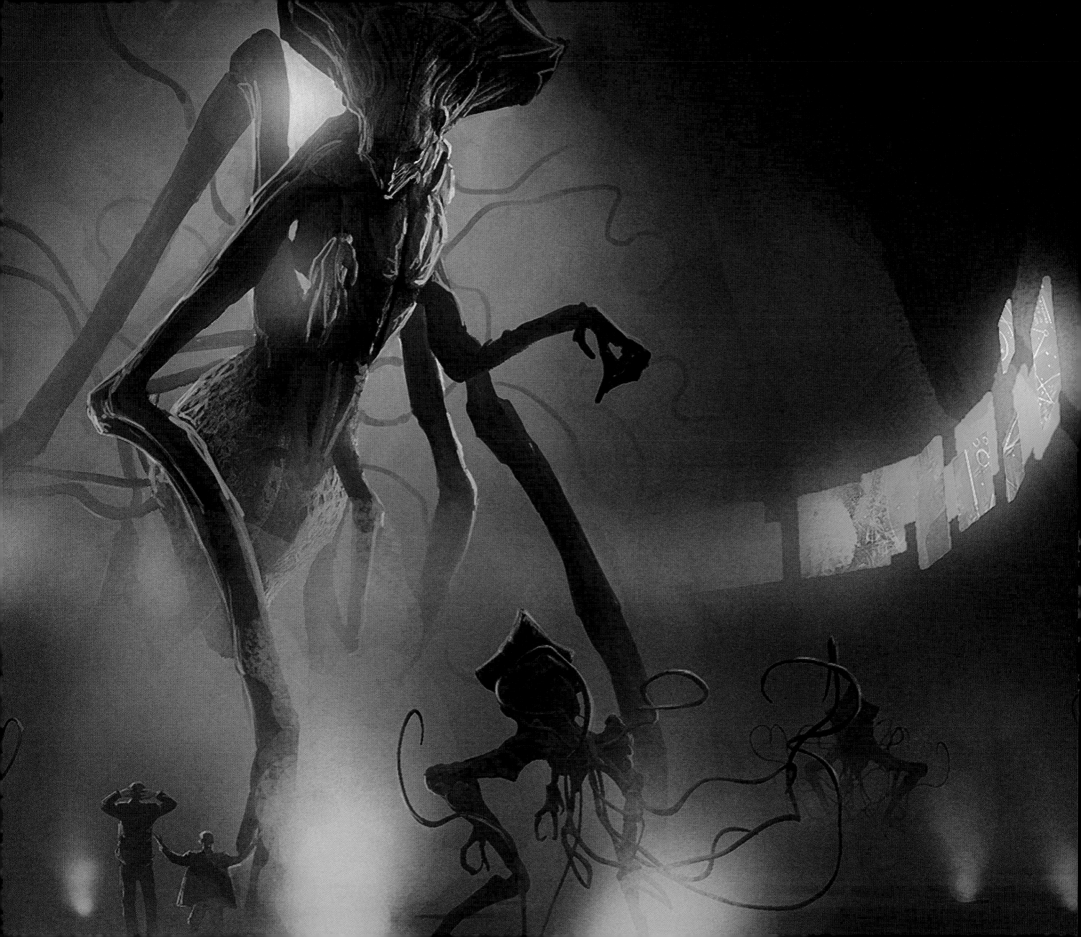

The movie is epic in every way: In scope, in ambition, in design. The stakes have never been higher, and our heroes will have to call on every weapon and tactic to defeat her and prove that 'resurgence' applies not to the aliens returning but to the human spirit. "People who love the first one, get ready," declares returning designer Patrick Tatopoulos, who worked on some early ideas before Sims developed them, "this is bigger. Giant. Bringing the queen to Earth is massive, she has to have a scale that justifies the enormous mothership. Roland does big stuff, and he shows us how these massive ships and this queen translates to our world."

It has to work within the context and reality of the film, which means bringing a genuine weight and physicality to the established rules; Standing out as a unique visual idea, but akin with the fictional world.

"She's huge, she's gigantic," says Sims. "The size of the Empire State Building or something like that. So I think there was an idea of: How do you make that look huge in the design and not feel like it would crush itself with sheer weight? You have to defy, somewhat, logic and gravity and everything like that because you have to make her look menacing. The logic of something that's that big would probably have a lot of bottom weight opposed to top weight. She had a lot of top weight, then thinner at the bottom, but to distribute the weight she had multiple legs that supported her. It made her very different to the soldiers or the colonists in that respect. She basically had an upper torso with arms and she had a back torso with a lot of legs, in some ways spider-esque. It created an interesting look then also they all had a basic through-line as far as the overall look: The skin, even the shape of her head had the same iconic shape that Roland created in the first movie. But that was her outer suit; with the inner part she was something unique.

"We needed to actually have her do a lot of stuff, like move very fast even though she's huge. Because of the sheer scale of her, she wouldn't have to move that fast. But to chase the bus we played around with her jumping, leaping, from one area to the next to get in front of our heroes, to cut them off. Just to make it more interesting, but also we had to design something in her suit that would look and make sense that she could actually do that kind of movement. So we're thinking how would the back legs work? Like a cricket or something similar. They're larger to give them that momentum to move up. But you're still dealing with a weight so huge that when it comes down it's going to disrupt all the earth around it and could possibly crush itself, so part of that the logic is that she has her own force field around her. It would also protect her from being fired upon, much like the mothership."

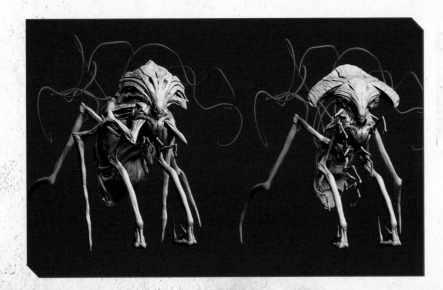

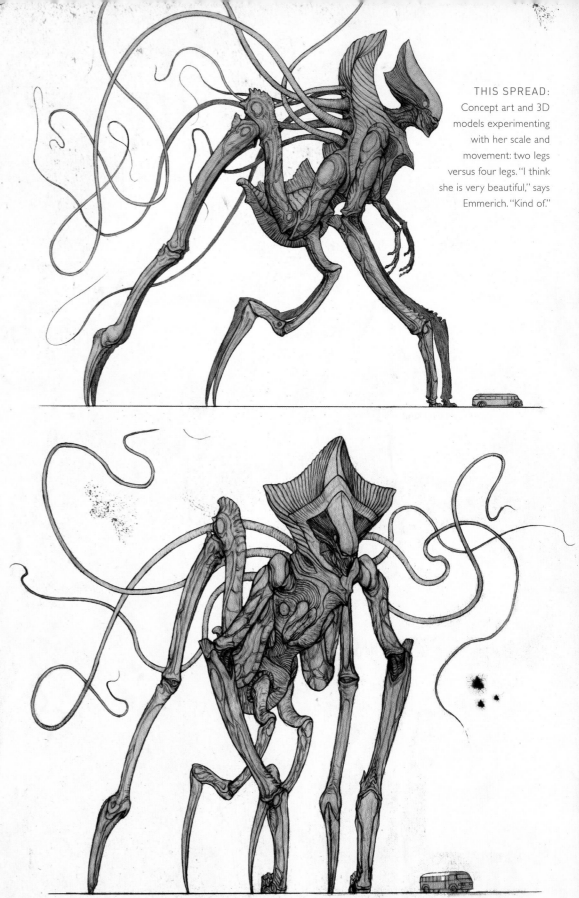

THIS SPREAD: Concept art and 3D models experimenting with her scale and movement: two legs versus four legs. "I think she is very beautiful," says Emmerich. "Kind of."

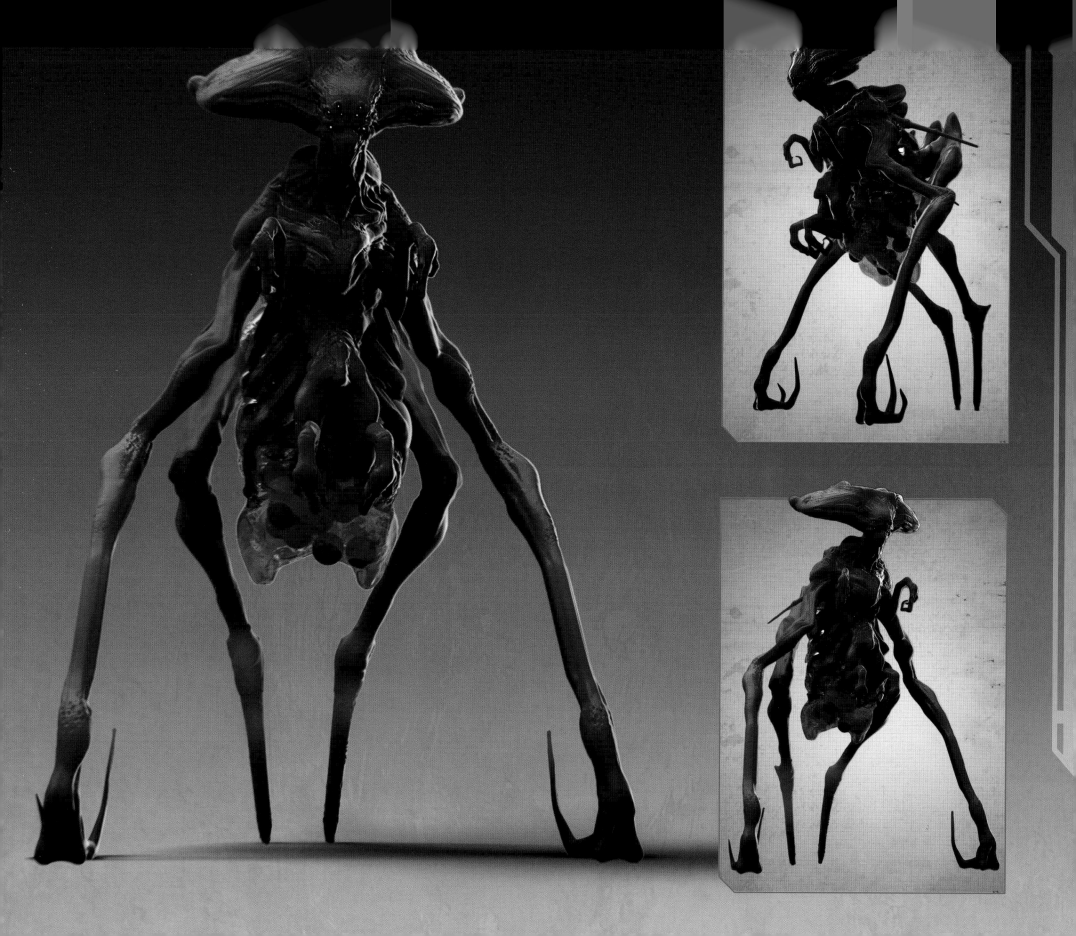

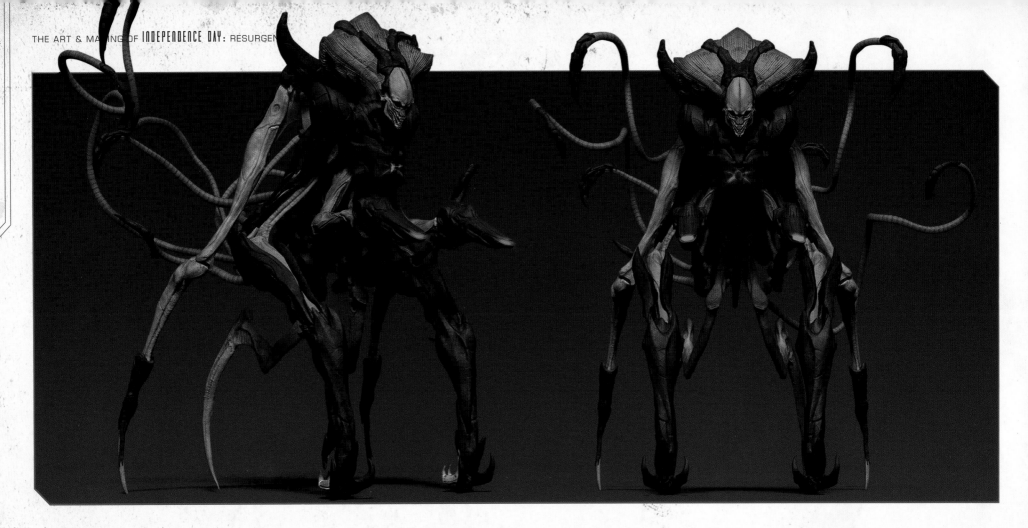

Drawn to Area 51 by Levinson, Okun, and the rest of the survivors in the hope of trapping and defeating her, it is clear that they have never faced anything like her before. Nothing of all their one score years preparation could have prepared them. And as she strides across the desert, the full extent of her capabilities become apparent.

"She has her own weapons," explains Sims. "The soldiers have their own guns that are on their back but would mechanically come forward and they can grab it. Roland really liked that so we did something similar with the queen but it comes from underneath, in the chest cavity. It would come out and she could grab it with both hands if she needed to. In a lot of ways it's like a sci-fi Gatling Gun. She would just cause disaster with this constant spray of lasers."

To do justice to this ultimate adversary many artists, including Weta Workshop, worked closely with Emmerich, redrawing, adding in VFX and animation cycles to accurately frame her in the shot, as well as refining all aspects of her personality, making her not just an alien but a *character*.

"She's the only one that has a mouth. Not that she actually speaks or anything like that, since they're all telekinetic," Sims continues. "For her it was more for the sheer terror and uniqueness. When you have a character [like her] you want to be able to emote something in the face and go through anger and it's difficult when there is no mouth. That was kind of a Roland decision to help illustrate these moments when she's frustrated. The tentacles were a great way of creating emotion as well. They're frantic, they stir up, and when she's really pissed you hear her screech and they just go crazy. So they had that purpose but she also used them for killing characters – grabbing them, swiping them. So they became another appendage as well. Those are the ways of using the tentacles as another appendage as opposed to them just being there for design or as an extra appendage that has no purpose."

"The tentacles are in scale to her 200 ft height," elaborates Barry Chusid. "A lot of time is spent on: Are they scaled, are they round, are they transparent, can you see them pulse, can you see things moving through them, are they solid, do they taper – how much- do they double-prong at the end, when they move do they snap? When she gets mad do they get darker, do they get harder? We try to refine all those things to make them unique to the circumstance. Roland, he's the writer and the director, and as the thing evolves he has that ability to make those little adjustments."

"She is all," is how the aliens describe her. "She's a killing machine," concludes Chusid. "Don't cuddle up to her."

ABOVE: "One of our first designs with her was she'd have these two guns that would come out and she'd grab them but it started feeling like a cowboy. I thought it was kind of fun but Roland went with the one big gun that comes out from underneath and she grabs it. It has a handle and she's able to spray things. It's probably the size of a skyscraper." Aaron Sims

BELOW: "The mouth had a purpose, the tentacles had a purpose, the multiple legs helped with keeping the weight distributed correctly when she's running around. Every aspect had to have a purpose." Aaron Sims.

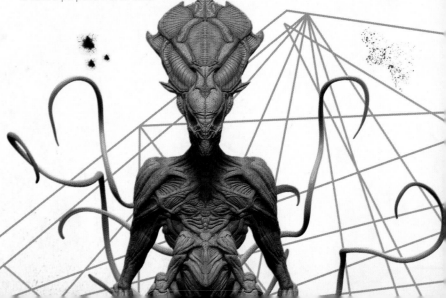

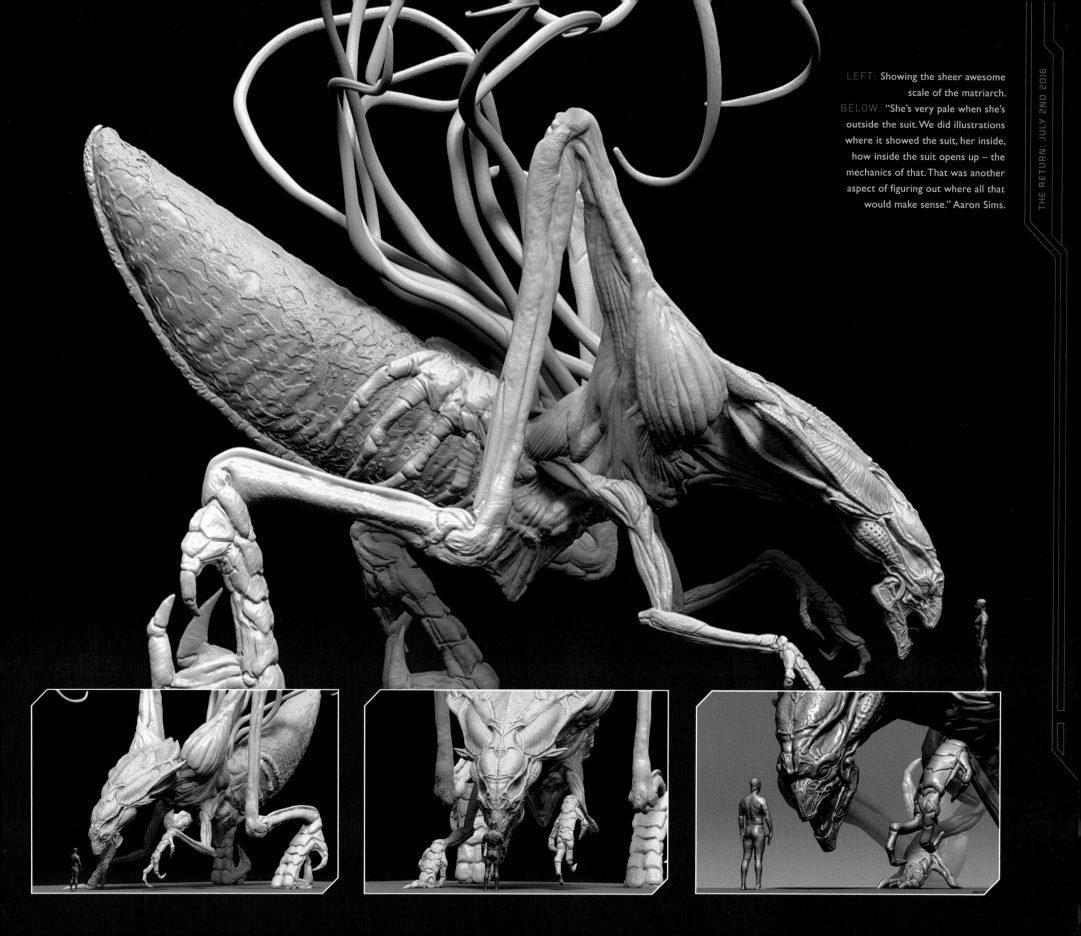

LEFT: Showing the sheer awesome scale of the matriarch.
BELOW: "She's very pale when she's outside the suit. We did illustrations where it showed the suit, her inside, how inside the suit opens up – the mechanics of that. That was another aspect of figuring out where all that would make sense." Aaron Sims.

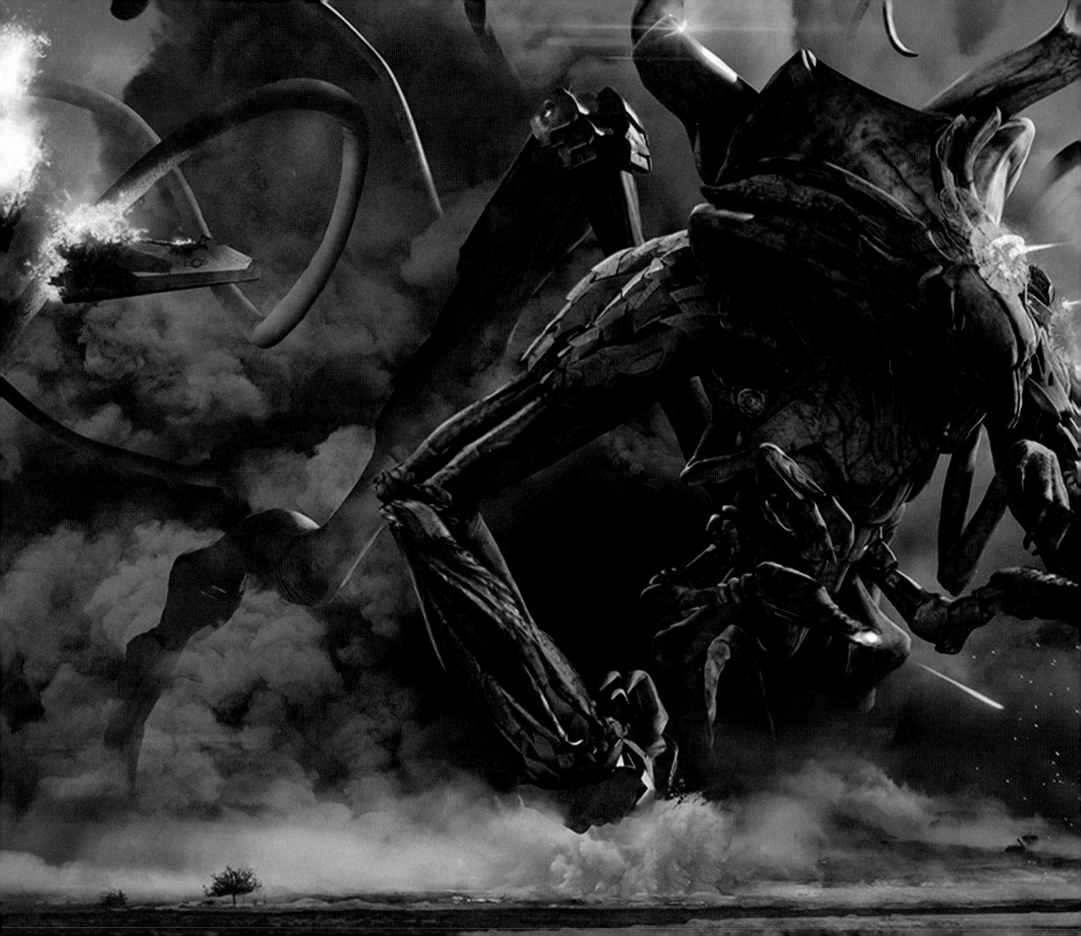

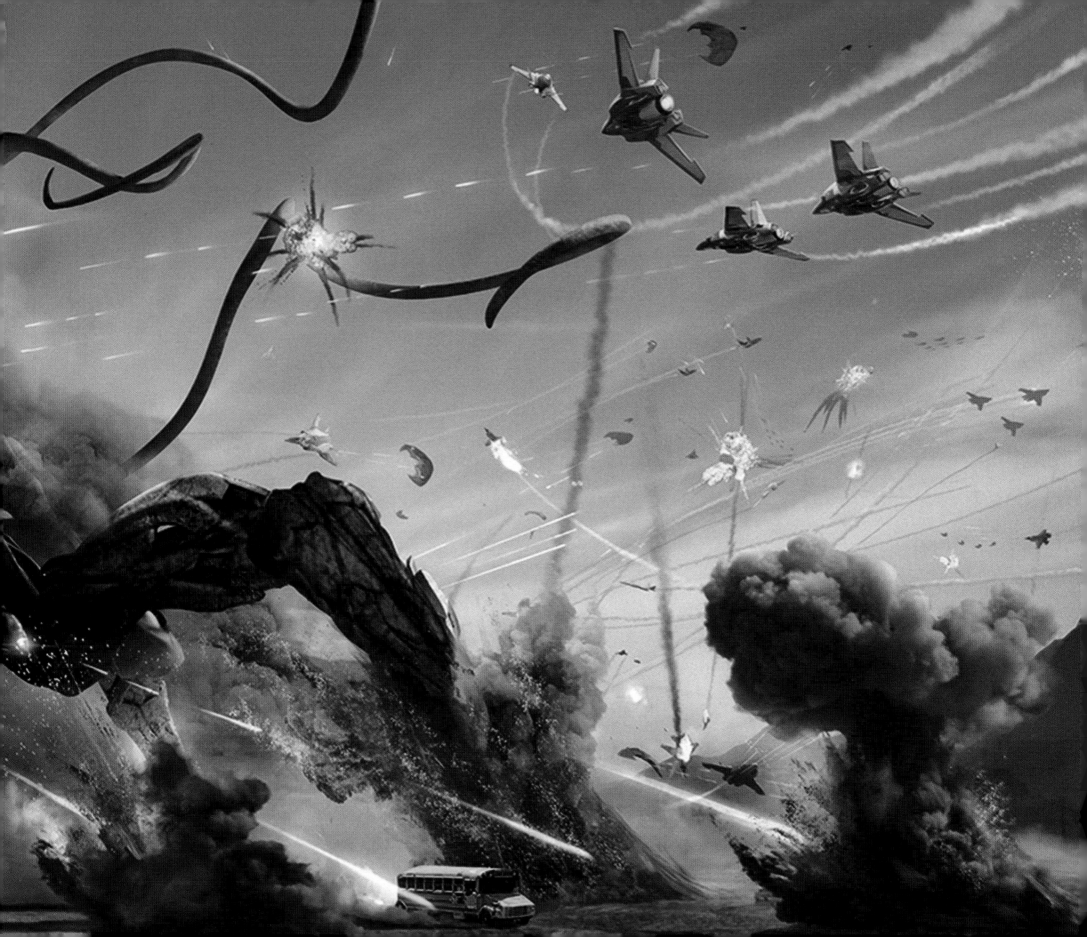

AFTERWORD

The fat lady has not sung.

They came back. They crashed our party. We had 20 years to prepare, but it still wasn't enough. Once again, they almost destroyed us. This time their Queen came with even bigger and stronger firepower than before and razed our cities to the ground – or, more accurately, raised our cities to the sky and then the ground. Our new technology, our defences, meant nothing. They were too many, too fast, too strong. And they're not locusts, they're parasites.

It was old fashioned equipment and tactics that saw us through. As well as bravery: allies I am proud to call friends worked together, selflessly, to protect us. Jake, Dylan, Patty, Catherine, Dikembe, (and, I guess, Floyd) as well as the countless others all stood against the invaders.

Because we still believe Earth is worth saving; life is worth preserving. I can try, but I can't phrase this as well as my good friend did. And there is nothing I can truly say to honour him, except:

Thomas J. Whitmore, we will always remember you for your sacrifice, courage, and, most importantly, your humanity.

Dad, I'm glad you've got the grandkids I could never give you. Please, please, please don't write another book.

I don't know if this planet will survive another attack, but what we've learnt is that there is more at stake than just our Earth. The galaxy, the universe, is under threat. Okun has told us we may have to journey farther than we ever have before. There are more queens to be defeated, more battles on a greater scale than we could have possible imagined. And greater possibilities for knowledge and hope than we have ever been offered are out there, waiting for us.

We must find our future. And fight for it.

David Levinson,
Cable repairman, Director ESD, chess wizard, human

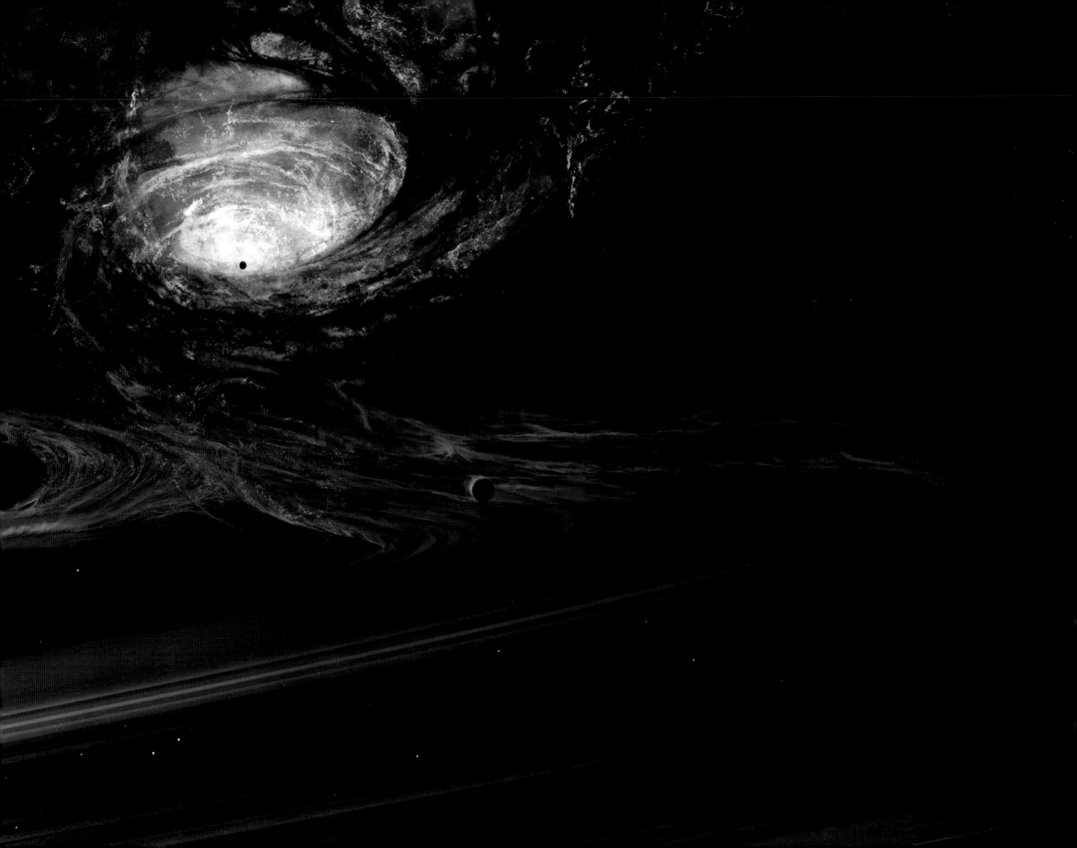

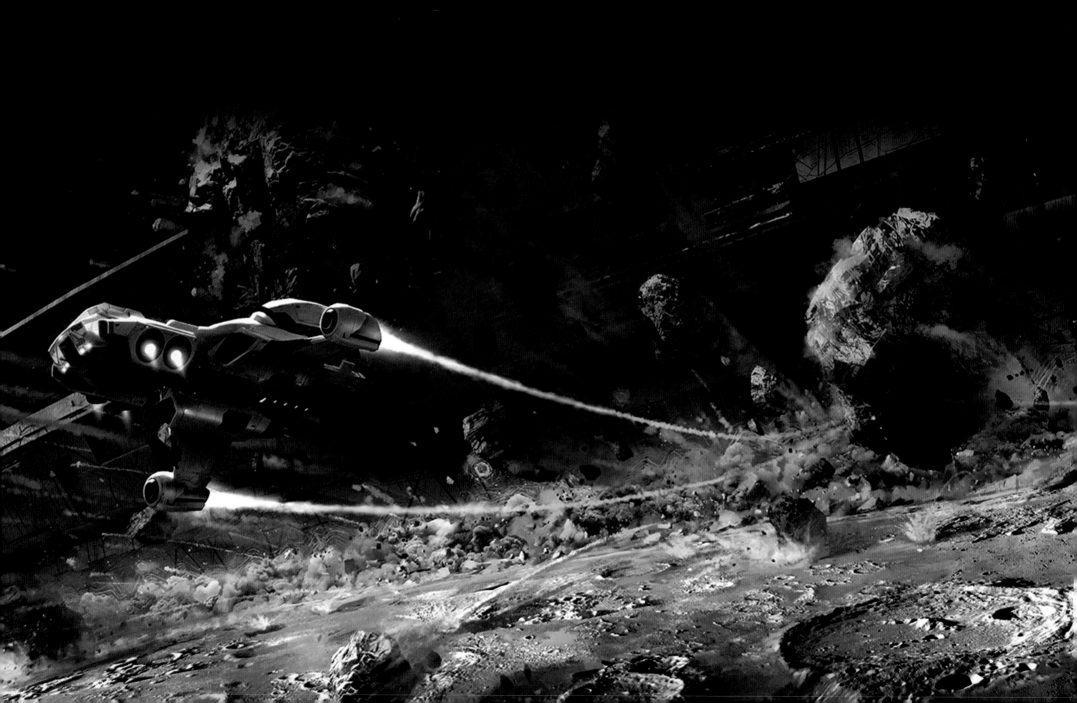

ACKNOWLEDGMENTS

THE AUTHOR WISHES TO THANK BETH LEWIS, CAMERON CORNELIUS, AND LAURA PRICE AT TITAN BOOKS, AS WELL AS JOSH IZZO AND NICOLE SPIEGEL AT FOX. THIS BOOK WOULD ALSO NOT HAVE BEEN POSSIBLE WITHOUT THE HELP OF MARCO SHEPHERD AT CENTROPOLIS AND ALL THOSE WHO GAVE UP THEIR TIME FOR INTERVIEWS. SPECIAL THANKS GO TO VOLKER ENGEL FOR HIS DEDICATION AND ENTHUSIASM FOR THIS PROJECT AND LASTLY, A HUGE THANK YOU TO ROLAND EMMERICH FOR MAKING SUCH AN INCREDIBLE MOVIE.

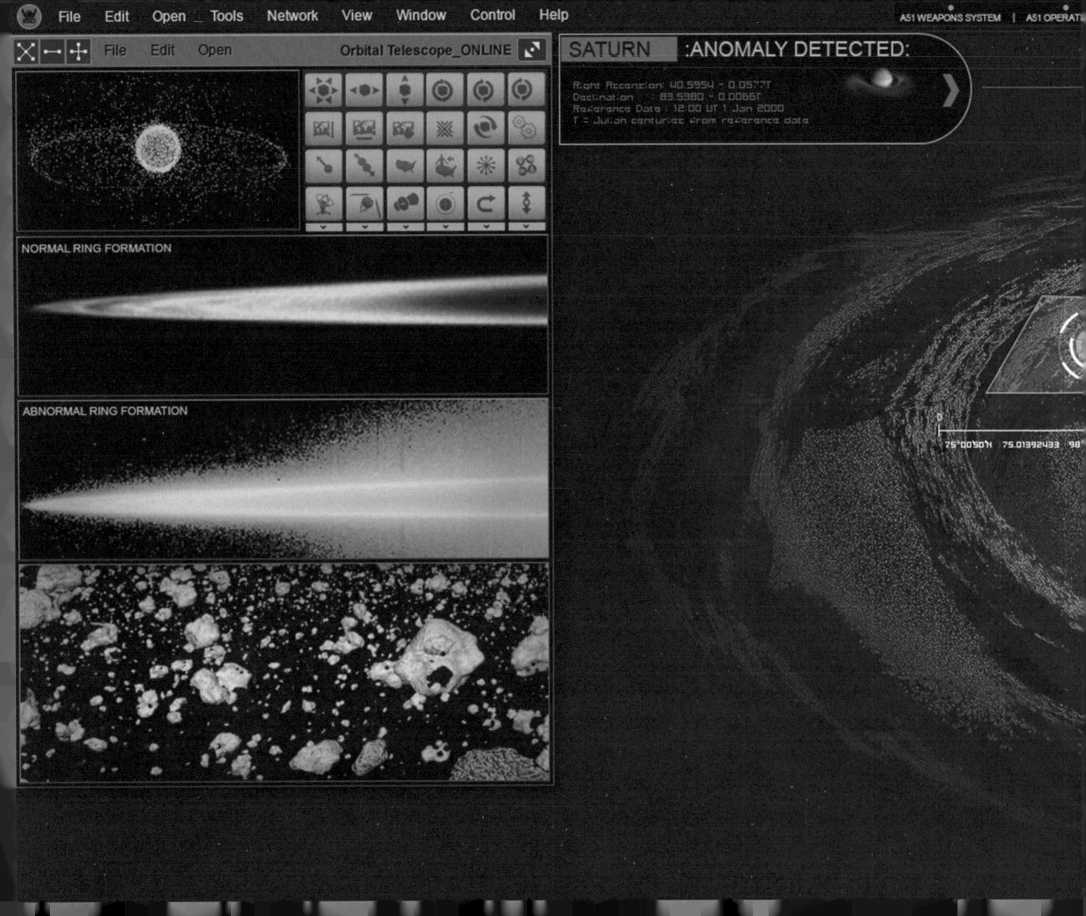

File Edit Open **Orbital Telescope_ONLINE**

SATURN **:ANOMALY DETECTED:**

Right Ascension: 40.5954 − 0.0577T
Declination : 83.5980 − 0.0066T
Reference Date : 12:00 UT 1 Jan 2000
T = Julian centuries from reference date

NORMAL RING FORMATION

ABNORMAL RING FORMATION

75°00'50"N 75.01392433 98°